MONET

Nothing has value except for the hunger one has for it....Things have real or
fictive value only for the need or hunger for them by which we are seized.
...The painter can and must tolerate everything, dare everything, risk
everything; his field is immense, extends to everything, embraces everything,
and has no other limits except first the *stupid* and then the impossible.

CAMILLE COROT

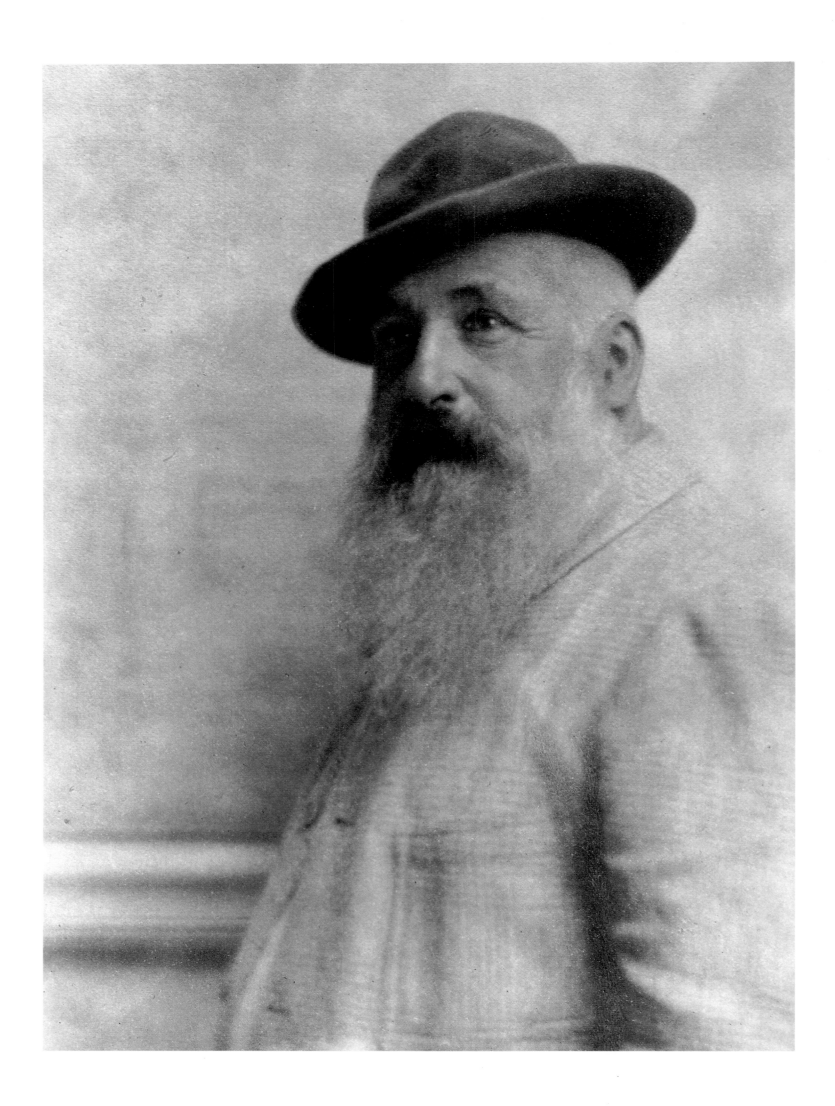

MONET

By Robert Gordon and Andrew Forge

Abradale Press
Harry N. Abrams, Inc., Publishers, New York

Portraits of Monet, December 1899, by Paul Nadar

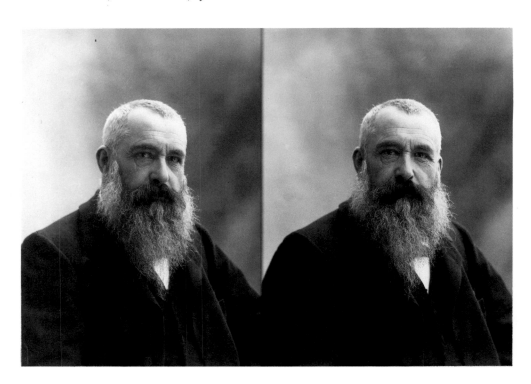

Editor: Robert Morton
Designer: Tina Davis Snyder
Editorial Assistant: Beverly Fazio
Translations from French: John Shepley

Library of Congress Cataloging-in-Publication Data
Gordon, Robert, 1946–
 Monet / by Robert Gordon and Andrew Forge.
 p. cm.
 Bibliography: p.
 Includes index.
 ISBN 0–8109–8091–6
 1. Monet, Claude, 1840–1926—Criticism and interpretation.
I. Forge, Andrew. II. Title.
ND553.M7G67 1989
759.4—dc19 89–159

On page 2: portrait of Monet, October 1905, by Baron de Meyer

Contents

Editor's Note: Titles for Monet's paintings throughout the book are those given by the painter himself or his principal dealer, Galerie Durand-Ruel, Paris, or as they appear in the catalogue raisonné by Daniel Wildenstein. In the text, titles are in French, except in the few cases where a painting has been in a public collection almost since it left the artist's studio and is therefore best known in English. Accompanying the illustrations and in the complete list of works at the back of the book, titles are shown first in French and then parenthetically and in italics in English; where the English title differs from a simple translation of the original, it does so because the museum or collection prefers the form given.

Acknowledgments

The origins of a book lie somewhere between daydream and dream. Its creation, though, requires a great deal of trudging and lugging, and throughout, many people have stood by me.

Andrew Forge comes first, for his text of insight and beauty—a heart-work on all these pictures. Robert Morton was involved from the very beginning. With his good judgment and concern he helped shape this book. My mother, Esther Gordon, my father, Edward Gordon, my grandparents Eva and Joseph Freidlin, and my brother Ron have always been there with good counsel and affection.

Monsieur Charles Durand-Ruel—grandson of the man most responsible for the popular success of the Impressionists—and all the wonderful people associated with his gallery have never failed to respond to my requests. I owe a great debt to them for their generosity. I am also grateful to the owners and directors of the Galerie Bernheim-Jeune, who opened up their extensive archives to my researches. Desmond Corcoran and Martin Summers of The Lefevre Gallery, London, stand out among all present-day Impressionist dealers. Their resourcefulness, warmth, and graciousness have marked me. Their lunches are a tradition.

And most of all, to my lovely Mary Jo, whose blue eyes touch me so very deeply. And to Orange.

I would like to give special thanks to the following:

THE UNITED STATES Bill Acquavella, his father Nicholas, Joan Buck, and staff at the Acquavella Galleries, Inc., New York; Rutgers Barclay of Barclay Fine Art, Inc., New York; William Beadleston and his associates Michael Findlay and Susanna Allen; Emily Berns; James Borynack of Wally Findlay Galleries, New York; Stephan Brown; Pat Ciaffa; Linda Cohn of The Art Institute of Chicago; Cindy Deubel, who was of great assistance in the collecting of pictures for this book; the late Harold Diamond; Ernie Dieringer; Beverly Fazio for her tact, wit, and perception; Richard Feigen and his associate Frances F. L. Beatty; David Findlay; Peter Findlay; Lucien Goldschmidt; Mr. and Mrs. Nathan L. Halpern; Norman Hirschl of the Hirschl & Adler Galleries, Inc., New York; Liza Kirwin; Stephen and Donna Leeb; Pierre Levai of the Marlborough Gallery, New York; Hugh Levin; Nancy Little of M. Knoedler & Co., New York; Barbara Lyons of Rights and Reproductions at Harry N. Abrams Inc., New York; John McCoubrey; Henry Mitchell, "Earthman" of *The Washington Post*; Charles Moffett; Otto Nelson and his wife Marguerite for talent, discretion, and the photography of all the Monet paintings in private collections around the city of New York; the family of Lilla Cabot Perry; John Rewald; Alexander Rosenberg of Paul Rosenberg & Co., New York; Rosenberg & Stiebel, New York; the late Sam Salz, who set a standard for art dealing, and his gracious wife, Mrs. Janet Salz; David and Lisa Schiff for their encouragement; the late Bill Seitz and his wife, Mrs. Irma Seitz; John Shepley; Dee Slack and Robbie Zanger; Charles Stuckey, with whom this project first began; Constance Sullivan; Eugene Victor Thaw; Elsa Weiner; the late John Hay Whitney and his wife for permission to publish the paintings and letters in their private collection.

FRANCE Madame Henriette Angel of the Collection Sirot-Angel; Hugues Autexier and François Braunschweig of the Galerie Texbraun; Librairie Pierre Berès; Mlle. Marie Berhaut and the members of the Caillebotte family; Mary Blume; Maître Bourdon;

Messieurs Yves Brayer and Claude Richebé of the Musée Marmottan, Paris;
Établissements J. E. Bulloz; the late James Butler and his wife, Mrs. Margot Butler;
Michel Castaing of Maison Charavay; Central Color, Paris; Musée Clemenceau;
Mesdames Jacques Arizzoli-Clémentel and James Barrelet-Clémentel; Monsieur Pierre
Arizzoli Clémentel; Jean-Paul Croizé; Madame Desprats and the Service d'Architecture
du Palais du Louvre; David Fox; Robert Gallimard; Alice Goldet; the late Monsieur
Georges Guibon; Noëlle Giret; David Hamilton; Madame Hilaire; Michel Hoog; Didier
Imbert; André Jammes; Madame Labat of the Archives Nationales; Monsieur Armand
Lanoux, Secrétaire Général of the Académie Goncourt; Rémy Lebrun; Monsieur Albert
Le'Gal; Madame Jeanette Leguicher; Aki Lehman; Monsieur and Madame J. P. Léon;
Musée Rodin; Madame Christiane Roger of the Société Française de Photographie;
Roger-Viollet; Monsieur Clément Rouart; Monsieur Denis Rouart; Monsieur Georges
Routhier, his family, and staff for their graciousness and discretion, and the
photography of paintings in private French collections and the Musée Marmottan and
the water-lily decorations at the Musée de l'Orangerie; Robert Schmit of the Galerie
Schmit, Paris; the late Georges Sirot; Maître R. Texier; Monsieur Vadé of the Société
Clause; Monsieur and Madame Michel Viandier; Librairie Jean Viardot.

ENGLAND Timothy Bathurst and the late David Carritt of Artemis Fine Arts (U.K.) Ltd.;
Bruce Bernard; Christie's; A. C. Cooper Ltd. for their high standard as fine art
photographers; Mrs. Pennie Cunliffe-Lister of *Country Life* Magazine; John Erle-Drax
of Marlborough Fine Art (London) Ltd.; Stanley Gillam of the London Library; Bevis
Hillier; John Lewis of the Department of Botany, and the Trustees of the Natural
History Museum, Offices of General Herborium; Lindlay Library; Jill Mathews;
Mathews Miller Dunbar; Jane Roberts; Miss Rose of Maggs Bros. Ltd.; Michel Strauss
of Sotheby's.

SWITZERLAND Ernst Beyeler and Claudia Neugebauer of the Galerie Beyeler Basel;
Marianne Feilchenfeldt; the late Manuel Gasser; Dr. Peter Nathan.

And, in addition: Nico de Jongh, Director of E. J. van Wisselingh, Amsterdam; the
Kuroki/Matsukata families; private collectors who wish to remain anonymous.

ROBERT GORDON

This book was conceived by Robert Gordon. When he proposed that we should
collaborate I welcomed the opportunity to complete some unfinished business with
Monet and at the same time to learn from Gordon's years of research and his
incomparable archive. My first thanks are to my co-author.

Why Monet, I have asked myself. Because no other painter of his stature ever
addressed himself so single-mindedly to the project of making pictures from looking;
or so violently came up against the contradictions that followed from that. The
project—of making art from appearances rather than from pictures and the hierarchies
of human life—is the real watershed between the old order and our own times; and
the absurdity discovered at the center of that project is painting's critique of itself and
its place in culture—a critique that has seemed at times to be ready to condemn
painting to something like silence or blindness. It has seemed to me that everything of
any weight that has been achieved in painting during the last hundred years has been
in some way shaped by Monet—if not by his achievement, then by his failure; if not by
his historical example, then by his myth.

Many voices have been important to me in trying to bring out this view of Monet,
above all the opposing voices of Adrian Stokes and E. H. Gombrich. David Sylvester,
Patrick George, and William Coldstream will recognize echoes of valued conversations
years ago, for which I cannot thank them sufficiently. Like all concerned with
Impressionism, my debt to John Rewald is very great indeed.

I would like to thank the John Simon Guggenheim Memorial Foundation for the
Fellowship that allowed me time to work on the text and to look at a lot of pictures
and places.

I would like to thank Wendy MacDonald Gordon, Kathy Perrone, and Jan
Cunningham for their generous help.

Finally, thanks to my wife, Ruth, whose good judgment and support have, as always,
meant so very much.

ANDREW FORGE

Étretat

When Monet was away on painting expeditions he would write home almost every day. He tells about the weather, about his encounters; he defends himself against reproaches for being so long away from home. Above all he tells about the trouble he is having getting anything finished. Wherever he is, on the Normandy coast, in Brittany or Antibes, in Norway or Italy, the story is the same: first the search for *motifs,* then an explosion of activity with many starts, followed by fury and frustration at the fickleness of the weather, despair at not being able to finish as much as he had hoped, promises of a happy conclusion next week, the week after, reports of work destroyed, his departure again postponed....Day after day he sits down to tell the same story, an incantation of hope and despair. It is rare indeed for his letters to report calm progress. He prefers the darker side, it seems, even if we allow for the fact that he would have more time to write on rainy days.

His painting trips are like voyages of colonial discovery. One senses him pushing forward into an unexplored territory that has to be mapped and subdued. His *motifs* are like unknown, unimaginable treasures to be won only after trial and hardship. Gustave Geffroy, his friend and biographer, first met him by accident on one of those campaigns; both were staying on a remote peninsula on the island of Belle-Île, the scene of the most violent paintings Monet had made up to that point. Geffroy took the painter for a ship's pilot in from the sea, "booted, clad...to face the wind and rain." No doubt Monet would have been delighted. His hardihood is legendary. Cut off by the tide at Étretat, a wave knocks him flying and he scrambles home drenched, his beard full of paint. His whiskers freeze in Norway. In Bordighera his head is roasted. His working day would start at four in the morning usually with a strenuous tramp across wet fields, rocks, or cliffs, not lightly equipped. To what end? What really was the goal of this fierce self-immolating discipline, reminiscent of that of a mountaineer, an explorer, or an athlete?

At Bordighera on his first campaign in a Mediterranean light everything looks so strange to him that he doesn't know which way to look. It is a fairyland, he writes to a friend, and "terribly difficult; one would need a palette of diamonds and precious stones."

Writing to Alice some weeks after his arrival, he admits cautiously that things are going better. "I see *motifs* where I did not see them at first; in fact it is going more easily; I find my first studies very bad; they are laboriously done, but they have taught me to see." But within a few days he is in despair again. He thinks he has been ill. He had been tortured by nightmares, his head has ached all day, he is good for nothing. He had dreamed that he had returned to Paris with all his new pictures and that when he got there he discovered that

all their tones were false, and nobody could make head or tail of the paintings. It is an interesting cluster of fantasies. Painting teaches him to see; but paint itself is inadequate, for what he sees lies beyond the limits of painting in an extravagant world of "diamonds and precious stones." This fantasy can easily turn into nightmare, a falsehood that appalls him and puts him off work. Not for long of course. To miss a day's work is torture. He is indefatigable, obsessed by painting. Nothing stops him for long, least of all physical obstacles or the ups and downs of his own performance.

Inadequacy, difficulty, impossibility—these are the very battle slogans of his campaign. Who or what is to blame, one might wonder, considering his endless hard-luck story: the weather for turning nasty, the season for changing, or Monet himself for insisting on the right to paint the unpaintable? His incantation is touched with superstition. Is he protecting himself from a jealous fortune? Projecting blame onto the weather for his own masterful curiosity and pride? Is he meeting vengeance halfway, like some Marsyas supervising his own flaying?

There is more than a touch of performance in his incantation. He is not only suffering the hardships of open-air painting but watching it all happening to him. These adventures he reenacts consolidate and prove the necessary fiction of his stance. For far too long Monet was rendered as an unselfconscious painting machine. From that position all the discrepancies between what he said he was doing and what he could be seen to be doing look equivocal. But we must accept his complexity. Much of his painting is made from observation. All of it is about observation, Cézanne's much quoted "Only an eye" refers to the role, not the actor. Our prevailing view of Monet—the independent, rugged, no-nonsense outdoor painter at one with his task—is Monet's view also. But to have a view of anything implies distance.

Monet was always aware of himself and his own repute. It was consistent with his tremendous ambition that he should read everything that was written about him and collect all his cuttings, receive the press, give interviews, and tell and retell the stories of his youth. He had a heroic view of his own life and was at pains always to present it in a certain light. When Émile Taboureux, the first of many journalists to interview him, asked to see his studio, Monet exclaimed that he had no studio, that he never had a studio: *"Voilà mon atelier!"* he told him, gesturing toward the Seine and the countryside in front of his house. This was in 1880. Monet had just completed *indoors,* based on studies made outside, some large canvases for the Salon. It was to be many years before he gave up the claim that everything he did was done directly from nature.

Monet was born in Paris on November 14, 1840, the second son of a small businessman who moved to the Norman port of Le Havre some five years later. Here another branch of the family, named Lecadre, had a business as wholesalers and ships' chandlers. Monet's father, Adolphe, joined the firm. The Lecadres were well established, with a large house in town and property nearby at the seaside resort of Sainte-Adresse.

At Le College du Havre, which Monet attended as a day boy, he studied drawing with a professional artist, François-Charles Ochard, who had himself been a pupil of David and who had shown portraits and landscapes at the Salon. (A dedicated teacher, Ochard had a number of pupils who became known as artists, one of whom, Charles Lhuillier, was later to become director of the École des Beaux-Arts at Le Havre and the teacher of Othon Friesz and Raoul Dufy.)

Monet's mother, who was remembered for the great beauty of her singing voice, died when he was seventeen. Relations were bad between father and son and became worse with her death. Monet was eager to leave school without taking his baccalaureate. This his father reluctantly allowed him to do. Monet's part was taken by his aunt, an amateur painter, who was sympathetic to his temperament and who made her studio available to him. Mme. Lecadre corresponded regularly with several artist friends, and she now turned to them for advice. One of these was the well-known painter Armand Gautier, a friend and contemporary of Gustave Courbet. Between them they were able to persuade Monet *père* to allow Claude to continue to practice drawing.

While still at school Monet had discovered that he had a talent for comic drawing and caricature. He now began to exploit this ability, selling his drawings to family friends and to well-known personalities in the city. His style was modeled on the caricatures he copied from the Parisian press. He had an arrangement with a local framer and color merchant named Gravier to allow him to exhibit drawings in his shopwindow. It was at this shop that the decisive encounter took place that, Monet was later to tell his biographers, led to his becoming a painter.

Eugène Boudin had been working in Le Havre and the neighborhood all his life. He had his frames made at Gravier's, and Monet had seen his work there. Monet's account of their meeting has all the ingredients of a conversion story. He had thought very little of Boudin's modest seascapes and landscapes painted directly in the open air. In fact he thought them "horrible, used as I was to the false and arbitrary color and fantastical arrangements of the painters then in vogue." Gravier had recommended Boudin to him, telling him that the older painter would have much to teach him. Monet demurred. Finally one day he

found himself in the shop at the same time as Boudin, and the introduction took place. Boudin was complimentary about the caricatures. But he told Monet that he mustn't stop there: "You must study, learn to see and to paint, draw, make landscapes." Monet resisted the advice, and it was some months before he gave in and, still doubtful, equipped himself to join Boudin out-of-doors. The thought of making paintings like Boudin's "didn't fill me with much enthusiasm."

They went out into the countryside not far from town. Boudin pitched his easel and began to work, watched by a skeptical Monet. Suddenly it was as if a veil had been lifted: "I had understood, I had seen what painting could be, simply by the example of this painter working with such independence at the art he loved. My destiny as a painter was decided."

According to Monet's later account, he now quickly broke it to his father that he intended to make painting his career, and left shortly afterward for Paris. In fact things cannot have happened with quite that dramatic speed. In Le Havre Monet had exhibited some landscapes painted under Boudin's tutelage and had applied to the city for a grant to allow him to study art in the capital. The application was turned down, but the committee's report, which acknowledged Monet's facility, makes it clear that he already had a certain local reputation as a painter.

In any case, he was in Paris by the spring of 1859, living on savings from the sale of his caricatures, armed with letters of introduction to several artists, including Armand Gautier and Constant Troyon, whom Boudin knew well. Troyon commended Monet's facility but told him that he must have a full professional training. He should enroll in a studio, work from the figure, copy in the Louvre, make thorough studies in the open air. He should spend the summer at home and come back to Paris in the autumn and commit himself to a studio. If Troyon had his time over again, he would work under Couture. Retelling all this years later, Monet dismisses this last suggestion. "Of course I never approached Couture."

By the following winter Monet was working in the Académie Suisse, which charged no fees, and according to his reports to Boudin was hard at work drawing from the figure ("It is a marvelous thing"). Meanwhile he was getting to know the city. He frequented the Brasserie des Martyrs, where he was amused to recognize some of the models for the caricatures he had copied as a schoolboy from the Parisian papers. Later he was to say that he wasted a lot of time. But it was a short enough period in his working life; he was not a convinced bohemian.

In the spring of 1861 he had to submit his name for military service. The

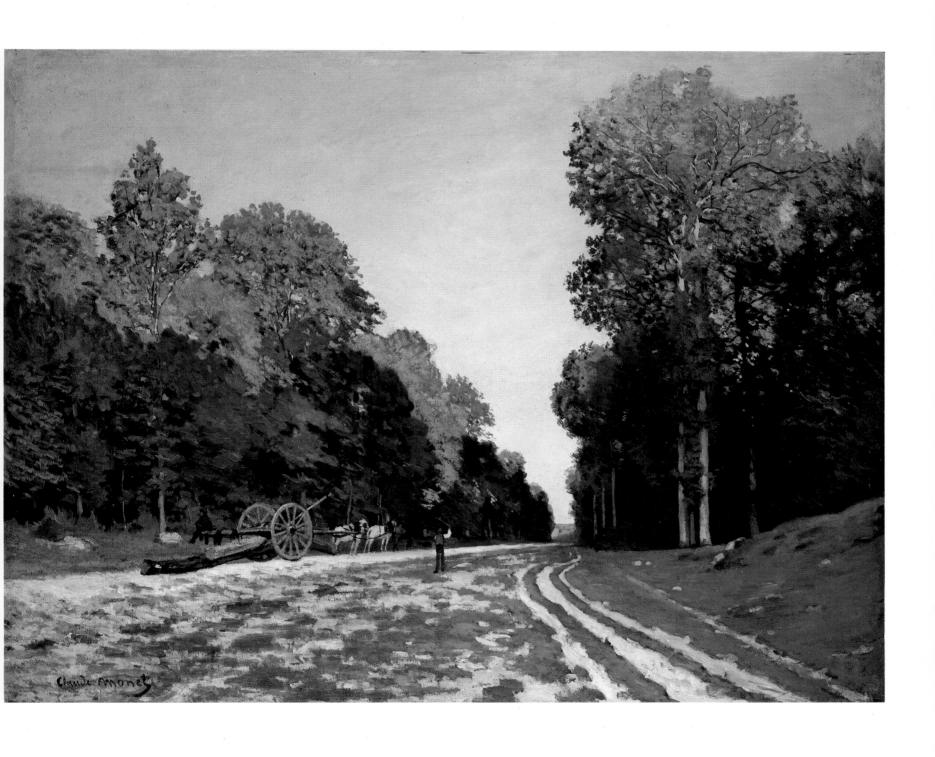

La Route de Chailly à Fontainebleau *(Road from Chailly to Fontainebleau)*. 1864

draft was in the form of a lottery, and he drew an unlucky number. His family offered to buy him out if he agreed to come home and enter the family business. But he refused and enlisted in the glamorous Chasseurs d'Afrique for seven years. As it turned out he served in Algeria for just a year (he later claimed it was five) because he contracted typhoid and was sent home on extended sick leave. While at home in Normandy he made another momentous friendship with an older painter. Johan Barthold Jongkind was working in the neighborhood of Le Havre. Monet had admired his work for some time and accepted the Dutchman's invitation to join him at work. He was later to pay a warm tribute to this passionate and eccentric painter, calling him the "true master" to whom he owed the final education of his eye.

Monet worked incessantly during his sick leave. His aunt, who was watching his progress closely and with a considerable sense of responsibility for his future career, undertook to buy him out of the army on condition that he commit himself to study with a recognized teacher. His father warned him that his allowance would be cut instantly if he acted independently. And so it was arranged. Auguste Toulmouche, a well-known society painter and a recent medalist at the Salon, had married a cousin of the Lecadres a few years earlier. He was now appointed to be Monet's guardian and mentor in Paris. Once again the young painter set off for the capital with studies to show. Once again he was told that he had brilliance, that he needed discipline, that he must study. Monet's mood was now somewhat different. He accepted the advice.

Monet entered the studio of Charles Gleyre in the autumn of 1862. Of all the revisions Monet was to make of his own past, the least endearing is his mockery and denial of Gleyre. This man, the teacher of Whistler, Renoir, Bazille, and Sisley, has become something of a scapegoat for the crimes of conservatism; yet he was neither an academician nor a teacher of the École des Beaux-Arts but an independent. Far from being the complacent blockhead of legend, he was a complex and sympathetic man whose own work caused him the utmost anxiety. Gleyre was particularly interested in landscape, and his studio had a strong record of success in the landscape category of the Prix de Rome. It may have been because of this that Monet chose to work under him; another reason may have been that Gleyre did not charge fees. Gleyre had a reputation as an open-minded teacher who placed the utmost value on individuality. Bazille's letters to his family speak about him with affection, and Renoir was later to make the simple assertion that Gleyre had taught him his métier.

Later in life, Monet claimed that he had left Gleyre's studio only a week or two after he had entered it. Gleyre had reproached him for being too faithful to the model and ignoring the antique, giving Monet the cue to leave: *"Filons*

d'ici!" (Let's split!) But the fact seems to be that Monet was still working in Gleyre's studio when the latter closed it because of poverty and failing health eighteen months later. There is a suspicious similarity between Monet's story and an incident in Zola's novel *L'Oeuvre.* No doubt this episode, like so much in the book, had been based on stories Zola had heard from his painter friends; but by the time they had reappeared in the novel they had gained the character of legends. It is certain, however, that Monet chafed at the thought of tutelage from an established teacher—above all, one forced upon him by family pressure. Among his friends, he never acknowledged Gleyre, and he ignored the customary identification of his teacher when he began to exhibit at the Salon shortly after leaving Gleyre's studio.

Monet's closest friend was Frédéric Bazille, a tall, good-looking southerner from Montpellier who was a year his junior. To satisfy his family Bazille was studying medicine as well as art. He had useful connections in Paris. His admiration for Monet was unstinting, and he helped him repeatedly. In the spring of 1864 Monet had worked in the Forest of Fontainebleau, painting among other pictures *Le Pavé de Chailly,* which was to be shown at the Salon of 1866. Later in the spring he invited Bazille to the Normandy coast for the first time, and they both worked at a farm called Saint-Siméon not far from Honfleur on the opposite side of the estuary from Le Havre. Bazille returned to Paris, and in August Monet was joined by Boudin and Jongkind. Later in the year Monet found himself completely penniless, and Bazille, not for the last time, bailed him out. That winter they shared a large studio in the Rue de Furstenberg overlooking the courtyard of the studio in which Delacroix had worked until his death two years earlier. Both artists were working on the sketches they had made in Normandy, preparing more elaborate versions for submission to the Salon in March. Monet's were both sea pieces, one a view of the estuary of the Seine near Honfleur, the other a view of the coast on the northern side of the estuary, near Sainte-Adresse. Both were accepted and well exhibited, and *L'Embouchure de la Seine à Honfleur* was reproduced in a souvenir album of the exhibition. It was a lively start to the career of a young painter scarcely more than a student. What particularly mattered was that his appearance was recognized by the conservative critic Paul Mantz, writing for the influential *Gazette des Beaux-Arts.* Mantz acknowledged the unknown painter's subtlety of tones, the quality of his observation, his sincerity. He also commented on his lack of finish, missing "that finesse that is to be gained only at the price of long study," but he hardly counted this against a marine painter who was in any case obviously a tyro.

With this comment in mind it is interesting to compare the two Salon

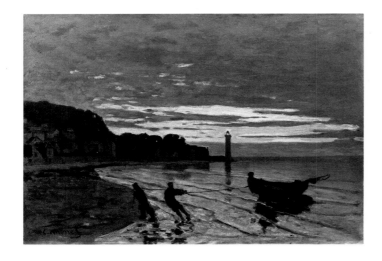 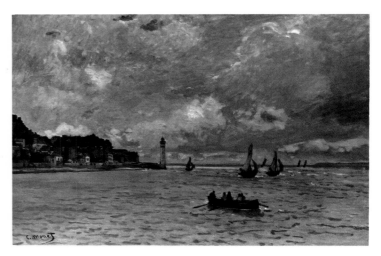

ABOVE, LEFT: Halage d'un Bateau, Honfleur
(Hauling a Boat, Honfleur). 1864

ABOVE, RIGHT: Le Phare de l'Hospice à Honfleur
(Lighthouse at the Hospice at Honfleur). 1864

canvases with the studies on which they were based. The paintings are both a meter and a half long, over twice the size of the studies. Both are rather literal enlargements in which the topographical data are accurately reproduced—the profile of the cliff of *La Pointe de la Hève* and the proportions of the lighthouse relative to the houses and trees at the point at Honfleur are scrupulously repeated. The dominant effect of both paintings is factual and descriptive, but there is also a discreet intention to compose, to give stability and moment to the incidentals of the scene through the geometry of the canvas. The fishing boat at the left of the Honfleur painting tilts its mast to the right, precisely anchoring the left bottom corner of the canvas; the lighthouse itself is exactly placed on the square of the shorter side. Meanwhile, fleeting details like seagulls, lapping waves, and figures on the beach are not only consciously arranged but realized with sharp definition and a focused and sometimes brittle attention. The overall pearly luminosity of the studies, the atmospheric blending of sea and sky, gives way in the larger picture to statements that are more highly differentiated, less drawn together.

When Tante Lecadre was writing to Gautier about the progress of her protégé, she remarked more than once that he seemed to be interested only in sketching. This worried her. She knew enough about the competitive professional world to see that her nephew must play for much higher stakes. Her professional contacts reinforced her opinion: he has talent and facility, things come easily to him; he must settle down to some serious study, to the education that a painter must have. Critics were to tell him much the same thing in print for the next fifteen years. Even his Salon painting for 1866, *Camille,* or *The Woman in the Green Dress,* which evoked a furor of enthusiasm from advanced and conservative critics alike, was subjected to the same reproach. However marvelously the dress was painted, Edmond About concluded after expressing his enthusiasm, this did not make it a picture. A well-written sentence did not make a book. What does a dress matter if the body within it is formless, if the head is not a head, if the hands are nothing but paws?

Thus a matter that had doubtless become highly charged during the painful wrangles with his family, and that, we can well imagine, was used as ammunition in his humiliating struggle for independence, was carried over into the public arena and became one of the key issues around which opinion of his work revolved.

In the criticism of the day, the matter of finish was simply one aspect of a larger question, the crucial distinction between a study *(étude)* and a picture *(tableau).* The distinction was as between native talent and education, between

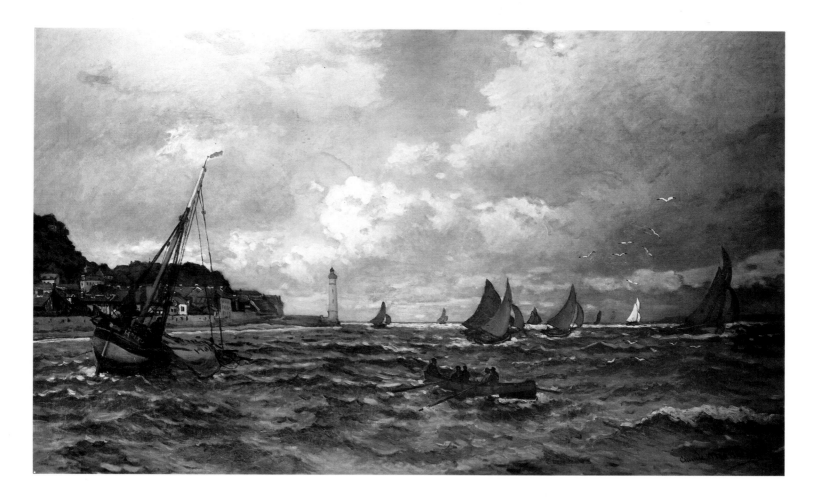

promise and achievement. Admittedly, the values of the sketch were coming increasingly to the fore. Landscape painters like Corot and Daubigny had been exhibiting sketches for some years, but always identifying them as such. Sketches were prized for their charm and freshness, as evidence of the sensitive eye and quick hand of an artist whose claim to be taken seriously must in the end, however, rest on his finished paintings.

With Monet this distinction was perfectly clear; indeed at various points in his life the question of finish became a dominant concern, almost an obsession. But it was a problem that had to be answered on his own terms. The meaning of "finish" had to be redefined, and this redefinition becomes a measure of his ambition and his drive for independence. The stubbornness with which he fights out this battle according to his own rules reminds us of Courbet's defiant assertion to Count Nieuwerkerke, Imperial Director of Fine Arts: "I told him that I was my own government."

Courbet was not only the most powerful painter in the Realist camp, he was also its most aggressive spokesman. He was continually in the public eye—reported, lampooned, feared, and adored. Every move he made against the Salon, the state, or popular opinion had been made in the full glare of public attention. In spite of Courbet's overwhelming egocentricity, every independent artist must have felt in some way involved in his battles. Monet may have first sighted the master of Realism during his own "wasted hours" in the Brasserie des Martyrs. He had been away in the army at the time of Courbet's short-lived experiment as a teacher in the winter of 1861–62, but by the time he was back in Paris the "school" and the manifesto that Courbet had published about his position as a teacher must have become firmly lodged in the mythology of the studios. During the time Monet was with Gleyre and for a while afterward, he was living in the Quartier Latin, Courbet's part of town. By the mid-sixties,

JOHAN BARTHOLD JONGKIND.
Entrée du Port de Honfleur
(Entrance of the Harbor at Honfleur). 1864

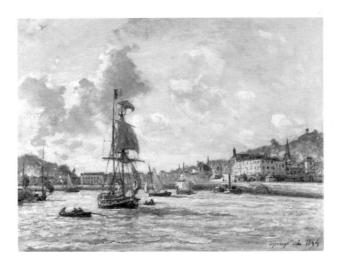

La Pointe de la Hève
(Cape of La Hève). 1864

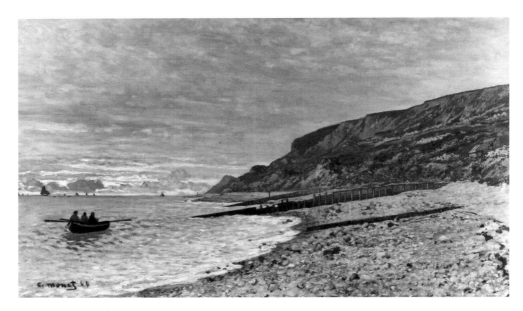

Chevaux à la Pointe de la Hève
(Horses at Cape of La Hève). 1864

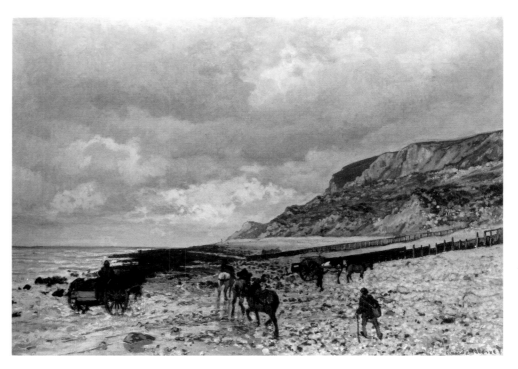

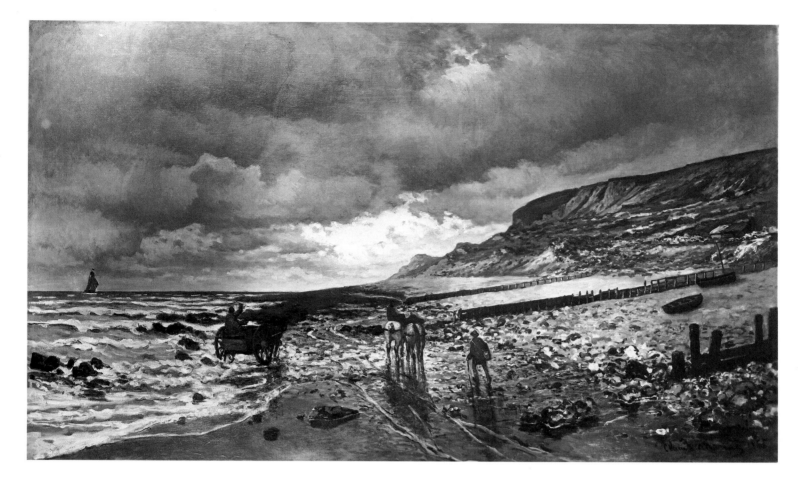

La Pointe de la Hève à Marée Basse
(Cape of La Hève at Low Tide). 1865

Courbet was showing generous interest in Monet's work and there was a degree of intimacy between them.

Courbet's famous letter to his students, so often quoted as the most complete statement of Realism, contains four essential assertions: an artist is his own master; an artist must be rooted in his own time; painting is a concrete art, dealing only with the real and the visible, never with what is only imagined; and beauty is in nature, and that once recognized by the artist it reveals its own expression: "The expression of the beautiful is in direct ratio to the power of perception acquired by the artist."

These assertions are the framework of Courbet's position. Of course they are fictions. But the fictions of a master are the pupil's protocols, and freedom is won through misunderstanding. Courbet had defined the philosophy of a generation. Not surprisingly Monet held to it with far greater consistency than Courbet ever did, deriving different meaning from it and following it to con-clusions that Courbet never dreamed of.

Unlike Courbet's, Monet's painting never addresses the past. Nor does it refer directly to other paintings (the general influence of contemporaries is of course an entirely different matter). With regard to time, if Monet ever did paint beyond the here and now, it is not because he was tempted to look backward in nostalgia or rivalry but because his relation to the present was so immediate that he had no choice but to approach the mystery of the experience of the passing of time. As to Courbet's last point, Monet's whole painting life can be read in relation to it. Nature could be a source of style as well as of subject matter; this was well understood as an ideal by the generation of Barbizon. But with Monet it took on a new, more literal meaning, and a completely new kind of painting was to result from it.

Even before he came to Paris, Monet was committed to landscape over other

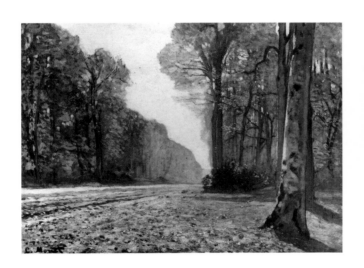

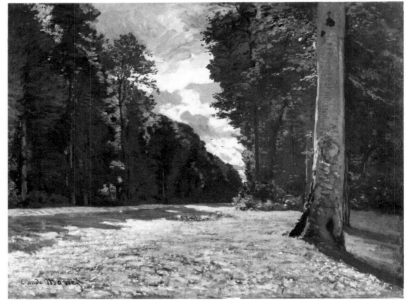

ABOVE, LEFT: Le Pavé de Chailly *(The Road from Chailly)*. 1865

ABOVE, RIGHT: Le Pavé de Chailly dans la Forêt de Fontainebleau *(The Road from Chailly in the Forest of Fontainebleau)*. 1865

genres of painting, and to working in the open air over other methods.

Landscape had become an increasingly important category of painting since the second decade of the century. A special section of the Prix de Rome had been dedicated to it since 1817. The theoretical writings of Valenciennes and Deperthes had given shape to a critical approach along academic lines. Deperthes, whose *Théorie de Paysage* had been published in 1818, restated a traditional distinction between a landscape of high style and a landscape of genre: *le style historique,* for which the models were Poussin, Gaspard, and Claude, and *le style champêtre,* for which the models were the Dutch. This distinction is, of course, merely an extension into landscape of the categorization of style that was central to academic theory.

This theory had become increasingly out of tune with the values of the time. The hierarchy of genres that placed history paintings at the apex of the pyramid reflected a like view of social organization. History painting was the most noble, the most serious branch of painting because it dealt with ideas contained in exemplary scenes from history. These values were expressed in highly controlled linear systems of form and an imagery that assumed familiarity with classical and biblical texts. The artist who practiced them was singled out not for his talent alone but also for his erudition and for qualities that required long training as well as extraordinary skill.

Romanticism projected quite different values. Freedom, informality, color, energy, imagination ("the Queen of the faculties," in Baudelaire's phrase), inspiration, passion seemed to make learning irrelevant. The effect of this shift in values is obvious: although you can tell with certainty whether I can draw a straight line, model a surface, or understand a text from Ovid, there must

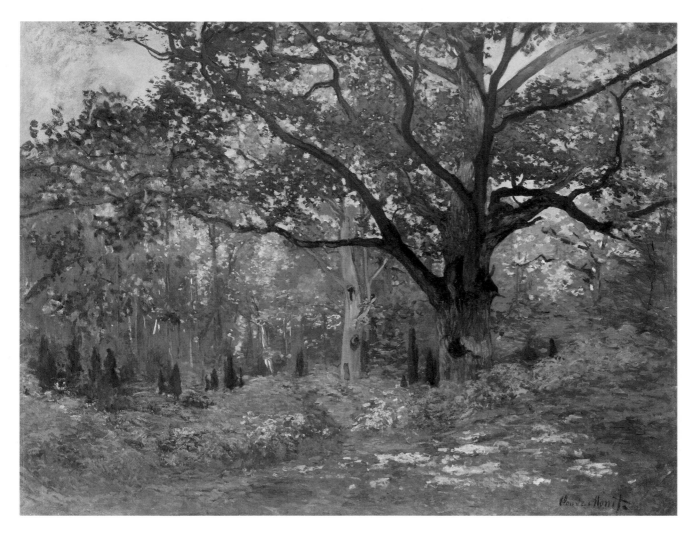

Un Chêne au Bas-Bréau (Le Bodmer)
(The Bodmer Oak, Fontainebleau Forest). 1865

be something vague, speculative, subjective about the way I judge your
imagination.

To the painters of Barbizon nature was a powerful symbol of freedom—
freedom from the city, from style, from convention, from constraint. Nature
became a kind of pantheistic substitute for heroes and saints and gods, and for
the fading aristocratic values they spoke for. Conservative critics, Baudelaire
among them, were to hold that landscape was a less intellectual, more modest
branch of painting than figure painting. What could a landscape mean unless
it had figures in it that told a story or presented a situation? The answer
is worked out in terms of the artist's own presence as observer. Théodore
Rousseau's formulation could stand for the whole school: "By composition I
mean what is inside ourselves, entering as much as possible into the external
reality of things." It is the other side of the same coin as Courbet's "Beauty is in
nature….As soon as it is found, it belongs to art, or rather to the artist who is
able to perceive it. As soon as beauty is real and visible, it has its own artistic
expression."

Nature, then, was the fountainhead of all that was unspoiled, unclichéd,
and unlimited in variety. Nature could unlock whatever originality existed in
the observer. Hence the special weight given to words like "sincerity" and
"naïveté." They were the touchstones by which this transaction could take
place. "I believe," Courbet said, "that every artist should be his own master."
And Baudelaire: "Absolute frankness, the means to originality," and "Despise
the sensibility of nobody. Each man's sensibility is his genius." Monet's drive for
independence is founded on exactly this idea. This is the bond that ties him to
direct painting. He stakes everything on absolute frankness, on the "genius" of

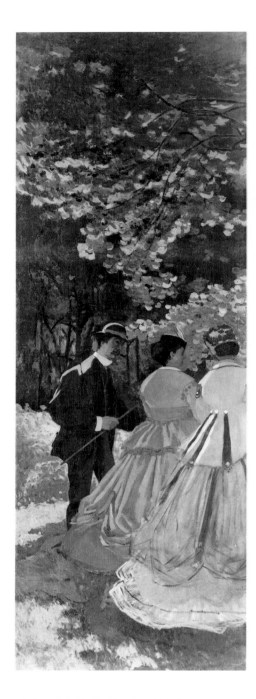

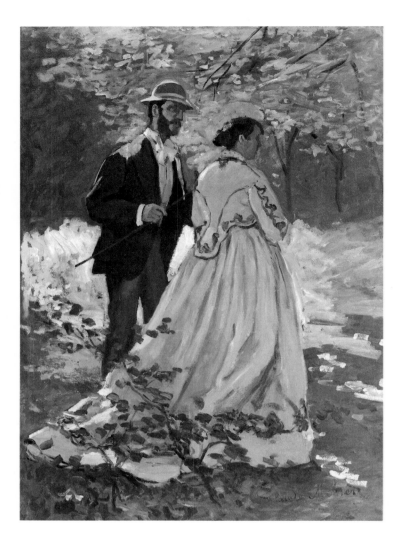

ABOVE, LEFT: Partie Gauche du Déjeuner sur
l'Herbe *(Left Section of Luncheon on the Grass).*
1865

ABOVE, RIGHT: Les Promeneurs *(Bazille and
Camille).* 1865

Painting Le Déjeuner sur l'Herbe *was a heroic
effort for Monet, a measure of his tremendous
youthful ambition. It is central to the Monet
legend, and the painter had great affection for
it. In 1904, in response to his dealer Durand-
Ruel's desire to bring some guests to his home,
including the German art dealer Bruno Cas-
sirer, Monet cautioned:*
Those gentlemen may come Thursday, the day
after tomorrow, but I must warn you that if you
want to talk about one of the two large can-
vases that are hanging in my studio, there is no
hope, they are there and there they will remain.

his sensibility. But the limits to "simple" spontaneity are cruelly enforced. It
cannot be simulated without becoming something else—a fact of which Monet
was supremely aware, in contrast, for example, to Sisley. What sets him apart
from any other pleinairist is the fact that when he has reached the apparent
limits of the approach, instead of withdrawing from it or changing direction he
allows it to transform his concept of a picture.

The Green Dress had been painted expressly for the Salon and, it is said, in
only four days. Monet was determined to maintain the impetus of the previous
year's success. He had hoped to show an enormous figure composition, a
canvas that would meet the criteria of the Salon *tableau* in the fullest sense but
that would also be a challenging manifestation of his position. The audacity of
what he attempted is breathtaking. Clearly he was modeling himself and his
work on Courbet and on the great figure paintings of the fifties with which
Courbet had imposed his intentions (it is worth remarking that Courbet had
been working in Paris for ten years before the first of his major compositions,
After Dinner at Ornans, had been seen at the Salon; Monet had been out of
Gleyre's studio for two).

Le Déjeuner sur l'Herbe was to be approximately fifteen feet by twenty, as
large as Courbet's *L'Atelier.* There were to be twelve life-size figures—a party
of picnickers in the Forest of Fontainebleau. If the scale and ambition of the
project were equivalent to Courbet's, the more immediate model was Manet,
whose *Déjeuner sur l'Herbe* had been the scandalous center of attraction at the
Salon des Refusés in 1863 when it had been exhibited under the title *Le Bain.*
But Monet's picnic was to be far more literal and mundane a scene than
Manet's, without old-masterish connotations, pictorial irony, or complicated

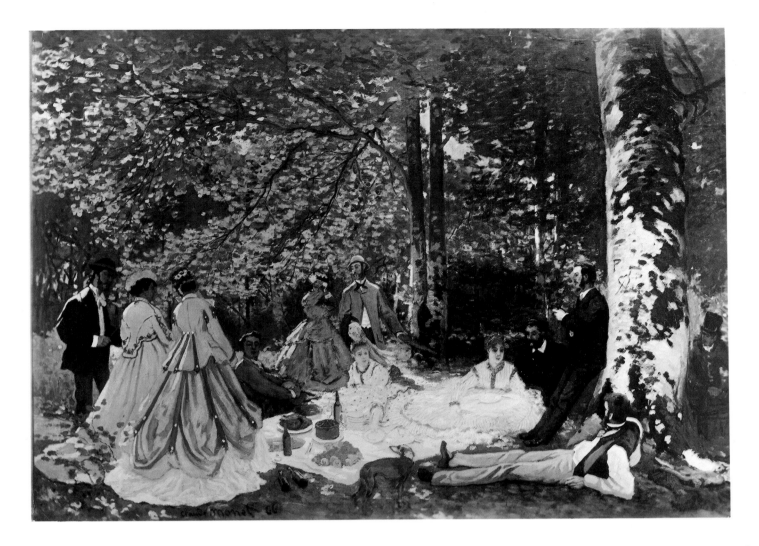

erotic overtones, true to the spirit of "sincere" landscape painting; an observation from real life, but on a monumental scale.

The project absorbed him completely. "I can no longer think of anything but my painting, and if it doesn't work out, I believe I will go crazy," he wrote to Bazille in a letter pleading with him to keep his promise to join him at Fontainebleau and act as model. Monet's procedure was to be along normal academic lines, which included direct studies in the open air, a complete sketch of the composition on a reduced scale, and the final work to be done in the studio.

He had been painting in the forest all summer. The few drawings we know that are connected with the composition suggest that his conception of the group began to form within a space derived from one of his forest *motifs*, a long perspective of a road through the trees such as *Le Pavé de Chailly*. But the deep perspective is closed up, its long diagonals becoming elements in the pyramidal arrangement of figures in the foreground. We are in a forest glade with trees on every side; in place of the road the picnic cloth holds the center. The scale is transformed by the figures grouped around the cloth or lounging against the trees. The models were friends and companions from Gleyre's studio: Sisley is thought to have posed for one of the figures, as did another painter friend, Albert Labron des Piltières. Bazille was used in a variety of roles. Among the women was Monet's new companion, Camille Doncieux. In the final version of the work Courbet's features seem to be present in the burly bearded figure in the center. For a long time the story was that the ultimate failure of the painting was due to certain discouraging remarks Courbet made about it. But there is no evidence that he saw it at Chailly. He did visit the

Study for Le Dejeuner sur l'Herbe *(Luncheon on the Grass).* Begun in 1865, signed and dated 1866

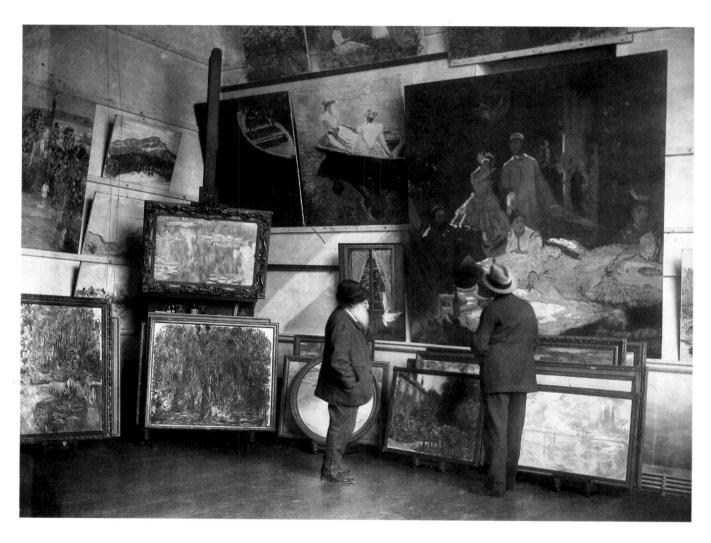

Monet showing the central fragment of *Le Déjeuner sur l'Herbe* to the Duc de Trévise

On his eightieth birthday, in 1920, Monet was visited by the Duc de Trévise. During a tour of his second studio, the artist proudly showed off the large central fragment of Le Déjeuner sur l'Herbe *to his distinguished visitor, who later recounted Monet's story of the painting in a magazine article:*

…the earlier one is a *Déjeuner sur l'Herbe* that I had done after Manet's; I proceeded, as everyone did then, with small outdoor studies and composed the whole thing in my studio. I'm very fond of this work, so incomplete and so damaged; I had to pay my rent and gave it as security to the landlord, who rolled it up in his cellar, and when I finally had enough money to get it back, you can see how it had had time to rot.

studio in the Rue de Furstenberg during the winter, and Bazille reported that Courbet was "enchanted" by the big painting, which Bazille predicted would be a dazzling success at the Salon.

The project stretched Monet to the limit of his powers. At the very beginning of the summer of 1865 he had been incapacitated by a leg injury. Then there had been Bazille's temporary defection, which had dragged on as he completed work of his own in Paris. When he finally joined Monet in August, rain held up work out of doors. Returning to Paris, Monet worked on the final version, and he was still struggling to resolve it in December when Boudin reported to his brother, "Monet is finishing his enormous *tartine,* which is costing him an arm and a leg." Perhaps the most serious physical blow to the project came when Monet had to move out of the studio in the Rue de Furstenberg. He and Bazille moved across the river to separate and much smaller premises. By the time the Salon deadline had arrived in March the painting was still not ready, and Monet submitted one of the large canvases of the road through the forest and the full-length portrait of Camille, painted at the last minute.

Le Déjeuner sur l'Herbe, therefore, was never seen by the public. The later history of the picture is sad. Monet kept it for years, then in 1878 had to leave it behind in Argenteuil with a landlord to whom he owed rent. It was now rolled up, and by the time he could retrieve it six years later parts had been ruined by damp. He cut out two fragments—the central group and the standing figures on the extreme left. After his death the central group was again cut down, for photographs of it hanging in Monet's studio at Giverny in the last years of his life show more than is now to be seen.

Our understanding of the picture is based on the sketch, which Monet sub-

24

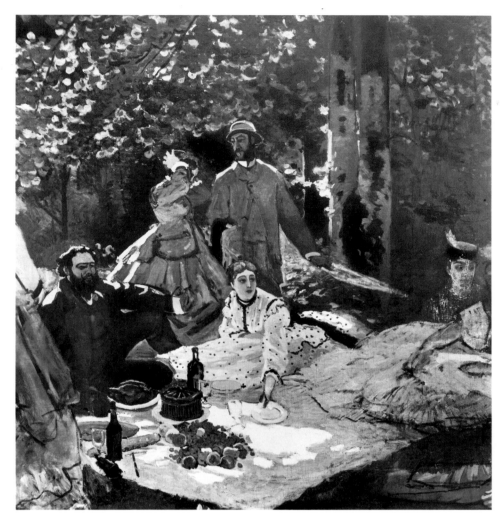

Partie Centrale du Déjeuner sur l'Herbe
(Central Fragment of Luncheon on the Grass).
1865

sequently reworked, signing and dating it 1866. It was bought in the seventies by Monet's friend and patron, the singer Jean-Baptiste Faure, later passing to the Schoukine collection in Moscow.

The figures in the *Déjeuner* are rather like people who have been arranged for a photograph, caught halfway between posing and getting on with the slow ritual of the picnic. Apart from the woman in the center, who offers a plate, nobody is doing anything much: there is no sign of conversation, no expressive gesture, not even a glance exchanged. The picnic cloth is what brings them here and makes sense of the scene. On the other hand, the wooden deportment of Monet's figures does not betoken indifference or absentmindedness. It expresses a vision that is cool, even, taking all that comes with an unshockable disengagement; a specifically modern posture that gives primacy to the eye.

Context is everything. In contrast to the low key of the human event, its calm ordinariness, the action of the light is violent and spectacular. The sun beats down through the trees, splitting the whole scene into fragments of light and shade. The light turns the leaves of the trees into mottles of green and gold. The leaves splinter the sky into blue shards. The figures are seen in patches. Light explodes over the head and shoulders of the man in the center and rakes the tree trunk on his left like a flame. Its reflection is thrown up from the white linen on the ground, blanching the faces of the girls, reducing the items of the picnic to a series of color blocks to which the names "chicken," "cake," "fruit," "bottle" can just be given. On the forest floor splashes of sunlight join with the mottle of dried leaves and tufts of grass.

The conjunction of these two features—the neutrality of the situation and the challenging violence of the light—makes it clear what Monet was attempting in

After retrieving the canvas, Monet cut off the relatively undamaged left-hand portion of the painting and the rotted right side. The central fragment, from which he removed parts of the top and bottom, remained with him until his death. At that time the painting measured 248 by 244 cm. These dimensions are confirmed by the inventory of Monet's home and studios in the archives of the Galerie Bernheim-Jeune, Paris. The photograph of the painting reproduced above was made in 1933, seven years after Monet's death. It was provided by Paul Rosenberg & Co., New York, whose gallery register affirms the dimensions given in the inventory. By comparing the photograph with the color reproduction of the central portion as it exists today (page 27), it is clear that at a later date, and by some unknown hand, the painting was once again cut down.

this vast undertaking. It was something as different from Courbet's earthy social analysis as it was from Manet's sophisticated reflections on the erotic in modern life. Monet was trying to present on an exhibition scale that particular area of painting that was specific to the direct study. He was trying to monumentalize the syntax of a sketch.

What went wrong? The left fragment of the large painting, now in the Jeu de Paume of the Louvre, perhaps contains a clue. By committing himself to this way of looking at the world in terms of light, Monet was relinquishing the strongest resource in the artist's armory: the power of drawing. The point can be illustrated by looking at the shoulder of the man in the Jeu de Paume fragment. All previous theories of drawing would have seen the meaning of this passage as being determined by the solid form of the shoulder. This would have given a logical sequence to the passage from light to dark. Light would be valued first for the way it explained the form; it would be an adjunct to drawing. But Monet sees that patch of light as freestanding. Its value is determined by its relationship with other patches of light in other parts of the picture. Its shape is almost incidental; it is simply one part of a general mosaic of light. What this boils down to is that this individual patch has to be thought of as flat, on equal terms with every other patch in the painting. This is not to claim that Monet was painting like Matisse; it is not a flatness deriving from a conviction about the flatness of painting as such but rather the application of a distant, landscape view of relationships to a passage that would up till now have been thought of above all as a problem of drawing. What else could that patch be but flat, given that it is not drawn from a center?

This internal flatness of the elements out of which the painting was made works very clearly on a certain scale. It is close to the code of the photograph, which records in an unbroken sequence the various patches of luminosity exposed to the sensitized plate. But to enlarge it to life-size was to land oneself with an image that hardly made sense. For there had been a very real and practical connection between the small scale and the elliptical idiom of the direct sketch, over and above the typical condition that it was done out of doors and very fast. In reading the sketch the eye naturally assumes a connection between the extent of the picture surface and the angle of vision it describes. If it can be scanned quickly, taken in at once, the connection between it and the artist's cone of vision can be imaginatively sustained. But once that connection has been broken, once the sketch has to be looked at piece by piece, all those condensations and shorthand formalizations begin to attract attention to themselves. They become opaque, in the way that a vastly enlarged detail of a Rembrandt or a Hals becomes opaque, making one wonder how it could ever

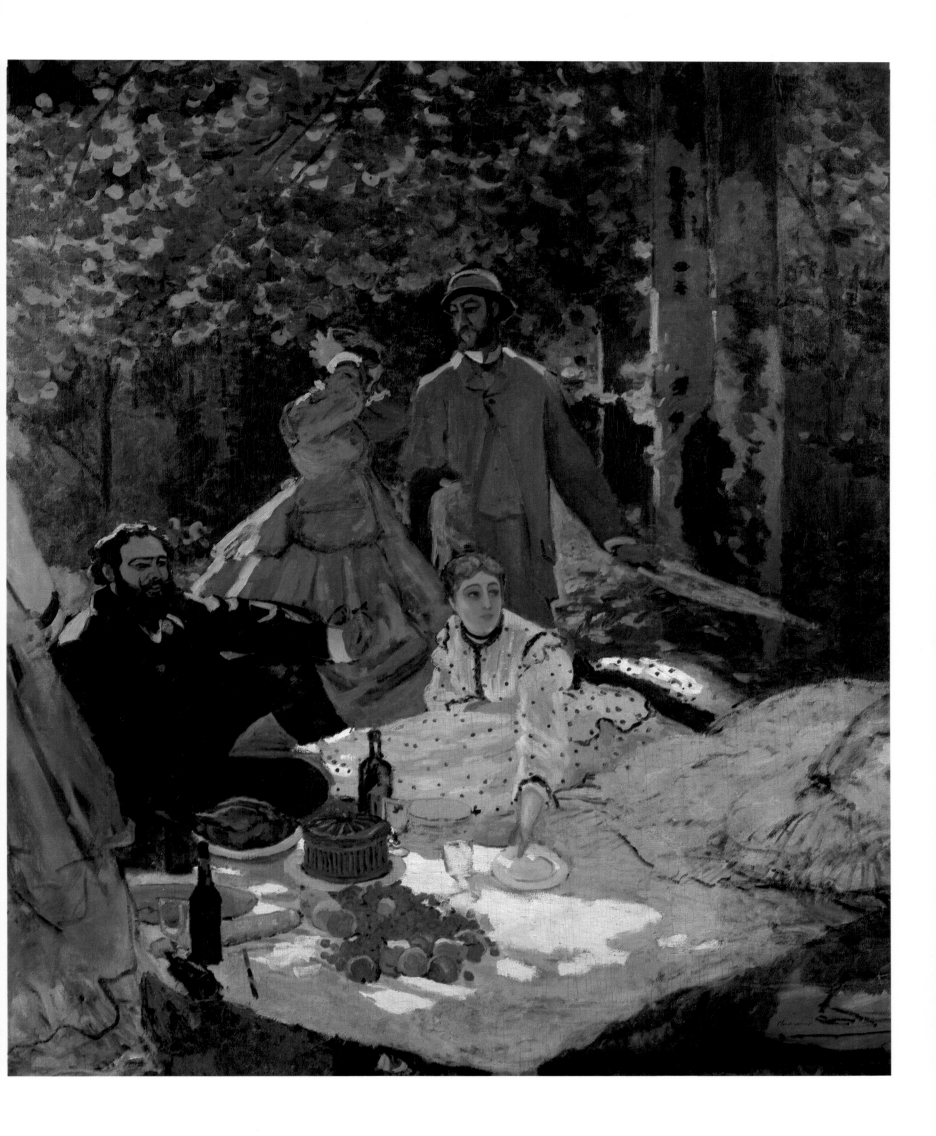

have signified an ear or a hand. To read *Le Déjeuner sur l'Herbe* in the sense in which it was conceived, one would need to look at it from an enormous distance. Monet, interrupted in his work by having to move his studio, the deadline approaching for the Salon, must have felt himself floundering. His brilliant studies enlarged to a flatness that was beyond credibility.

One senses something of his despair in the reworking of the Jeu de Paume fragment. In the redrawing of the nearest woman's skirt, he seems to be trying to remind himself of her three-dimensional presence. At the same time, he clings to his outrageous project. She shall be there as one block of color among others—or not at all.

The following spring Monet returned for a second bout with the project of a full-size Salon figure composition founded on the syntax of the sketch. This time it was to be on a smaller although still ambitious scale. The *Femmes au Jardin* is two and a half meters high against the estimated four and a quarter of the *Déjeuner*. The project was to carry the picture through on the spot, and Monet rigged a special easel over a trench so that he could lower the canvas far enough to work on the upper part of it. He saw to it that there were models on hand. Far from withdrawing from the difficulties encountered with the *Déjeuner*, he was pushing the idea to an even more extreme point. At least the year before he had remained true to the traditional procedure of working from studies to the sketch to the finished work. Now, in planning to carry the whole thing through in direct contact with the subject, he was having to face the contradictions of scale in a way they had never been touched on by any painter.

He worked in the garden of a house he had rented in Ville-d'Avray, near Paris. But again the original plan was compromised by circumstances. When his credit ran out, Monet had to beat a retreat, leaving behind a number of canvases that he slashed to prevent their being sold. He was still working on the painting the following January in his lodgings in Le Havre, where the painter Dubourg saw it and reported on it in a letter to Boudin.

It was refused by the Salon. Bazille bought it for 2,500 francs, to be paid in monthly installments. After his death in the Franco-Prussian War, his family gave it to Manet in exchange for a Renoir portrait of their son. Manet returned the big painting to Monet after some sort of quarrel. It remained in Monet's studio until 1921, when it was bought by the state.

As a marine painter, a landscape painter, or a portraitist Monet was acceptable to the Salon committee. The *Femmes au Jardin* made the extent of his ambition clear. The doors were closed. The rejection was a stunning blow and marked the lowest point of his fortunes to date.

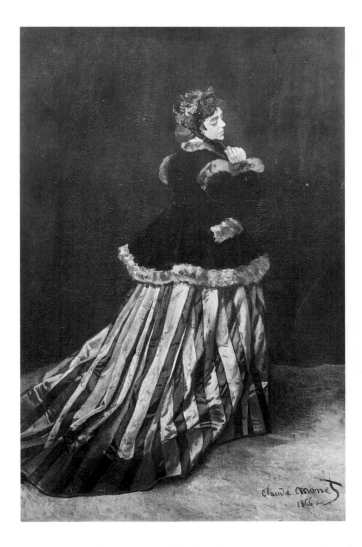

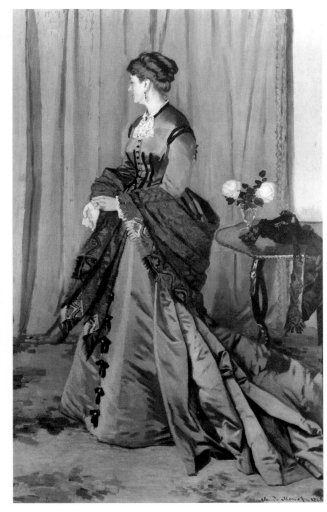

Although *Femmes au Jardin* is a genre scene like *Le Déjeuner sur l'Herbe,* it has even less by way of incident than the earlier picture. Has it a remote ancestor in Courbet's *Demoiselles au Bord de la Seine?* If so, none of the carnal suggestiveness of that painting has passed over. Two proposals have been made for the sources of the Monet: a photograph of Bazille's sisters that he had shown Monet, and a costume illustration from one of the many fashion magazines of the day. And indeed the picture has just that feeling of daydream, of a glimpse of bourgeois arcadia that such illustrations have, but here raised to a level of poetry in which the flowers, the dresses, and the beautiful women augment the timeless sunlight and only Camille's melancholy eyes from behind her bouquet contain the slightest hint of mortality.

What would it mean to paint such a scene directly? Obviously it is not within the range of any painter to carry it through by a single act of virtuosity. Geffroy told the story that when Courbet visited the younger painter and found him not working because the sun had gone in, he asked him why he did not get on with the background. This is taken as an instance of the breach in understanding between Courbet and the generation of the sixties, with their new concerns. It is supposed to show that Courbet couldn't understand that Monet's real concern was with the ensemble, not with individual parts. But if this had been all that Monet was attending to, it seems no less curious that he was able to work with parts of that ensemble continually coming and going. Camille, who posed for three of the figures, could not have been in three places at once. Did she pose for studies, now lost? Did Monet paint in the garden when she was not there? And what exactly was he doing in his hotel room in Le Havre?

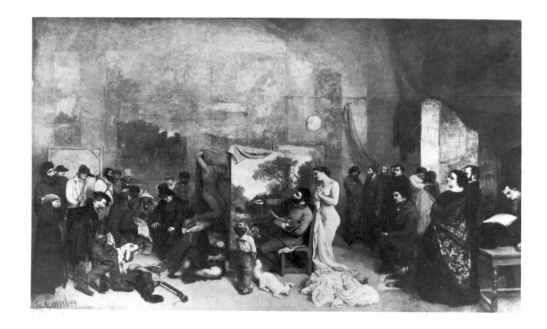

GUSTAVE COURBET.
L'Atelier du Peintre, Allégorie Réelle,
Déterminant une Phase de
Sept Années de ma Vie Artistique
*(The Painter's Studio, a True Allegory, Defining
a Seven-Year Phase of my Artistic Life).* 1854–55

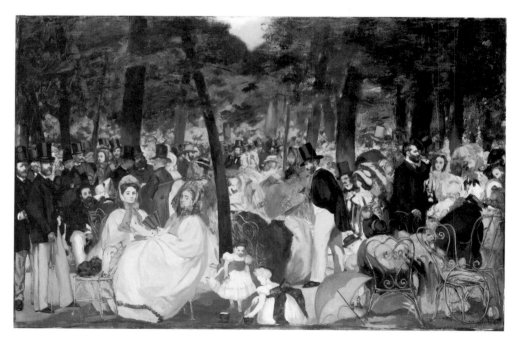

ÉDOUARD MANET.
La Musique aux Tuileries
(Concert in the Tuileries Gardens). 1860–62

OPPOSITE: Femmes au Jardin *(Women in the Garden).* 1866

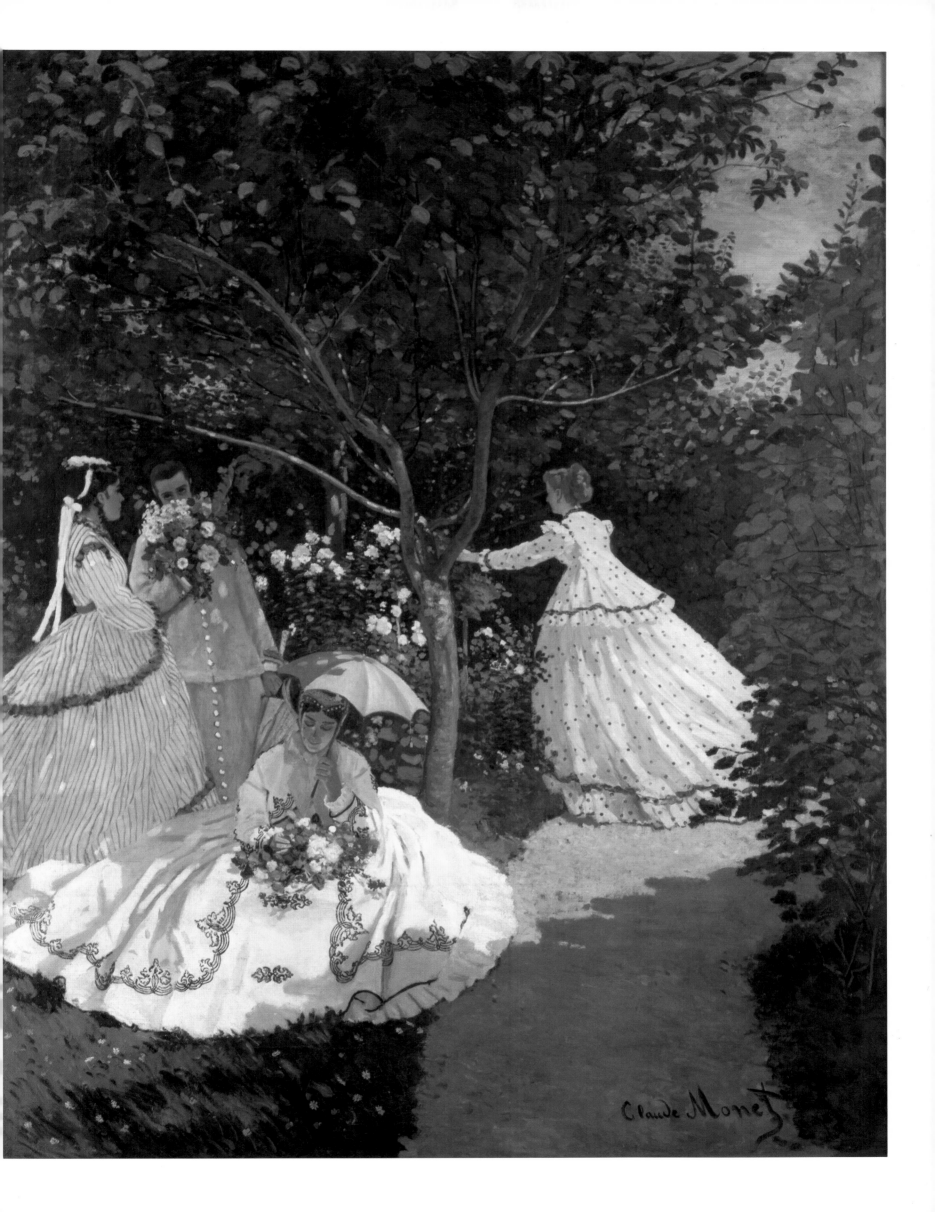

Questions like these remind us of the complexity of the project and the subtle tension that exists among learning and looking and remembering, between the concept of the undertaking as *picture* and as *method*. We must never lose sight of the fact that Monet's (or any painter's) claim to be painting what he sees is a figure of speech, a declaration of bias, an enthusiasm, a self-imposed discipline, a polemical point—all this rather than a statement of literal fact. For a painter can only register what he sees in terms of what he already knows. The degree to which he can bring new data into his painting rests as much as anything on his ability to open up and render plastic the picture types he knows.

In the *Femmes au Jardin* Monet's conception of his subject is reshaped by the lessons of his own *Déjeuner sur l'Herbe*. He is minimizing the contradictions between the scene and the painting; we feel that he is looking for a concordance between his flat color marks and what they depict.

The *Femmes au Jardin* appears to have been composed on the canvas. A dark ground shows through certain passages, though it is not clear whether this was a uniform dark tone applied over the priming or whether what we see are traces of a brown underpainting. In any case the lighter tones of the painting can be thought of as marching forward from that dark bass. The trees at the back of the garden form a dense screen of darkness in which the only openings are the passages of sky that peep through among the leaves. In contrast to the deep penetrations into the heart of the forest that Monet had attempted in *Le Déjeuner sur l'Herbe*, here the depth of the foliage is built up in closed layers, from the darkest green-brown similar in value to the bass note of the canvas, forward into the gold-greens of the bush on the right. This simple and powerful progression of green, in which each plane is stated in a new order of foliage, is paralleled by the simple order of light. A single, more or less unbroken bar of sunlight strikes diagonally across the garden, catching the woman in the spotted dress, the little fruit tree, and Camille settled on the grass, her head shaded by a parasol. The path is split into a brilliantly luminous rose-pink and a reddish violet shadow. The two standing figures to the left are in the shade of the tree; but there is a hint, a tremor across them, that tells us that the foliage is not so dense there and is more of a filter than a barrier to the light. And such is the force of its reflection off the warm path and Camille's dazzling dress that it seems to irradiate them in an even glow.

Unlike the earlier painting, here there is no place where the effect of light is to disintegrate. There is no equivalent to those violent shards of light that seem to be wrenched from the surfaces that support them. On the contrary, each form, each entity, whether it be an entire figure or a run of leaves, dark green

against the rose-pink of the path or gold-green against the dark green of the distant foliage, is allowed to stand out with simplicity and directness against its ground. The light on the heads is such that there are no abrupt shadows: the light on the face of the seated Camille is even, the warm glow falling downward through the parasol balanced by the cooler reflections up from her outspread skirt. The four dresses are all pale, summery, and with the exception of the tan suit carry a hint of transparency. Their shadows can be seen as modulations—from creamy white into lilac and rose and blue—in which their purity of color is fully sustained.

Throughout the painting the flat, uncentered drawing of Monet's landscape approach is supported by the material he is working with, rather than working against it. His flat touches of the brush, the units out of which the picture is built, are at one with what they designate, and this concordance is all the stronger for the nature of the items described. Can there ever have been a painting in which such an array of blobs, dots, stripes, beads, buttons, petals, and leaves play together with such effect? The bouquets, the flowerbeds, the dresses, and the trees are all called on to contribute their rhythms to the surface of the painting. For example, traces of the scalloped pattern, black on white, that embellishes the border of the dress of the seated Camille are followed around the profile of her arms and shoulders, abruptly flattening their form. An exactly similar effect derives from the flowers, especially the scarlet roses, geraniums, and gladioli. The power of their saturated color is such that one cannot tell whether they are in light or shade, nor can they be exactly located in depth: their brilliance overrides the tonal system of the picture. Their part is to form clusters of vivid color that set a dream of heat and fragrance between the eye and the architecture of the illuminated space. Neither of these phenomena—the broken embroidered pattern nor the vivid red flowers—was likely to have been embraced so joyfully by Monet unless he had recognized and courted the effect they had on the structure of the picture.

If the *Déjeuner sur l'Herbe* had been undertaken in a certain spirit of rivalry with Manet, the *Femmes au Jardin* reflects his influence at a much deeper level. Manet's complex innovations as a figure painter are epitomized in the way he ignores the conventional passage in a form from light to dark through a half tone. Instead of placing his subjects in a raking light in order to bring out their tactile plasticity, he presents them as if the light was coming from the same direction as his glance, giving an unprecedented emphasis to the subjects' quality as simple, seen shapes, unbroken by light. This aspect of his painting, with its novel directness, was of the greatest importance to Monet, showing him a way to organize the intractable flatness that followed from

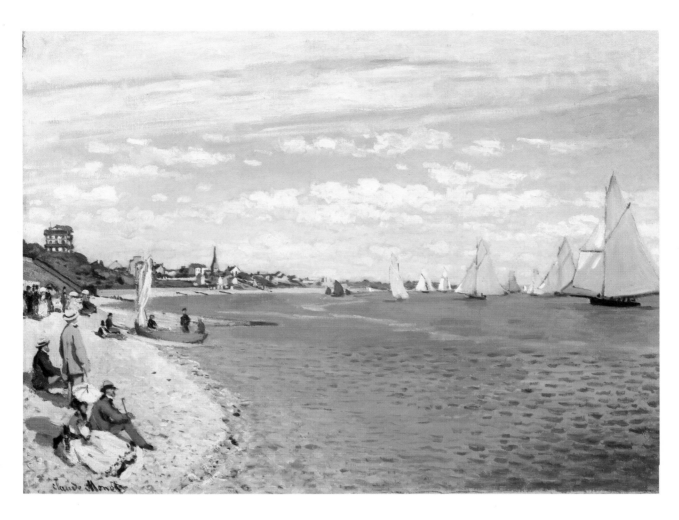

painting large figures in the language of the sketch. In the *Femmes* he does not allow the light to fragment. But because he is concerned with a particular effect of sunlight coming into the picture at an angle (and not with a controlled studio light like Manet's) he has to arrange things rather carefully to avoid violent effects of chiaroscuro. The angle of the parasol plays its part in this, as does the reflective whiteness of the seated Camille's dress and the placement of the two standing figures in the shade.

The two artists had been linked ever since Monet's two sea paintings had been noticed at the Salon of 1865. This was the Salon of Manet's *Olympia,* a painting that had thrown him yet again into the center of scandal. Certain critics had amused themselves on the subject of the similarity of the painters' names: the story was that Manet thought he was being made fun of, and for some while he had avoided meeting the younger artist. They were finally brought together by the critic Zacharie Astruc after the Salon of 1866 and became fast friends.

The line that runs from the Courbet of *L'Atelier* to the Manet of *La Musique aux Tuileries* and from Manet to the Monet of *Femmes au Jardin* is one of the most mysteriously pregnant in the whole of painting. Somehow along this line Realism, the project of an art based on external reality, turns itself inside out. Courbet shows himself in his studio performing at the easel, the center of a world of admirers and picturesque companions. Manet, in his *La Musique aux Tuileries,* appears at the very fringe of the crowd, one figure among the many. people loitering around the bandstand. As for Monet in the *Femmes au Jardin,* he is standing at his easel with pulleys in the garden at Ville-d'Avray. We sense his presence, the presence of his eye, in every mark, every accent, every move

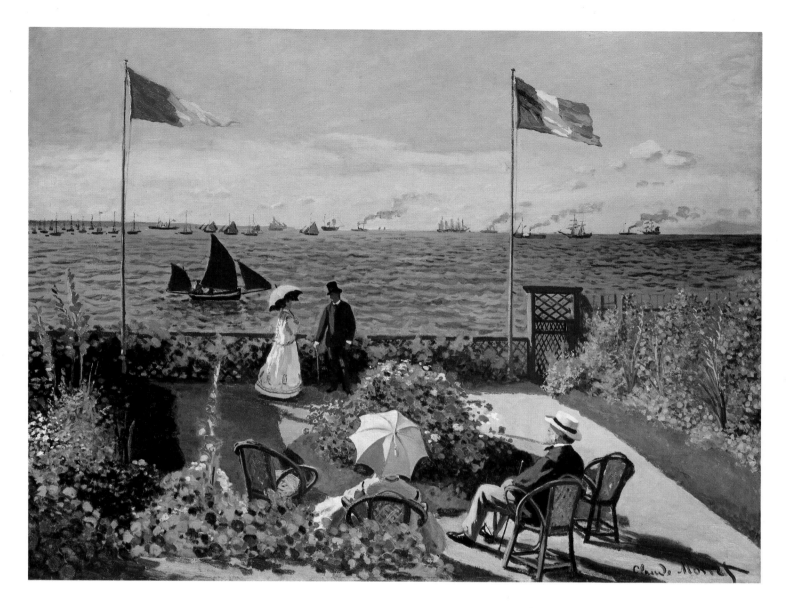

Terrasse à Sainte-Adresse
(Terrace at Sainte-Adresse). 1867

in the painting. We cannot wish it away: it determines everything. The very material out of which the painting is made has been garnered by it. Infinitely less complex than Manet, with none of his historical irony, Monet is far closer to Courbet in the directness of his appetite for the physical world. But he is Manet's contemporary and accomplice. The aestheticizing, detaching power of Manet's example is inescapable, for Manet's flatness is surely a celebration of visibility itself.

Monet's relations with his family were tense. Tante Lecadre was still sending him a small allowance. She was proud of his success with the *Green Dress* but disapproved of his alliance with Camille. He spent the winter at Honfleur, where, besides working on the *Femmes,* he painted a large canvas of the harbor with fishing boats. He went back to the farm where he had stayed with Bazille three years earlier and painted in the country lanes, sometimes in the snow. These were early instances of a lifelong procedure by which Monet would go back to places where he had worked before and paint them again under changed conditions.

Both his submissions to the Salon of 1867, the *Femmes au Jardin* and *Le Port de Honfleur,* were refused by a particularly hostile committee. This was the occasion for the extraordinary remark that Monet later attributed to Jules Breton: "It's precisely because he's making progress that I voted against him." Monet made arrangements with the dealer Latouche to hang the big garden painting in his window in the Rue Lafayette.

It was an important moment to be in Paris. There was a second Exposition Universelle—the first had been in 1855—divided between the Champs-Élysées

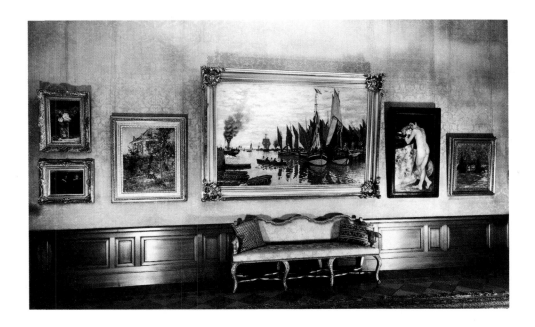

The picture gallery of the Arnhold residence, Berlin

and the Champ-de-Mars, with large displays of art in both sections. Repeating his experiment of twelve years earlier, Courbet presented his work in a specially built pavilion, this time on the Place de l'Alma. When it opened it displayed one hundred and fifteen of his paintings, a survey of his work to date. "I've astounded the entire world," he wrote to his patron Alfred Bruyas; "…all the painting in Europe is on show in Paris at this moment. I shall triumph not only over the moderns but even over the old masters."

Manet had also decided to present his paintings independently. Instead of submitting anything to the Salon he too had built his own pavilion at the Exposition, where he showed fifty paintings. A notice that accompanied the exhibition adopted a conciliatory tone: "It is sincerity that endows works of art with a character that makes them resemble a protest, although the painter has only intended to convey his impression—M. Manet has never desired to protest."

After he closed his exhibition, Courbet offered his pavilion for rent. Several of the younger artists, disenchanted with the Salon and no longer hoping that the administration would do anything for them, attempted to raise the funds for an independent exhibition. Bazille wrote home describing the plan, which included not only his friends and contemporaries but older painters whose reputations were already formed, such as Courbet, Corot, and Daubigny. "With these people, and Monet, who is stronger than all of them, we are sure to succeed." This plan fell through, but the idea anticipated the group exhibitions after the Franco-Prussian War that finally established the independent painters of Monet's generation.

Meanwhile Monet had applied to the authorities for permission to paint from the upper windows of the Louvre, and together with Renoir he painted a group of cityscapes from this vantage point.

Camille was pregnant. Monet turned to his father for help, persuading Bazille to second his appeal. The answer was uncompromising: he must abandon his mistress if he expected to count on support from his family; Tante Lecadre must not be distressed. Adolphe Monet's own mistress had recently borne him a child, a fact that probably colored his attitude; but he makes no mention of this in his reply to Bazille. Monet left Camille in the charge of a medical-student friend and went home to Normandy, where he spent the summer as pensioner of his family. His anxiety was intense, and he wrote letter after letter to Bazille, cajoling him for loans that would allow him to be at Camille's bedside when the baby came. "I would be terribly unhappy if she was to give birth without what is proper.…" Was it because of this distress that Monet developed an eye condition that prevented him from working in the open air?

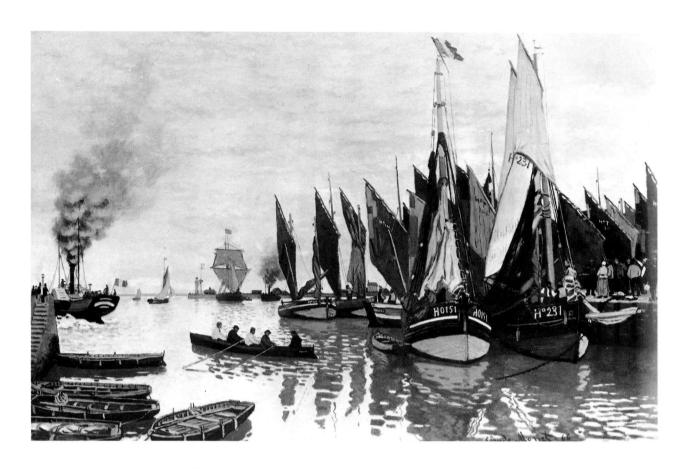

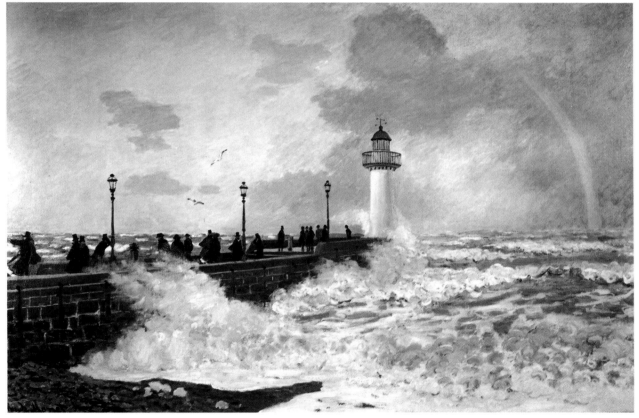

ABOVE: Le Port de Honfleur *(The Port of Honfleur)*. 1866

BELOW: La Jetée du Havre *(The Jetty at Le Havre)*. 1868

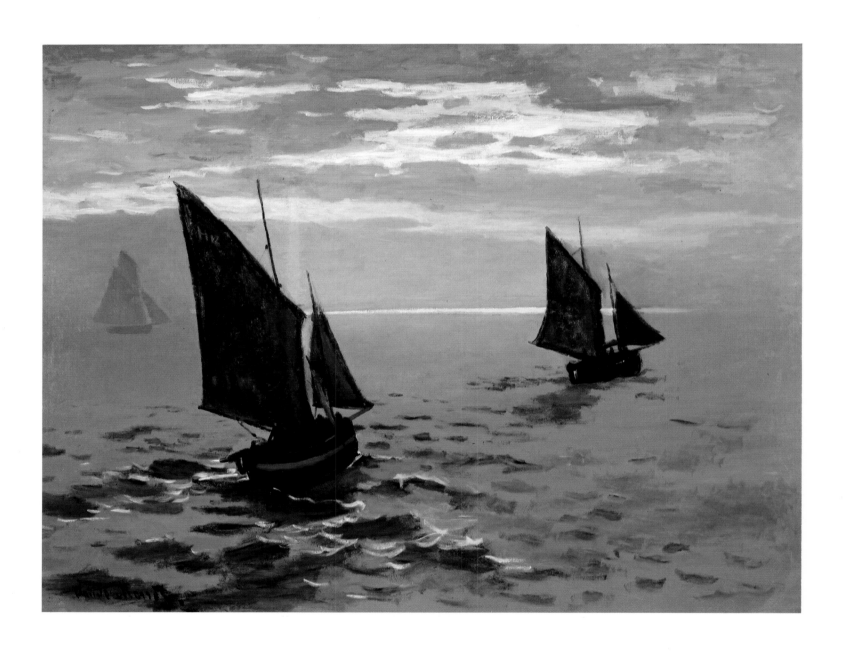

Bateaux de Pêche en Mer *(Fishing Boats at Sea)*. 1868

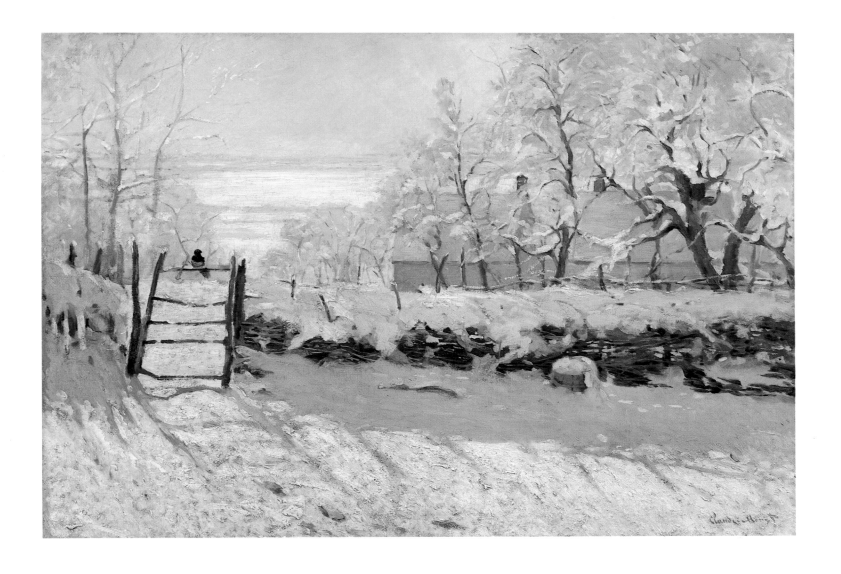

La Pie, Effet de Neige, Environs de Honfleur *(The Magpie, Snow Effect, Outskirts of Honfleur)*. 1869

La Route de la Ferme Saint-Siméon, Effet de Neige *(Road from the Saint-Siméon Farm, Snow Effect).* 1867

Two weeks later he reports that his eyes have improved. Meanwhile he is enjoying the support of his family, for his work at least. The summer produced numbers of canvases: views of the harbor at Le Havre and of the beach at Sainte-Adresse, and the ambitious *Terrasse à Sainte-Adresse,* in which his father, Tante Lecadre, and other members of his family are framed by flowerbeds and flags against the glittering backdrop of the sea.

In August Camille gave birth to a son, Jean. Monet was with her from time to time and during the winter was using Bazille's splendid studio in the Rue de la Condamine (now the Rue de la Paix). Early in 1868 he was back in Le Havre working on another large sea piece for the Salon. He entered two such paintings —*La Jetée du Havre* and one, now lost, of boats leaving the harbor. Only the latter painting was accepted, but it attracted the enthusiastic attention of Émile Zola, now an ardent spokesman for the independent painters.

With the approach of spring Monet was able to take lodgings he had found with Zola's help at Gloton, near Bennecourt on the Seine not far from his future home at Giverny. Here he painted one of the most crucial pictures of his life, *The River (Au Bord de l'Eau, Bennecourt).* Once again this retreat to the country ended in near disaster. Money ran out and Monet made his escape to Le Havre, where a possible patron, Louis-Joachim Gaudibert, had expressed interest in his work. There was also an international exhibition of maritime painting in Le Havre that summer. Both Boudin and Courbet were showing, and Monet, represented by four canvases, won a medal. The Gaudiberts, a wealthy merchant family, commissioned full-length portraits of their son and daughter-in-law. They also bought two of Monet's major sea pieces to save them from his creditors. Their patronage was extremely timely, allowing Monet the first taste of security he had enjoyed with his new family. He had taken lodgings for Camille and Jean up the coast at Étretat, and with the portraits finished he now joined them. A letter to Bazille written that December reflects a marvelous vigor and contentment after the frustration and agony of the preceding months. He is again filled with plans for figure paintings—a family interior with the baby, and an outdoor painting of sailors: "And I want to do it in a sensational way." He descants on his contentment, the delights of domesticity; he would like always to live in a quiet corner of nature. He doesn't envy Bazille in Paris; he doesn't miss the evenings at the Café Guerbois with Zola and the others. For it is not in that milieu one does one's best work, but alone in nature:

One is too preoccupied with what one sees and hears in Paris, however strong one is, and what I do here will at least have the merit of not resembling anyone, at least I believe so, because it will be simply the expression of what I myself will have

experienced, I alone. The further I go, the more I regret even the small amount of knowledge that I have. It is certainly that which cramps one the most. The further I go, the more I notice that one never dares to express what one experiences fully. It's funny. That's why I am doubly happy to be here, and I believe it will be a long time before I come back to Paris....

There is something infinitely touching about this letter, in which the idealized pride and happiness of the young father fuse with the artist's ambition and his ruthless drive for an independence of which he is absolute master. It is as though his quiet provincial lodgings, made magical by the presence of his beautiful mistress and their baby, had been transformed into an idyllic land where innocence and untrammeled expression were within his grasp.

But of course he did go back to Paris. His career could only be fostered there. Again Bazille let Monet use his studio to work on paintings for the Salon, a sea piece and the miraculous *La Pie,* the prize of the joyful winter at Étretat.

Both were rejected. Monet turned again to Latouche, who exhibited one of the Sainte-Adresse canvases in his shopwindow. Boudin reported that it attracted crowds for as long as it was on view.

Recognizing the need to be within convenient distance of Paris, Monet found lodgings in a cottage in the hamlet of Saint-Michel, near Bougival where he had worked two years before. Bougival, on the left bank of the Seine between Chatou and Pont-Marly and easily reached from the city, attracted crowds of boaters during the summer; the river was lively. Furthermore, there was sympathetic company: Renoir was staying with his parents a few kilometers away near Louveciennes, where Pissarro also lived with his family.

Monet was hard up again. Begging letters to Bazille convey exaggerated expressions of poverty—"For a week we have had no bread, wine, fire to cook on, or light"—and also envy and frustration at his friend's security. "Here I am again stopped for lack of paint. Lucky soul, you at least will be able to bring back lots of canvases. Only I will have done nothing this year. It makes me furious at everyone, I am wickedly jealous, I am in a rage: if only I could work everything would be all right."

Renoir had been bringing succor in the form of food lifted from his parents' table. He and Monet had been working closely together. In the long letter quoted above, Monet goes on to tell Bazille of his frustrated plans for the Salon. "I had indeed a dream, a *tableau,* the bathing place at La Grenouillère, for which I have made some rotten sketches, but it is only a dream...." He adds that Renoir too had the same idea.

La Grenouillère was a floating restaurant, a racy rendezvous for boatmen and their friends. Pontoons connected it to a tiny island and to the riverbank.

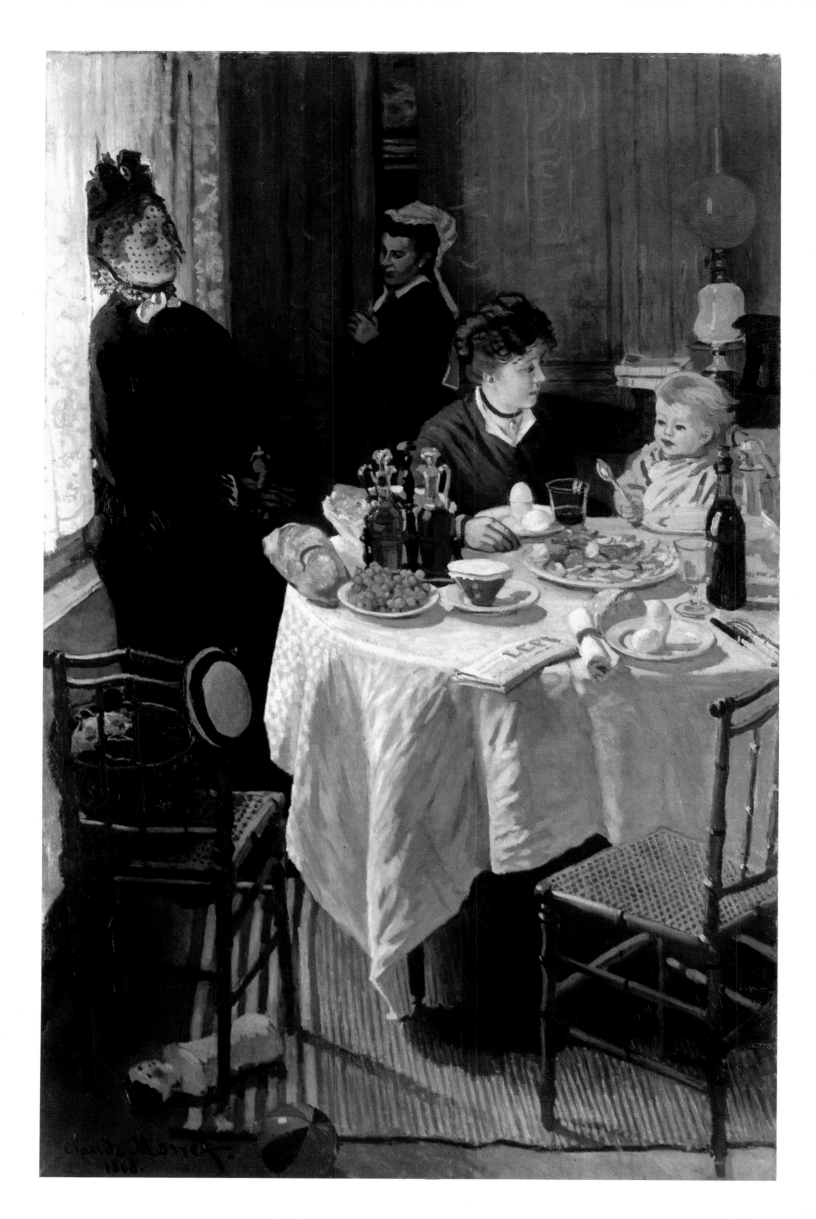

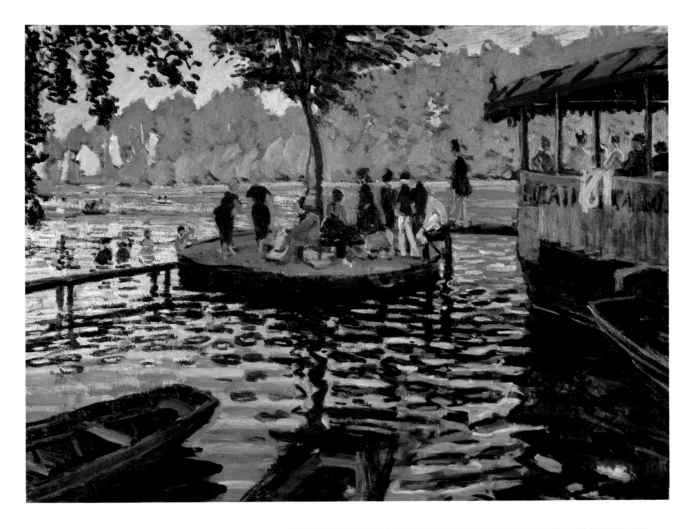

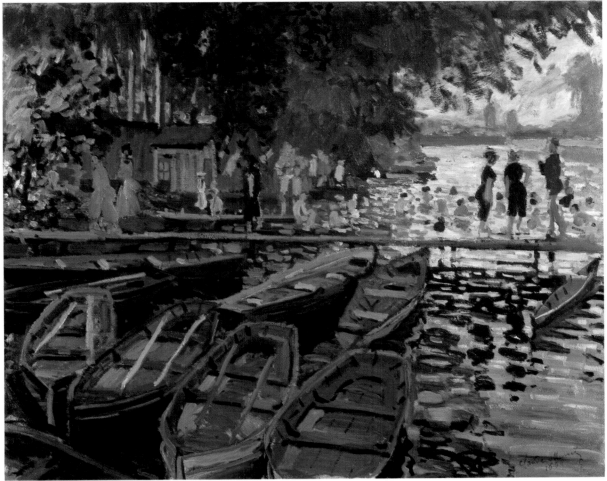

ABOVE: La Grenouillère. 1869

BELOW: Les Bains de la Grenouillère *(Bathers at La Grenouillère).* 1869

OPPOSITE: Le Déjeuner *(The Luncheon).* 1868

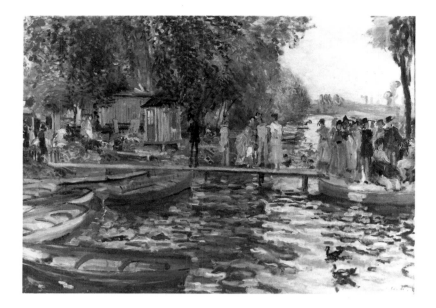

OPPOSITE, ABOVE: La Grenouillère. 1869

OPPOSITE, BELOW: The picture gallery of the Arnhold residence, Berlin

The two illustrations at the far right, both previously unpublished, reveal a great deal about Monet's lost painting of La Grenouillère, the scene of those weeks of camaraderie he shared with Renoir in September 1869. The painting itself, which has been known to date only through a poor-quality reproduction in a book, can now be seen with precision: this plate was made from a contemporary photograph which belonged to the collector Eduard Arnhold. Its size can now also be determined by comparing it with other works of known dimensions in this photograph of the Arnhold picture gallery. The paintings on the wall of the Arnhold gallery are, from left to right: Édouard Manet, L'Artiste (Marcellin Desboutin), 1875; Alfred Sisley, Le Pont d'Argenteuil, 1872; Monet, Le Banc, 1873; Manet, Jeune Femme Étendue en Costume Espagnol, 1862; Camille Pissarro, Vue de Marly-le-Roi, 1870; Monet, La Grenouillère, 1869.

There were moorings for skiffs, and a bathing section. Top hats chatted with bathing caps; rippling water and the filtered, flickering light of willow and poplar created a lively theater in which were celebrated the pleasure rites of the weekend out of town. It was a *motif* that gave both painters exactly what they needed at that time, and the few weeks they were there together were one of those rare and marvelous periods of symbiosis between artists when each is student and teacher to the other, spurred equally by rivalry and regard.

There are only four of Monet's "rotten sketches": one in the Metropolitan Museum of Art in New York, one in the National Gallery in London, a minuscule study of two boats, and a mysterious, more expanded version of the Metropolitan picture, known only from photographs. (Another painting, *L'Embarcadère*, is usually associated with this period, but it is not certain that it was done at La Grenouillère.)

At La Grenouillère all the most daring features that had been immanent in Monet's work of the last four years fused into an entirely consistent style. Perhaps liberated by Renoir's decorative insouciance, he recognized the total interpenetration of light, surface, and atmosphere as his deep *motif,* and fully accepted it as a process in color, on the palette, and in his hand. For the time being he was purged of Courbetesque heaviness.

In the event he did submit to the Salon of 1870 two pictures, *Le Déjeuner* and probably the lost *La Grenouillère*. Renoir, Sisley, Bazille, and Pissarro were all accepted. Monet was not. The jury included Millet, Corot, and Daubigny. By now Monet's exclusion had become something of a scandal. Corot and Daubigny resigned from the jury, and several critics commented on it.

Was the lost *La Grenouillère* the *tableau* Monet had told Bazille about? For a long time the only clue there was to this painting, which had passed into the hands of a German collector, Eduard Arnhold, and was destroyed during World War II, was an old and blurred black-and-white illustration. Its dimensions could only be guessed at. But recently Robert Gordon has discovered a photograph of it hanging among other paintings in Arnhold's house. From this it appears to be of comparable width to Manet's *Young Woman Reclining in Spanish Costume* (now in New Haven), whose dimensions are 94.6 by 113.7 cm. This is considerably larger than the two studies but not very large for an exhibition picture. There is a slightly greater range of scale in the details of foliage and figures, but the total effect is carried along with the same broad momentum as in the studies. Its broken surface, its elliptical drawing, the simultaneous activity of all its parts constitute the very material of the picture. Monet was presenting as a finished and definitive statement a construction based on the terms of the sketch.

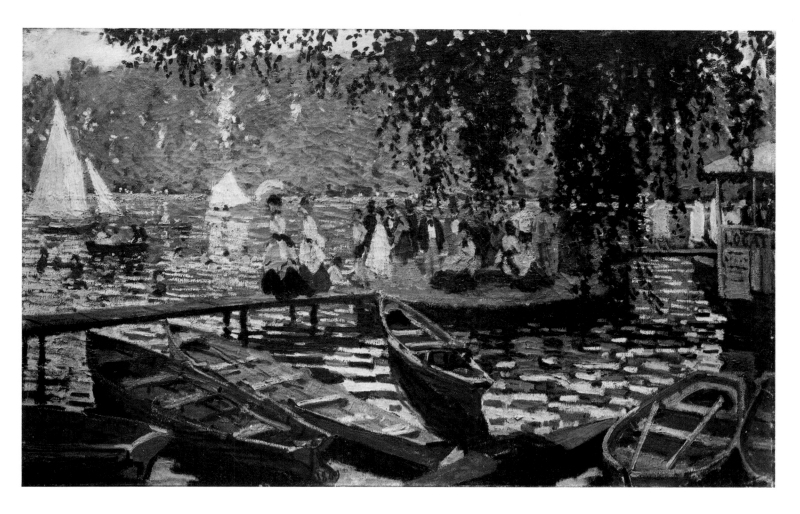

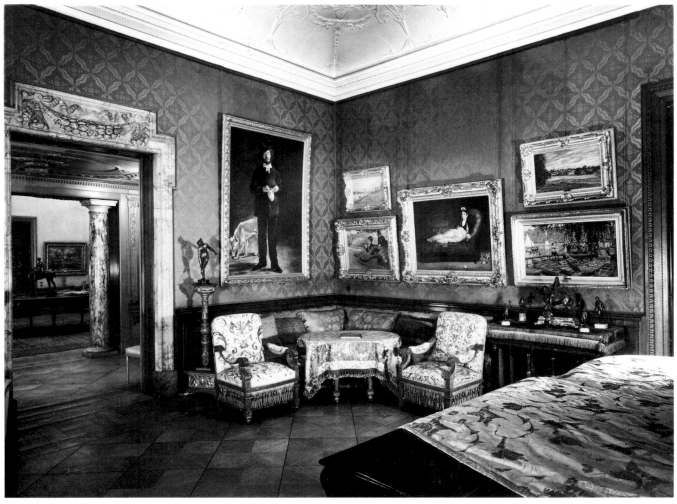

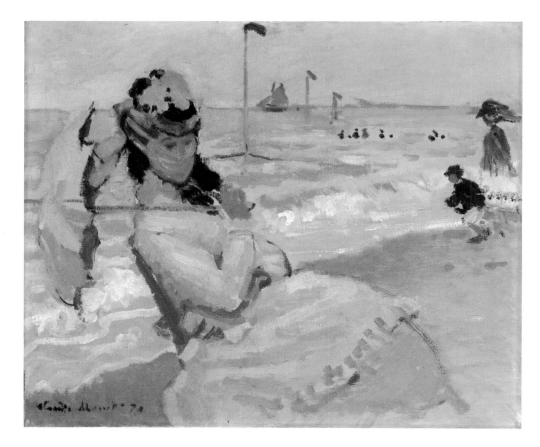

Camille sur la Plage de Trouville
(Camille on the Beach at Trouville). 1870

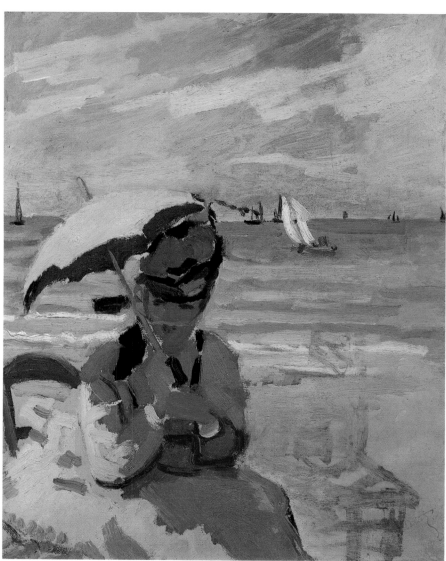

Camille Monet sur la Plage à Trouville
(Camille Monet on the Beach at Trouville). 1870

His rebuffs at the Salon finally convinced Monet that there was no
opening there for his tremendous ambition. He turned his back on the
institution and determined to carve out a position for himself independently.
Yet in a sense the Salon had served his purpose. He had won some fame
on its walls as a landscapist and a portraitist; the foundations of his reputation
had been laid. It had only been when he had challenged convention with
large-scale compositions that defied proprieties of genre and finish that
he encountered total resistance. It may be that he was singled out, that the
established painters recognized him as the most dangerously subversive talent
of the younger generation and closed ranks against him. But that in itself was
distinction of a sort, and one that guaranteed his standing among his col-
leagues. In any case we can hardly doubt that like Courbet he was able to gain
resolution from being able to picture himself as a marked man.

The decade of the seventies was the period of pure Impressionism, of
modestly sized canvases, few larger than could be conveniently handled out of
doors, in which a completely new conception of pictorial unity was worked out.
For Monet the decade began in disaster—the Franco-Prussian War, the death of
Bazille—and ended in hardship and mourning with the death of Camille and
with Monet struggling to support not one family but two. Between lay a
period of intense and marvelously fruitful creative effort and a few years of
comparative contentment.

In June of 1870 Monet married Camille by civil process. Courbet was one of
the witnesses. The summer was spent at the seaside at Trouville. Boudin and
his family were near, and Monet commemorated afternoons on the beach with
a series of little paintings of such vivid observation and economy of means that
they are as memorable as any of his larger works.

In July France had declared war on Prussia. The ostensible reason was
Napoleon III's fear of the possible accession to the Spanish throne of Prince
Leopold of Hohenzollern, which would have advanced the power of Prussia to
France's southern frontier. But Napoleon's dictatorship was deeply unpopular
in France, and the war, in which he mistakenly believed his armies would
be more than a match for the Prussians, was an adventure embarked on to
recapture popularity. On the Prussian side the war was welcomed as a way of
accelerating Bismarck's policy of German unification. Having appointed the
empress his regent, Napoleon left Paris on July 28 to take command of the
army at Metz. By September 2 the key battle of Sedan had been fought with
heavy casualties, Napoleon had been captured, and his main armies of the field
had surrendered. When the news of Sedan reached Paris a Republican Govern-
ment of National Defense was quickly formed. The capital prepared for siege.

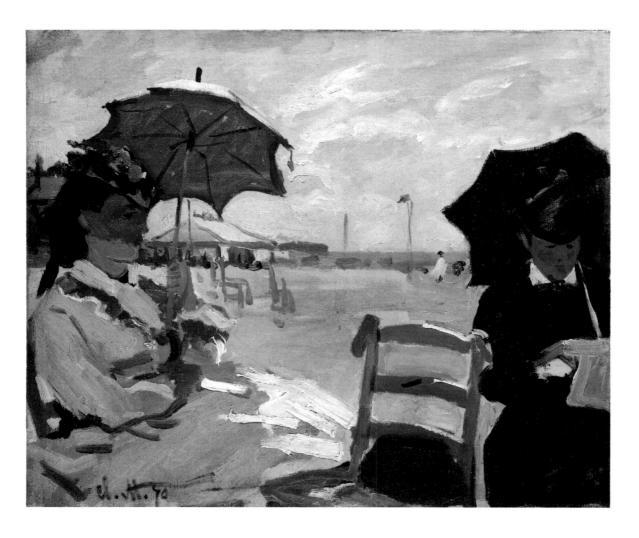

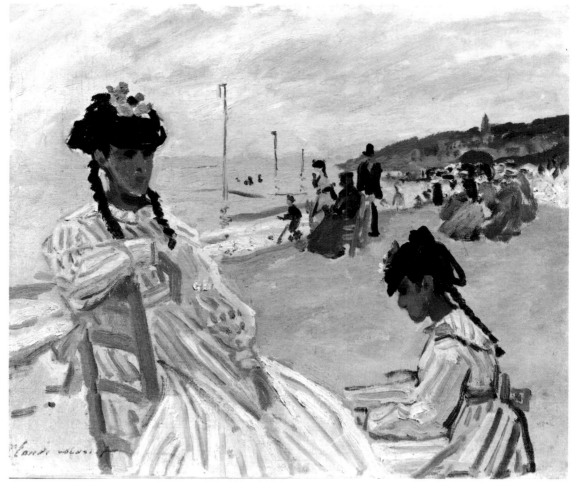

The provinces were swept with patriotic sentiment. In Normandy preparations were made to defend the ports from the Prussians.

Monet was still on the reserve list, and his main thought was to avoid service. Sometime during the autumn he boarded a boat for London, leaving Camille to follow with Jean at the earliest opportunity. He found lodgings in the West End of London and was soon in contact with fellow refugees.

One of these was Charles Daubigny, whom Monet had known for several years and who was now enjoying some success with the London public with his paintings of the Thames. Daubigny introduced Monet to his dealer, Paul Durand-Ruel. It was a momentous meeting. Durand-Ruel, whose father had built his business in Paris around Corot and the Barbizon painters, had transferred his gallery to London, where he hoped to build a market for modern French painting. He was already aware of the work of the younger generation and now welcomed contact with Monet, whose work he continued to support in the years that followed. Relations between the two were to have their ups and downs, and as his prosperity increased Monet, who was nothing if not a tough businessman, was to play other dealers off against Durand-Ruel. But it was Durand-Ruel more than any other whom he had to thank for that prosperity.

Durand-Ruel put Monet in contact with Pissarro, who was living with relatives in the suburbs of South London. They both submitted work to the Royal Academy, unsuccessfully, and both showed at Durand-Ruel's gallery and in the International Exhibition at the South Kensington Museum. Their work aroused no interest at all; indeed to London eyes, familiar not only with Constable but with the palette of the Pre-Raphaelites, it may have looked somewhat old-fashioned. It was to be several decades before the originality and power of Impressionism were understood in England.

The months in London were not productive for Monet. He worked in the parks, at Westminster, and at the docks, but they are cautious paintings, far less advanced than the work of the preceding two years. He was not yet ready to celebrate the gray gloom of the city, but merely to describe it. Thirty years later London was to be the occasion for astonishing chromatic fantasies. Later still Monet was to tell the art dealer René Gimpel that of all cities London was his favorite. Certainly it is hard to think of anywhere in the world where his perennial theme, *l'enveloppe*—the total, unbroken fabric of appearance—was more palpably in evidence.

By the end of May 1871 Monet was on his way to Holland, where he settled at Zaandam for the summer and painted canals and windmills with the utmost verve. These paintings consolidate and to some extent systematize the

EUGÈNE BOUDIN.
La Plage de Trouville
(Beach Scene). 1865

OPPOSITE, ABOVE: La Plage de Trouville
(The Beach at Trouville). 1870

OPPOSITE, BELOW: Sur la Plage à Trouville
(On the Beach at Trouville). 1870

Eugène Boudin wrote this charming memoir to Monet:
…I can't resist the desire to go back to an already distant past on the occasion of your son's wedding.

He surely doesn't remember me and yet I carried him more than once on my shoulder, in the evening when he used to come with his mother to visit us on the Rue d'Isly. How these memories carry us toward a past that was not always filled with joys. We all had some painful anxieties at that time as far as cash was concerned. And I can still see you with poor Camille in the Hôtel de Tivoli.

I've even kept from that time a drawing that shows you on the beach. They are there, three women in white, still young. Death has taken away two of them, my poor Marie-Anne and yours. One of the three is left, still in good health. Little Jean is playing in the sand and his papa is sitting on the ground, a sketch in his hand—and not working. It's a souvenir from that time that I've always devoutly kept.

ABOVE, LEFT: La Tamise et le Parlement
(The Thames and Parliament). 1871

ABOVE, RIGHT: Moulin à Zaandam
(Windmill at Zaandam). 1871

*In 1873 Durand-Ruel, with galleries in Paris,
London, and Brussels, published a monumental
catalogue containing some 300 engravings of
paintings. The poet and critic Armand Silvestre,
in his preface, referred as follows to the paint-
ing by Monet reproduced opposite:*
M. Monet is the one who, by the very choice
of his subjects, most betrays his preoccupa-
tions....On the slightly agitated water, he likes
to juxtapose the many-hued reflections of the
sunset, of the gaily-colored boats, of the scud-
ding clouds. His canvases shimmer with pol-
ished metallic tones of waves lapping in small
strokes of separate colors; and the image of the
shore trembles in them, the houses standing
out in them as in that children's game in which
objects are reconstructed by pieces.

experiments started at La Grenouillère. Monet had a substantial number of
them when he arrived back in Paris.

The winter in Paris had been ghastly. The city, surrounded by the Prussian
army, was near starvation. The season was bitterly cold. At the beginning of the
new year the Prussian artillery began to bombard the city, which capitulated on
January 28, 1871. The Prussians entered the city on March 1 and occupied it for
four days. Shortly after their departure the workers of Paris rose against the
republican government, which fled to Versailles. The Commune was declared.
Courbet, who had preached socialism for years, was placed in charge of the
national collections.

Paris was now besieged by the Versailles government, whose troops entered
the city after heavy fighting. The Commune collapsed on May 28. There fol-
lowed a period of brutal suppression during which many thousands of workers
were imprisoned, driven into exile, or executed. Anyone who had taken an
active part in the Commune was at risk. Courbet was arrested and condemned
on flimsy evidence for having directed the destruction of the Vendôme Column.
When Monet arrived in Paris in the fall one of his first actions was, with
Boudin and Gautier, to visit Courbet in a prison hospital.

Monet found a studio in the Rue de l'Isly, not far from the Gare Saint-Lazare,
and set about reassembling his scattered work, some from the family of Bazille,
some from Pissarro's house in Louveciennes, which the Prussians had used as
an abattoir. Pissarro had lost hundreds of his own canvases. Some of Monet's
survived.

It is difficult to imagine the atmosphere of the capital at the time of his
return. A treaty had been signed with the Prussians under which, besides the
restoration of German-speaking territories in the East, France was committed
to a massive indemnity. Destruction in Paris was extensive. Families and whole
neighborhoods had been decimated. Many of Monet's closest friends had
remained in Paris, either as combatants or as passive witnesses to famine and
death. Monet's closest friend, Bazille, had volunteered for the Zouaves at the
outset of the war and had been killed in November 1870 at the battle of
Beaune-la-Rolande.

Not a hint of this shows in Monet's painting. That winter, helped by Manet,
he found a house in the riverside suburb of Argenteuil, fifteen minutes by train
from Paris. Here he was able to enjoy the most fruitful few years of his life
so far.

Durand-Ruel, now back in Paris, was buying from Monet regularly. A small
circle of collectors was becoming interested in his work. Soon he was able to
move into a larger house. His ménage included two servants and a gardener.

La Zaan à Zaandam *(The Zaan River at Zaandam)*. 1871

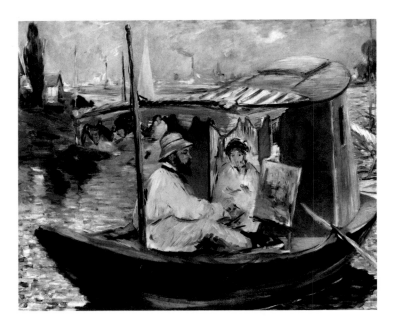

ÉDOUARD MANET.
Monet Peignant dans son Atelier
(Monet Painting in his Floating Studio). 1874

*Looking back on his friendship with Manet,
Monet told an interviewer:*
...It was in this studio, from which I could see
forty or fifty paces away everything that was
happening on the Seine, that I did my first boat-
ing scenes of Argenteuil, until the time came
when a good sale all of a sudden put enough
money in my pocket to buy myself a boat and
to have a cabin built on it of wooden planks,
where I had just enough room to set up my
easel. What wonderful hours I spent with
Manet on that little boat! He did my portrait
there. I did his wife's and his. Those wonderful
moments, with their illusions, their enthusiasm,
their fervor, ought never to end.

The glowing sense of bourgeois well-being that radiates from the paintings
made in the garden at Argenteuil was based on the fact. Monet stayed at
Argenteuil for six years, working mostly in the neighborhood but with short
visits to Rouen (1872), Étretat and Le Havre (1873), and possibly Holland (1874),
and working in Paris in 1873, 1876, 1877, and 1878. Following Daubigny's
example he had a boat equipped as a floating studio.

But his security was precarious. In 1875 the economy, which had been
booming since the end of the war, took a downturn. Durand-Ruel found
himself overstocked and stopped buying. Once again Monet faced hard times.

John Rewald has described in great detail how the independent artists
presented their work to the public in a series of eight cooperative exhibitions
between 1874 and 1886. Monet was a central figure in these efforts, and he
made major contributions to the first four exhibitions. He was recognized as
the dominant figure of the landscape wing, and it is appropriate that it should
have been the title of a painting of his, *Impression, Soleil Levant,* that was
seized on by the critic Louis Leroy as the cue for his mocking name for the
group.

To some of the Impressionists—notably Pissarro, the only one to show in
all eight exhibitions—the idea of cooperative activity outside official channels
was a matter of principle. To Monet and Renoir on the other hand it had little
meaning beyond the circumstances of the time. Renoir showed in the Salon of
1879, where he enjoyed considerable success with his portrait of Mme.
Charpentier and her children. Monet, perhaps encouraged by this, perhaps
also by promises of sales from Durand-Ruel's rival Georges Petit, with whom
he was now doing business, went back to the Salon in 1880, offering two
landscapes, only one of which was accepted. Shortly afterward he held a one-
man exhibition, still something of an innovation, at the offices of the
Charpentiers' review, *La Vie Moderne.* From this point on nothing that he
showed was ignored, and although it was still some years before he was
without financial anxiety, his prices rose steadily, as did the number of his
imitators, and to a younger generation of painters and critics he was
unassailably established.

But the late seventies were years of dire frustration and hardship. Among the
thirty paintings Monet showed at the third Impressionist exhibition was a large
canvas of white turkeys in a field. This was part of a suite of four decorations
that had been commissioned by one of his collectors, Ernest Hoschedé, to
embellish a room in his country house, the Château de Rottembourg, at
Montgeron.

Hoschedé, a flamboyant character, the director of a department store in

Paris and an occasional art critic, enjoyed the company of painters and was frequently among them at the Café Guerbois. He had made a lot of money during the postwar boom, but his fortunes fluctuated. In periods of prosperity he was an enthusiastic collector and had bought from Pissarro, Sisley, Degas, Manet, and Monet. In 1874 he had been forced to sell his collection. It had attracted surprisingly high prices.

Sisley and Manet had both worked at Hoschedé's château when Monet arrived for a stay of several months in the autumn of 1876. During his visit he formed a deep friendship with Hoschedé's wife, Alice. They may have become lovers.

Shortly after his return to Argenteuil, Monet took a room in Paris in the Rue Moncey not far from the Gare Saint-Lazare, the station for Rouen and the Normandy coast as well as for Argenteuil and Bougival. Here, in a burst of intensive effort lasting a little over two months, he painted twelve canvases of the station.

In the fall he decided to leave Argenteuil. It was rapidly losing the character it had had at the beginning of the decade and was becoming the industrial center it is today. The family moved to Paris, leaving debts behind that took Monet some years to settle.

Hoschedé was again in financial straits. In the spring of 1878 he was ruined and had to auction the collection that he had built up since the sale of 1874. The second sale was a disaster, Monet's sixteen paintings going for less than 200 francs each. It was perhaps the worst period in Monet's life. Camille had never regained her strength after the birth of the new baby, Michel, in March of that year. She was dying. Monet looked for help wherever he could find it among friends and collectors, lamenting his age and the plight of his family. More than once he was unable to work for lack of materials.

Hoschedé had lost not only his collection but his château. Apparently on the pretext of economy, Mme. Hoschedé now decided to join forces with Monet. Again with help from Manet, a house was found at Vétheuil, a distance downriver from Argenteuil, farther from Paris. The two families moved in September 1878—four adults, one mortally ill; eight children; and servants—to a house of modest dimensions. Alice Hoschedé nursed Camille with devotion. Ernest Hoschedé spent time in Paris. Monet painted. Camille died, terribly emaciated and in pain, on September 5, 1879.

At the time of Camille's death an incident took place that has become a part of the Monet legend. He painted a study of her on her deathbed. This was not in itself extraordinary. What is extraordinary was his later comment on it, which Georges Clemenceau quoted in his book on his friend's work. Monet

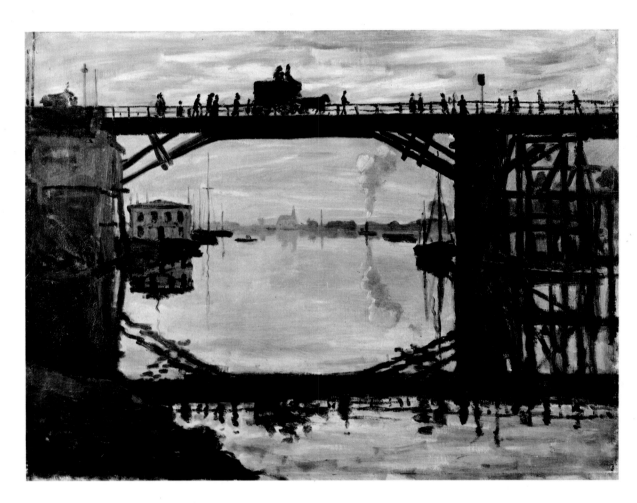

Le Pont de Bois
(The Wooden Bridge). 1872

Vue de Rouen
(View of Rouen). 1883

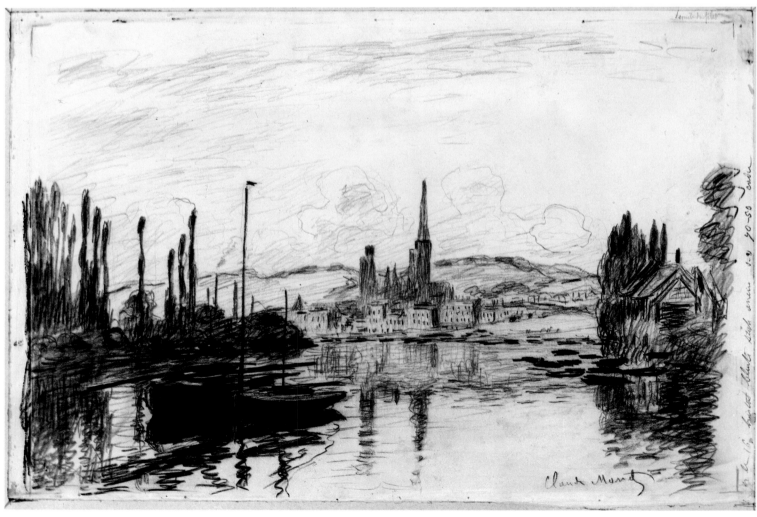

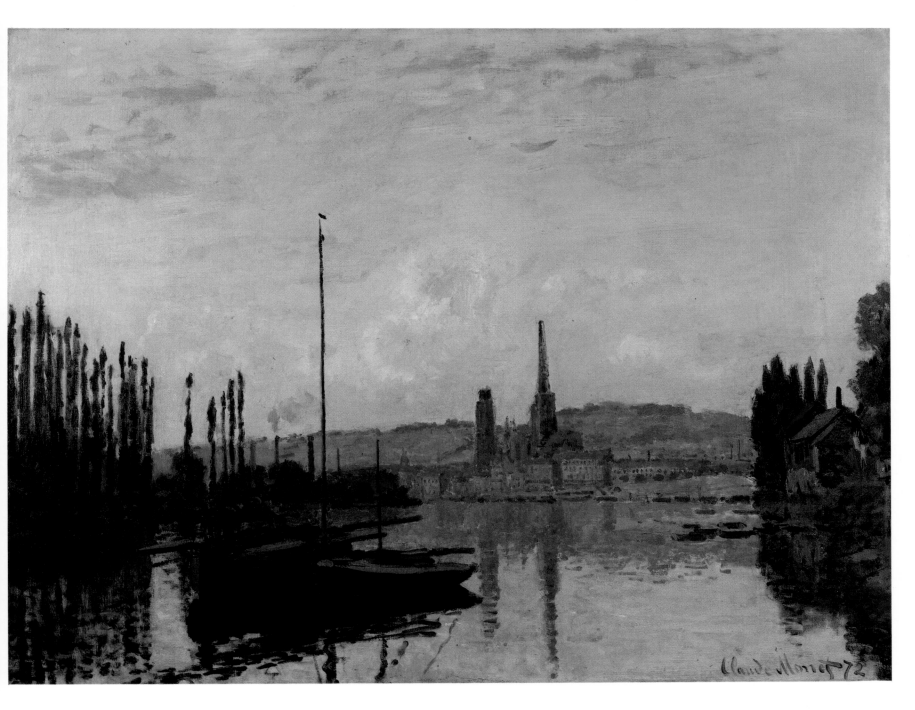

Vue de Rouen (*View of Rouen*). 1872

The drawing at left is not a study for the painting above but was made from the finished picture as an illustration for an important article that appeared in 1883. The subject was a retrospective exhibition in which Durand-Ruel showed over fifty paintings by Monet. Writing in the conservative and influential Gazette des Beaux-Arts, *Alfred de Lostalot commented respectfully on Monet's talent while still debating whether Monet's painting out-of-doors could be considered more than sketching. In the same journal two years later he made up his mind: His pictures are not sketches: neither he nor anyone else could add anything to them.*

There were two bridges across the Seine at Argenteuil: a road bridge of wooden arches supported on stone piles, built forty years before Monet painted it, and, not far away, a recently built railway bridge of concrete and cast iron. Between them lay the industrial port of Argenteuil. Both bridges were destroyed by the French army in retreat from the Prussians. By the time Monet arrived in 1872, repairs on the bridges had begun. The painting at left, remarkable for its square-cut symmetry, records a temporary structure of wood that allowed road traffic into a town that had suffered Prussian occupation and was now busily reconstructing.

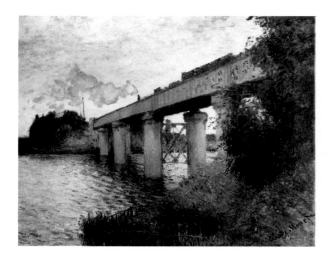 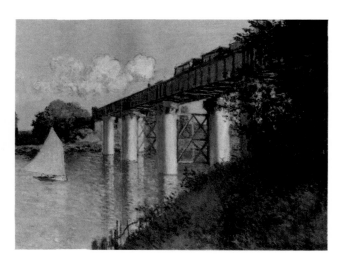

ABOVE, LEFT: Le Pont du Chemin de Fer, Argenteuil *(The Railroad Bridge, Argenteuil)*. 1874

ABOVE, RIGHT: Le Pont du Chemin de Fer, Argenteuil *(Railroad Bridge)*. 1874

used the episode to dramatize his bondage to painting. Rather than describing his act as a last devotion to his dead wife, he exclaimed at the unnaturalness of what he had done. For he had been aware even at her bedside of the detachment with which his painter's eye had assessed the fall of light across her face, had identified the sequence of values, had translated her ravaged and irreplaceable features into a painting problem. It was perverse, and he had compared himself to a beast of burden harnessed to a millstone—the millstone of his métier, which cut him off from ordinary human experience.

Monet was not the first artist to feel trapped by his vocation, the obsession in his life that cuts him off from life, and indeed episodes of this kind appear in the novels of Zola, Flaubert, and the Goncourts. But with him the complaint has a special edge to it: it is not the obsession he is complaining of but the very nature of the activity. There is something uncanny about the particular state of mind that concentrates itself so exclusively into the channels of disinterested vision that even identities begin to dissolve.

We are all specialists in the way we use our eyes. A painter, perhaps, needs to reflect more than most on his specialization. The old studio injunction to "copy stupidly" is simply a reminder that one kind of interest tends to exclude other kinds. When we are putting our eyes to practical purposes we do not notice how things change shape through foreshortening, or the way the color of something is modified by light and shade or distance, to take common examples that might, to a certain painter, be matters of extreme consequence. Monet's concern with the expression of light through color, with the unifying *enveloppe,* depended on a degree of detachment that was without precedent.

Only occasionally in ordinary life do we catch glimpses of the world as pure appearance, in which identities are, as it were, loosened from their moorings and floating free—as perhaps when we are just rising out of sleep and the room around us drifts into view like a flotilla of nameless patches of color. Such moments do not fail to evoke memories of early childhood, of dreamy, unfocused existence when, it seems, the frontier between "here" and "out there" is only vaguely defined. A state of innocence it might be called, or at least irresponsibility. Such states are unbidden. We find ourselves in them. But when an artist moves into this state, he does so at will, through disciplined practice with nothing dreamy about it. He is a sharp-eyed specialist in vagueness, capable of a kind of regression at will.

Monet is supposed to have said that he would like to be able to see like a blind man who has suddenly regained his sight. It is a shocking figure of speech and violently expresses his longing for pure visual sensation, far beyond that which his trained eye could uncover. There is something paradoxical,

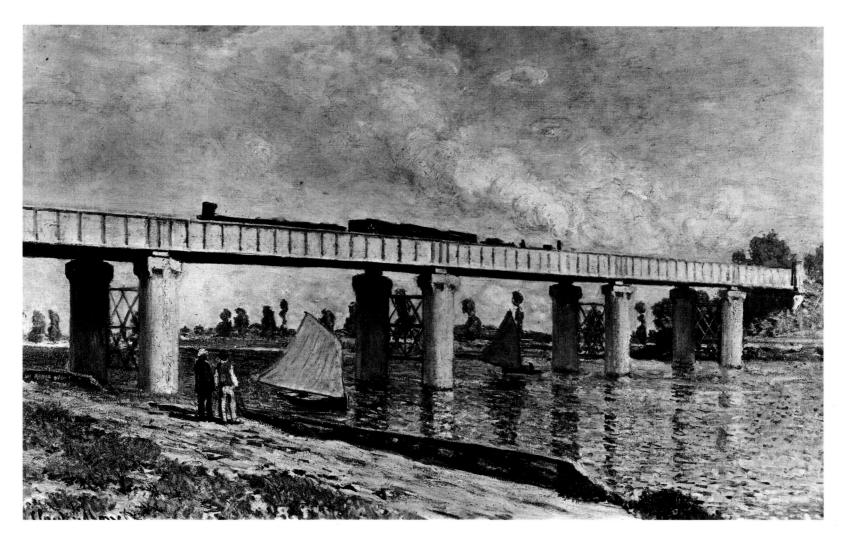

Le Pont du Chemin de Fer à Argenteuil
(The Railroad Bridge at Argenteuil). 1873

perverse, about this longing on the part of so self-conscious and proficient a painter, a longing for innocence that he must have known was inaccessible. The idea has the force of a myth, a nineteenth-century equivalent of the dying myth of a Golden Age. Rooted in Romanticism (the bohemian is what he is precisely because he places himself outside the conventions and perceptions of ordinary life), this myth receives a new and authoritative definition from the appeal of positivism. The "blind man" is a mythical hero facing a world of raw phenomena. His empiricism is complete.

The nineteenth century loved science for its neutrality and for the promise of power and momentum this neutrality seemed to hold—the power to understand and control the natural world. For Monet the ideal of a pure and neutral empiricism takes on an irresistible emotional force. It provides him with a radical critique. The goal of unbiased perception calls into question not only the categories of ordinary life but the categories with which the world of art had ringed itself around. For the denial of categories places nature over learning, phenomena over symbol, allegory, or narrative. Nothing was to be proved by it, nothing argued, nothing upheld—except a view of the truth condensed into the truth of light. Monet's eye was his first line of attack against the enemy, against everything that was stale, worn out, conventional, artificial —everything that dimmed or falsified the luster and sparkle of life. That the bastion of these weary conventions was the Salon itself, the state institution to which, like every young painter, he had to look for his preferment and his inheritance and which stubbornly refused it, gave the spice of anger to his stance.

According to the Wildenstein catalogue raisonné, one hundred and ninety

Although by mid-century the railway had transformed French life, it had not been depicted except in popular topographical prints, guide books, and the press. The first painters to treat it were Monet and his contemporaries, and it was consistent with their commitment to realism and to the character of modern life that they should do so. Both Pissarro and Cézanne had painted railway landscapes before Monet painted the railway bridge at Argenteuil. (Within a few years Monet was to paint the greatest of all railway images, his canvases of the Gare Saint-Lazare.)

Here the sailing boats appear to provide a contrast between the old and the new: in fact these are not working boats but the pleasure craft of amateur yachtsmen, as new and typical as the railway that brought the weekend sailors to Argenteuil.

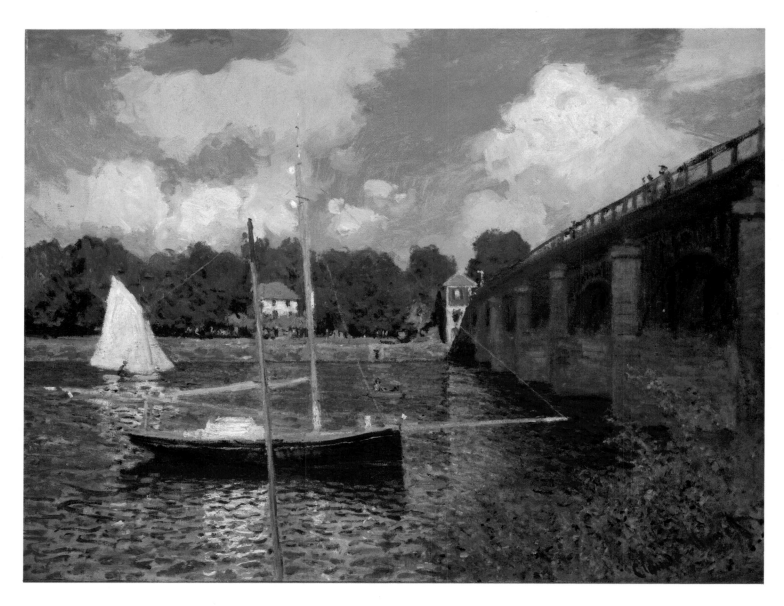

Le Pont Routier, Argenteuil
(The Bridge at Argenteuil). 1874

The two paintings opposite, and one of the harbor at night, were painted from Monet's hotel window in Le Havre in 1872. Impression, Soleil Levant *was one of the twelve works—seven were pastel sketches—that Monet contributed to the first exhibition of the group later to be known as the Impressionists. It was because of a facetious reference to this painting by the critic Louis Leroy that the name Impressionist gained currency. Years later, looking back on that first independent exhibition, Monet told Maurice Guillemot:*
Landscape is nothing but an impression, and an instantaneous one, hence this label that was given us, by the way because of me. I had sent a thing done in Le Havre, from my window, sun in the mist and a few masts of boats sticking up in the foreground....They asked me for a title for the catalogue, it couldn't really be taken for a view of Le Havre, and I said, 'Put *Impression.*' From that came Impressionism, and the jokes blossomed....As for me, I gained as much success as I could have wished, which means I was energetically hooted at by all the critics of the time.

paintings survive from the decade preceding Monet's arrival at Argenteuil. For the six years he was there, there are listed two hundred and sixty. The Impressionist language had given him a power over appearances, over *all* appearances, as though he had found in it a wide-open channel through which the commanding current of his eye could flow with total freedom. One can well imagine how for a short while the "objectivity" of Impressionist vision must have appeared to writers like Zola the crowning phase of the Realist project— a vision without *parti pris*, competent, for the first time in painting, to survey human life in its context, the world of man as a continuous extended phenomenon. It was of course an illusion, like any theory of objectivity in art. But the Argenteuil years remind us of Zola's ambition. Two kinds of subject claimed Monet's attention there: the world outside, and the world of his family—Argenteuil, on the fringe between the metropolis and the unchanging countryside, the river with its yachts and bridges, its factories and tree-lined towpaths; and the enclosed garden or nearby meadows as the habitat of Camille and Jean. Modernity impinges on Argenteuil. Camille's world is Cythera.

Once Monet had given up trying to make his name with large figure compositions, people played a less and less important part in his pictures. He gave himself over to landscape and to the light of open air.

What did—or could—a landscape without figures, and painted in a spirit of objectivity, *mean?* The question had been in the air for some time. Baudelaire had voiced it in his review of the Salon of 1859:

If an assemblage of trees, mountains, water, and houses such as we call a landscape

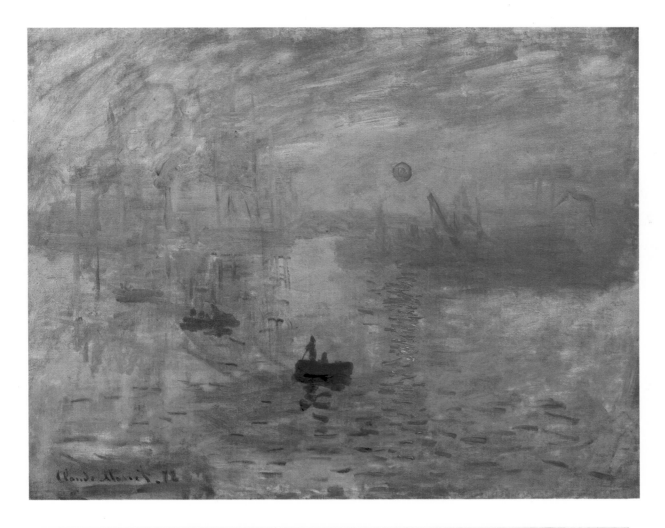

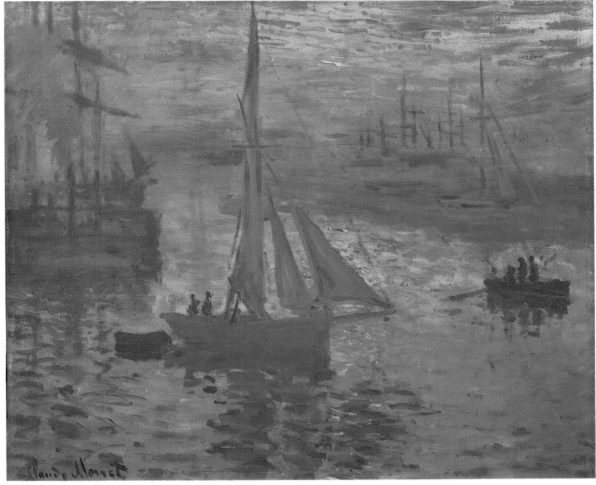

ABOVE: Impression, Soleil Levant *(Impression, Sunrise)*. 1873

BELOW: Soleil Levant, Marine *(Sunrise, Seascape)*. 1873

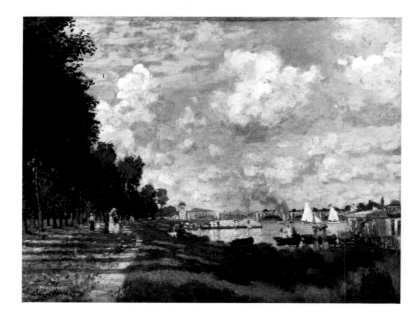 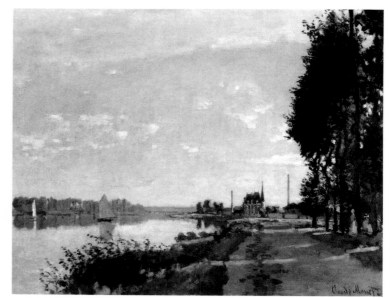

ABOVE, LEFT: Le Bassin d'Argenteuil
(The Seine at Argenteuil). 1872

ABOVE, RIGHT: La Promenade d'Argenteuil
(Argenteuil). 1872

At Argenteuil a promenade ran along the north bank of the river to the east of the town. The river was straight and wide at this point, and it was on this reach that regattas were held, watched by spectators on the promenade. To paint the picture at left above, Monet faced upstream toward the road bridge and, beyond it, the port area of Argenteuil. To paint the work at right above, he stood with his back to the town, looking downstream. Monet returned to this spot in the late summer of 1877 to paint his last canvases at Argenteuil before moving, briefly, to Paris.

is beautiful, it is not so of itself, but through me, through my own grace and favor, through the idea of feeling that *I* attach to it....Any landscape painter who does not know how to convey a *feeling* by means of an assemblage of vegetable or mineral matter is no artist.

Today's landscape painters, he says, try to look at nature as though in a world without men, "an odd sort of operation that consists of killing the reflective and sentient man within them...."

When Monet began to show his Impressionist canvases at the independent exhibitions during the seventies, more than one critic reproached him for his lack of feeling. He revealed nothing of himself. "No inner feeling," Charles Bigot wrote of the 1877 exhibition, where Monet was showing thirty canvases, including eight of the Gare Saint-Lazare, "no subtlety of impression, no personal vision, no choice of subjects to show you something of the man and something of the artist. Behind this eye and hand, one looks in vain for a mind and soul." Monet's paintings contained a shift in values for which there was as yet hardly any critical language. To what end his sketchiness? To what end his "objectivity," his suppression of the "reflective and sentient man" within him? As to the informality of his language, a sketch was expected to reveal what the artist was thinking about in its most direct and vivid form. It was to be the living seed of his larger project; it was also a collecting of information, a gathering in of particulars, but selected and organized and abbreviated in relation to the large idea. The concept of objectivity that Monet was working with introduced a whole range of critical problems that rendered the expectations of most of his critics anachronistic.

New values, new meanings were appearing. The direct experience of landscape gives the key to everything Monet painted—the crowded boulevards and railway stations no less than the scenes of boating, the garden luncheons no less than the fields of poppies or the snow-filled lanes. The distinguishing features of landscape, its qualities of depth, extent, variety in weather and season, of a visible atmosphere, of constantly changing illumination, the glitter and flicker of surfaces in different planes, the asymmetrical nonaxial character of its forms, and above all its seamless continuity—all these imposed specific features on his canvas once they were studied directly, once they were seen and taken as pictorial material. His total, fanatical commitment to his view of truth to what he saw forced certain events onto the canvas. There is an insistent relationship between the *motif* and what is happening on the canvas. The result of this relationship can be seen in many lights, brought back from different *motifs* or from the same *motif* under different conditions. What is crucial is a process that can be described as finding the picture in the *motif,*

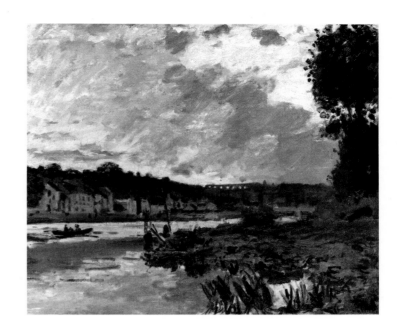

La Seine à Bougival, Le Soir
(The Seine at Bougival). 1870

not the other way around.

It will be worth making a detour to get at this more clearly. Another critic had made a point similar to Bigot's at the time of the first independent exhibition. In the course of an otherwise sympathetic review, Armand Silvestre observed, "It is an effect of the *impression* that he pursues exclusively, leaving the search for *expression* to the devotees of line." But why should Silvestre take it for granted that line is more expressive than the kind of painting Monet was doing? An answer can be proposed from two directions. First, the whole tradition of "intellectual" painting, an art of ideas, stemming from Renaissance academicism, of which the last important representative was Ingres, was a tradition of drawing. It was a figure art: its roots were in the sculpture of antiquity. The figure was both the source and the object of thought and feeling, and this is what drawing, in this tradition, defines.

Formally the strongest characteristics of the human figure are its symmetry and its centeredness. A sense of form based on the figure is a sense of form with a center. The figure is convex in its movements; it has a core.

In life we can discriminate a human figure under almost any circumstances. It becomes an instant point of focus, as though one of the main tasks of our eyes is to be able to identify and interpret other human presences.

Drawing can be thought of as a way of making out forms on a flat surface. Figure drawing operates from the center of the human presence. Nothing outside the figure has significance equal to its own forms. The convexities that bound it are frontiers between it and the outside world, between what matters more and what matters less—between figure and field. The principles and hierarchies of figure drawing in the central tradition run parallel to the functions of discrimination deeply embedded in our perceptual systems. This is one of the crucial places where the way we perceive the world and the way we read the language of painting connect.

Nothing in Monet's work suggests that he had any deep interest in the figure as such, either as an autonomous psychological being or as a focus of desire. Although he must have worked from the figure as a student, nothing remains— a significant fact when one considers how jealously he conserved his paintings later. The nude is unknown in his work. Libido flows elsewhere. Neither his portraits nor his family groups betray the slightest interest in carnal grace. From this point of view his sense of form is not only unresponsive but utterly undistinguished. There is nothing of that passionate rifling of detail—the articulation of a wrist, the juncture of head and neck, the quality of a hairline—that conveys so much of Cézanne's eros; none of that sense of the luxury of form that comes from Renoir whether he is looking at a cheek, a

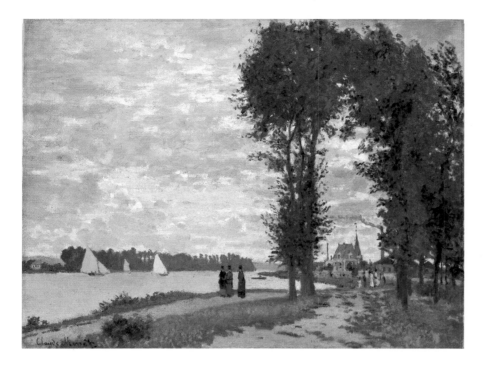

Les Bords de la Seine à Argenteuil
(The Banks of the Seine at Argenteuil). 1872

Bateaux de Plaisance à Argenteuil
(Pleasure Boats at Argenteuil). 1875

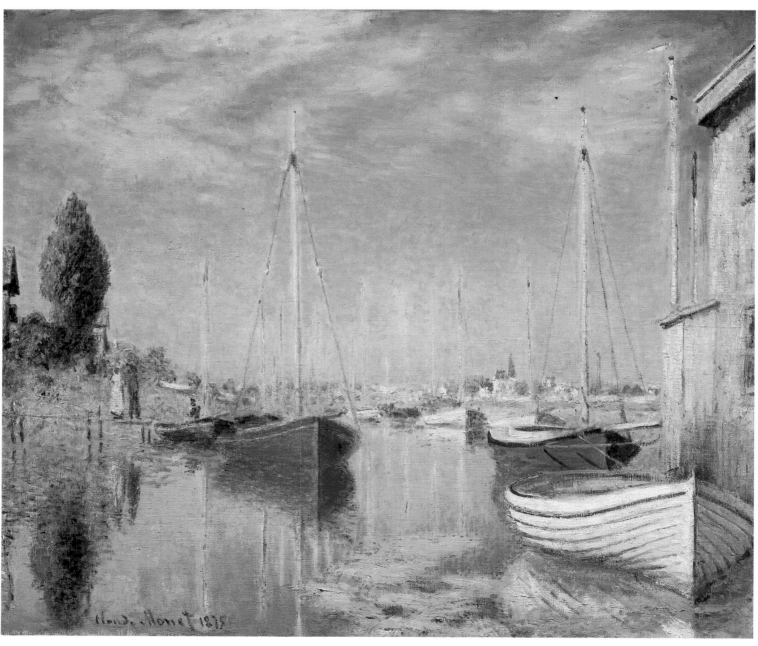

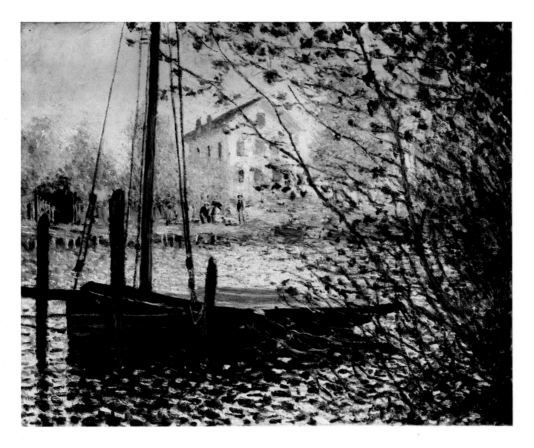

Bords de l'Eau, Argenteuil
(Riverbanks, Argenteuil). 1874

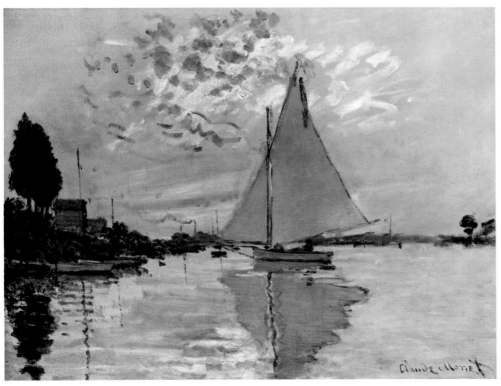

Voilier au Petit-Gennevilliers
(Sailboat at Le Petit-Gennevilliers). 1874

By the time Monet worked at Argenteuil, the town had become an important center for yachting. A leading Parisian yacht club had its headquarters there, and during the Exposition Universelle of 1876 Argenteuil was the site of an international sailing competition.

Boats had been a favorite subject for Monet ever since he had begun to paint. More than once he had painted his family as spectators of yacht races at Sainte-Adresse. At Argenteuil, where boats could be hired by the hour, the activity on the water provided a perfect theme. Yachting epitomized the new relationship with the out-of-doors that was being established by the middle classes of the city. Monet was in a sense part of this: his floating studio was his version of this idyll. In it he could move up and down the reaches used by the racing boats, and he could work from it moored among the yachts in the basin.

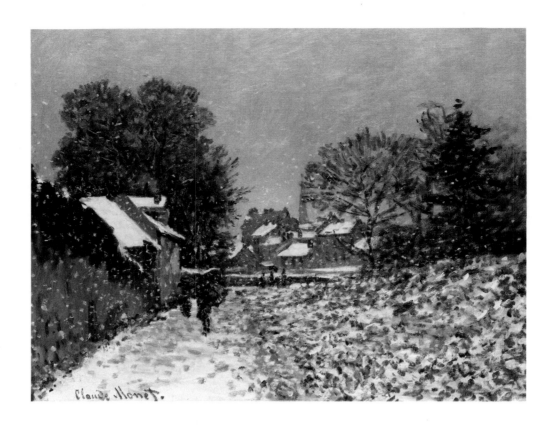

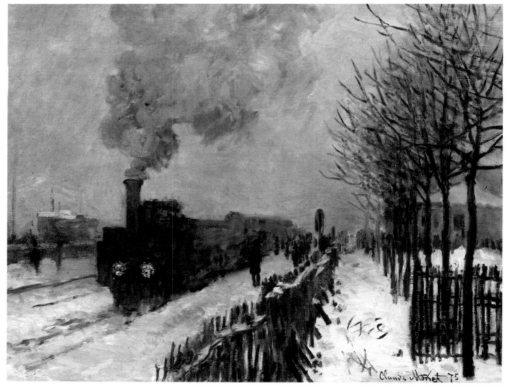

ABOVE: Neige à Argenteuil *(Snow at Argenteuil)*. 1874

BELOW: Le Train dans la Neige. La Locomotive *(Train in the Snow. The Locomotive)*. 1875

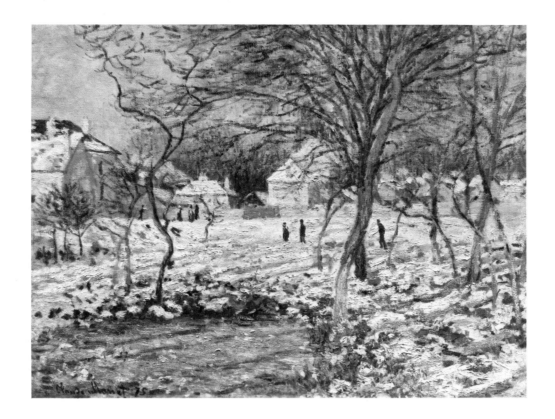

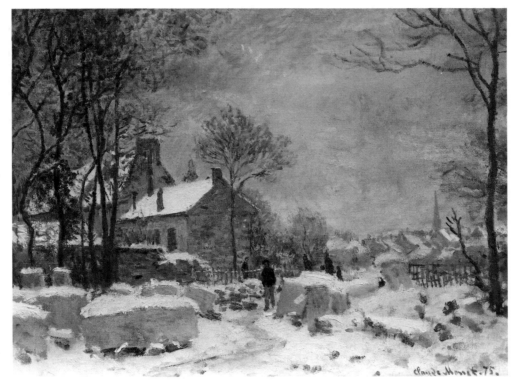

ABOVE: La Mare, Effet de Neige *(The Pond, Snow Effect)*. 1875

BELOW: Effet de Neige à Argenteuil *(Snow Effect at Argenteuil)*. 1875

Argenteuil was an industrial town surrounded by farmland and estates that were rapidly dwindling as middle-class suburbs spread out from Paris. For a while it exactly suited Monet's commitment both to the modern world and to nature. The two were, of course, irreconcilable in reality, but in these paintings of the railway and the back streets of the town, the contradiction is resolved: under the dual inspiration of Japanese prints and the spectacle

of thick snow, Argenteuil becomes a place transfigured and etherealized by white.

Japanese popular prints had been the objects of intense scrutiny on the part of some painters since the late 1850s. In Monet's circle they were something of a cult. Although he seems to have begun to collect them only in 1871, when he was in Holland, his work before this makes it clear that he had looked at them closely. The composition of Terrasse à Sainte-Adresse *(page 35) is*

inconceivable unless we allow for the Japanese example.

Monet's love for Japanese forms is subtly expressed in these views of Argenteuil in which the snow allows him to develop the odd arabesque of a twisted sapling by a pond, or of a skein of smoke drifting up from the locomotive. There is a delicacy in the paintings of this winter and a calligraphic refinement that rarely appear in his work.

ABOVE, LEFT: La Seine près d'Argenteuil
(The Seine near Argenteuil). 1874

ABOVE, RIGHT: Effet d'Automne à Argenteuil
(Autumn at Argenteuil). 1873

*The Petit Bras was the southern arm of the
Seine as it flowed past a large island—L'Île
Marante—downstream from Argenteuil. It was
a favored anchorage for yachtsmen, an alterna-
tive to the crowded moorings near the bridge.
Monet made several paintings here with boats,
but in the picture at right above there is a sense
of seclusion. The deserted banks make a frame
that distances the far-off town. Monet's floating
studio allowed him to mingle with the traffic on
the water; but it was also a retreat from that
traffic, his private observatory. In the paintings
that flank this one, Monet is not participating in
the life of the river but drawing back from it,
observing it from behind a screen of vegetation.
There is no path for the eye to follow through
the middle ground, only an immediate fore-
ground and a distance. The yachts and the town
seem unapproachable, and their remoteness
gives an added poignance to the moment of
light, the sky furrowed in rose and gold as the
sun sinks.*

breast, a bowl of fruit, or a summer meadow; certainly nothing of Courbet's lumpen randiness. In the 1868 *Déjeuner* Camille's hand resting on the tablecloth is simply a coarsely painted pile of matter. The velvet ribbon that circles her neck is merely noted, as are the folds of the bib tucked up to the baby's chin. What clues and invitations to their weight and warmth Monet turns aside!

His portraits tell the same story of indifference. It is almost as though his early dabbling in caricature, with the facile and conventionalized play with likeness that this entailed, has left something dead in his response to the specific life in another's face.

Nor as a rule do his figures behave except within the most wooden limits. An early Fontainebleau forest scene has a stock faggot carrier. It is almost Monet's only attempt at somebody related to his environment through work. Figures on the seashore might clutch at a hat or fling out a pointing arm, but they are nothing more than dolls doing it. The bathers and loungers at La Grenouillère are mere blobs, mere brushstrokes, and the charm and animation we discover in them stem as much from the effort of deciphering Monet's shorthand as from the figures themselves.

What it amounts to is that he is applying the distanced scanning appropriate to landscape to all that the landscape contains. But his view of landscape takes its terms far more from the city, where the streets are filled with strangers, than from the country, where everybody knows everybody else's business. He has nothing at all to do with that line of thought that joins Millet, Pissarro, and Van Gogh in celebration or pity of peasant life. In certain moods, Monet would remind people proudly that he was born a Parisian, even if at others he would declare himself a man of the out-of-doors. His view of the countryside is often that of the weekender: the riverbank at Argenteuil with its yachts and rowboats, the blossom-filled orchards, the strollers through the scented hayfields. The one exception, a canvas of laborers unloading coal from barges, painted in 1875, with its uneasy amalgamation of Zolaesque social realism and Japonaiserie, is almost comically untypical.

The key paintings in the development of this landscape view of people were perhaps the canvases that Monet painted from a high vantage point in the Louvre during the spring of 1867. These are crucial experiments in which he seems to be pushing the principles of Realism to their furthest limits. The scenes he paints stretch from the street below to the skyline. The pavements are teeming. Monet's high viewpoint precludes accommodation between what he sees and any familiar scheme of landscape composition; at the same time his method precludes the conventions of the panorama. It is as though he is

Coucher de Soleil sur la Seine *(Marine View— Sunset)*. 1874

Paris, Pont Neuf, after 1854.
Photograph by Charles Soulier

*Charles Soulier photographed this view from
approximately the same vantage point—a bal-
cony of the Louvre—from which Monet, in 1867,
would paint the three pictures of Paris which
follow (opposite and page 71).*

experimenting with a kind of anticomposition in which once the dome of the
Panthéon has been fixed, every other feature is simply fitted in as it comes.
There can be no doubt that photography was important to Monet. Both the
process and its result offer a kind of model for what he was doing. The camera
lens inevitably includes what lies within its view. It cannot do other than "see"
the world as an unbroken sequence of light-reflecting surfaces, the relation of
each to each determined by the camera's position. Nowhere in these paintings
does one sense a decision to leave out or alter something because it does not
fit easily. In *Le Jardin de l'Infante* the shape made by the garden in the im-
mediate foreground is awkward in the extreme: we are looking at its formal
layout aslant; its axis seems all wrong, as does the curve of its railing. Yet this
awkwardness is completely appropriate to other aspects of the painting—our
distance from every part of it, its blankness, the feeling that it is all surface that
we cannot reach by virtue of our position. And the way Monet represents the
figures in *Le Jardin de l'Infante* is reminiscent of the images of figures on the
pavement that the long photographic exposures of that time produced,
flickering, blurred, the faceless material of the ever-moving crowd.

Down there on the pavement the eye is paramount. It does service for all the
senses in an environment where sounds have lost their specificity and location,
noise reigns, and everyone is a stranger to everyone else. The people on the
London pavement in front of the shopwindow in "The Man of the Crowd," a story
by Poe, "seemed to be thinking only of making their way through the press. Their
brows were knit, and their eyes rolled quickly; when pushed against by fellow-
wayfarers they evinced no symptom of impatience, but adjusted their clothes and
hurried on." The eye is paramount too because of its unique capacity to distance.
Each of us defends against the shocks of the street with our eyes, once they have
mastered the confusion, the sheer number of individual messages. Even today
one can rediscover this fact on the pavement near a large railway terminal. One
will see a traveler from the country trying to *see* each face that passes and
preparing himself or herself for some kind of encounter. Sooner or later the
bewilderment and stress involved in this effort will be allayed as the eye learns
its city skills. It becomes a passive spectator of more and more material; the
myriad, competing invitations become a general spectacle—a transformation
that the shopwindow is there to serve, as Walter Benjamin pointed out in his
essay "On Some Motifs in Baudelaire," from which the quotation from Poe
is borrowed.

Six years after the Louvre paintings, in the high style of Impressionism,
Monet was to bring off a supreme statement of the city as landscape. This is
the first of two paintings of the Boulevard des Capucines that he made from

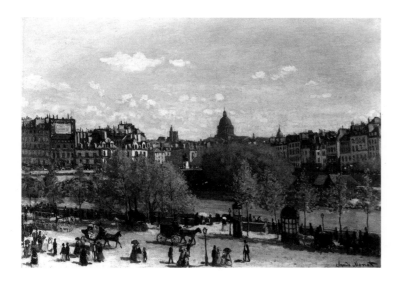

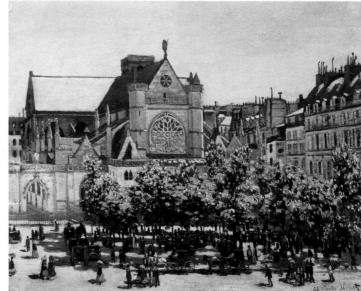

the studio of the photographer Nadar, the scene of the first Impressionist exhibition. The whole volume of the street is conceived as an event of light and shade. The buildings opposite, the trees, and the thoroughfare crowded with carriages are fused into a golden mesh of sunlight. The broad pavement teeming with figures below is in the shadow of the building from which Monet is painting. In spite of the powerful diagonal of the boulevard, which drives toward the right top corner of the canvas, it is not perspective that shapes the space so much as the dense, light-filled, powdery atmosphere, which, through the perfectly judged relationship of warm and cool tones, gold and gray-blue, provides a kind of screen against which the myriad events of traffic and crowd can be seen quivering and effervescing. The eye scans in any direction; there is no definitive junction of forms, no definitive release into the distance, no focus, no event. It is truly a landscape, for all that is urban about it. People, carriages, horses, windows, awnings flutter like a kind of man-made foliage.

Perhaps one reason *Le Boulevard des Capucines* is such a satisfying picture has something to do with those two observers on the right. They seem to rehearse Monet's own relationship to the spectacle below. Like spectators in a box at the theater, the street spread out in front of them, they can take or leave its endless performance.

It is an exemplary picture, for the Impressionist style makes sense only if it is linked to vision, to the act of looking out onto the world. Yet the painting is not merely descriptive; it has another motive that seems at first to be antithetical to description. Some of Monet's supporters among the critics saw his work as an advance form of Realism. This was Zola's line, and it continued to be Clemenceau's. Others, impressed by its aesthetic distance, advanced the idea of *le décoratif,* a self-sufficient art made for no other reason than to be looked at. Both are true but one-sided accounts. The missing element is the developing concern with the descriptive process itself.

The internal features of the style developed jointly by Pissarro, Renoir, and Monet during the two or three years before the war are easy to describe. Mostly they derive from the techniques of sketching *en plein air.* They are shaped by the mode of observation that landscape engenders—considering things at a distance, in parallel vision without tactile projection, in unbroken spatial relations. The palette is cool rather than warm, reflecting the artists' interest in reconstructing the quality of outdoor light rather than studio light. Observation focuses on the circumstances of the moment, on *l'effet,* which comes to include not only the time of day and the particular quality of light but the quality of the medium through which surfaces are seen, *l'enveloppe.* To put it another way, aerial perspective is removed from the realm of studio

Art critic Gustave Geffroy described Monet's handling of a bustling street scene in La Justice, March 15, 1883:

Boulevard des Capucines was long used as an argument against M. Claude Monet's painting. Fortunately we have finally come to understand that setting down a crowd and doing a portrait of a man are two different things. The precise work that may be suitable for reproducing the features of a model, the individual character of a face, is out of place here where we are dealing with houses presenting themselves by blocks, carriages passing each other, circulating pedestrians; here one does not have the time to see one man, one carriage, and the painter who lingers over these details will not succeed in capturing the confusion of movements and the multiplicity of color spots that constitute the whole. M. Claude Monet has not fallen into such an error; his canvas is as alive and restless as the Paris that inspired it.

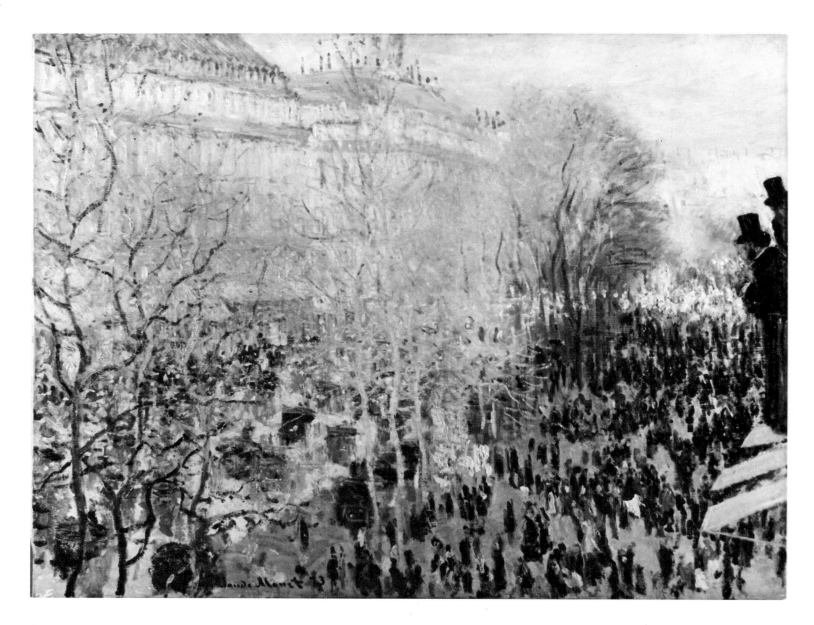

Le Boulevard des Capucines (The Boulevard des Capucines). 1873

OPPOSITE: Le Jardin de l'Infante (The Garden of the Princess, Louvre). 1867

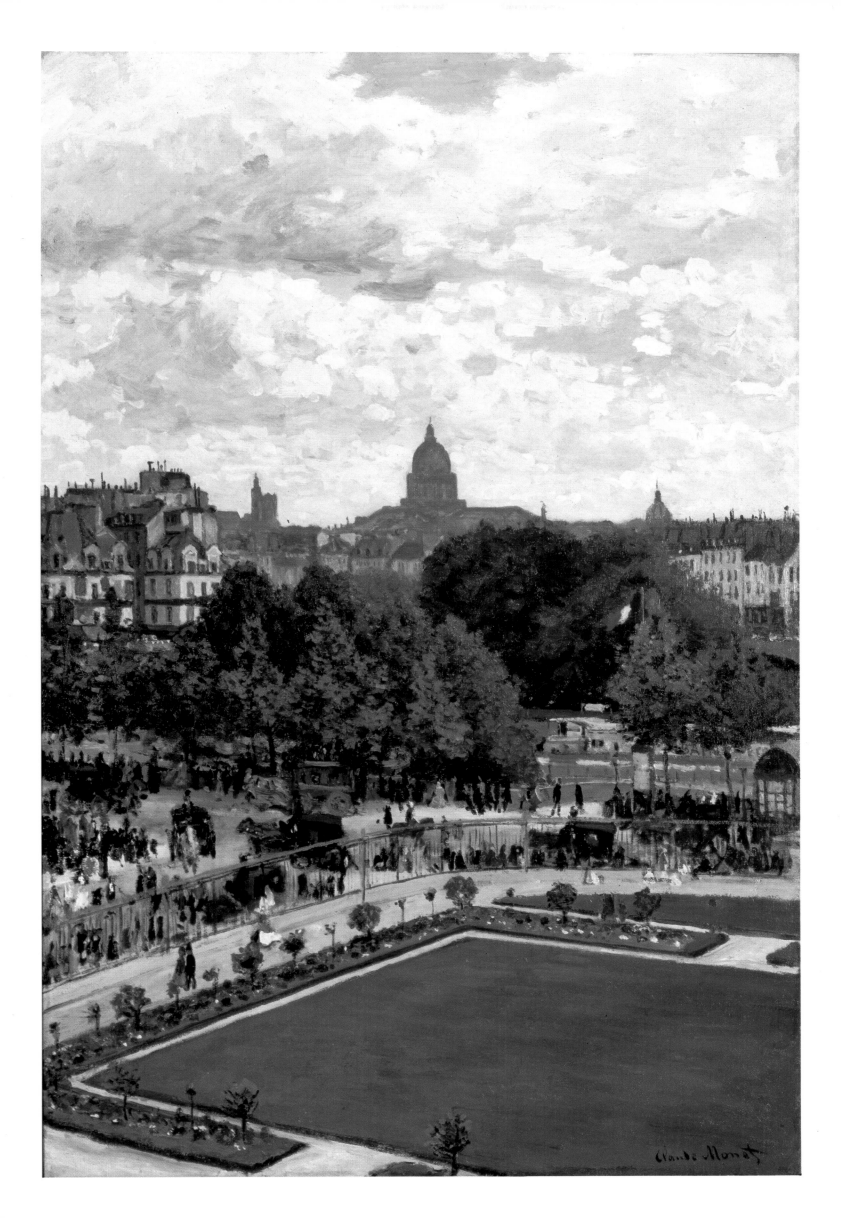

Le Boulevard des Capucines
(The Boulevard des Capucines). 1873

convention and studied as an actual phenomenon, as an event in color relationships. This is the marvel that produces the Impressionist palette, the insight that the whole visible world can be reconstructed on the level of color. Color—pure, variegated, shot—can take on the quality of light, not by the traditional schema of light and dark tonalities but by its simultaneous interaction on the picture surface. The question of the color of shadows preoccupies the Impressionist painters; it is the very area that academic art conventionalizes through modeling and the generalizing power of the dark ground, conceived as darkness or the absence of color. The Impressionist pigeon grays, gunmetal greens, violets, lavenders, lilacs, cornflower blues do not depend on their darkness to work as shadows but on their crisp interaction with the warm elements that make up the other half of the equation. Transitions of light into shadow become transitions of positive color, never a degradation of the light.

It is often said that the earth colors and black are excluded from the Impressionist palette, but this is not invariably so. What matters is that these pigments, no longer needed for their traditional function to model, are now used as colors in their own right. By the same token, the traditional studio practices of working on a dark ground, usually a reddish brown, or laying in the broad features of the painting in earth tones, methods that Monet had continued to follow in his large figure compositions, were gradually dropped in favor of working directly on a white ground. (Here Renoir's experience as a ceramic decorator probably gave him the lead.) The elaborate scumbles and glazes that academic painters had used to develop strongly modeled forms out of toned grounds were no longer relevant. Impressionist paint during the

seventies was applied directly and opaquely with frank and open brushwork—although it cannot be overemphasized that Monet's color is in no way disorderly or random. He continued throughout his life to structure his palette with great care, moving from few colors to many as the work progressed.

Sketching technique is above all rapid. The aim is to record information and summarize a general effect. The reproaches leveled at Monet for not being able to impart "finish" were based on a reading of his marks as sketched approximations. It was some time before it could be seen that his touch, with all its roughness, was as integral to his style, and as precise in its intention, as his high-key palette. The terms of the sketch are formalized.

Once the sketch is allowed as an end in itself, its descriptive features can be contemplated for their own sake, distanced from their functions as mere shorthand. *The River,* that great painting in which, it seems, all these features come together for the first time with depth of meaning, is not so much a picture of a girl sitting on a riverbank as a picture of a way of seeing and describing a girl sitting on a riverbank. The magic of those little paintings on the beach at Trouville from the summer of 1870 is not simply what they tell us about Camille and Mme. Boudin at the seaside but the way they open up for our contemplation the forms Monet invents to stand for that moment. His painting decisions, on the palette, on the canvas; the way he is judging his marks, setting them against his observation of the scene, reading them, *making them out;* the condensations and elisions he allows, the brevity of detail, the clarity of color, patch on patch; in short, the working of his sense of how the life and light of his observation are to be epitomized in paint—these, it seems, provide the material of his Impressionist paintings to which we respond on

the level of content. To call these paintings decorative is merely a way of describing this bracketing frame of mind in which he frees himself from the insistencies of the subject. To call them Realist is a way of describing the context of the task he had set himself. At the center, for the time being, is notation.

It is hardly surprising that this aspect of Monet's work is little discussed by his contemporary critics. We have the advantage of looking at Monet across Seurat, Van Gogh's drawings, the Analytical Cubism of Braque and Picasso, Mondrian's pier and ocean, none of which would have been conceivable if Impressionism had not opened up modes of description as subject matter. There were no ready answers to Monet's questions to himself about how he saw. Each painting has the potential of being a unique problem. Of course this cannot literally be so, but the thought is present as a promise and a threat. Here the formative effect of the *motif* is paramount.

Let us return to Camille on the riverbank at Bennecourt. She sits at the foot of a tree, looking out toward the far bank. The grass she is on is sprinkled with summer flowers. The tree over her head filters the light that falls on her. The gaps in its foliage reveal patches of blue sky and the sunlit houses on the far side. The water is unruffled and carries a still reflection of the houses and rising land beyond. Through this reflection, the blue of the sky envelops Camille from her shoulders down in a zone of cobalt drawn to a point by the ribbon on her hat in the immediate foreground. Something exactly similar happens with the warm reflections of the walls and roofs and distant foliage. Warm gray, mushroom pink, cream, they are gathered into the warmth of her neck, her ear, the lost profile of her brow and cheek. But something is missing in this equation. The golden flick of light on the back of her neck, the dark warmth of her hair are tighter, harder, more energetic than the calm, outspread world of the far bank. That energy beats strongly in the russet dark-ness of the tree trunks. They take the sunlight fiercely, gold on dark brown, burnt orange on black. Camille mediates between the two banks—the open sky and the distant houses, and the vivid darkness of the trees. Nor is this sense of her role in the picture limited to color. The sharp knob of her head and the rounded, ballooning blouse and skirt reenact both the alert vigor of the tree trunks and the gentle, swelling sunlit prospect; her pose is rooted, sheltered and sheltering, her gaze streaming alertly out.

Although many passages here are brushed quite broadly, the whole surface is punctuated by accents, sharp little fragments of color. The source of these, we tell ourselves, is in the foliage of the near tree. The leaves are seen mostly in silhouette against the sky and the river light. Blackish green, they become

Au Bord de l'Eau, Bennecourt (*The River*). 1868

La Gare Saint-Lazare
(The Gare Saint-Lazare). 1877

individual brushstrokes, densely clustered in places, spreading in sprays as Monet follows the tree out to its extremities. On the extreme left, sunlight catches some of them: they become brushstrokes of yellow-green, just as the fragments of sky become brushstrokes, shots, of blue. This vivid fragmentation of the tree into brushstrokes imparts a special kind of energy. The eye responds to it not only as a descriptive reduction of something seen at a distance but also as a kind of life on the canvas. Something in the picture itself patters, flutters, vibrates, breathes. It is not simply a tree described but a tree possessed in a language that, although impelled and shaped by the urge to describe, ends by generating its own life.

The flowers in the grass become dots of pure color, light on dark. Windows on the far side become oblong dots, dark on light. Somewhere on the far bank are tiny figures, sky blue, window gray. Grass accents, boat accents, shadow accents dance. This is no mere arbitrariness. These rattles and taps of accents are verified by the foliage of the tree, as one might say the miraculous blue banding of the lower half of the canvas is verified by the river and its reflective surface.

Any way of working implies a philosophy, a position. Technique is the first embodiment of content. The more evolved the technique the more clearly this may be seen. Meaning accrues with manipulation. The painter sees this and responds. His recognition is added to the earlier content and informs further manipulation. A dialogue develops between the maker and the made that is unique to the conditions of making. It has its past and its future, its own limitations and hence its own unique possibility of freedom. Did Monet foresee the drumming of those black-green dabs when he started to paint the trees over

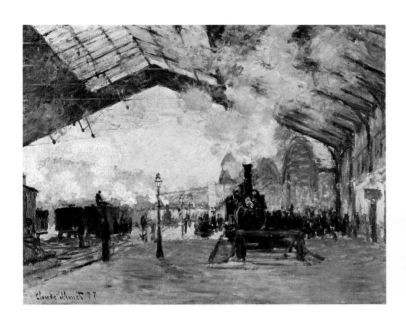

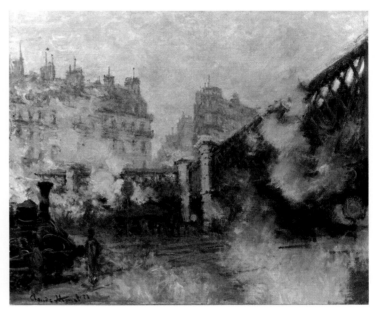

Camille's head? Or at least foresee them in all the richness of their future? It seems that when one of the factors included in a technique is an element of apprenticeship to appearances, then those appearances are included in the formative dialogue. The idea of a picture shapes the *motif;* the *motif* in turn shapes the picture. Painting willy-nilly pictorializes the world; it is the painter's fantasy to terrestrialize the painting. For him the *motif* weightily epitomizes the picture and offers conjunctions that, although they do not lie outside his ken as a painter or he would not be able to see them, nevertheless transform his sense of what a picture might be.

Consider two aspects of nature that Monet was to make essential themes, water and atmosphere. He once said that the sea meant so much to him that he would like to be buried at sea in a buoy. Time after time he finds in the sea a reflection of his inner states. In his early work we can hardly mistake the Romantic identification with the little storm-tossed fishing boats or the pounding waves on the jetty at Le Havre, favorite subjects when his own struggles for independence from his family were at their height. Later, frozen floods on the Seine at the time of Camille's death or tempests off the coast of Belle-Île play who knows what part in assuaging his inner turmoil.

But there is more to water than this. Water gives back an apparently unending series of revelations, not only through its own nature as *motif* but, by a kind of alchemy, of broader pictorial possibilities. The extent of the sea; its infinite variety in oneness; water's power to take up the quality of the sky, the day, the weather and yet remain itself; its power to reflect, and thus offer up symmetry; its power to reflect even as it is itself in movement and thus to interpenetrate, to annex, to fragment, to disperse appearances while yet holding

ABOVE, LEFT: La Gare Saint-Lazare, le Train de Normandie *(Saint-Lazare Station, Paris).* 1877

ABOVE, RIGHT: Le Pont de l'Europe, Gare Saint-Lazare *(The Pont de l'Europe, Gare Saint-Lazare).* 1877

Early in 1877 Monet was granted permission by the railway authorities to paint in the Gare Saint-Lazare. He took up temporary quarters close to the station in a small apartment in the Rue Moncey, for which Gustave Caillebotte paid the rent. Caillebotte later owned three of the paintings that resulted. Eight of the canvases were shown at the third Impressionist Exhibition in the same year. They attracted shocked attention. One critic reported that Monet was trying to give his viewers the sensation that travelers experience when several locomotives blow their whistles at the same time.

The Gare Saint-Lazare had personal meaning for Monet. It was the terminus of the line that would have brought him to Paris from Le Havre as well as from later addresses along the Seine. All his life, this station was to be his gateway to the city.

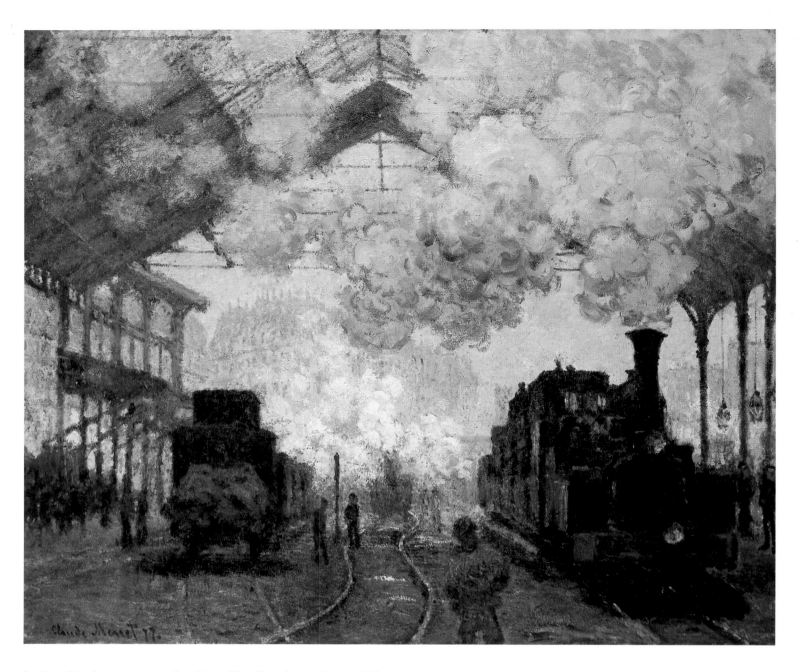

La Gare Saint-Lazare, Arrivée d'un Train *(Gare Saint-Lazare, Paris)*. 1877

These paintings, which celebrate the modern world more outspokenly than any others in his work, were his final statement in this direction. Within a few years all outward traces of contemporaneity will have vanished and the painter's own modernity will find its expression only in the stylistic innovations of his paintings, not in what they depict.

For four of these canvases, Monet was standing inside the station itself. The rails stretch away into the glare of outside light, but it is not so much by his attention to their perspective that Monet sets up his spaces as by the contrast between the dim interior and the luminous outside. The two worlds are joined and reshaped by the billows of steam and smoke. The pitched

roof of the station plays a vital part, giving an arrow-like direction to the sky.

Other paintings in the group were made in the broad railway yard outside the station. We picture Monet finding a site for his easel among a maze of switches and sidings, the shunting locomotives and the departing trains continually blocking and changing his view. This yard was crossed by the Pont de l'Europe, and in one picture it too provides a roof, a fast-moving diagonal for Monet's sky. Four years earlier Manet had depicted a woman and a child in a garden nearby. In his Gare Saint-Lazare, now in the National Gallery of Art, Washington, the little girl in white looks down onto the tracks where Monet is now working.

OPPOSITE, ABOVE: La Gare Saint-Lazare, Vue Extérieure *(The Gare Saint-Lazare, Outside View)*. 1877

OPPOSITE, BELOW: La Gare Saint-Lazare, à l'Extérieur. Le Signal *(Outside the Gare Saint-Lazare. The Signal)*. 1877

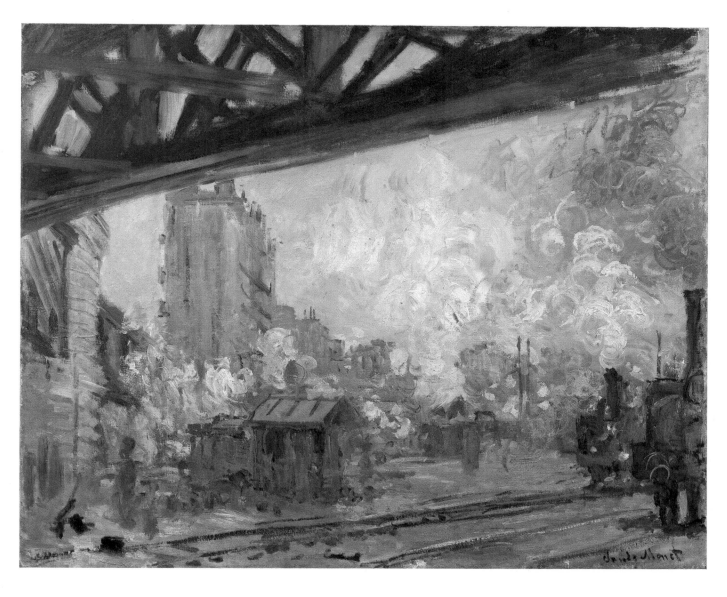

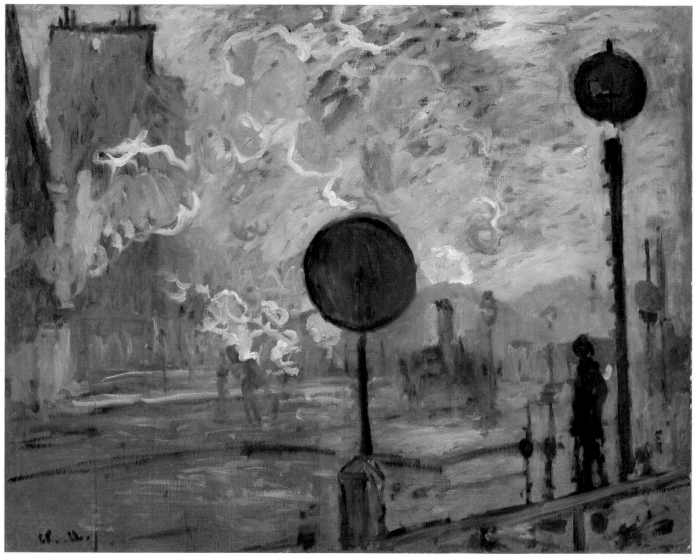

them within a larger, more inclusive order.

The rippling water of the Seine at La Grenouillère or of the Dutch canals two years later had to be painted directly. This meant to accept water's fragmentation, its highlights and reflections, its restlessness, and to read its action in terms of color. There is opened up a sense of interpenetration that affects everything. On the right of *Les Bains de la Grenouillère* the water—a panoply of interlocking plates of color—involves sky, pontoon, bathers, trees, boats. The water is not drawn as it would have been by either a Canaletto or a Turner; it is re-created in a vivid weave of brushstrokes, none of which lock onto its pictured surface but which shimmer and rock on the eye. A powerful blue dominates the foreground, moving back to a pale cerulean beyond the pontoon, shot with lemony white highlights, gold-green, olive, rose, blackish blue, umber. This passage gives the key to every other aspect of the picture. On the left light breaks through the trees. Their luminous trunks stand out like golden stripes, scaled to the same brushstroke as the blue-and-lilac-shadowed oars in the boats. Everything on the left breaks up into touches—dim, muted stripes; flicks; blobs—as it does on the right in the brilliant action of sunlight on water. Two women in long dresses walk back into the land. Flowers send out sparks of color. Sunlight strikes faces—tiny points of luminous pink among the leaves and brownish gray trunks. Swimmers are dissolved in the light, broken into figurative luminous specks half lost in the glitter. Everything is everywhere.

Water offers more than its own features. It is, in a sense, the model for how Monet can see other things. The vision that he was developing of the atmosphere itself is analogous to his understanding of water and was perhaps shaped by it. To be able to imagine the atmosphere as a continuous unbroken *enveloppe,* to be able to imagine every visible thing located within that *enveloppe,* washed and colored by it, to understand that the *enveloppe* is the condition of being able to see anything at all, is akin to being able to imagine air as we imagine water. Fog, falling snow, smoke, the haze of a hot day, all are extreme conditions that bring this fantasy nearer.

But this transmutation from water to air, from substance to reflection, from the local item to the condition of seeing it, goes further still. The *enveloppe* in its oneness and variety is a model for the canvas itself.

In the group of studies made in 1873 from his hotel window overlooking the harbor at Le Havre, Monet lays in each canvas as a unified field of gray—warm smoky gray in one, bluish night gray, or pearly dawn gray. Is it that the foggy dawn and the water of the harbor are described by this means on the canvas, or that the grayed canvas is seen as an oblong of luminous fog? Sky and water

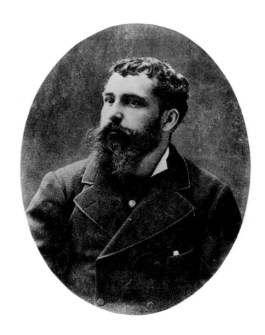

in *Impression, Soleil Levant* are hardly distinguishable. Boundaries that are fundamental out there are the finest of nuances here. The paint becomes the place and an effect by permission of the place and the effect, its glooming, opalescent oneness, its foggy blankness, its featureless, expectant emptiness that resembles, for the painter, an empty, uninflected canvas. The accents of blue-gray and orange that finally precipitate the sunrise and the boats and masts in this empty field are like last-minute revelations that had to wait, not only for the particular glimmer of orange to burn its way through the fog and find its reflective path onto the water and Monet's eye but for the canvas itself, pregnant with the foggy space outside, to be ready to receive it.

Water and its companion atmosphere become active as principles of selection. They break down the boundaries between things, diffuse light, spread reflections, redistribute identities, flatten, bond everything together within the oneness of a condition of light. Their action in the world epitomizes Monet's vision and his practice on the canvas, as his practice epitomizes what he sees in the world. In *Le Pont Routier, Argenteuil* the river offers back to the sky its light, irradiating the undersurfaces of the bridge; bringing the reflection of the tower at the end of the bridge down the canvas so that the reflection makes a columnlike interval between the columns of the bridge and the masts to the left; spreading the colors of boats and sails like little vivid increments of light throughout its surface. The degree to which any of these forms are realized in themselves is controlled by the *enveloppe,* the condition of light as it is embodied in water and sky.

In 1877 Monet embarked on his great group of paintings of the Gare Saint-Lazare. In several pictures the sky is framed by the triangular span of the roof. Inside the station it is filtered by the glass roof. Outside it is like a solid arrow-shaped block of light. Between the two zones, the blue-violet shade and the rosy gold outside, great plumes of steam and smoke like curling refractive screens rise between us and the magical pull of the road out of the station, the great doorway of the modern city, the luminous haze into which the shining perspective of the rails disappears. That smoke, with its special promise of energy and movement, its power to mediate between inside and outside, serves also to dissolve and reshape the boundaries between the two. In one picture the roof of the station is redrawn by it, cut into sections that the unfolding smoke itself seems to support like a billowy architecture. In another it marks out the spaces contained within the station, passing from light into shadow, rolling back in its own perspective. In *Le Pont de l'Europe, Gare Saint-Lazare* smoke drifts and curls out from under the station roof across the whole picture, from immediate foreground to sky, blotting out rails, reshaping the

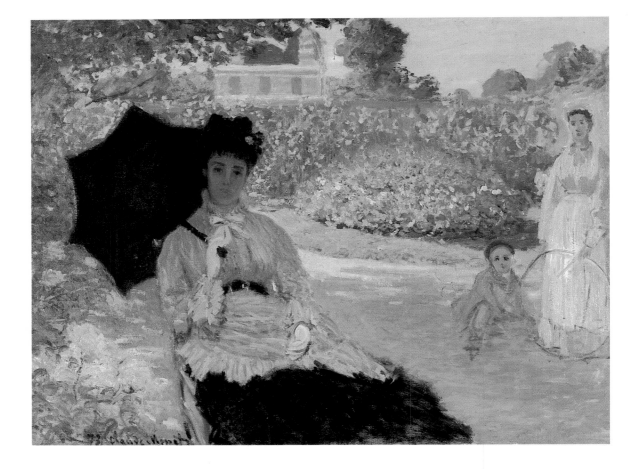

Camille au Jardin, avec Jean et sa Bonne
*(Camille in the Garden with Jean and his
Nurse).* 1873

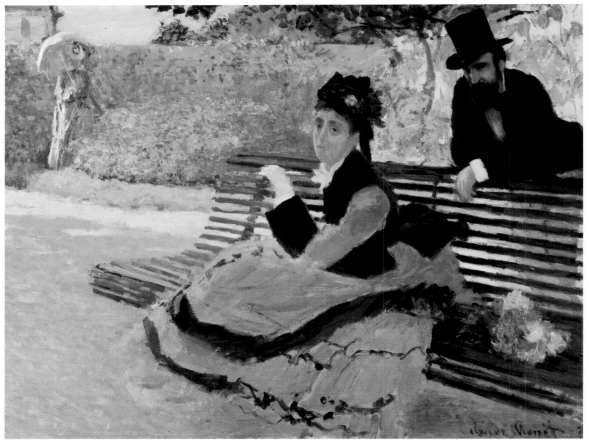

Le Banc *(Madame Monet on a Garden Bench).*
1873

OPPOSITE: La Promenade. La Femme à l'Ombrelle *(Woman with a Parasol—Madame Monet [Camille] and her Son).* 1875

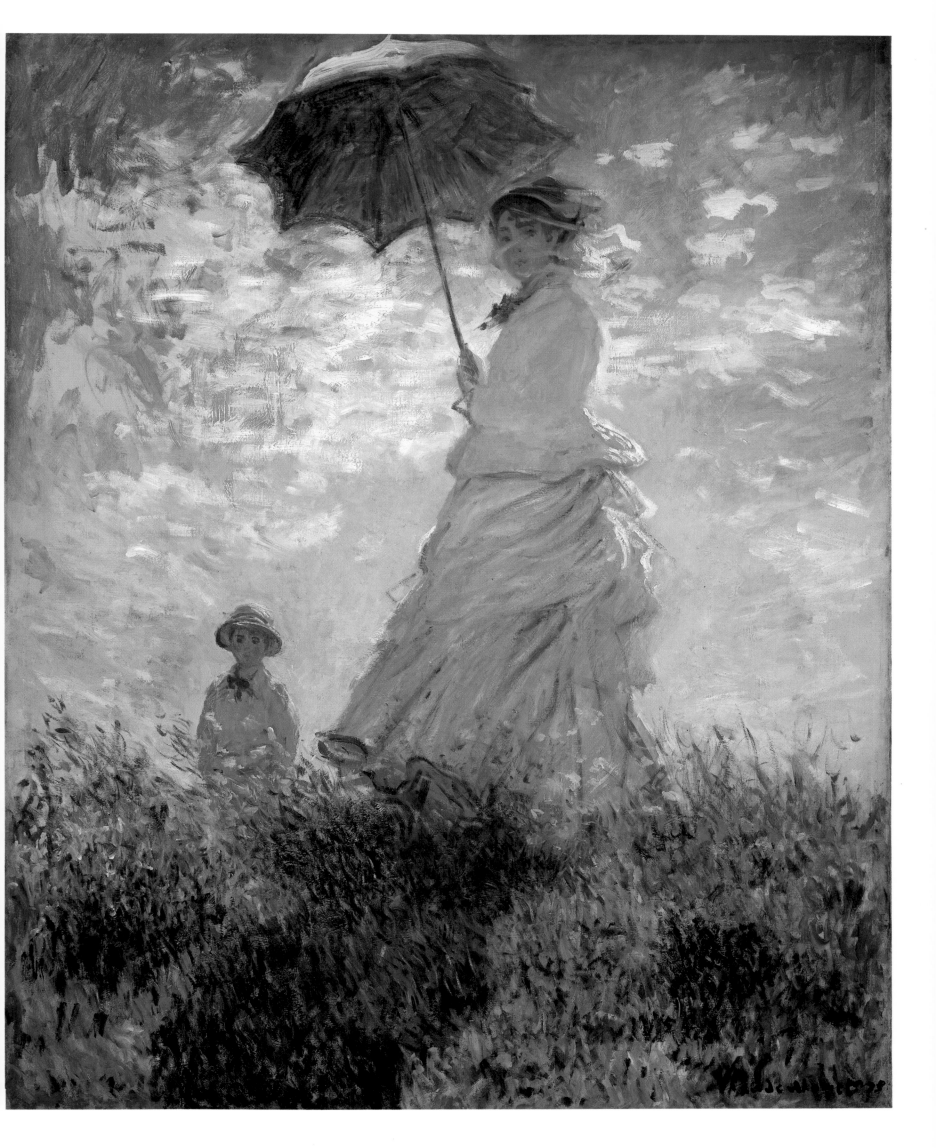

hard girders of the bridge, throwing a misty screen behind the locomotive whose funnel it isolates in silhouette, joining with the haze of the sky to turn the tall houses into distant peaks.

A list of Monet's *motifs* during the seventies would be much more than a list of things or conditions painted. It would be the beginning of an outline of his ideas of what a painting could be. Snow gives a precise coloration to shadows and a kind of picture in which powerful light is evoked without chiaroscuro and in universally positive color. In the winter of 1874 in particular, snow yields idea after idea. Falling, as in *Neige à Argenteuil,* it gives a palpable thickness, to be plotted out in blobs and dots, between the horizon and where the painter is standing. In *Le Train dans la Neige: La Locomotive* it reveals the whole scene—locomotive, smoke, fences, bare saplings lining the station platform, the solitary figure—as a series of gray arabesques on a white ground. The snow draws for Monet, draws in Japanese.

In the spring, a whole hillside is painted through a swelling curtain of apple blossoms. The myriad scarlet points of a field of poppies are outside any normal gamut of values; they hang in a haze that is neither the field nor the picture's surface but somewhere in an atmosphere between the two. Crowded flowerbeds; city streets; the masts of boats wobbling in reflection; smoke, steam, fog—all offer models of pictorial structures. The vocabulary Monet had developed, the high-key palette of pure color, the range of mark, the mastery of ellipsis, all this allows him to paint anything and to look in any direction. Whatever *motif* he turns to will hold clues for new pictorial events. This will happen in a real existential situation in which the relationship in time and place between the idea and the making of the picture is unbroken. The brush moving at will in any direction, freed from traditional centered drawing, accumulating on the canvas color that is unattached to the skin of the things depicted, seems to weave an equivalence between the whole field of vision and the picture surface. Later it is open to him to lock a mark onto a particular identity or to twirl it back and forth between one "thing" and another, to paint directly toward the layer of light and atmosphere between himself and the surface of things. But this freedom could never have been found if it had not been for the passage through the early seventies when the dialogue between *motif* and canvas was at its most excited.

It is hardly surprising that the figure comes to play a less and less important part in Monet's subject matter. The human presence in the landscape is the painter's own, Monet's eye, and his subject is not merely what he sees but how he sees it, the condition of vision and the continuing, inexorable question of how these conditions are to be stated in pictorial terms.

Camille et Jean Monet au Jardin d'Argenteuil
(Camille and Jean Monet in the Garden at Argenteuil). 1873

There is a moment, though, during the years at Argenteuil while Monet was enjoying his family and the proximity of Renoir and Manet, when his mastery of the play of light and atmosphere on the figure out of doors takes on a special poetry. It happens in the garden, the first of his own he had enjoyed. Something of his contentment in this garden comes over in the pictures that his friends made there—in Manet's sketch of Camille and Jean with Monet working at a flowerbed, or in Renoir's painting of him at his easel among a blaze of dahlias.

Enclosed, leafy, dappled with light and shade, beds filled to overflowing with geraniums, gladioli, dahlias, the garden becomes a compact world, a house turned inside out, a landscape in which there is nothing that does not stand for human choice and attention. Here, with a peculiar and most poignant intensity, Monet can study the interaction of figures and surroundings. For him it is more than a frame for Camille and Jean. He sees them merge with it, lulled by it, and in their summer reveries as much a part of it as a sleeper in his bed.

Manet, with whom Monet was now intimate, seems to have been in his thoughts when he was making two paintings in the summer of 1873, *Le Banc* and *Camille au Jardin, avec Jean et sa Bonne. Le Banc* is an arrangement that anticipates Manet's *Dans la Serre* of 1879. It was as near as Monet ever got to the kind of modern conversation piece that was so important to both Manet and Degas, although it has none of their wit or nervousness. The life of the picture is in the way it is seen. Camille, dressed to the nines, looks dolefully away from a top-hatted visitor who has evidently brought her a bunch of flowers. He is clearly made out, his hat and white shirt crisply profiled against the leaf-mottled wall behind him. He is leaning his forearms on the back of the garden bench that she is sitting on, and the rest of him is seen through the

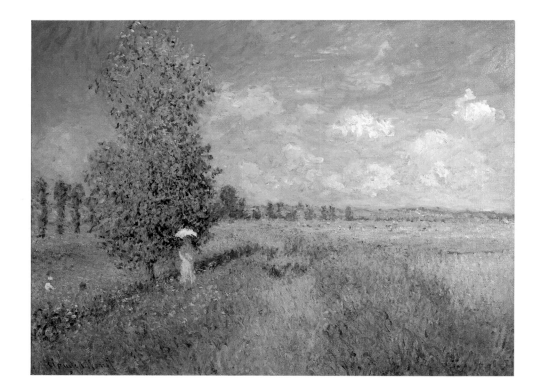

L'Été, Champ de Coquelicots
(Summer, Field of Poppies). 1875

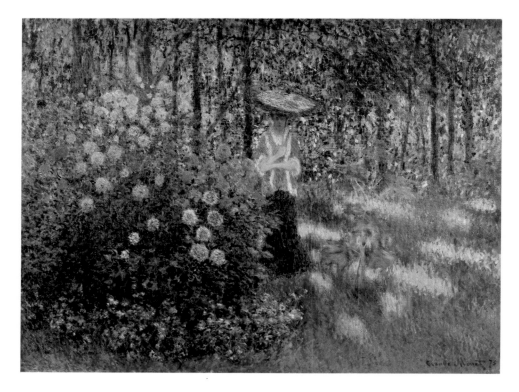

La Femme à l'Ombrelle au Jardin d'Argenteuil
(Woman with Parasol in the Garden at
Argenteuil). 1875

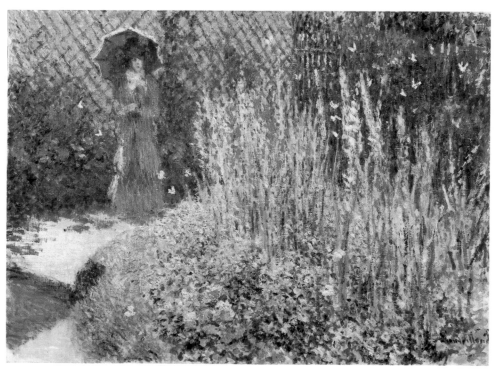

Les Glaïeuls *(Gladioli)*. 1876

Le Déjeuner *(The Luncheon)*. 1873

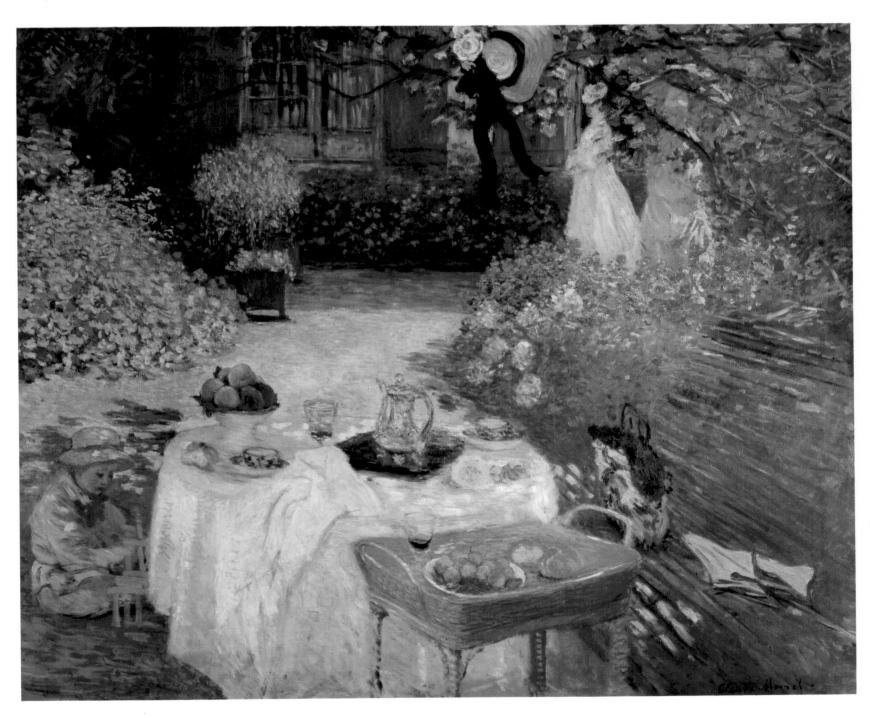

gaps between its slats. One can just construe his legs, indolently crossed, in gray trousers; but the first impact of that passage is of a stack of gray stripes alongside a stack of pink and green stripes—the garden path and the flowerbeds behind the visitor, which here, under the circumstances of Monet's point of view, merge simultaneously on the order of the slatted bench. Camille's curiously uplifted hand seems at first glance to be explained by a slanting support—a cane or folded parasol perhaps—and it is only after a second that one realizes that this is an illusion, an optical coincidence. The "support" is in fact part of the bench and in a different plane from her hand.

It is the kind of momentary conjunction we associate with the camera. There is something perverse about its appearance in a painting; but consider what follows from it. If it is an arrested gesture of Camille's we are looking at, its meaning is altogether ambiguous. Is she about to turn to her left to pick up the flowers? Is her gesture a dismissive response to something that her visitor has said? Is it the beginning of a wave to that tall, parasoled figure standing beyond the geraniums at the bottom of the garden, a wave that has been interrupted by a word from the painter? We have no idea: this is not a conversation piece. At the same time, the unease that we feel about its meaning is quickly discharged when we allow her hand to rest on its illusory support. We can flick back and forth from one reading to another: fragile, ambiguous circumstances alternate with the stable ordering of the picture. Something comparable happens in a quieter way with Camille's dress and how we fit it into her surroundings. Warm gray, trimmed in black, it seems to consolidate her partnership with the man behind her and at the same time to billow outward into the haze of the sun-filled garden, adding density, with its notes of pink and gunmetal green, to the light on the path and the dusty green of the hedge. Our reading of it too seems to flow back and forth, curling now toward one connection, now toward another. The two near figures seem almost to be supported by this movement, to swim up close to us on the surface of an atmospheric medium that stretches back to the luminous flowerbed, the corner of the house, and the vapor-laden blue of the sky.

In *Camille au Jardin,* untypically for Monet, Camille stares straight out of the canvas toward us, her melancholy eyes located exactly at the crossing point of the main lines of the composition. Her head is in shadow, flattened, and there is an extraordinary sense of the garden gathered into her, as though she is its representative or as though our gaze out into the garden is returned to us through her glance. In both paintings, Camille's dress is treated as an open form, its edges broken, scalloped, ruffled, petaled. The profile of her bonnet is flowerlike. Monet is using the qualities of the dress to develop the interaction between her figure and the garden, as he had done in the *Femmes au Jardin* of 1868, but now it is less contrived and is the natural consequence of the way he sees the garden. In a third painting, *Camille et Jean Monet au Jardin d'Argenteuil,* Camille, her arms raised to adjust her hair, is half concealed among the flowers and foliage. Her dress is spotted with light polka dots as if in a formalized concentration of the flicks and speckles that make up the leaves and flowers and splashes of light that encompass her. The very conception of

the painting has to do with the envelopment of her figure in the foliage. She is half lost, a torso, a fragmentary glimpse, a part of a greater whole. Jean sprawls on his back in the foreground like a casually dropped toy, and his relaxed, sleepy, unconscious posture speaks of fusion. And in *Les Glaïeuls* of 1876 Camille stands on the threshold of a corner of shadow formed by a dark hedge and a wall covered with a diamond lattice. Between her and us is an oval flowerbed filled with geraniums, ground ivy, and the tall spikes of gladioli. There is a heavy noon light of late summer; Camille is just in it, her parasol outlined by it. There is something wraithlike about her light-broken presence, as though the light could dissolve her completely away. The crowded plants and the ragged oval of the flowerbed give an amplitude to the foreground space that seems almost to squeeze out the narrow corridor of shadow at the top of the picture, the zone in which Camille hesitates half in, half out. Between her and us the air is made palpable by a cloud of white butterflies that dance back and forth in a marvelously judged constellation that seems to carry the glitter of the light through every inch of the canvas. Camille is half buried in the fluttering heat, half lost in a pollen-laden world of scent, heavy petals, and glossy leaves.

This characteristic of fusion, a melting together of things with things, a dissolving of boundaries, is not simply a quality discovered in the blooming luxury of sunlight and described: it is discovered again in the action of the picture. The painted surface, reconsidered as an array of color, insists on it.

The great composition of 1873, *Le Déjeuner*, is a premonition of those grand diffusions that Monet will return to years later in the water garden at Giverny. The canvas is big, something over a meter and a half by two meters. The figures of Camille and her maid and the little boy are not more than glimpsed at its periphery; the main events of the picture are the casually placed remains of a noon meal in the garden, a parasol left on the slatted bench, a sunbonnet dangling from an apple branch—invitations to the garden all spread about at random, signs of domesticity, the geraniums blazing on the far side of the gravel like a welcoming hearth.

The painting goes through astonishing transformations when viewed at different distances. Seen at a reasonable viewing distance, where the brush-strokes hang together at their most descriptive and the full expanse of the canvas can be subtended by the eye, the space in the painting is dominated by the garden seat, which establishes a flowing perspective running to the bed of geraniums at the left. From this distance the table in the center falls easily into this order of perspective. Seen close to, however, something very different happens. Now the basket juts forward like the prow of a ship, cleaving the space on either side. The thrust of the garden seat is brought to a standstill. It is now a barrier, a wall, beyond which are isolated pockets of space each harboring its own inhabitants—Camille, Jean in the left foreground, the summer hat, the flowers; each to be discovered slowly within the matrix of the total painting, of which one's memory as a complete coherent view from a fixed position is carried forward to this new reading and yet is not displaced by this new reading but rather twisted against it.

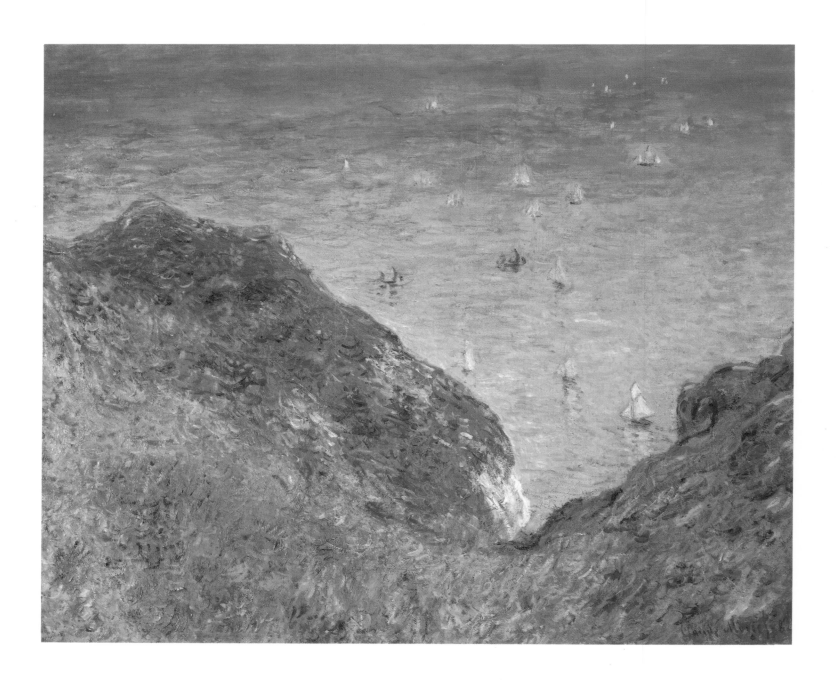

Sur la Falaise de Pourville, Temps Clair *(On the Cliff at Pourville, Clear Weather)*. 1882

Vétheuil is at the apex of a vast curve in the Seine. A large island
lies in midstream between the town and the hamlet of Lavacourt on the
southern bank. In Monet's time the two were linked by ferry. Behind Vétheuil
chalk hills rise steeply, cut in places into cliffs. Orchards and gardens line the
riverbank under the shelter of the cliffs. On the other side of the river, behind
Lavacourt, the land is flat, a watery alluvial plain that stretches away as far as
the eye can see.

Soon after moving to Vétheuil in September 1878 Monet put into commission
the floating studio he had used at Argenteuil. He explored the islands and the
long curving reaches of the river. On land he painted the orchards on the
Vétheuil side and, from the towpath at Lavacourt, up and down the river and
across to the town, where the pointed tower of the fifteenth-century church
provided a focus for the clustered houses.

The winter of 1878–79 was extremely cold, the following winter harder still.
The season matched Monet's state of mind. The December after Camille's
death he painted numerous canvases of the frozen river. With the thaw came
floods, recorded in paintings in which the surface of the river, lined by the
poles of bare poplars, is crowded with floating ice and debris. Leaden grays
and a weary, rusty purple become the keynotes of canvases that are sadder
and at first sight more flaccid than anything Monet had yet painted.

The internal problems of his work were vastly complicated by external
pressures. His continual need for sales led him to let too much out of his studio
too quickly. The brief events of the flood, for example, produced numbers of
paintings that are neither studies nor pictures but rather pseudo studies. Some
of his staunchest friends pointed this out. Used to reproaches on this score
from conservative critics, Monet was particularly stung when he read a
translation of an article that Zola had written for a Russian journal. He had
mistaken these painters, the novelist wrote, for a genuinely modern school, but
they were merely the forerunners of that school, nothing more. As for Monet,
their leader, he appeared to be exhausted by a too hasty production. He was
satisfied by mere approximation: "He does not study nature with the passion
of true creators."

Monet was to hear the same complaints from his collectors, such as Jean-
Baptiste Faure and the Romanian doctor Georges de Bellio, to whom he was
continually turning for help. Durand-Ruel too was urging him to make
"finished pictures." Monet had been negotiating with Durand-Ruel's rival
Georges Petit, who finally bought a group of the Vétheuil river paintings.
Unlike Durand-Ruel, Petit was convinced that Monet should return to the Salon
so as to give confidence to his collectors. Partly influenced by this advice, and

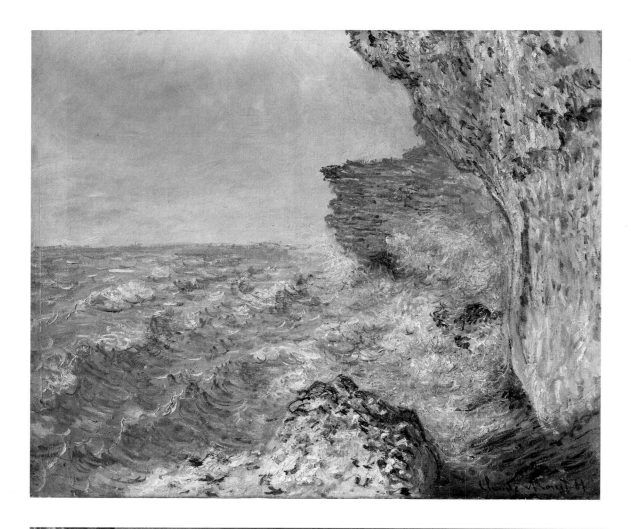

La Mer à Fécamp
(The Sea at Fécamp). 1881

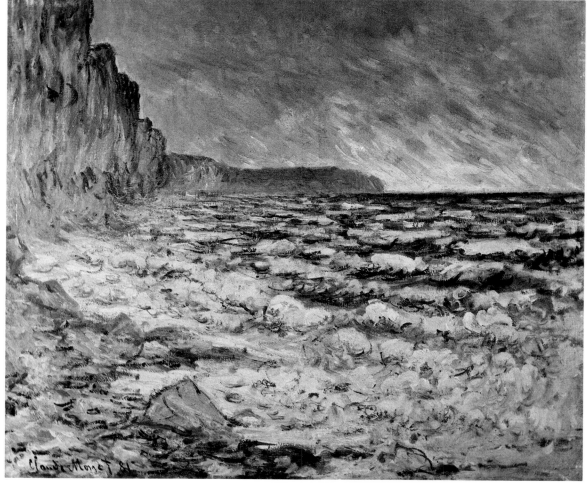

Fécamp, Bord de la Mer
(Seashore at Fécamp). 1881

Les Glaçons *(Ice Floes)*. 1880

perhaps partly by the remarkable success Renoir had enjoyed in the Salon of 1879 with his portrait of Mme. Charpentier and her children, Monet decided to enter for the Salon of 1880. It was a decision made in a spirit of calculated worldliness. Monet's feelings toward the Salon were no more friendly than they had ever been. His uneasiness is reflected in a self-justifying letter to Théodore Duret in which he tells the writer that he is working on three paintings intended for the Salon. Two of them, he believes, will be accepted, for they are "sensible," "bourgeois." "It is a crude part that I am about to play, not to mention that I shall be treated as a traitor by the whole [Impressionist] group, but I believe it is in my interest to play this part...." What else can he do? He has to sell more work, and this will surely be possible "once I have forced the doors of the Salon."

Of the two paintings he finally submitted, both large riverscapes based on studies made earlier, only one was accepted, and that was skied, hung too high. It was not, however, ignored and even received notice from the Marquis de Chennevières, an official of the École des Beaux-Arts, who remarked in a review that its pale and luminous tonality made all the other landscapes in the room appear black. This was the last occasion Monet was to show at the Salon, but within a few years the exhibition would be crowded with his imitators and pale tonalities and broken brushwork would be the fashionable norm.

His predictions about his colleagues were quite accurate: Pissarro and Degas were furious about Monet's defection to the Salon, and Degas even broke with him as a friend. The Impressionists no longer existed after this as a coherent group. Although Monet continued to be regarded as the central figure in the movement, he showed at only one more of their group exhibitions, that of 1882, abstaining in 1880, 1881, and 1886. From now on his main interest was in the one-man show. His first followed on the heels of the Salon in 1880 at the offices of the periodical *La Vie Moderne,* of which Renoir's patron Georges Charpentier was the proprietor.

Charpentier had initiated a series of one-man exhibitions and had already shown Manet and Renoir. Monet's show opened while the Salon was still running. Duret wrote an introduction for the exhibition in which he elaborated the notion of Monet as a thoroughgoing pleinairist but contradicted the idea that his paintings were mere sketches. In fact, he argued, the most radical thing about Monet was that he committed himself unconditionally to a complete picture in front of nature. Monet worked from a first, broad statement through many adjustments and refinements to a finished state, but without loss of immediacy.

This, certainly, was Monet's aim. However, as the years passed it seemed

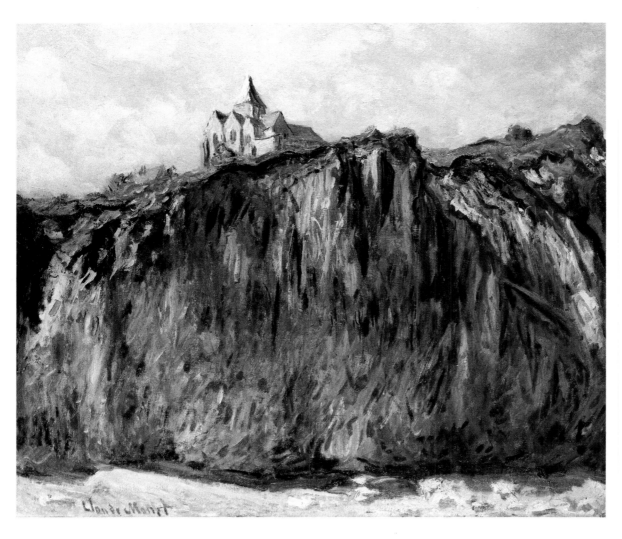

Église de Varengeville, Effet Matinal
(Church of Varengeville, Morning Effect). 1882

more and more elusive. The limitations latent in the Impressionist language, now that it was mastered, became more and more worrying. The crisis in Monet's work—a crisis that extends throughout the eighties, the most experimental period of his life—was exacerbated by the complexities of his private life—his unresolved relationship with Alice Hoschedé and his desperate need for money—as well as by his relationship to his contemporaries. In 1880 he was entering his forties, was at loggerheads with several of his old friends, and was being observed critically by an emerging generation of independent artists and their supporters, to whom he was a heroic and dominating parent figure. Typically, he put a brave face on the situation. At the time of the exhibition at *La Vie Moderne,* in the first of many interviews, he told Émile Taboureux, *"Je suis toujours...impressioniste"*—a message, perhaps, to Pissarro. The two Salon paintings, made in the studio, can hardly have been dry when he said it. It was on the same occasion that he laid down the legend of his self-taught independence.

Toward the end of the summer of 1880, Monet visited his brother in Rouen, who took him to stay at his holiday villa in the little seaside village of Petites-Dalles. It had been several years since Monet had faced the restless beaches of the Channel. Only four hurried studies resulted from this visit—two of cliffs, two facing straight out into a choppy sea—but by the following March he was back on the coast again, at Fécamp, making the opening move in a series of campaigns that were to take him away from home for weeks and months at a time each year throughout the eighties.

The summer of 1880 had turned out well. Sales had improved; some new collectors had appeared. Monet repaired his relationship with Durand-Ruel,

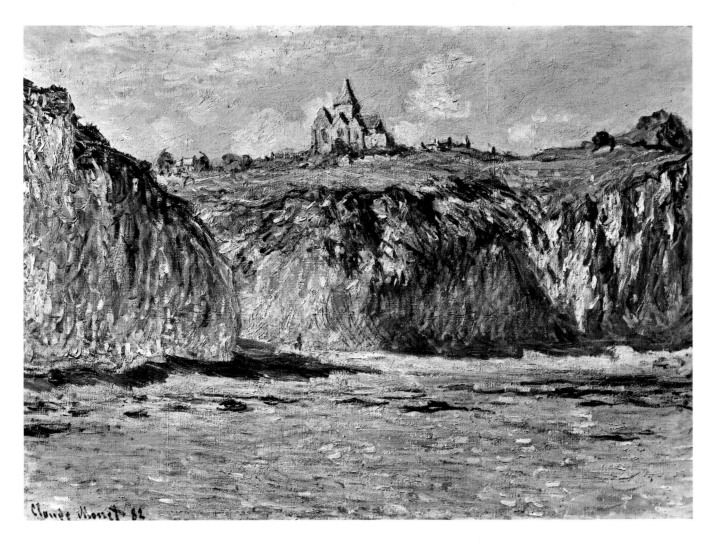

Les Falaises et l'Église à Varengeville
(Cliffs and Church at Varengeville). 1882

whose own affairs were taking a turn for the better and who was now able to renew his purchases from Monet and some of his colleagues. Monthly payments in return for regular shipments of work gave Monet a degree of calm that was immediately reflected in the quality and adventurousness of his output.

The lease on the house at Vétheuil ran out in the autumn of 1881. Monet had been concerned about the education of his older son and with this in mind took a house at Poissy, about thirty kilometers upriver from Vétheuil, closer to Paris. Alice Hoschedé moved with him, giving a more deliberate and scandalous appearance to their ménage, which up to now could have been explained as a consequence of Camille's illness and death. Now Ernest Hoschedé, still trying unsuccessfully to reconstitute his fortune, began to put pressure on his wife to rejoin him. Monet stayed away for much of the spring. He could no longer receive Hoschedé. His letters to Alice betray extreme anxiety. He was evidently devoted to his possessive and resourceful companion, whom he eventually married after Hoschedé's death in 1891.

Perhaps emotional anxiety acted as a spur of sorts: 1882 was a year of almost superhuman productivity. Monet's campaign started in February at Dieppe. Soon he moved a short way down the coast to the little village of Pourville, where he painted at the foot of the cliffs and from their tops, where he found two important subjects: one a little church perched on top of the cliff's edge overlooking the sea, the other a Napoleonic coastguard hut built as a lookout at the time of the British blockade. These huts, in Monet's time used mostly by fishermen, were dotted along the Channel coast. He had painted a study of one of them near Le Havre in 1867 and was to paint them again in the nineties.

998. Varengeville. — Sur les falaises

996. Varengeville. - Sur les Falaises

Three postcards of Varengeville—Sur les Falaises *(Varengeville—On the Cliffs)*

During his painting campaigns along the Normandy coast in 1882 and again in 1896–97, Monet scrambled along the gorge of Petit Ailly looking for different angles from which to paint this cabin. Situated about midway between the beach of Pourville and the church of Varengeville, it was the motif for the paintings reproduced on pages 98–99 and 150–51.

995. Varengeville. — Sur les Falaises

Monet went back to Pourville later that summer with his family. It was not a success. The weather turned against him. As he was so often to do, he made scores of starts he was unable to finish. His mood alternated between euphoria and despair. Alice was bored. Monet painted indoors as the rain fell—bouquets of roses, peonies, chrysanthemums; a brace of pheasant. He continued to work on his Pourville canvases after returning to Poissy.

The following winter his reexploration of the Normandy coast took him to Étretat, where he had spent some weeks in 1868–69. Étretat was the site of the most famous cliff formation on the French coast, a beauty spot whose spectacular chalk arches and flying buttresses had been painted by Delacroix and Courbet as well as numberless topographers. Courbet, six years dead, must have been vividly present in Monet's mind at this time. Of all the painters of the preceding generation he was in every way the most important to Monet, an exemplar who inspired him and challenged him at a far deeper level than the retiring Boudin. They had been at their closest on the Normandy coast. In an uncharacteristic claim, Monet wrote to Alice that he was planning a large painting of the cliffs "after Courbet," adding that the project was "terribly audacious." The large painting never materialized. The weather turned violent; he had to work from the shelter of the hotel, from which, just like any tourist, he could see the well-known view of the Porte d'Aval and its Needle sticking up into the sea. But Courbet's aggressive presence is surely there in his path, to be acknowledged and finally to be buffeted aside in studies that start with the picturesque view of the array of cliffs and go on to close-up pieces of the cliff, extraordinary declarations of mass, tremendous displacements of gravity, blanched presences like the bones of ruins of the cathedrals of giants.

During the winter of 1883–84 the lease on the house at Poissy drew to a close. It had been a place Monet had hated, and he had done little work there. He longed for a permanent base where he could at least paint and face misfortune with a good heart, as he put it to Durand-Ruel. He began to explore the reaches of the Seine around Vernon and on one of these journeys discovered Giverny, an obscure little village on one of the branches into which the river Epte divides before it joins the Seine. Here he found a farmhouse to rent that exactly suited his needs. It stood at the foot of a hill between the main road of the village and the track of a little railway that joined Vernon and Gisors. A large garden ran down to the railway, and beyond were a willow-lined stream called the Ru, water meadows, tall plantations of poplars, and, a few kilometers on, the Seine itself. As an environment it had everything Monet needed.

With Durand-Ruel's help the debts at Poissy were settled, and the move to Giverny was made in April 1883. No sooner had the family arrived and started

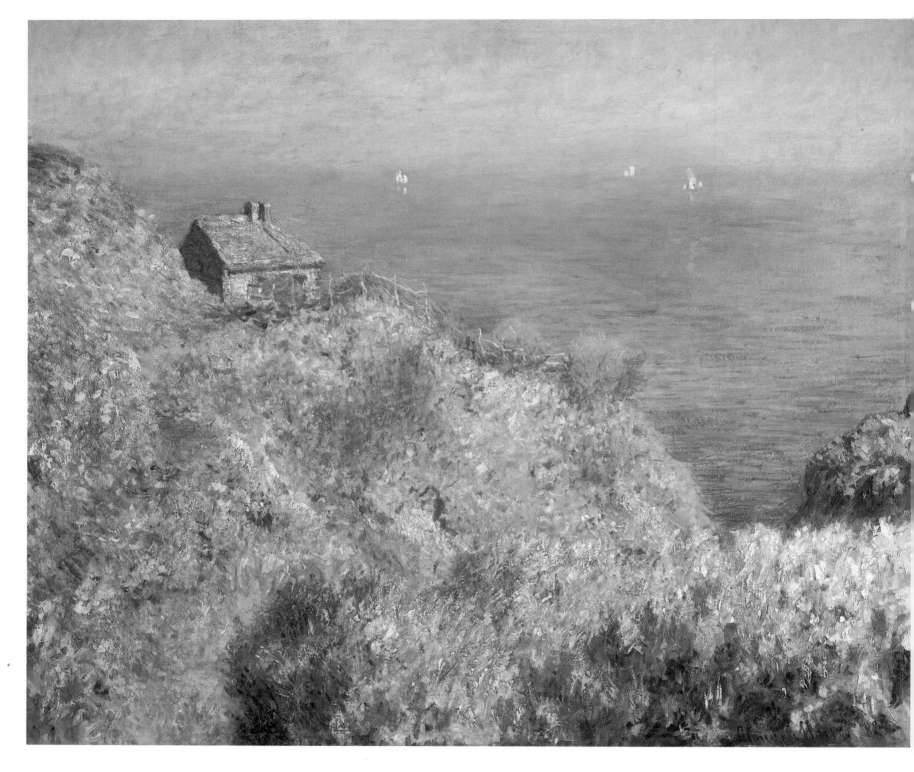

La Cabane de Douanier à Varengeville *(Custom Officer's Cabin at Varengeville)*. 1882

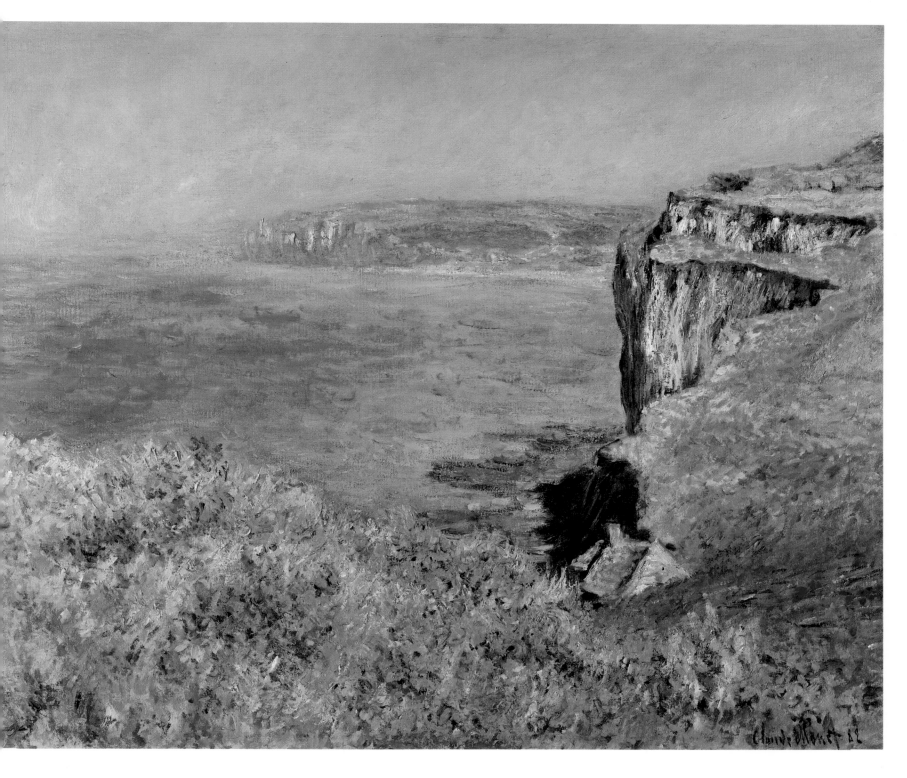

Falaise à Varengeville *(Cliff at Varengeville)*. 1882

On March 27, 1883, the closing day of an exhibition devoted primarily to Monet's Normandy coast paintings at the Galerie Durand-Ruel, Philippe Burty published this comment in the newspaper La Republique Française:
"He paints from afar," one of his colleagues has told me, expressing in a striking way his method, which consists in fact of not bending over the easel in order to follow the silhouette of the objects with the brush, but in order to lay on the touch that is supposed to evoke the idea of the tone more than the memory of the detail. It is "from afar" that one must judge these paintings, and the myopic of eye or feeling discover nothing in them but a confused, jumbled surface, rough and flossy like the other side of a Gobelin tapestry....But at a distance, under a regular light, the effect imposes itself by the knowledge of the lines, the moderation of the tones, the breadth of the masses, the intensity of the bursts of sunlight, the softness of nightfall.

Two photographs:
ABOVE: the Porte d'Aval and the Needle, Étretat
BELOW: the Porte d'Aval and the Needle seen
through the Manneporte

*Étretat was a small fishing village on the Nor-
mandy coast about halfway between Le Havre
and Dieppe, famous for the spectacular forma-
tions of its chalk cliffs. These are among the
topographical wonders of France and their
arches and pinnacles had attracted painters—
and when the time came, photographers—
throughout the nineteenth century. Isabey,
Delacroix, Diaz, and Courbet are only the most
distinguished of Monet's predecessors. By the
time Monet was working there, the cliffs were
extremely well-known and Étretat was a popu-
lar summer resort. However, hardly a trace of
the town shows in Monet's painting, and only
the timeless fishing boats reflect man's presence.*

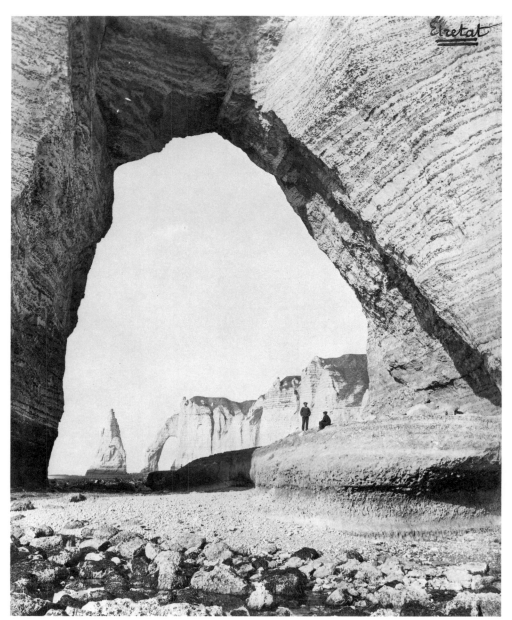

*Courbet had worked here in 1865. It is not sur-
prising that Monet should have declared his
intention of "doing Courbet" at Étretat. Monet
was connected to the older painter by ties of
admiration and friendship, and it was he whom
Monet most needed to challenge. Besides, this
was Normandy, Monet's coast.*

*The tremendous forms of the cliffs, seen close-
to from the level of the beach, give opportunities
for the development of mass and substance new
in his work. But there is something airy and
vulnerable in Monet's cliffs, and a far greater
sensitivity to the interaction of chalk, sea, air,
and light than in Courbet's.*

*The chalk arches gave Monet rich oppor-
tunities for compositional experiment. His view-
points were limited by the tide. The arches are
powerful forms in themselves, and frames
through which he can sight.*

GUSTAVE COURBET.
Plage d'Étretat, Soleil Couchant
(Beach at Étretat, Sunset). 1869

GUSTAVE COURBET.
Falaise d'Étretat après l'Orage
(Cliff at Étretat after the Storm).
1870

Étretat, Mer Agitée, also known as Falaise à Étretat (*Étretat, Rough Sea,* or *Cliff at Étretat*). 1883

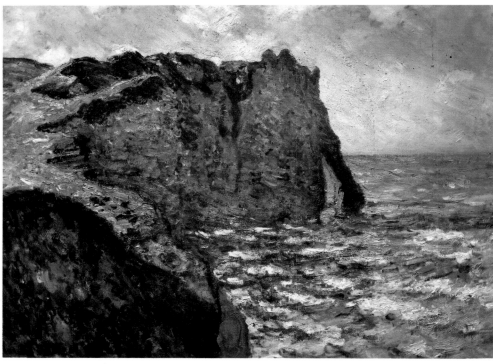

OPPOSITE, ABOVE: L'Aiguille et la Falaise d'Aval *(The Cliffs at Étretat).* 1885

OPPOSITE, BELOW: La Porte d'Aval, l'Aiguille d'Étretat *(Cliffs at Étretat).* 1886

La Falaise d'Aval
(Cliff at Étretat). 1885

Although Monet was described by one hostile critic as nothing more than an "atmospheric stenographer," there is no question that he went to great lengths to achieve the specific effects represented in his paintings. The artist recounted the following episode to François Thiébault-Sisson:

Monet told me how, finding himself at Étretat on a day of equinox, he had insisted on reproducing a storm in all its details. Having found out exactly how high the waves might come, he had planted his easel at the proper height so as not to be submerged by the water in a winding hollow of the cliff. As an extra precaution, he had had his easel lashed with strong cords and his canvas fastened firmly to the easel. After which he had started painting. The sketch was already going famously when there was a downpour from the sky. At the same time, the storm redoubled its violence. Stronger and stronger, the water rose in furious breakers and gradually came closer to the artist. Monet, indifferent to everything, was working furiously. All of a sudden, an enormous billow tore him from his folding stool. Choking and submerged at the same time, he was about to be swept away when by a sudden inspiration he let palette and brushes go and grabbed the rope that held his easel. But he was still being rolled like an empty barrel, and if it had not been for two fishermen who happened to be on the cliff, he would have gone to dine with Pluto.

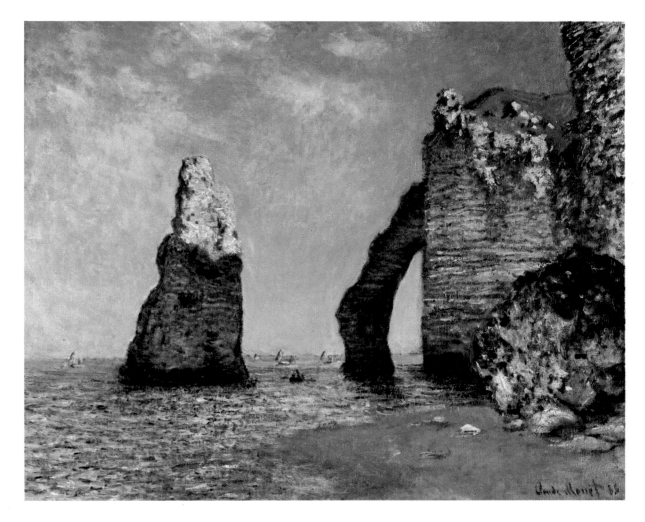

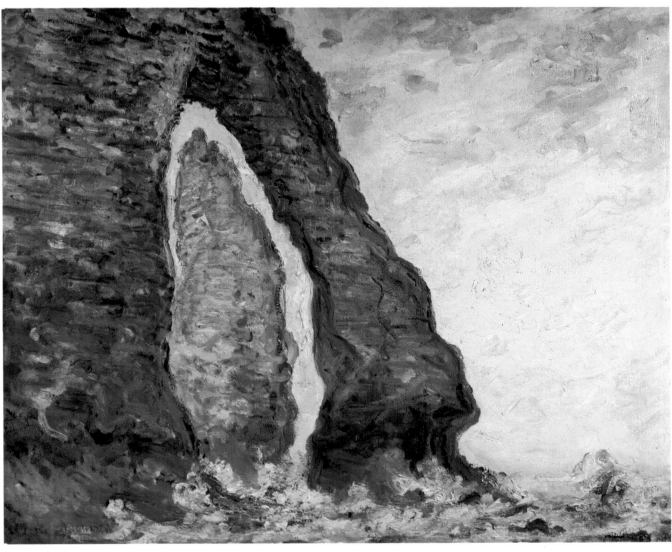

unpacking than the news came of Manet's death. Asked by Manet's family to act as a pallbearer, Monet again had to appeal to Durand-Ruel for the fare to Paris and help with the purchase of a black suit. The other bearers were Antonin Proust, Henri Fantin-Latour, Alfred Stevens, Zola, Duret, and Philippe Burty. Cézanne and Pissarro attended.

Back at Giverny, Monet began at once to plant the garden. The base he had longed for was becoming a reality. He was to live at Giverny for the rest of his life. He bought the property in 1890 and gradually extended and elaborated it until it became a self-sufficient domain. But as a painter his beginnings there were tentative.

One of his first concerns was the construction of a small building on the Seine where he could keep his boats and store canvases. His first paintings were made from the water, studies of the islands in midstream and views across the river with low horizons and watery foregrounds.

Renoir had been traveling far afield in a search for new subjects and a different light. That winter Monet joined him on a trip that took them into Italy as far as Genoa, visiting Cézanne at L'Estaque on their way back. It was Monet's first view of the Mediterranean since he had been on military service as a youth. He decided to go back as soon as he could, cautioning Durand-Ruel not to tell Renoir so that he could work in privacy. In January 1884 he was installed in a pension in Bordighera, just inside Italy. The impact of the southern light and flora was electric. He made friends with Francesco Moreno, the owner of a large villa nearby, who allowed him to paint in his estate, a wonderland for Monet, filled with palms, lemon groves, olive trees, flowering vines, mimosa, and other exotic flowers that dazzled him. He was there until April, moving briefly to Menton before returning to Giverny.

In the fall of 1885 Monet went back to Étretat for his final, grandest campaign there. It was on this occasion that he became friendly with Guy de Maupassant, whose account of Monet at work, "The Life of a Landscape Painter," was published in the periodical *Gil Blas* in 1886. At work, Maupassant says, Monet is less a painter than a hunter. He describes him setting out followed by children who carry five or six canvases that he had already started with views of the same *motif* seen at different times and under different conditions. Monet works first on one, then on another, according to the light, lying in wait for a particular gleam or the passage of a cloud, then nabbing it with a few strokes of his brush.

Next year he was in Brittany for the first time, exploring a coastline of dark granite instead of the chalk of Normandy, transparent ultramarines and bottle greens instead of the cloudy ceruleans of the choppy Channel shallows. Brittany had for some years been in vogue among artists for its cheap living and the apparently timeless way of life of its peasants and fishermen. (There were no fewer than forty-five paintings with Breton subjects in the Salon of 1888.) Monet, following the advice of his friend the novelist Octave Mirbeau, who had a house in Brittany, made his way to the island of Belle-Île, to a tiny village called Kervilahouen on a peninsula on its southwesterly tip. From here he could explore the spectacular reddish brown cliffs and deep bays and inlets—Port-Coton, Port-Goulphar, Port-Domois—with their beetling rocks, their needles and pyramids and crouching lions hammering the Atlantic rollers into foam. The wind was ferocious: Monet was there from September to the end of

November, all through the equinoctial gales. He became friendly with an Australian painter, John Peter Russell, from whom he took over the services of a retired fisherman called Poly (François Hippolyte Guillaume) who became devoted to him, acting as his porter, braving any kind of weather in his oilskins to get the intrepid painter to his site. In the inn at Kervilahouen Monet met Gustave Geffroy, who was on the island to research the life of the revolutionary agitator Auguste Blanqui, who had been exiled there. Later Monet was visited by Mirbeau, who reported in a letter to Rodin that the results from this campaign would show a new aspect of Monet's talent: "A powerful, imposing Monet…whom we have not yet known." And indeed these are paintings of an unprecedented violence in which one senses far more than the capture of a transient appearance—a condition of light, a particular state of the sea—but rather the capture of a state of being, an awe borne out in the waves and jagged rocks. They are by far the most expressionistic of his works, perhaps because the *motif* itself had become not just an appearance but an all-embracing physical experience.

A few days before he left for home Monet wrote to Durand-Ruel: "I have nothing that's finished and as you know I can't really judge what I've done until I see it again in the studio, and I always need a moment of rest before being able to put the final touches to my canvases."

His next major campaign took place at the beginning of 1888. He went back to the Mediterranean, finding lodgings in the Château de la Pinède, Antibes, on a suggestion from Maupassant. Renoir was not far off, staying in Aix with Cézanne. But again Monet, who was anxious to be alone, hoped that Renoir would not discover where he was. To his dismay, however, he found that the Barbizon painter Henri Harpignies was installed in the same hotel, along with a number of his pupils, who watched Monet at work from a distance, incredulously. Again the southern light seduced and astonished him, throwing him into a state of feverish appetite. Again his greed for the *motif* was baffled by a sense of its impregnability, of his own frailty and the intolerable limits of his means. Some days everything goes well. Others end in exhaustion; his eyes burn out. He dies of boredom when he is not working. There is no relaxing, only "my painting which obsesses me and torments me. I don't know where I'm going; one day I believe I have a masterpiece, then it turns to nothing; I fight, I fight without advancing. I think I'm searching for the impossible, although I'm full of courage."

He came back from Antibes with thirty-six canvases, ten of which were shown as a group that summer in Paris by Theo van Gogh, with whose firm, Boussod and Valadon, Monet was now doing business. Responding to an eagerly awaited description of them Vincent van Gogh wrote to his brother with astonishment at Monet's mastery in completing so much so quickly. He compares him to an old lion able to bring down its quarry with a single blow.

The following spring Monet made a trip with Geffroy to the center of France, to a tiny village called Fresselines on the uplands above the confluence of the river Creuse and one of its tributaries. A friend of Geffroy's, an eccentric poet named Maurice Rollinat, lived here. Rollinat took his visitors to a famous vantage point overlooking the river in its deep gorge. Like many of Monet's favored *motifs* at this time, it had all the characteristics of a beauty spot. He was back within a few weeks, staying at Fresselines from February until May.

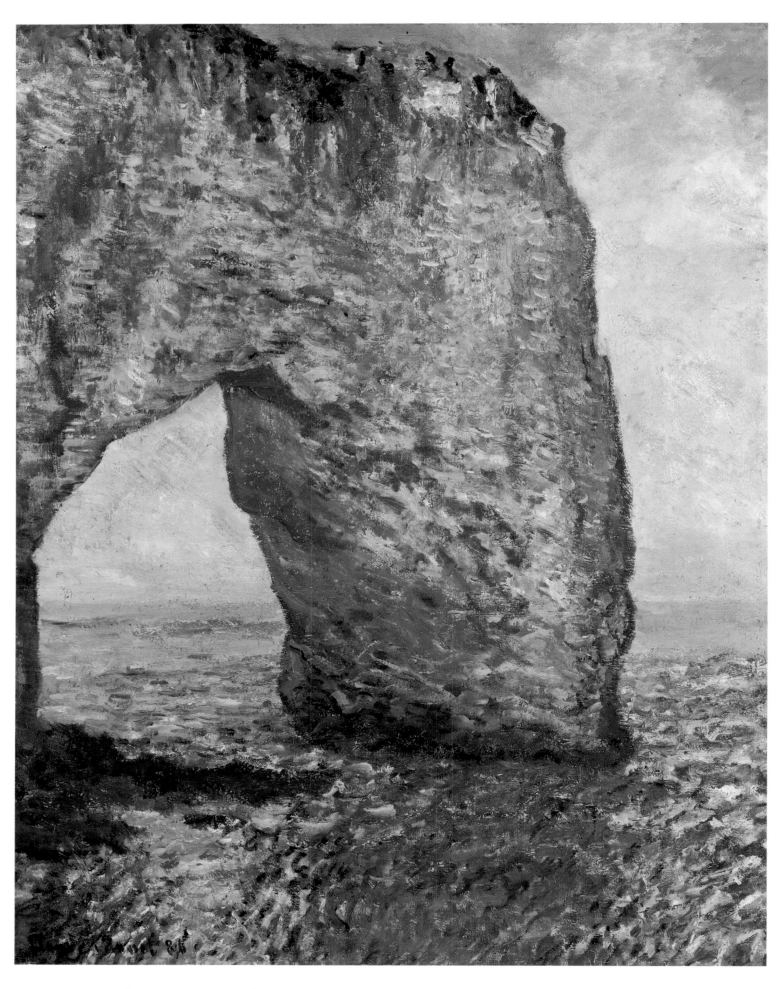

La Manneporte près d'Étretat (*The Manneporte, Étretat, II*). 1886

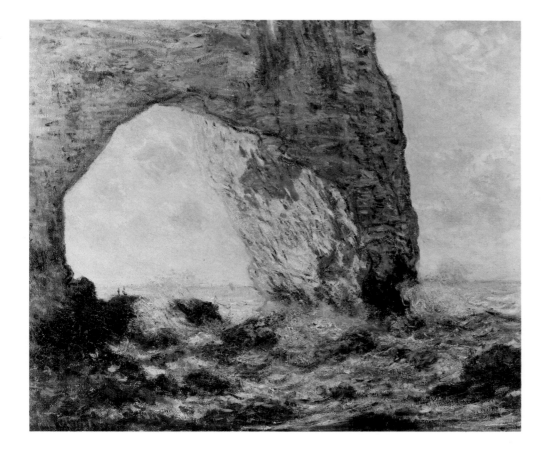

La Manneporte
(The Manneporte, Étretat, I). 1883

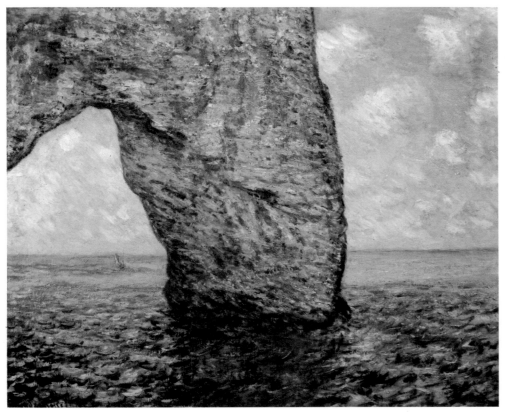

La Manneporte, Marée Haute
(The Manneporte, Étretat, High Tide). 1885

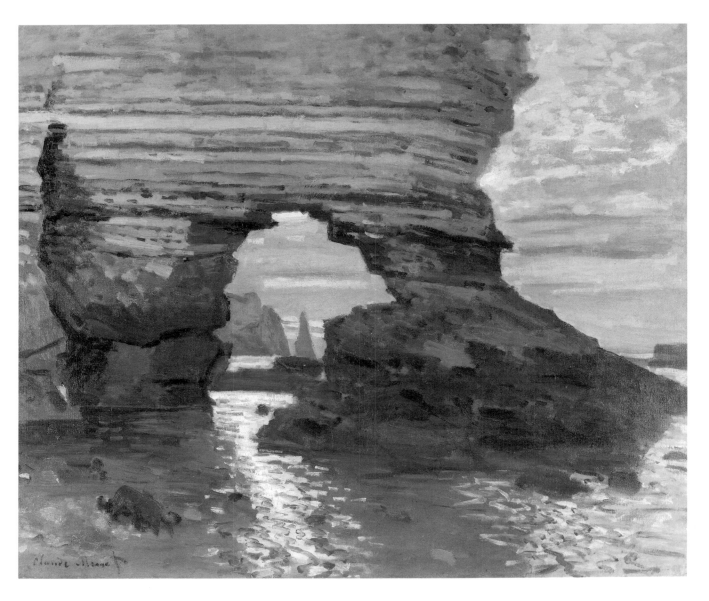

La Porte d'Amont, Étretat
(Cliffs at Étretat). c. 1868–69

*The view of the "needle" rock and the Porte
d'Aval as seen through the keyhole shape of the
Porte d'Amont has all the qualities of a natural
wonder—the kind that picture postcards are
made from. Monet had painted it on an earlier
visit to Étretat and in both the 1868 and the two
1885 versions shown here we sense his con-
centration on the sea and the features he could
see through the arch from his own precarious
viewpoint. The extremities of the picture could
be finished from memory. The painting at the
far right is in fact a decoration, one of a pair
that Monet painted on the doors of a wardrobe
in an inn at Gonneville-le-Mallet, some ten kilo-
meters down the coast from Étretat. Obviously
done from memory, the decoration reconstructs
the original painting with fidelity, yet the dif-
ference of purpose is clear. In the decoration his
brush is not responding to the empirical prob-
lem set by the motif but to the demands of a
decorative unity. This panel is a reminder that
Monet had not lost contact with a tradition of
domestic decorative painting in spite of its
apparent incompatibility with plein-air
empiricism.*

This was to be the last of his exploratory campaigns, although he continued
to travel for another twenty years—to Normandy for three seasons in the mid-
nineties, to Norway in 1895, to London on three occasions, and finally to
Venice in 1908. But the campaign in the Creuse Valley marks a change. Of
course there are the usual setbacks, the complaints of changing weather, of
impossibility. The extreme climate of central France seems to have taken
Monet completely by surprise. His powerful good health lets him down and he
suffers from colds and rheumatic pains, leading him to complain that he is
getting old.

Spring overtook him before he had finished with winter. This is the occasion
for an extraordinary episode. The paintings he was working on featured a
gnarled oak tree that stood at the bottom of the ravine near the confluence of
the two rivers. It had burst into leaf, and Monet, in a gesture of imperial
omnipotence, hired workmen to strip the leaves, reversing the seasons so that
he could continue to paint.

What is new about the campaign is that his long-established practice of
working from the same *motif* on several canvases becomes, for the first time,
codified. One can see intimations of a shift of intention, a new content. Instead
of the many versions appearing to be the pragmatic consequence of working in
a certain way—the sharpshooting way that Maupassant had described at
Étretat—the versions begin to present themselves as a totality that is foreseen
and intended, both as method and as result. The series, so long implicit in his
work, has finally declared itself.

The year 1889 was extremely important for Monet. For ten years he had been

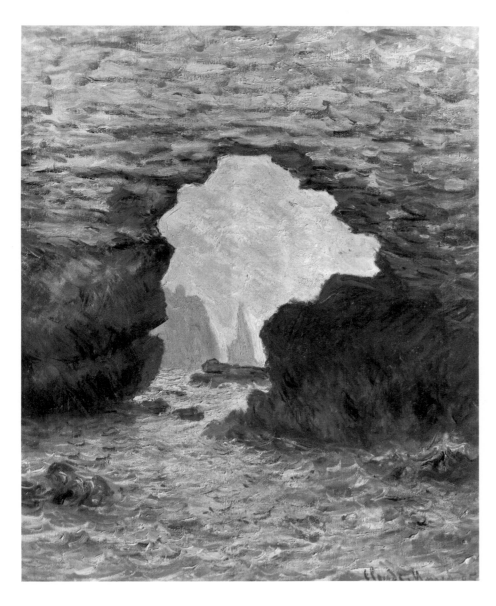

L'Aiguille Vue à Travers la Porte d'Amont
(The Needle Seen Through the Porte d'Amont, Étretat).
1885

L'Aiguille Vue à Travers la Porte d'Amont
(The Needle Seen Through the Porte d'Amont, Étretat).
1885

working out the implications of Impressionism—not doubting its premises as Renoir had done, nor searching for alternative ways of approaching them as Pissarro had done, but stubbornly pushing deeper and deeper into the mysterious issues raised by the original commitment to out-of-doors light.

He had had more than the weather to worry about while he was in Fresselines. Another Exposition Universelle was due to open in May, and a review of the century's painting was to be held at the new Palais des Beaux-Arts in which Monet was represented by three canvases. Meanwhile, with an eye on the expected influx of visitors, Georges Petit was planning an ambitious exhibition, a joint retrospective of Monet and Rodin. In Monet's case there were to be no fewer than one hundred and fifty canvases, representing all periods of his career and culminating in groups of paintings from Belle-Île, Antibes, and the Creuse. Monet ran into difficulties when he tried to persuade old collectors such as Duret and Faure to lend work, and Durand-Ruel himself refused at first, presumably unwilling to help his business rival with loans. "Oh, how I curse that exhibition," Monet wrote with rather hasty syntax, "and what a lot of trouble I made for myself over it, but also what need, what ambition, and what vanity!" In the end, reluctant lenders gave way.

It was an appropriate moment to review his position. Although Monet had shown regularly each year during the decade and had received a full measure of critical attention, he had been working in isolation. It was a long time since he had worked side by side with his contemporaries. His closest friends were writers like Mirbeau, Geffroy, and Clemenceau who regarded him as their own and gave back to him in an amplified form his own version of himself.

The climate was changing. The dominant tendency in literature was Symbol-

LEFT: Bordighera. 1884

RIGHT: Bordighera, Italie
(Bordighera, Italy). 1884

Although he was entranced by the light and by the unfamiliar plants and trees in the south, Monet had difficulty in finding motifs. At Bordighera it seemed that everything was overgrown and he was tormented by the suspicion that he was in the wrong place.

Often under these circumstances Monet would make conventional picturesque views as if to prepare himself for future exertions. In the picture at right above, the windswept lines of the pine trees make a frame for the distant town in a painting that takes us back to sentimental souvenirs of the Grand Tour. In the work to its right, on the other hand, the cranking trunk of an ancient olive tree is used with great originality to contain and animate a passage of almost undifferentiated foliage. It is as though the picture itself has been twisted out of its vertical axis; a frame of shimmering light.

ism, and under its influence younger painters were turning away from pleinairism and toward a studio art, an art of ideas and subtle moods that was above all synthetic. The appearance of Seurat's *Grande-Jatte* at the Impressionist exhibition in 1886 had been a turning point. Monet's work had been embraced by more than one Symbolist writer, but it is doubtful if the younger painters most deeply involved in Symbolism could see it in this light. In an article titled "Symbolism and Painting" (1891) Albert Aurier wrote that the painting of Monet and Pissarro could only be a variant of Realism: "Fundamentally, like Courbet and indeed more than he, they are interested in nothing but forms and colors, the substratum, and the ultimate object of their art is material reality."

The catalogue to the Petit exhibition was introduced by Monet's old friend Mirbeau, himself recognized as a Symbolist. A version of his essay had already appeared as the introduction to a show that Theo van Gogh had arranged in London, when it had been translated into English. Mirbeau was inspired by unqualified admiration: for him, Monet was the greatest painter alive. Part of his greatness was that he was uniquely independent. Alone among his generation, he had broken completely with the past and had rejected earlier art as the foundation on which to build. Instead, like a modern scientist he had examined nature without preconceptions and without memories. Mirbeau describes a state of mind in front of one of Monet's canvases in which "art disappears, is effaced, and we find ourselves in the presence of living nature alone, nature completely conquered and tamed by this miraculous painter."

The source of this sensation, Mirbeau says, is the character of Monet's theme: something seen in its instantaneity, exactly as it is, under its conditions, not generalized but in its exact light and at its precise moment. In Monet's

extreme sensitivity to that presentness, that total instant, Mirbeau finds the quality of poetry that puts Monet in a class of his own. Mirbeau pokes some fun at painters who are prepared to work from nature over an extended period—a morning, an afternoon—and whose art is therefore generalized and cut off from the truth, the "unique source of the dream...." For Monet on the other hand the moment of the *motif* could not last for more than about thirty minutes, even if it was returned to again and again and not in the spirit of improvisation but with premeditation and an almost scientific control.

We can sense in Mirbeau's argument a defense of Monet not so much against conservative opinion as against the criticisms coming from the direction of Seurat's circle, with whom Pissarro was now temporarily aligned. The formidable critic Félix Fénéon had attacked Monet the year before for what he called his vulgarity and his inability to reflect. Fénéon's version of *"l'instantanéité"* as a *motif* was dismissive. It was a corner of nature merely glanced at, as if through a shutter snapped open and closed. It was summary and approximate. Monet's method might be heroic—he pictures Monet "juggling with his stretchers, buffeted by the south wind"—but its results were insignificant, "an affair of geography and the calendar."

This almost symmetrical opposition between Mirbeau and Fénéon does indeed represent a contradiction in Monet's work itself, a contradiction that was brought home to him agonizingly with each canvas he struggled to carry beyond its first stage. How was a complete picture to be built out of a fragment of time? How could the sense of the momentary be consolidated?

A possible prelude to our consideration of Monet's series might be to question the matter of his compositions.

LEFT: Étude d'Oliviers à Bordighera *(Study of Olive Trees, Bordighera)*. 1884

RIGHT: Villas à Bordighera *(Bordighera)*. 1884

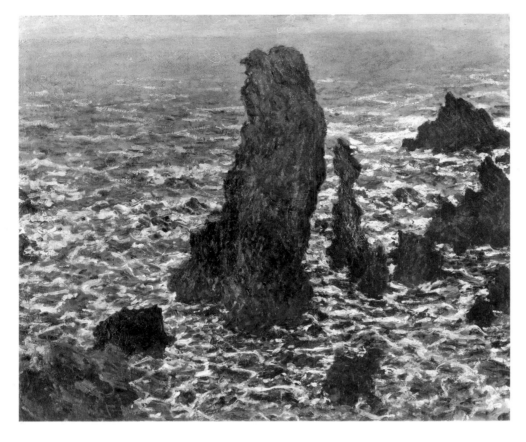

Rochers à Belle-Île
(Rocks at Belle-Île). 1886

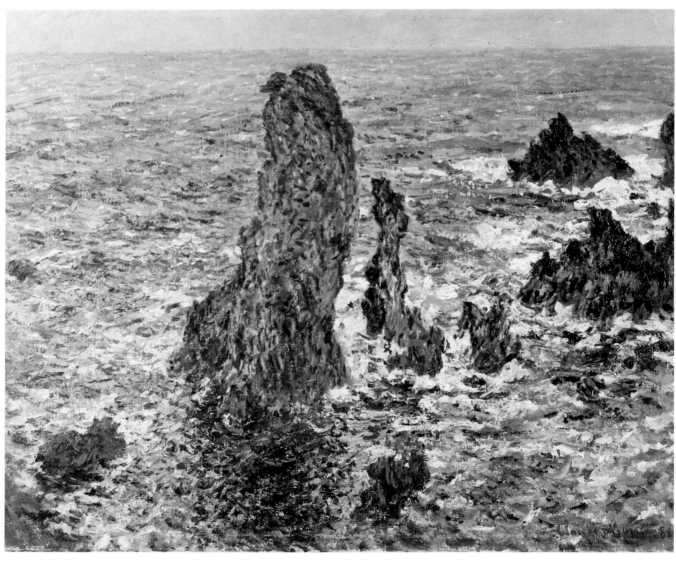

Pyramides de Port-Coton, Mer Sauvage
(Pyramids of Port-Coton, Stormy Sea). 1886

According to Gustave Geffroy, Monet was *inspired to paint along the coast of Belle-Île by a description in a guidebook. That account could well have been the following lines by Gustave Flaubert, which appeared in a book of his travel essays published posthumously in 1885, the year before Monet's painting campaign:* The tide was going out, but in order to pass one had to wait for the waves to recede. We watched them coming. They foamed in the rocks at water level, swirled in the crevices, leaped like fluttering scarves, fell back in cascades and pearls, and in a long oscillation brought their large green surface back to themselves....[We] regretted that our eyes could not go all the way to the heart of the rocks, to the bottom of the seas, to the end of the sky, in order to see how stones grow, how waters are made, how stars catch fire....Meanwhile we were crawling over the rocks, whose perspective changed for us with every turn of the coastline....On one side, it was the sea, whose waters leaped in the low rocks; on the other, the straight, steep, impassable shore.

Tired, dizzy, we looked for a way out; but the cliff still advanced before us, and the rocks, endlessly stretching their dark masses of greenery, followed one after another with their uneven tops, which grew while multiplying themselves like black ghosts emerging from beneath the soil.

Les Pyramides de Port-Coton, Belle-Île, Effet de Soleil *(The Pyramids of Port-Coton, Belle-Île, Sunlight Effect).* 1886

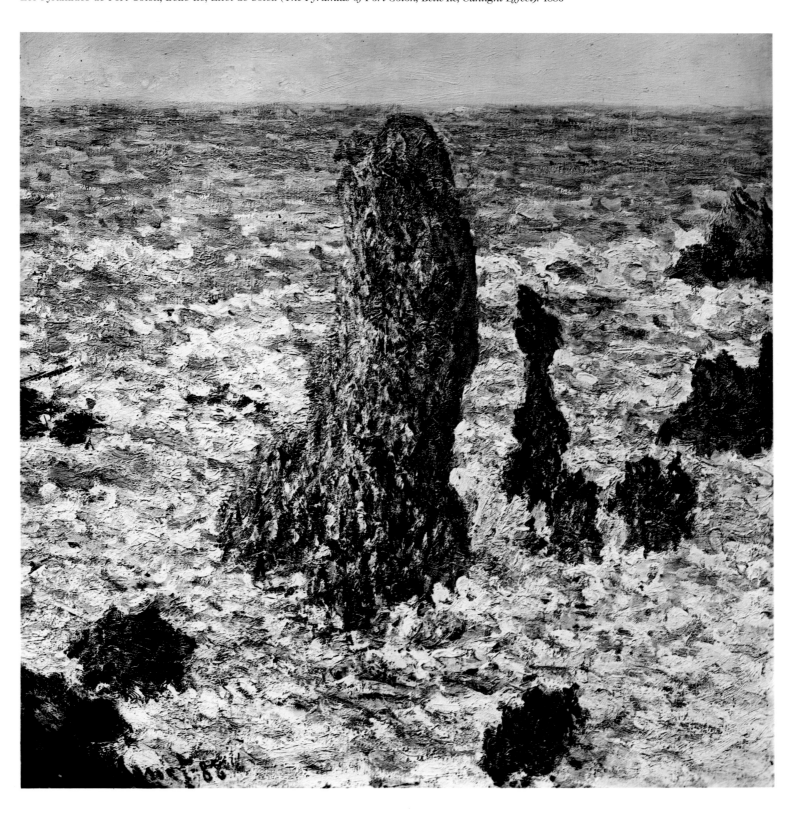

Bloc de Rochers à Port-Goulphar
(Rock Formations at Port-Goulphar). 1886

BELOW: Port-Coton, le Lion
(Port-Coton, the "Lion"). 1886

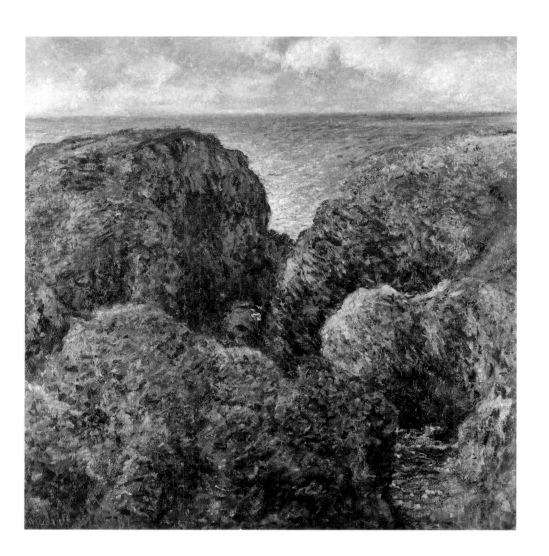

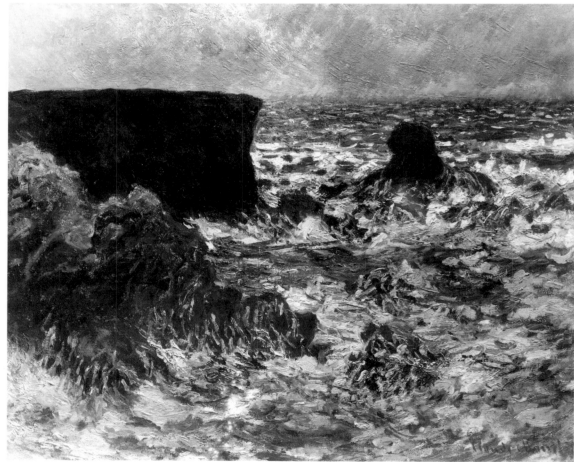

OPPOSITE, ABOVE: Bloc de Rochers,
Belle-Île *(Rock Formations,
Belle-Île).* 1886

OPPOSITE, BELOW: Côte Rocheuse,
Rocher du Lion, Belle-Île *(Rocks
at Belle-Île).* 1886

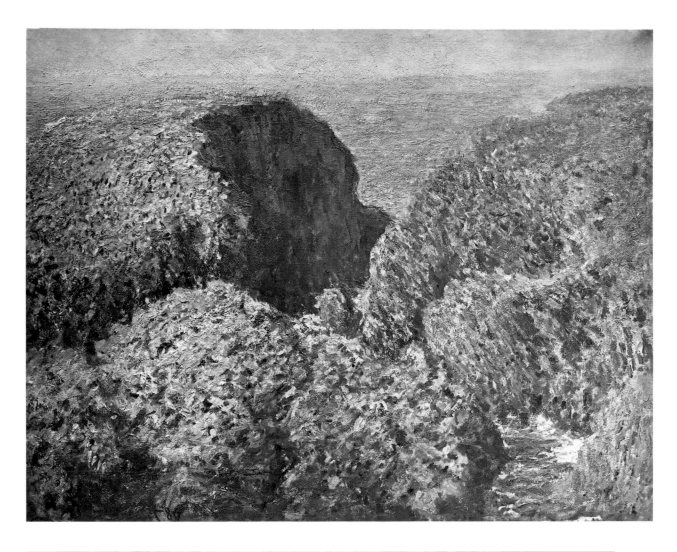

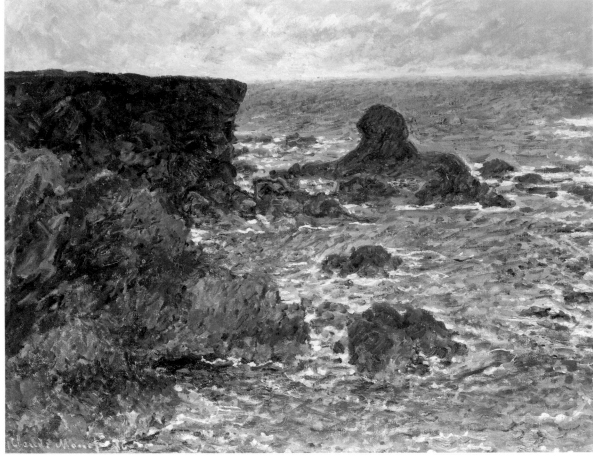

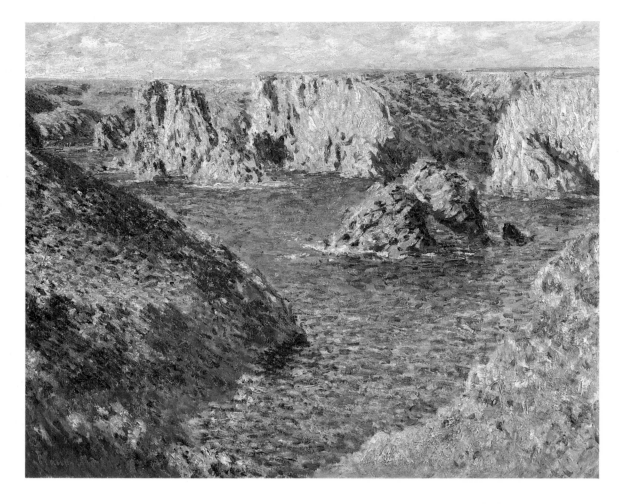

Port-Domois, Belle-Île,
also known as Port-Donnant:
Belle-Île. 1886

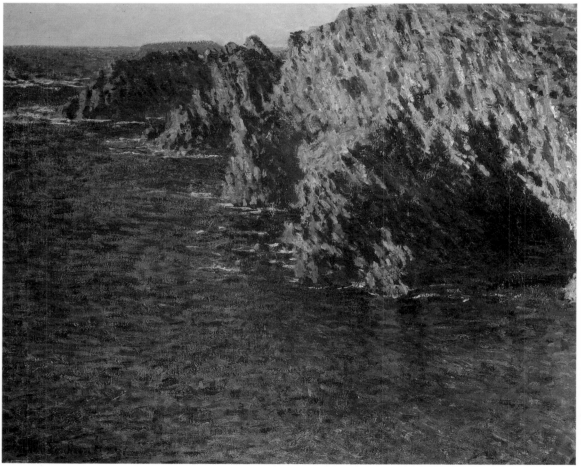

OPPOSITE: Pointes de Rochers à Belle-Île *(Points of Rock Formations at Belle-Île)*. 1886

Grotte de Port-Domois
(Grotto of Port-Domois). 1886

*The following excerpts from letters trace the
beginning of the friendship between Gustave
Geffroy and Monet and add a picture of the
coast of Belle-Île. Both letters were written by
the critic to his mother and are dated, respec-
tively, October 3 and October 8, 1886:*
Tomorrow morning I shall leave Le Palais to go
and spend two or three days in a small village
nearby called Kervilahouen. It is a village near
the lighthouse with some twenty houses at the
most. The reason I have decided to go there is
that I met an unknown friend there, Claude
Monet, one of the truly genuine painters of our
time, about whom I wrote an article in the past
and who sent me a fine letter in reply. He has
been there for the last three weeks and…for
the few days…I shall at least have someone to
talk to over lunch and dinner.

We are in the depths of the countryside, down
on the farm, surrounded by manure…but also
surrounded by the sea. The sea is at the end of
a small footpath—and what a splendid sea, full
of rocks and coves, with enormous waves when
the wind blows in off the sea, smooth as a lake
when the breeze from the land scarcely ripples
the water.…And we have seen magnificent
sights, of sand and stones so stunning as to take
your breath away for the rest of your days.
Monet is doing wonderful things here.

116

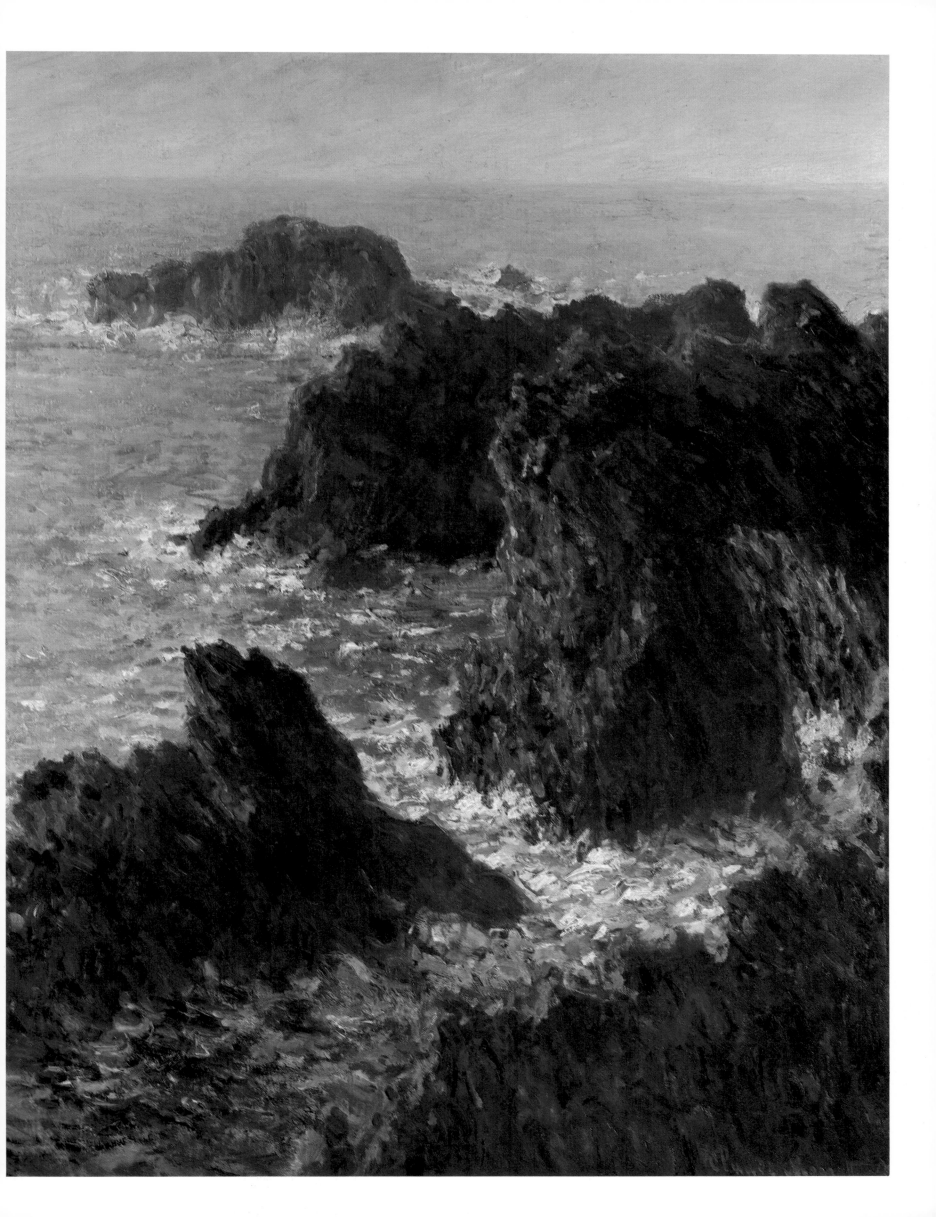

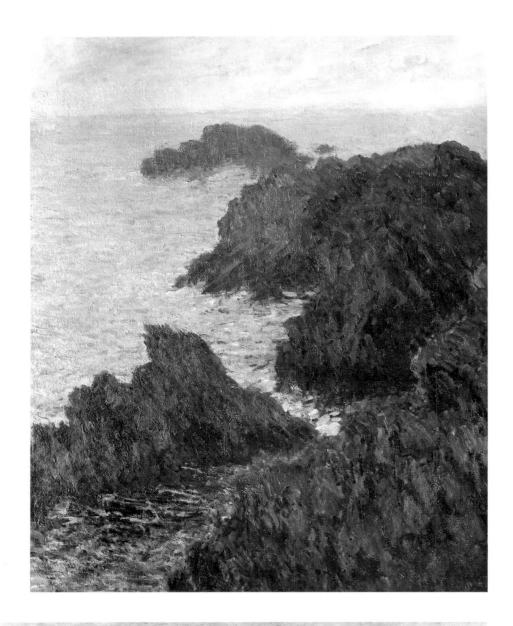

Rochers à Belle-Île, Port-Domois
(Rocks at Belle-Île, Port-Domois). 1886

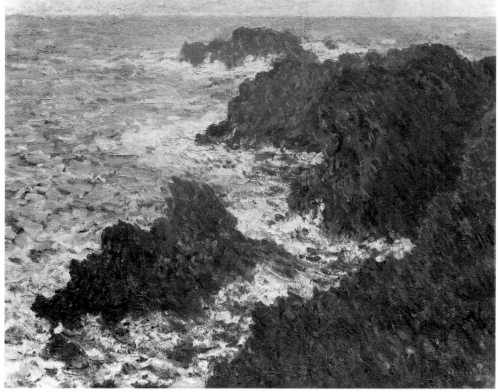

La Côte Sauvage
(The Wild Coast). 1886

Monet wrote this letter to his friend and fellow painter Gustave Caillebotte on October 11, 1886:
My dear friend,
As for me, I've been here a month and I'm grinding away; I'm in a magnificent region of wilderness, a tremendous heap of rocks and a sea unbelievable for its colors; well, I'm very enthusiastic although having plenty of trouble because I was used to painting the Channel and of course I had my own routine, but the Ocean is something completely different.

Pointe de Rochers à Port-Goulphar
(Point of Rock Formations at Port-Goulphar).
1886

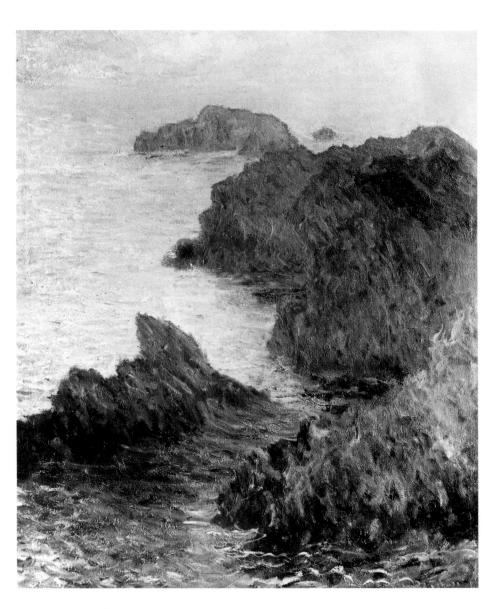

Mer Démontée *(Raging Sea).* 1886

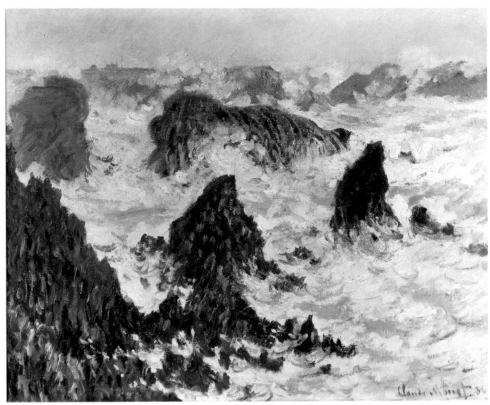

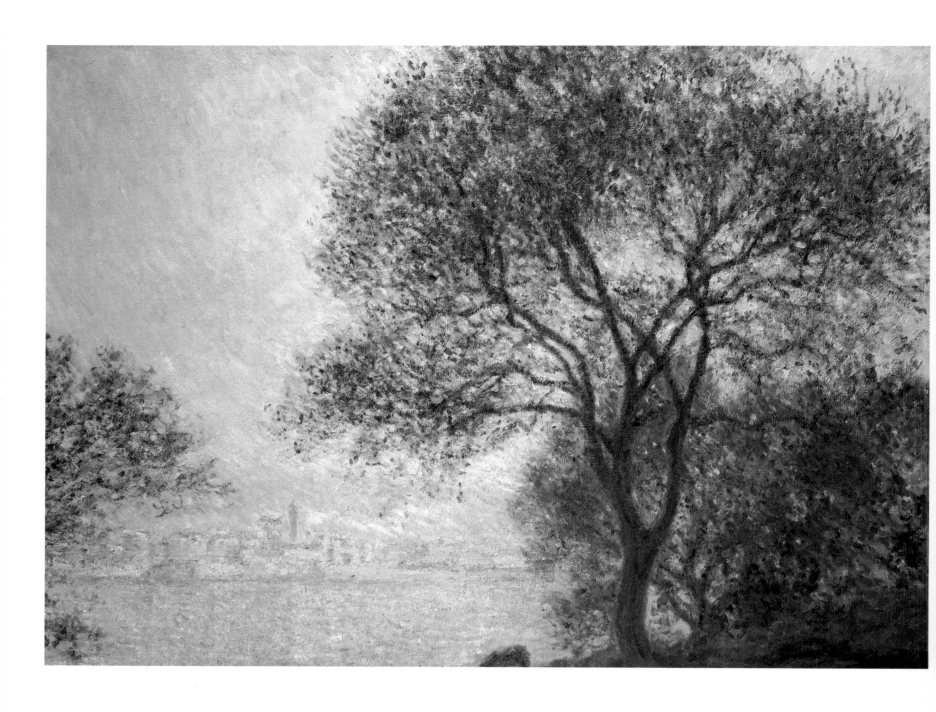

Antibes Vue de la Salis (*Antibes Seen from La Salis*). 1888

At Antibes, as elsewhere, Monet alternated between joy and despair. Early in February 1888 he wrote to Auguste Rodin, the sculptor, with whom he was scheduled to have a joint exhibition:
I'm working from morning to evening, brimming with energy....I'm fencing and wrestling with the sun. And what a sun it is. In order to paint here one would need gold and precious stones. It is quite remarkable.

At the end of February, in quite a different mood, he wrote the following to his friend Gustave Geffroy:
I work here in the morning and evening and these days I've been taking advantage of the bad weather to go out and look around. Today the weather is dreadful and I'm very much afraid that it will continue and that my studies be jeopardized. I try very hard but am not very pleased. The more I go on, the more I look for the impossible, the unreachable, and at times I'm afraid I'm fooling myself. In the end, it's an eternal struggle.

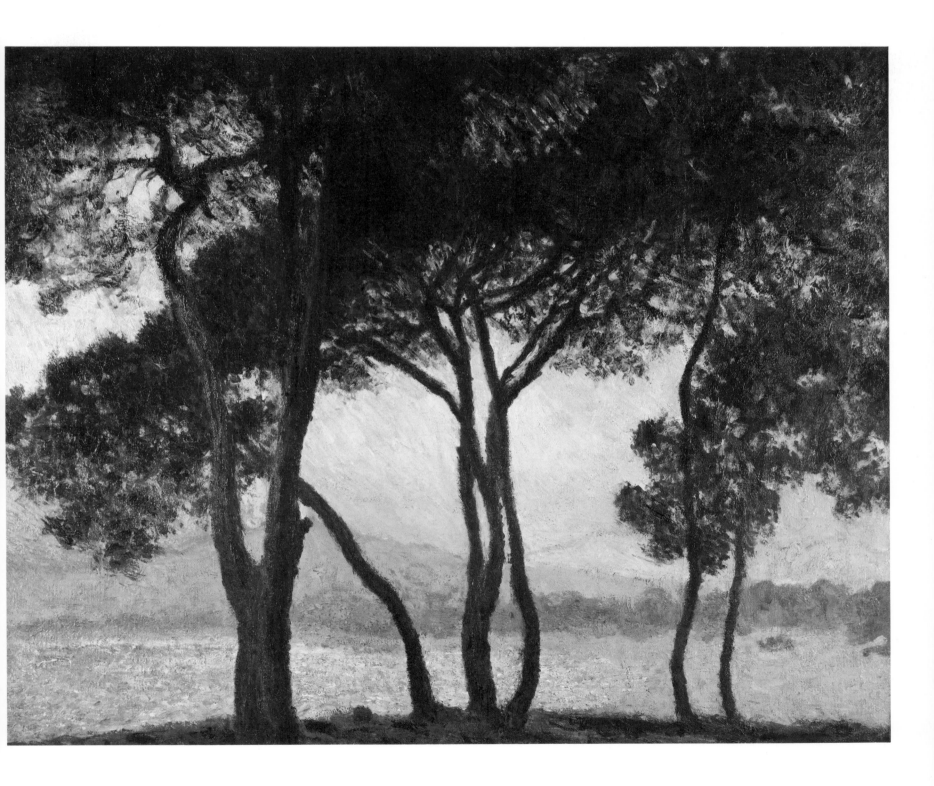

Juan-les-Pins. 1888

Plage de Juan-les-Pins *(The Beach of Juan-les-Pins).* 1888

The opinion of fellow painters about the work Monet achieved at Antibes in the first months of 1888 is recorded in this series of letters, the first from the Australian painter John Russell to Vincent van Gogh and the second two from Vincent to his brother Theo:

Before I left Paris I lunched with M. Rodin… and M. Claude Monet, saw ten of M. Monet's pictures done at Antibes. Very fine in color and light of a certain richness of envelop. But like nearly all the so-called impressionist work the form is not enough studied. The big mass of form I mean. The trees too much wood in *branches* for the size of the *trunk* and so against fundamental law of nature. A lack of construction everywhere. He is undoubtedly a remarkable colorist, and full of courage in attacking difficult problems. We should all do the same. 'T is the only way to get strong. Luckily here in Belle-Île I am forced to try all

122

Arbres au Bord de la Mer, Antibes *(Trees by the Sea, Antibes)*. 1888

things, figures, landscape, sea, cattle etc., etc.

[Russell] says that he has had a very beautiful bust of his wife done by Rodin, and that on this occasion he lunched with Claude Monet and saw the ten pictures of Antibes. I am sending him Geffroy's article. He criticizes the Monets very ably, begins by liking them very much, the attack on the problem, the enfolding tinted air, the color. After that he shows what there is to

find fault with—the total lack of construction, for instance one of his trees will have far too much foliage for the thickness of the trunk, and so always and everywhere from the standpoint of the reality of things, from the standpoint of lots of natural *laws,* he is exasperating enough. He ends by saying that this quality of attacking the difficulties is what everyone ought to have.

It is great that Claude Monet managed to paint

those ten pictures between February and May. Quick work doesn't mean less serious work, it depends on one's self-confidence and experience. In the same way Jules Guérard, the lion hunter, says in his book that in the beginning young lions have a lot of trouble killing a horse or an ox, but that the old lions kill with a single blow of the paw or a well-placed bite, and that they are amazingly sure at the job.

Monet made a first visit to the Creuse River valley at the end of February 1889, traveling with Geffroy. The poet Maurice Rollinat, who lived in the village of Fresselines, acted as their guide and showed them the "stupefying and somber beauty" of the valley. Monet became enchanted with the idea of painting the winter landscape. He returned to the area on March 7 with this in mind, hoping to bring back a new series of paintings to show at a joint exhibition with Auguste Rodin planned by the Galerie Georges Petit in Paris. Conditions could not have been worse: blustery weather, mud, rough terrain, and a raw wind that made his painting hand so chapped and cracked that he was forced to wear a glove lined with glycerine. Even the return of good weather brought with it mixed blessings, as he explained to Alice in a letter dated May 3, 1889:

I've been up since four-thirty and have worked at three canvases. With what joy did I see this beautiful weather, but also what a disappointment on arriving at a spot where I had not been able to go for three weeks. So many changes, and the sun reflected in the water in diamond sparks. I almost gave up because it's blinding, but it is distressing to abandon a whole series, and, believe me, I got used to it and if I have three or four days like this, I'll be saved.

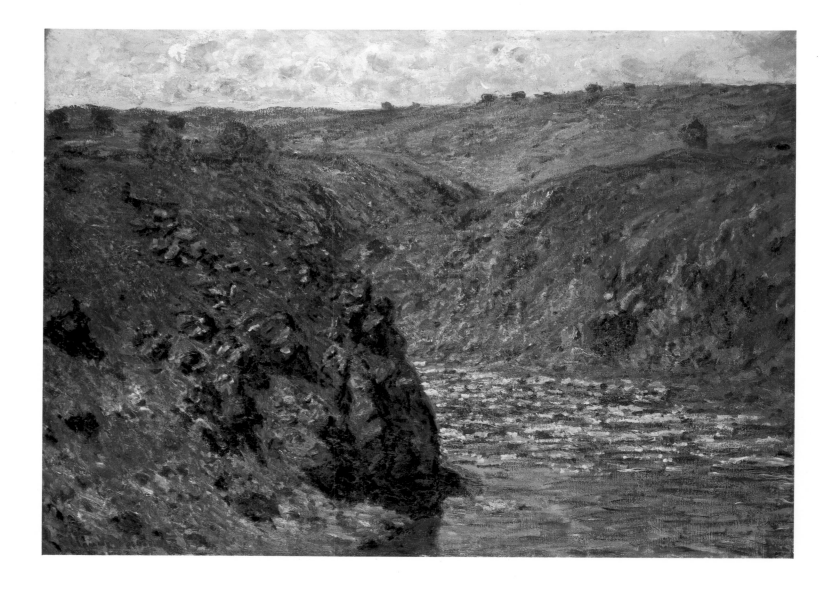

Les Eaux Semblantes, Creuse, Effet de Soleil *(Eaux Semblantes at Fresselines on the Creuse)*. 1889

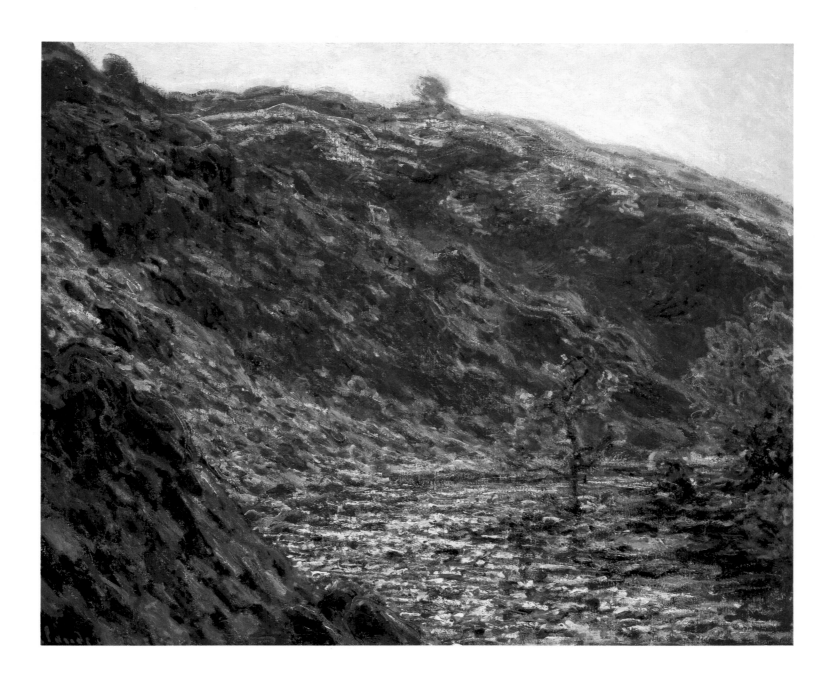

Ravin de la Petite Creuse *(Ravine of the Creuse)*. 1889

Among the legends associated with Monet is the story of the old oak tree at Fresselines. Two letters from the painter to Alice dated May 8 and 9, 1889, detail the negotiations required to return a springtime scene to the wintery look it had when he began painting:
I'm going to try to offer to pay fifty francs to the owner of my old oak tree to have all the leaves of the said tree removed, otherwise I can't [continue] and I have five canvases on which it figures, on three of which it plays the whole role. But I'm afraid it won't work because he's a not very friendly rich man who had already tried to prevent me from going into one of his meadows, and it's only thanks to the intervention of the parish priest that I was able to keep going there. Well, this is the only salvation for these canvases....

I'm delighted, the unexpected permission to remove the leaves from my beautiful oak tree has been graciously given me! It was quite a job to bring ladders tall enough into this ravine. At last it's done, two men have been busy at it since yesterday. Isn't it something to finish a winter landscape at this time of the year?

The story survives; the painting, shown at right, was plundered during World War II and has disappeared.

OPPOSITE, ABOVE: Le Vieil Arbre à Fresselines *(The Old Tree at Fresselines).* 1889

OPPOSITE, BELOW: Le Vieil Arbre au Confluent *(Torrent, Dauphine, Montagnes).* 1889

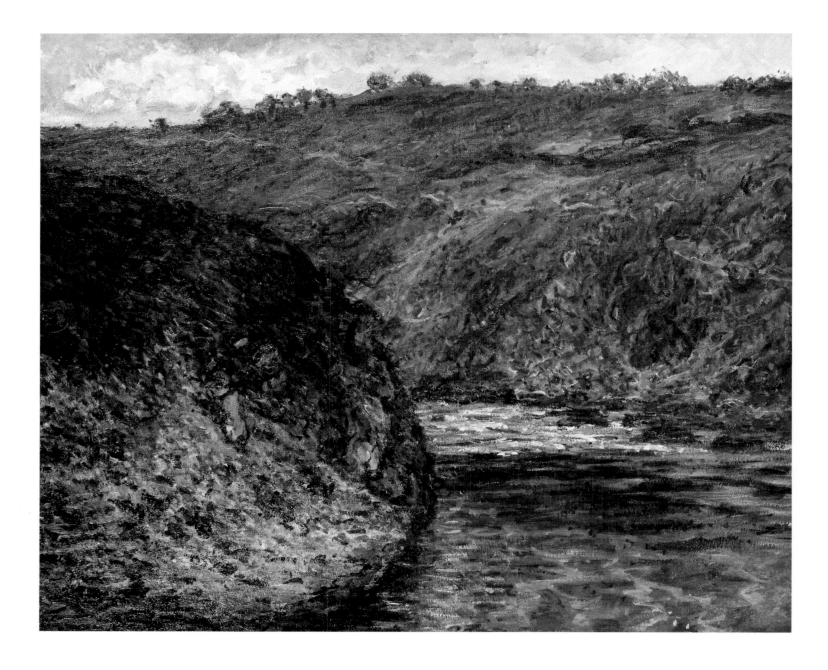

Les Eaux Semblantes, Temps Sombre *(Eaux Semblantes, Cloudy Weather).* 1889

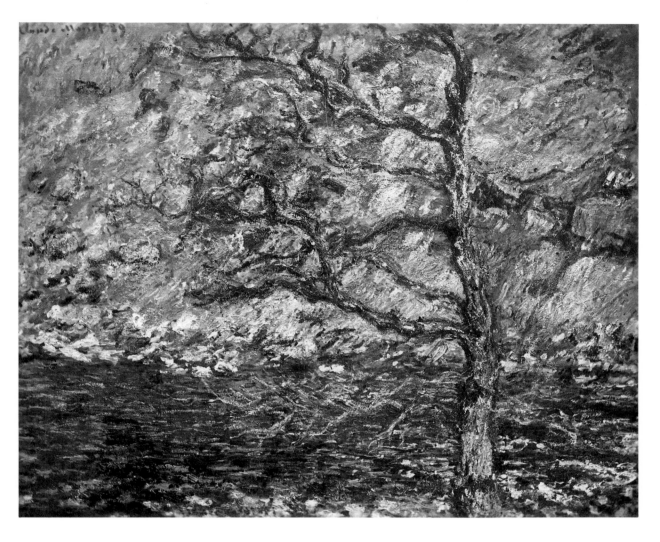

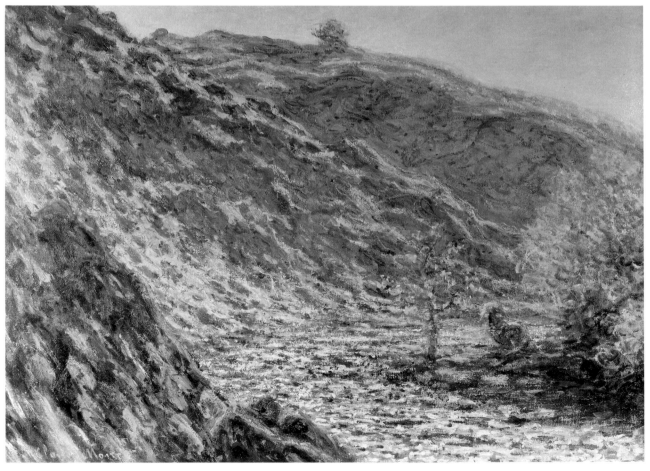

127

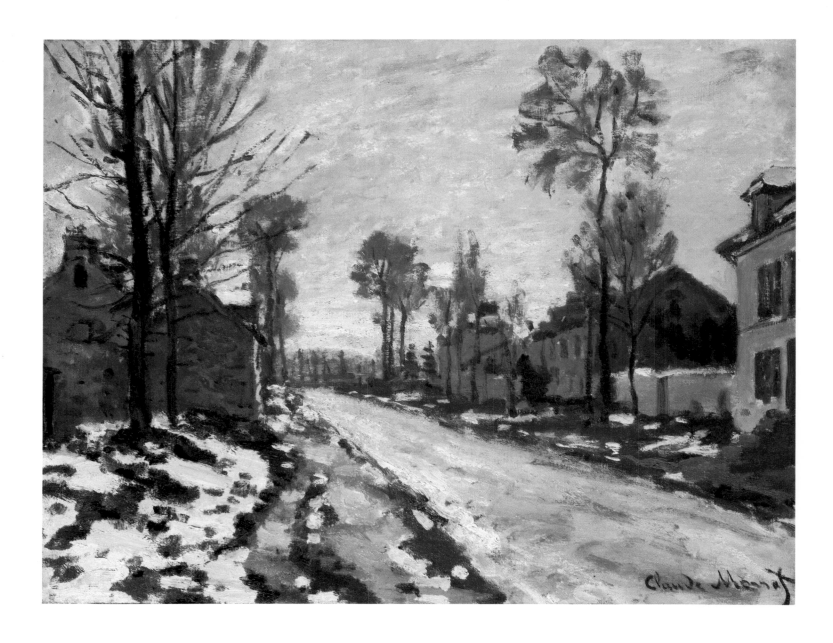

Route à Louveciennes, Neige Fondante, Soleil Couchant *(Road to Louveciennes, Melting Snow, Sunset)*. 1870

Monet's working travels of the eighties were indeed campaigns, heroic raids in which he pictures himself pushing into the unknown, suffering the privations of battle, annexing whole provinces. It is as though there is no limit to the hunger of his eye or the magic potency of his brush; Maupassant's hunter is a kind of magician too: "He grabbed hold of a downpour beating on the sea and threw it on the canvas. And indeed it was the rain he had painted this way, nothing but the rain shrouding the waves, the rocks, and the sky, barely distinguishable under that deluge." Surely this is more than literature; somehow it matches a facet of Monet's own fantasy, a facet of which the underside is his despair that he has missed, failed, not risen to the occasion. Often the failure can be laid at nature's door: "I'm working a lot…but the more I go on, the more trouble I have in bringing a study to a successful conclusion, and at this time when nature is changing so much in appearance, I am forced to abandon canvases before they're completely finished." But the terms of the situation are of Monet's own choosing. He could have stayed at home.

It would seem that his anxiety about completion, an anxiety that is like the inescapable shadow of his conquering ambition, doesn't turn on the problem of how to transform a sketch into a picture in the older sense so much as on how to bring out and substantiate those very characteristics that caused the painting to be taken for a sketch in the first place. He tells Durand-Ruel that he has his own idea of finish—but it is not the same as the public's, has nothing to do with a "licked" surface. Freshness, speed of observation, fleetingness had somehow to be locked into a structure developed over a period of time, reworked, subjected to internal criticism, a structure whose very purpose was to sustain the qualities of phenomenal immediacy that had been, until now, uniquely the domain of the sketch.

Monet's correspondence makes it abundantly clear that he expected to go on with his paintings in the studio, although he was reluctant to say as much publicly. The physical evidence of the picture surface suggests that these reworkings were often substantial and protracted, far more than mere finishing touches. The nearly simultaneous *a la prima* Impressionist brushstrokes are lost now in a densely layered crust of paint in which, through a new repertoire of twirled and dragged strokes, the later layers of paint are woven into earlier ones. More complex color is worked into the earlier, simpler layers in different qualities of thick and thin, opaque and transparent. The process is extended. Paint surfaces range from wet to half-wet to dry. Lower layers offer a rough, toothy surface across which fluid strokes skip and scrub. Half-dry paint is teased by a later brush. No doubt the origins of this exceedingly complex repertoire of texture and mark lay in tribulation, in frustration and labor. But

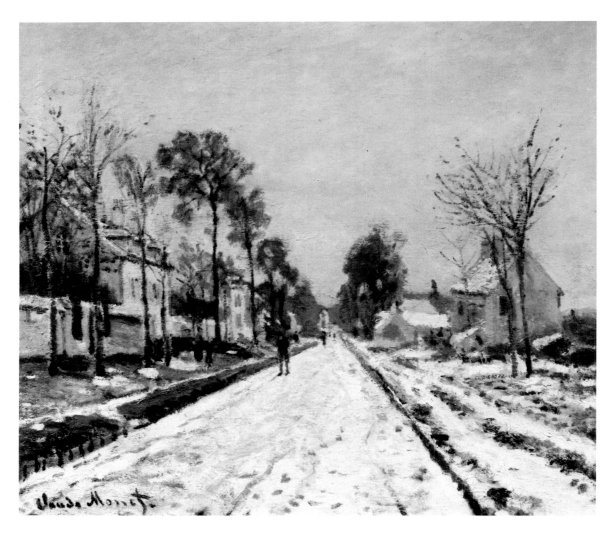

Route à Louveciennes, Effet de Neige
(Road to Louveciennes, Snow Effect). 1870

For nineteenth-century open-air painters a view looking down the length of a road was an essential schema. Borrowed from Dutch landscape painting of the seventeenth century, the type had been firmly established by Corot and Millet and their generation, to be taken up by Monet and Pissarro. The road receding into the distance inevitably carries a symbolic load: any road can become the Road of Life, a destiny, as it does in the hands of a Hobbema or a Van Gogh. For Monet and Pissarro, in their different ways, it is perhaps the ordinariness of the motif that matters, its readiness. It was what Pissarro saw when he stepped out of the front door of his house at Louveciennes and looked right or left. But in that ordinariness both Pissarro and Monet discovered rich compositional material that they continued to work with and transform for years to come. It was in these road views that the reciprocal value of perspective was most fully realized: observed perspective locates the visible world in depth; it also locates the observing eye. It defines the relationship between the seer and the seen within a geometrically precise structure.

Monet was very quick to turn second thoughts and corrections to his advantage and to seize from the potential chaos a unique painterly language. We need to imagine a frame of mind in which the content of the sketch is somehow held apart from the act of sketching itself. This implies a certain distance from the headlong experience—out there, caught in the wind, caught in the unsatisfactory dialogue between palette and out-of-doors light—a distance that allowed for reflection but without the sacrifice of immediacy that second thoughts so often demand.

Academic art tells us that knowledge takes precedence over experience. Romantic art—which means all serious art since 1800—says the exact opposite. But the moment it proclaims the sovereignty of experience it is inserting intention between the impulse and the deed. The rubric of intention allows the Romantic artist to find metaphors for what he is doing: "I will paint *as if* I am able to see instantaneously" or "I will paint *as if* I had never seen another picture" and so on. Without that "as if" and its enabling fiction he is condemned to indulgence and self-parody. Armed with it he can begin to see himself and to move himself to genuine strenuousness. Psychologists have often reminded us of the horrible shock Monet would have had if he had really been able to see the messages that came in through his eye. But by claiming that this was what he was painting Monet was able to spin a content for his efforts, a thread of intention that led him deeper and deeper in the development of his pictures, which were not real showers of rain, as Maupassant pretended on his behalf, but constructions to be read.

Under the sign of pleinairism the whole matter of composition takes on a new quality, an ambivalence, involving the *motif* as well as the painting, choice

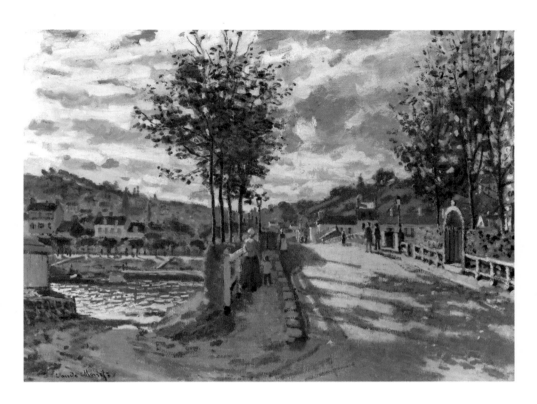

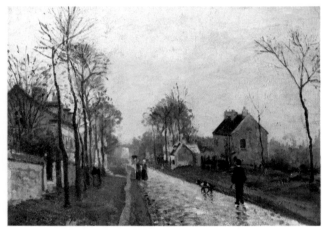

and selection as well as construction. No longer linked to narrative order or to a principle of appropriateness, the organizing factor now is not a known order of pictorial construction but a physical viewpoint. This in a sense becomes the subject matter, and we can follow Monet's recognition of this shift in value from the sixties to the end of his life.

To our eyes, familiar with his later work, the paintings he made for the Salon of 1865 from sketches of the Seine estuary at Honfleur look composed to an extreme degree. Every seagull, every rock, the angle of every mast—all are fitted into place to make a harmonious whole. But this is composition from the outside and has more to do with a notion of pictorial decorum than with the vision of the studies on which it was based. Only a few years later a typical Impressionist study such as *Route à Louveciennes, Effet de Neige* of 1870 convinces us that every feature of the composition derives from the painter's own standpoint in front of the *motif*. It is the painter himself who is at the center. We know exactly where his feet are; the foreground of the picture seems to drop below the edge of the canvas to where he is standing, somewhat to the right of center. The right and left boundaries of the canvas assert a decision, a framing action over against the focus of the road. The road rushes away like an arrow, its target the vanishing point dead ahead, and the nominal focus of the painter's gaze. The painting is constructed as though the whole scene radiated from that single point of focus. The artist's position is implicit in every measurable feature of the picture: the height of the horizon, the geometry of the directions of every edge, the edges' angles of incidence, the intervals of the verticals, or their alignments, pinpointing his position in space. The great crossing of horizontal and vertical is a location, within the depicted

world, of the painter's eye.

Many times in the early years of Impressionism Monet seems to be reminding himself of the connection between pictures and looking. Sometimes his reminders are issued by a surrogate: by his father, for example, in the *Terrasse,* where, his back to the painter, he enjoys the breezy scene in front of him as a picture, framed by the two flagpoles that carve the view into a rectangle. It is a part played in *Les Régates à Sainte-Adresse* by the whole family, staring out to sea while Monet enfilades them with his looking. The part of active looker is superbly taken by Camille in *The River* of 1868 and is enhanced by the presence of a little figure on the far bank who appears to be drawing her. In the complex *Le Déjeuner* of the same year, Camille's double glance at the baby—maternal and intimate in her seated pose; distanced, cool, and dreamy in her standing one—seems to exonerate the painter from further engagement, leaving his looking free to move with perfect detachment throughout the room. (We can hardly miss the importance he gives to the vertical alignments springing from the perspective of the floor, fixing his point of view.)

To paint directly, to follow the rules of the plein-air game, means to start with what is given from a particular position. Occlusion—the cutting off of a far form by a nearer one—and the alignment of forms in different planes in space become crucial factors of construction, as any photographer knows. These effects have little significance in studio painting, where every relationship is invented at will and nothing is given. But for the open-air painter they are binding: when he moves, his subject moves. The overlapping of every feature reminds us that his *motif* is what he sees. The attention he gives it is the measure of the importance he attaches to his point of view over all other possible ones. He could look in any direction, so his act of definition is charged with a sense of the openness of his field as well as the precision with which his attention is focused and offered up to the boundaries of the canvas.

This is what gives such special point to a group of canvases Monet painted in 1877 and 1878 on the riverside at Argenteuil and on the Île de la Grande Jatte. The Argenteuil paintings are of a view along the promenade looking toward the town that he had painted in the first summer he was there, except that now, instead of standing on the promenade and looking along its perspective, he is below it on its bushy bank, nearer the water. The immediate foreground is a shapeless mass of foliage and flowers that in one painting, *La Seine à Argenteuil,* rises to his eye level, cutting off the entry to the promenade and the reach of the river. His viewpoint is still a cardinal factor, but now its quality is of concealment, not entry. The five canvases from La Grande Jatte were

painted during a short period in Paris between leaving Argenteuil and moving to Vétheuil. In all of them the river is seen through a thin screen of trees, their branches just coming into leaf. In four of the five none of the bank is visible as foreground. The trees cut the canvas at top and bottom. Barges on the water glide past. It is as though we join the painter in watching them secretly, without being seen ourselves.

Although he returns hundreds of times to the open perspectives, these few paintings with screened entrances are prophetic of much that was to happen to his work during the eighties and later. And one is tempted to connect their appearance with the shift in his subject matter once he has left Argenteuil. From now on the presence of modern life is felt only indirectly.

What makes a *motif*? The major ingredient will be the painter's sense of pictures, that accumulation of images in his bones, that investment that makes him a painter. The power of the down-the-road type of *motif,* of which *Route à Louveciennes, Effet de Neige* is an example, can be described on a succession of different levels. At the most local level is the circumstance that the landscape painter will need to find a convenient place to stand, not too far from his lodgings. At the other end is the road's seeming universality. Whether the painter looks up the road or down it, the configuration of the road in perspective will be the same, a rough compelling triangle driving to the horizon, flanked in various ways with houses, walls, trees. However humble the particulars there will be something here that calls up a version of a grand landscape construction, an array of vertical intervals linked by diagonal movements in perspective. Each new *motif* will be like a discovery—and a return. But a return in which familiarity and recognition are the occasions for more particular discoveries, for finer nuances or more outspoken declarations. We sense this in Monet's habit of repetition, the way he not only will tackle a *motif* in pairs of versions but will go back to it a year or a decade later, a lifelong practice of which the series of the 1890s and 1900s were simply a formalization marking a late stage in his explanation to himself of what his art was about. Each encounter with a particular *motif* adds its increment of meaning to that configuration and sows the seed for further encounters with that place under other conditions, or with other places whose strangeness is like a challenge in which novelty and stirred memory press against each other for dominion over the imagination—as they do with any of us as we walk from the station through the streets of a city we are visiting for the first time.

Previous formations allow for later recognitions and are transformed in the process. Monet writes to Alice from Bordighera complaining about the first

À Travers les Arbres, Île de la Grande Jatte
(Through the Trees, Island of La Grande Jatte).
1878

La Seine à Argenteuil
(The Seine at Argenteuil). 1877

Monet had worked beside the Seine on the promenade at Argenteuil during his first year there. (See page 60.) He went back to this site just before he left the town for good. In his later paintings (one of which is shown at right, below) there is a different feeling. Instead of facing the perspective of the promenade and following it deep into the distance, Monet takes up his position on the side of the embankment with a thicket of flowering plants between him and the open spaces of the river. This type of view is also seen in the painting of the Seine at Vétheuil at the far right, below.

There are other canvases of a similar nature, painted on the Île de la Grande Jatte in which the river is viewed through a transparent curtain of branches on which the first foliage is beginning to appear. In an even more extreme way, these paintings (above) indicate a change in Monet's art in which the immediate spectacle of modern life loses its interest and makes way for something more private. Figures will become rare and his observations from nature will become the material for a private world. Critics during the eighties and nineties used expressions like "dream" and "wonderland" to characterize that world—hardly terms that could ever have been applied to the first paintings from Argenteuil.

OPPOSITE, ABOVE: Les Bords de la Seine, Île de la Grande Jatte *(Banks of the Seine, Island of La Grande Jatte).* 1878

OPPOSITE, BELOW: Au Bord de la Seine, près de Vétheuil *(Banks of the Seine, Vétheuil).* 1880

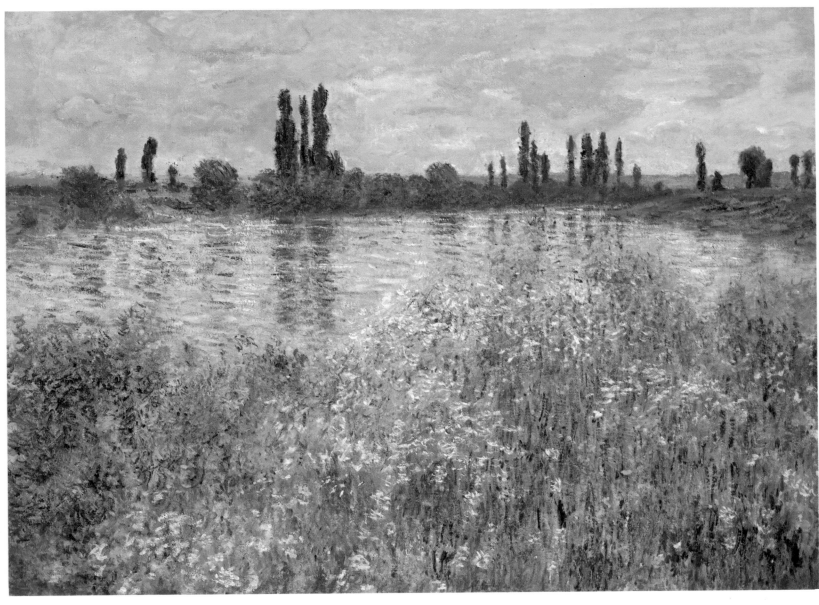

paintings he had done there. They are "stiff," he tells her. But at least they
have taught him to see this strange landscape, and thanks to them things are
going better. It was a particularly difficult campaign because, as he told her in
another letter, "large general subjects are rare here. It's too dense, and they are
always pieces with many details." Was he in the wrong place, he wonders.
Along the coast near Monte Carlo he has seen "the most beautiful spot on the
whole coast: the subjects there are more complete, more like paintings...."

What he means is clear enough from the paintings he brought back from
a brief stop at Menton—broad, picturesque, garish views with mountains,
coastline, and winding road falling into place with the bland and recognizable
sweep of a conventional beauty spot. What had been left behind at Bordighera
is by contrast a formless tangle of bushes and creepers, lacking pictorial
distinction, glittering, brimming with unfamiliar colors—pink, apricot, emerald
—almost without top or bottom, foreground or distance. Monet resolves this
exotic problem most successfully in a group of five paintings from 1884 called
La Vallée de Sasso, in which the scene is reduced to a small hut with the
diagonal of the palm-covered hillside crossing the more distant diagonal of the
hill beyond. Somewhere within these pictures we can make out the bones of an
earlier *motif*, vastly different in local detail but comparable in feeling—the
three canvases of 1882 of a path running down to the sea near Pourville. It was
another "formless" subject, without picturesque features, "dense," anything but
a "large general subject," but one that yielded up its hot and intimate nature in
a comparable system of interlocking furry diagonals, a kind of crotch.

Behind these compositions, in turn, we might sense the presence of those
perspectives, those down-the-road configurations, that had given such point
and presence to the diagonals that Monet seizes on as structural features,
running from corner to corner of the canvas, rather than merely as the signs of
a perspective receding into the distance. Looking back at paintings like *Route à
Louveciennes* we notice the way he lines things up—taking the evidence of his
eye, placed in a particular spot—as the cue to a flaglike division of the canvas,
the very essentials of recession giving the material for a pattern on the surface
of the canvas.

These views in deep perspective were of enormous importance to his
thoughts about landscape; but to bring this out fully we need to see these types
of view against another, very different type, which we may connect with his
experience as a painter of the sea.

The theme of the sea, empty of all incident, uncut by cliffs or shore, is not
numerically important for Monet—far less in fact than it was for Courbet or
Whistler. There are two studies from Petites-Dalles of 1880, a group of four

Chemin Creux à Pourville
(Sunken Path at Pourville). 1882

from Pourville in 1882, and one study from Honfleur of 1886. Even so, we must
infer the importance of this theme. To look out to sea, to face those two endless
zones of water and sky and the mysterious edge at which they meet, is to face
one of the strongest intimations of infinity. The feelings evoked by the sea are
incomparable. For any painter who will have pondered them at the seaside
those two parallel bands must pose a special problem: how can they become
pictorial? When the artist looks outward, his back to the land, the horizon
expands as an unbroken edge. The sea is massively one, the occasion for
infinite and monotonous movement. There are no linear perspectives, no
occlusions, no vertical features to anchor the eye. Only the height of the hori-
zon within the frame hints at the level of the painter's viewpoint, but even this
has nothing precise to tell about where we are in the expanse. We could be
near or far. We cannot tell precisely what place or plane or feature we are
facing. Each "part" is neither more nor less important than any other. There is
no equivalent here to the purposeful, measured movement back to the horizon
that we know from perspective views; instead there is a kind of wandering in
which we are immersed in distance, enfolded by it—a paradoxical kind of
distance that seems to stretch out in front of us without limit and at the same
time to wrap us around.

With the sea as *motif,* the canvas has a different value from the one it has in
a perspective view. The latter represents a single eyeful: we picture the canvas
rather precisely as cutting the painter's visual cone at ninety degrees. But an
empty expanse cannot be thought of like this. The observer's sense of being at
the center of perspective is replaced by an ever open invitation to movement,
reorientation, and fusion.

When Monet painted a sea populated with boats, he was working in a well-
established marine tradition. But already by the late sixties he had been
sufficiently affected by the Japanese woodcut to be capable of visualizing the
sea as a flat, frontal block of color, parallel to the picture, as in the *Terrasse.* By
this time he would have known Courbet's marines, and those of Whistler too,
in which the empty sea, whether dominated by a single wave or conceived as a
cool band, is shown as a simple, irrefutable image of infinity. This view of the
sea, reduced to its minimal formal elements, became a model for a host of
other subjects, opening up the possibility of composition that was above all else
parallel, frontal, and embracing.

Monet rediscovers the sea in all the frontal approaches to landscape—
looking across the Epte or the Creuse to its far bank, paintings in which all
movement is lateral and the canvas itself seems to take up the part of the
flowing water. He rediscovers it in a painting like *Le Saule* of 1885, in which

Le Chemin de la Cavée à Pourville
(Chemin de la Cavée at Pourville). 1882

Chemin de la Cavée, Pourville. 1882

OPPOSITE, ABOVE: La Vallée de Sasso—
Bordighera *(Valley of Sasso, Bordighera)*. 1884

OPPOSITE, BELOW: Champ de Coquelicots,
Environs de Giverny *(Poppy Field near Giverny)*.
1885

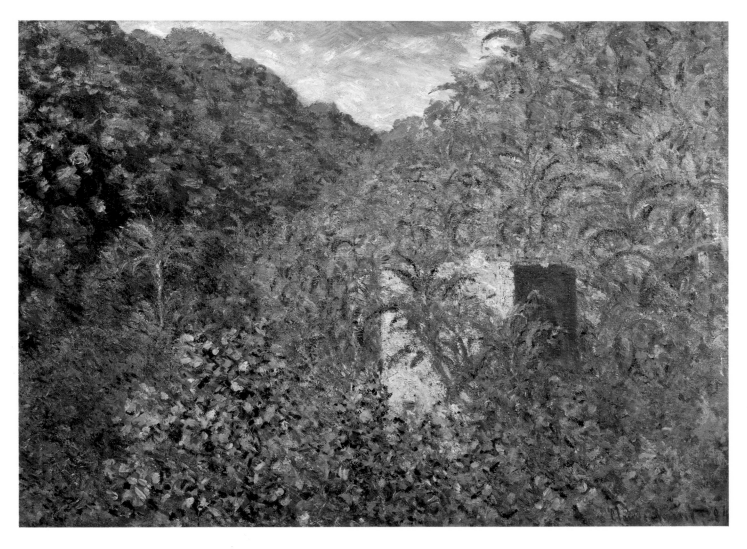

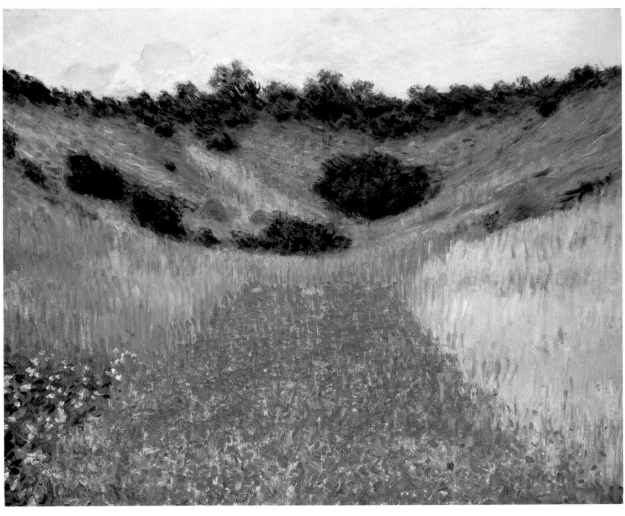

ABOVE: View of the Sea at Sunset c. 1874

Rivière de Pourville, Marée Basse
(River at Pourville, Low Tide). 1882

Gros Temps à Étretat
(Rough Weather at Étretat). 1883

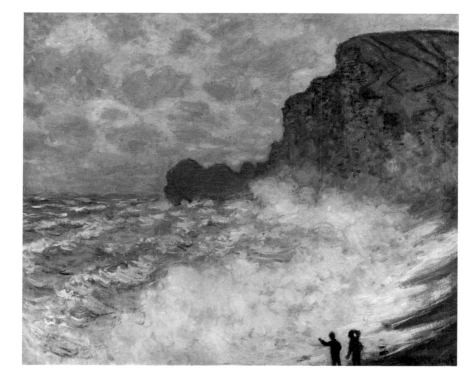

water, riverbank, water meadows, distant poplars, and sky cross the canvas
in horizontal luminous bands.

It is surely the sea, and the pictorial thoughts attendant on the problem the
sea poses, that teach him how structure and inflection can be found within
very narrow limits, whether a mass of more or less uniform foliage or in fog. It
is the sea, surely, that points to the redistribution and spreading of focus that is
such a feature of his later work—an experience of space without pathways—
and the sea that suggests those extraordinary manipulations of geometry that
brace his most open paintings.

The interplay between the openness of the sea and the closed geometry of
perspective, between the infinite and enveloping space of the level horizon and
the measured movement into distance of the view down the road, is a theme
that informs a great deal of the work of the eighties. There is a *motif* that is
like a meeting point between the two compositional types—a view with open
sky and water on one side and the coast or riverbank on the other. A common
enough view (where else is the painter to look after turning away from the
horizon?), it raises special problems because it is obviously lopsided. How is the
open half to be held in balance with the closed half? Even Monet's unities of
light and atmosphere are challenged, and in canvas after canvas we see him
experimenting with geometrical structures, almost always based on diagonal
alignments that move across the whole canvas from corner to corner and often
work in conjunction with the simple divisions of the canvas such as the square
of the shorter side.

The same idea is developed in the campaigns in Normandy when Monet is
painting the cliffs from the level of the beach. In *Falaises près de Pourville* of
1882 the face of the cliff makes a tense arc against the sky, dividing the painting
into a closed area of land and an open area of blue sky and clouds and sea.
This open area is almost exactly proportional to the shape of the white canvas,
a rectangle of 1 to 1.35. The profile of the cliff and the cuts and folds that mark
its edge set up directions that relate with striking exactitude to diagonals
drawn from this rectangle, as though this blue zone of emptiness somehow
controlled the features of the land. Again there is the feeling of a kind of
decomposition. Certain features have been split away from their normal place
and function, their implied relationship to the viewer transformed. The more
"formless" the *motif,* the more pointed this feeling.

Vétheuil dans le Brouillard (1879), of which Faure had told Monet that it was
too white and so unfinished as to be not serious, a painting in which hardly
anything is to be made out at all, proves, as we look at it over a period of time,
to be not only completely "there," completely realized, but to be founded on a

James McNeill Whistler
Harmony in Blue and Silver: Trouville. 1865

*The open sea and the night sky are the two
great images of infinity, dear to the Romantic
vision. The Romantic theme of the onlooker,
dwarfed yet resolute in the face of vastness, is
carried over into Realism in Courbet and
Whistler and Monet. But when working directly
from observation, sensation is paramount. The
parallel bands of sea and sky provide composi-
tional elements that speak directly of openness
and vastness.*

 *Athough Monet did not often paint an empty
sea straight on, he was extremely susceptible to
its majestic appeal and his lifelong relationship
with the sea must have helped to shape the sub-
ject matter of the last twenty-five years of his
life, the pond at Giverny.*

Plage et Falaises de Pourville, Effet du Matin
(Beach and Cliffs at Pourville, Morning Effect).
1882

rigorous architecture. We discover built into the opalescent mantle of fog—itself an impossible color: bluish pink, yellowish violet—a mysterious and transparent skeleton of which the bones are little more than hints of accents yet precisely felt and playing a profound role in the organization of the painting. The faintest breath of cobalt establishes a kind of strut out of the top right corner, locating that corner of the frame and at the same time driving back to the horizontal row of pale warm smudges that is Vétheuil. Another such strut, very slightly warmer, braces the bottom right corner. The struts are so faint as to be hardly visible at first; but once they are seen, their action in the painting is indisputable. Under their influence the accents of the houses and their intervals are measured in toward the left corners with a certain trembling precision. Far from being unfinished, it is a painting that has been worked over for a long time, a painting in which every visible feature has been worked through.

What do these mysterious struts represent? Nothing at all in a literal descriptive sense. Nonetheless one cannot doubt that they are "seen," essential parts of the texture of the painting, in which observation from the subject and reading of the picture are woven together like the warp and woof of a tough fabric. One senses in features like these a kind of awakening in Monet to his own process of seeing or, rather, to processes within the action of painting that return his seeing to himself.

Among the categories of viewpoint and aspect I have been discussing, this is clearly a frontal, out-to-sea subject, painted from his floating studio or some point on the opposite bank. Vétheuil hovers in front of us. We cannot approach it by connected pathways but only lose ourselves in it, immerse ourselves in the fog that immerses it. Nor can we retreat to the certainty of the painter's exact position. His viewpoint is everywhere: the canvas is witness to that. Vétheuil looks back at us. Somehow the boundaries between subject and object, viewer and viewed, have become porous, open to a two-way exchange.

We will notice this shift of meaning even more vividly in the images that followed from Monet's reexploration of the Normandy cliffs. The place, as always, contributed special problems and revelations, although in these pictures Monet's love for Japanese art bears fruit; the "aesthetic code that evokes presence by means of a shadow, the whole by means of a fragment," as he put it to the critic Roger Marx.

These are paintings founded on high viewpoints. The subject is grasped in lumps, pieces, separated in space but boldly juxtaposed in the eye and offered to the canvas without linking passages. The ground drops away, vertiginous spaces open up. Unknown volumes of dead ground lie between one lump

Falaises près de Pourville *(Cliffs near Pourville)*. 1882

and another. The eye is no longer tethered at the threshold of the picture to advance from foreground to middle ground and distance but free to swoop out from its precarious perch, taking in enormous distances simultaneously.

In three of the four paintings of the church at Varengeville from 1882 it is impossible to tell whether the russet, bushy lump of ground with its two pine trees at the bottom of the picture is the formation he is standing on or whether there is dead ground between. Between it and the next fold of the cliff is a deep trough whose width one explores as atmosphere, a volume of green, violet, and rust shadow. Beyond that further cliff, with its church, lies the sea and unseen chalky precipices and unknown volumes of air. It is a radical invention: a landscape that does not contain an invitation to enter it on foot but instead re-creates the conditions of seeing, a field for omnipotent movements of the eye, conflating distance, accepting as a self-evident and sufficient world the visible front of things.

Consider how the Varengeville pictures are held together. Two slanting screens intersect—the pine trees and their piece of ground, and the church on its cliff. Between them a world of light and atmosphere, beyond them the thick distance of sea and sky. But notice how those slanting screens thread themselves together so that each is interpenetrated by the diagonal order of its opposite partner, the diagonal drift of the pine trees finding a resting place on the left edge of the far hillside, the reciprocal drive of the far hillside penetrating the bushy foliage of the foreground as far as the bottom right corner of the canvas. This airy zigzag is like a diamond-shaped net thrown between the two formations, trapping atmosphere and light.

Another theme of the campaign of 1882, the *cabane des douaniers* is the occasion for a wide range of experiment. It is an out-to-sea idea with a lump of cliff interposed at the bottom of the canvas. The little hut imposes a special quality. It is seen from above and behind, so that its lively toylike perspective imposes a strong direction. It is as alert as a figure pointing out to sea, and it exercises the same kind of focus. Its pointing goes one way only, from the cliff to the horizon. The ground it is standing on is cut and folded; in most cases a deep gully runs between it and where Monet is standing. The brow of the cliff rising against the sea carries intimations of the unseen abyss, a yawning fall. The sides of the gully are overgrown with bushes and tufted grass. We have access to the hut by eye alone, swift and easy when the light is behind our backs, more strenuous when the light breaks across the bushes from the side or the wind ruffles them. The compositional problem of how to hold together the cliff and the distant sea, how to make coherent a painting whose center is an enormous invisible hole, evidently delighted Monet. He paints many ver-

Vétheuil dans le Brouillard *(Vétheuil in the Fog)*. 1879

sions of it in 1882, all from slightly different vantage points, some with the light behind him, falling evenly on the cliff and reducing its contrast with the bright sea, others with the light in his eyes, silhouetting the hut and emphasizing the odd wandering profile of the cliff. The state of the sea, calm and sunny or choppy in a brisk wind, offers a principle of organization. In the fiercely brushed *Marée Montante à Pourville,* the cabin is pushed over to the extreme right of the canvas, its gable end cut by the edge of the canvas but reconstituted in the triangular fall of light across the corner of the wall and into the grass. The sea is rising and furrowed by row on row of waves curling back across the bay in diagonal ranks that match the diagonal of the cliff. The eye can repeat the rough pyramid shape of the cliff (itself a version of the eave of the cabin) anywhere across the extent of the view. It seems to echo toward the horizon, to be drawn out endlessly in the repetitive movements of the waves.

There are two paintings of this subject from the campaign of 1882 in which Monet surveys it from farther away and much higher up. The cabin is at the very foot of the canvas. The cliff behind it almost fills the canvas. Monet painted even more extreme versions of this view on his last session on the coast in 1897. In one of them only a crack of sea is visible on the right edge of the picture. The rest of the surface is filled with nothing but an enormous lump of land. It is a startling, aggressive composition, an image of extreme power. The broken, near-vertical edge of the cliff seems to eat up the right edge of the canvas, and the whole cliff seems to rear up and claim the painting, to incorporate the picture into itself.

Such images, with their masterful, almost bullying connotations, recur from time to time, like trials of strength, explosions of pent-up energy in which Monet takes whole hillsides to stand for his canvas. Appropriately it was just such a picture that he gave to Clemenceau, *Le Bloc* from the campaign at Fresselines. The extraordinary formation of the chalk cliffs at Étretat gives Monet another such opportunity, and there are paintings in which the land comes down out of the sky, there is nowhere for us to stand, the mass of the cliff is thrust at us without the option to advance or retreat. More remarkable still are the paintings of the Needle seen through the Porte d'Aval, in which this thrusting violent annexation of the canvas by the cliff is repeated by analogy within the arch. The Needle just fits into the frame of the arch and seems to be jammed into it just as the arch itself is violently jammed into the canvas.

The campaigns of the eighties produce landscapes of a completely new type. Paradoxically, all signs of Monet's concern with the modernity of his subject matter vanish. There are no more railway trains, no more iron bridges or factory chimneys, no more city folk in fashionable clothes. The places he paints are often well-known holiday resorts or beauty spots, but there are no trippers on the beach at Étretat any more than later there are farm workers and threshing machines around the haystacks or communicants on the steps of

Rouen Cathedral. His thoughts about the present and its relationship to painting were taking him in a different direction.

It was no longer modern life that preoccupied him as it had over the Boulevard des Capucines or in the echoing turmoil of the Gare Saint-Lazare but that slot of now, flickering between anticipation and memory, the present itself. No painter had ever approached that brink as closely as he was doing, for it was his own experienced present that was the issue, not another's imagined present. There was no example to help him. He had burned his bridges as far as the culture of pictures was concerned, committing himself utterly to his here and now. Yet the closer he approached that endlessly unrolling moment of presentness, the more extended his contemplation of it. The painting insisted on this paradox.

It is no wonder that when Clemenceau came to write about Monet's series of the facade of Rouen Cathedral, he fell back on the robust and tangible concept of chronology to explain them. He regretted that they had not been hung with a more obvious or logical time scheme, describing them almost as if they had been individual photographic shots as in an Eadweard Muybridge sequence, as if each image represented a moment captured. The implication of this reading was that Monet would have painted very quickly, that his attention to the moment was in some sense comparable to a photographer's. Yet, a few years earlier, Monet had written in a much-quoted letter to Geffroy that he had come to realize that instantaneity could only be achieved by working slowly. This letter is of such interest that it is worth quoting at length.

I'm grinding away, sticking to a series of different effects, but the sun sets so early at this time that I can't go on....I'm becoming so slow in working as to drive me to despair, but the more I go on, the more I see that I must work a lot to succeed in rendering what I am looking for: "instantaneity," especially the envelope, the same light spread everywhere, and more than ever I'm disgusted by easy things that come without effort. Finally, I'm getting more and more frantic with the need to render what I feel and I hope to go on living not too disabled, since it looks as if I'll make progress.

It is what the paintings tell us: that *"l'instantanéité"* is in the recognition of a certain unique unity, a structure to be developed within the picture, not to be captured from the outside. Speed of observation, deftness of hand, for which Monet had an abundant gift as well as twenty years of incomparable practice, had led him further and further toward the abyss, the nothingness of the instant. The more attuned the eye and hand were to capture a moment, the more elusive the moment became, shorter, inimitable, darting.

"Ah! Yes," he wrote to Pissarro, commiserating with his colleague about the speed with which a snowfall had melted. "It was beautiful, but unfortunately gone too fast....I almost envy those who work inside, there must be fewer disappointments."

Les Peupliers à Giverny *(Poplars at Giverny, Sunrise)*. 1887

Cultivated poplars are as typical a feature of the river valleys of northern France as olive trees are of Tuscany. For Monet they were essential, offering him an endlessly varied succession of models for pictorial ideas, both in the larger aspects of composition and in the fine structure of the picture surface. In paintings like these, in which the main forms of the landscape are drawn parallel to the canvas, Monet has relinquished any idea of local incident or focal point. The trees present a frieze that the eye can explore back and forth, as if exploring a fluttering wall of leaves, sky, and sunlight.

These are paintings that give some weight to the idea of pantheism in Monet's attitude. Just because there is so little to see by way of incident one becomes aware of his reverence for a place that is unnamed and undefined until painted, a nowhere that is nonetheless given its genius loci.

OPPOSITE, ABOVE: Un Tournant de l'Epte *(A Bend in the River Epte, near Giverny)*. 1888

OPPOSITE, BELOW: Arbres en Hiver, Vue sur Bennecourt *(Trees in Winter, View of Bennecourt)*. 1887

Cabane de Douanier *(The Custom House at Varengeville)*. 1882

La Pointe du Petit Ailly *(The Tip of the Petit Ailly)*. 1897

La Mer-Vue des Falaises *(The Sea-View from the Cliffs)*. 1881

Au Val Saint-Nicolas, près Dieppe, Matin *(On the Cliffs, Dieppe)*. 1897

These four paintings are inconceivable except in the context of plein-air painting. They could never have been invented. They are the results of tasks that Monet set himself in special locations, and even if it was the gradual and complicated development of his sense of the pictorial that finally opened up these locations to him as motifs, the final appearance of the pictures is determined by an experience of a real place and a real viewpoint.

There is no entrance to these pictures: we are "in" them at once. Nor are there points of focus: we need to look everywhere on the canvas without giving special value to one place over another, and it is only through this all-over reading that the great spatial drama of the cliff top comes into its own and we are able to locate and feel the vertiginous drop to the surface of the water—beyond the boundaries of the canvas.

OPPOSITE, ABOVE: Cabane de Douaniers à Varengeville, Effet du Matin *(Customs Cabin at Varengeville, Morning Effect)*. 1882

OPPOSITE, BELOW: Marée Montante à Pourville *(Rising Tide at Pourville)*. 1882

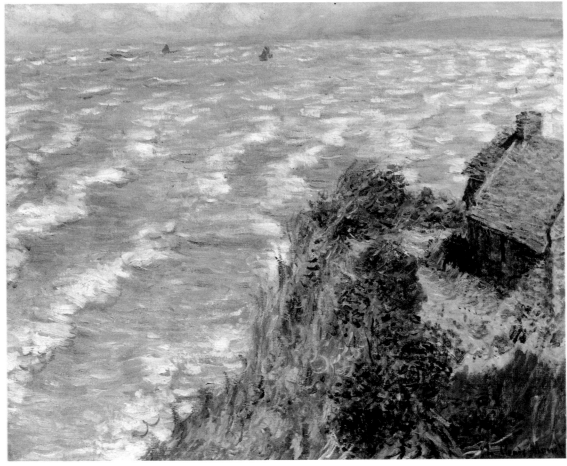

Église de Varengeville, Soleil Couchant
(Church at Varengeville, Sunset). 1882

L'Église de Varengeville, Soleil Couchant
(Church at Varengeville, Sunset). 1883

*The drawing was not made from nature,
but was done after the painting at top to illus-
trate a magazine article—paintings being more
difficult to reproduce at the time.*

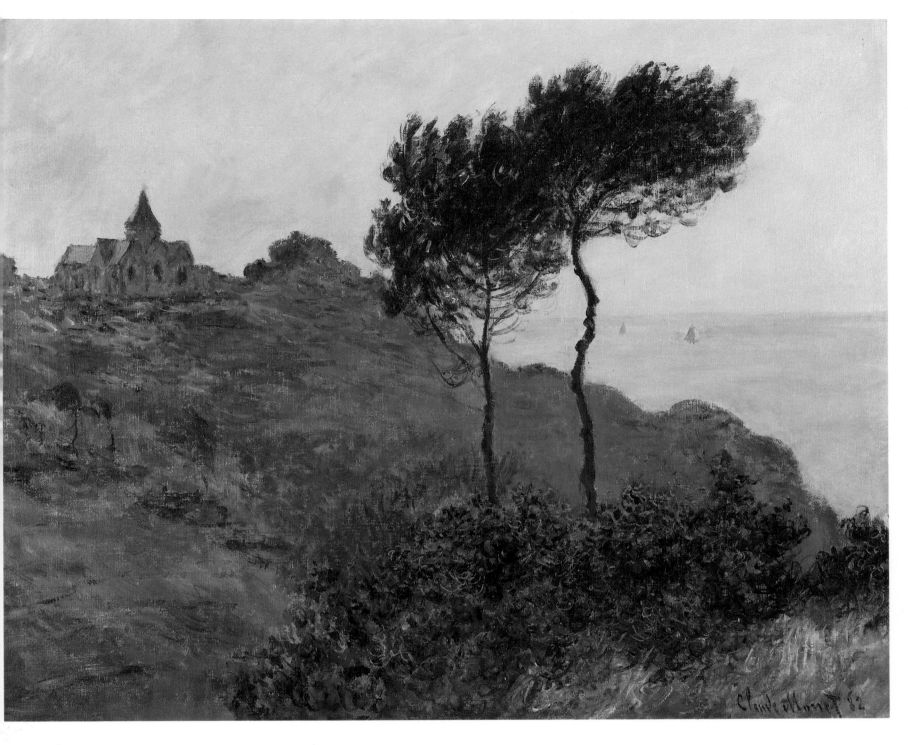

Église de Varengeville, Temps Gris, also known as L'Église sur la Falaise, Varengeville
(*Church at Varengeville, Cloudy Weather,* or *Church on the Cliff, Varengeville*). 1882

Monet painted this subject four times from exactly the same point of view during the summer of 1882; an instance of a practice that became formalized after 1889 in his series works.

There is something sentimental and dated about this motif, with its quaint little church on the cliff top and the picturesque pine trees. It is reminiscent of old-fashioned books for amateur photographers on how to compose landscapes. Taste was never Monet's strong point. However, there are important features in the structure of these pictures.

There is no immediate entry to them. We do not know whether the foreground is the formation that Monet is standing on or whether there is dead ground between him and it. Dead ground—ground that we cannot see—is almost as significant to our reading of the picture as the ground we can see. What lies between the scrubby bushes in front of us and the hillside beyond? What lies on the other side of that hill and the sea? In a traditionally composed landscape we would have been led forward toward the horizon. Here distance is forced upon us, raw and problematic.

The picture is held together by the intersecting diagonals of the hillside and the pines. It is an unorthodox structure that owes something to Japanese art, to which Monet makes an explicit tribute in the role played by the tree trunk—half in, half out—in the works opposite.

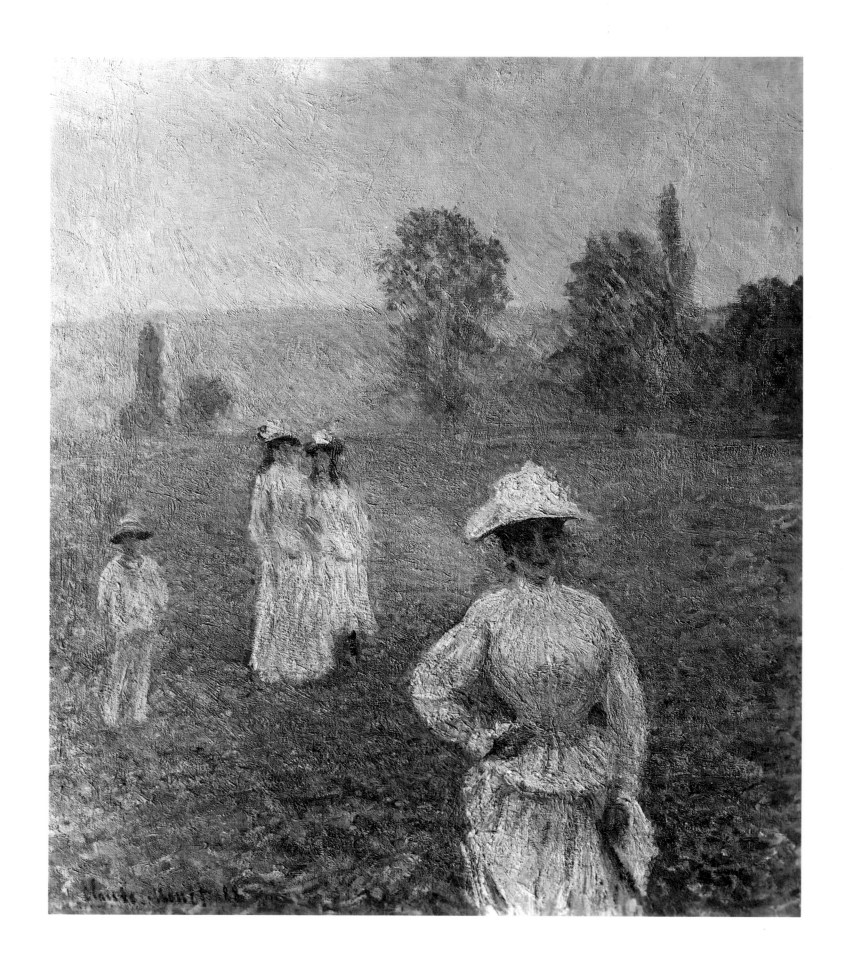

Promenade, Temps Gris *(Promenade, Cloudy Weather).* 1888

During the summer of 1889, in the aftermath of the retrospective at the Galerie Georges Petit, Monet threw himself into an untypical undertaking. Manet's *Olympia* had been on view for the first time in many years during the Exposition Universelle, and Monet conceived the idea of raising a public subscription to buy it and present it to the Louvre. He wrote scores of letters to his friends and collectors. Zola, doubting Monet's motives, took the line that Manet would enter the Louvre at his own time and without Monet's help, and he refused to subscribe. The list grew, however, and the purchase price of 20,000 francs was achieved by the beginning of 1890. There was then the resistance of the administration to be overcome. Antonin Proust demurred and felt the heat of Monet's wrath. *Olympia* entered the Luxembourg, finally reaching the Louvre in 1907 under the orders of Clemenceau, himself persuaded by Monet. In a sense Zola had been right. In fighting on behalf of his dead friend, Monet was not only defending Manet's memory and helping his widow; he was claiming a place for himself as the dead painter's heir, the most authoritative among the independent artists.

As Monet entered his fifties he was able to leave financial anxiety behind. In 1889 Theo van Gogh had sold a painting of Antibes for the record price of 10,350 francs. Within two years Monet's total receipts for the year were over 100,000 francs. When his landlord at Giverny decided to sell the house, Monet bought it. Now, under Alice's surveillance, surrounded by his enormous family, he settled into the life of his middle years, a life that had all the outward signs of the solid, provincial bourgeois: servants, gardeners, a magnificent table, and, when the time came, several motorcars.

He was a celebrity. As the years went by, painters of all nationalities, but particularly American, were drawn to Giverny, which became something of an artist's colony, its lanes and meadows dotted with umbrellas and easels during the summer. Monet remained aloof, telling eager tyros who approached him merely to look at nature. But he was at home to journalists, and a succession of interviewers made the trip to Giverny to be shown the garden and his collection of his own and his friends' work and to be regaled with reminiscences.

Ernest Hoschedé died in March 1891, Alice by his bedside. He was buried at Giverny. The third Hoschedé girl, Suzanne, had fallen in love with an American painter, Theodore Butler, whom John Singer Sargent had introduced to the family. Monet experienced all the jealous anxieties of a father. But inquiries made through American friends were reassuring, and Suzanne and Theodore were married in July 1892. A week before, Monet and Alice had themselves been quietly married "in order that things can be done properly…so that M. Monet can take my father's place and give me away in church…," as Suzanne

From his earliest years Monet had been aware of the special challenge of painting figures in the open air. In 1888 he wrote to Théodore Duret:
I am stuck in some important canvases. I am stubborn. I am working more than ever and at new attempts, some figures in the open air as I understand them, treated like landscapes. It is an old dream that still bothers me, it is so difficult, I try very hard. It absorbs me to the point of almost making me ill.

Gustave Geffroy commented on one of these paintings in an essay:
On the other canvas, in the same landscape, at the same crossing of the meadow, the season more advanced and the light softly veiled by the foreshadowing of dusk, the whole is sweet and languid, of a mauve and fading harmony. The earth becomes colored by fumes of incense, the sky deepens with mystery, the strolling women, so present, so real, evoke dreaming thoughts, of glorious stained-glass windows illuminated by the twilight of a mystical sun.

wrote to Butler. (The Butlers' marriage lasted only a few years. After the birth of a second child, Suzanne became ill and died. Butler then married the eldest Hoschedé girl, Marthe.) The two halves of the family were to become even more deeply entwined when, toward the end of the decade, Jean Monet, who was working as a chemist with his uncle in Rouen, married his stepsister, Alice's second daughter, Blanche.

Although the family and the domain at Giverny were the center of Monet's private life, it was some years before he found his most important subjects there. The campaigns away from home resulted in self-contained groups of canvases that have their own character and speak of special qualities of experience. Each campaign was a period of great emotional intensity and titanic effort. They are the central effort of each year: in 1885 forty-eight paintings from Giverny, forty from Étretat; the following year twenty-five from Giverny, thirty-nine from Belle-Île; in 1888 twenty-four from Giverny, thirty-six from Antibes.

Clearly a great deal of reflecting and repainting went into the work Monet brought home, much more than he was willing to admit at the time. Between the campaigns there was much activity. Monet explored the hillsides and orchards, the poplar-lined streams and the water meadows beyond the railway line at the bottom of his garden. Between 1882 and 1885 he devoted a lot of time to a rather complicated suite of panels made to decorate the doors of Durand-Ruel's dining room in Paris at 35, Rue de Rome. In the summers of 1884 and 1885 he painted groups of small haystacks in the meadow between the Ru and the Epte, paintings that anticipate the series of *Meules* (stacks of hay or cereal grains) of 1890–91. There are river subjects painted from his floating

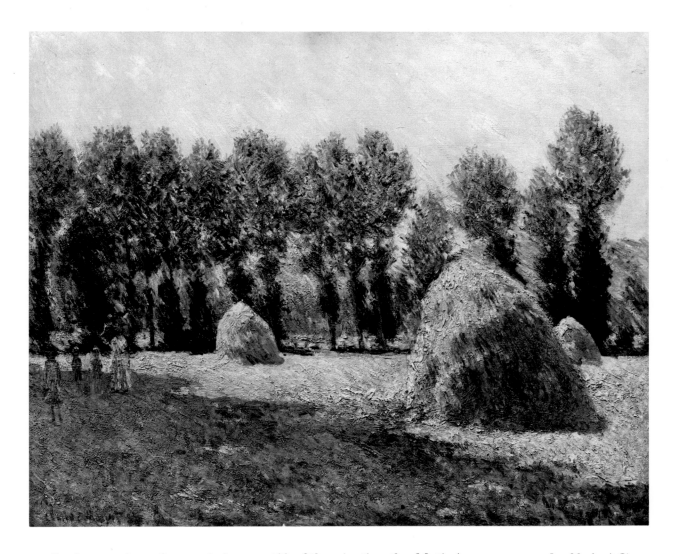

studio that touch on the great river *motifs* of the nineties, the *Matinées sur la Seine.*

Toward the end of the decade there is a sudden reemergence of figures. Monet's family was growing up. The Hoschedé girls surrounded him. Blanche had begun to paint. Suzanne, his favorite model, appears like a reembodiment of Camille in a white dress, parasol against the sky. She strolls with her sisters through the evening meadows, flowers among flowers. And later, at the oars of a rowboat, she is seen from above with long tresses of riverweeds streaming like green hair in the transparent water.

In the autumn of 1888 Monet began to work from a group of stacks, probably of wheat, belonging to a farmer named Queruel, in a nearby field, the Clos Morin. He made five studies, two of single stacks, three of two stacks, one large, one small. That spring he was at Fresselines, where he made an extended series of views of the Creuse Valley from the same position under various conditions of weather and light. Back in Giverny in the early summer he turned to a sequence of views, a field of poppies, a hayfield, the corner of a field of oats, painting several canvases of each from exactly the same position and holding to the same cut and placement. With the harvest and the building of the stacks in the late summer, he picked up where he had left off the year before. The work continued until the following spring and ended with a total of twenty-five canvases. It was with this group, which was shown by Durand-Ruel in the summer of 1891, that Monet's concept of the series was consolidated in the public's mind. The exhibition was a spectacular success. It was as though with the stacks something definitive had at last appeared out of the Impressionist program, something that the public could understand as being far more

The turn-of-the-century postcard and the photograph above, taken at least a decade after Monet painted the Meules *series, reveal the agrarian character of Giverny. At right center in the photograph is Monet's house, to which he had recently added an extension, permitting a larger kitchen on the ground floor with increased space above for his large family; at the right is the skylight of his second studio.*

Meule *is often translated as haystack. It is not a mistake that any farmer would have made in the days before the combine harvester. Shown in the photographs at left and in Monet's paintings at right are cereal stacks, built of sheaves of wheat or oats, thatched with straw and standing until the spring when the grain will be threshed. In any cereal-growing region they would have been proud and obvious features of the winter landscape, representing a farmer's fortune, his good husbandry, and the labor of the previous summer. They appear in the work of many painters who took the work of the fields as their subject: in Millet, in Pissarro (who also painted a steam threshing machine), and in Van Gogh. These stacks have distinctly different shapes from those made of hay, as Monet's own painting on the previous page will show.*

than a sketch.

Much later Monet was to pretend to the Duc de Trévise that it was with the stacks that he had first become fully aware of the mobility of light. "When I began I was like the others; I believed that two canvases would suffice, one for gray weather and one for sun! At that time I was painting some stacks....One day I saw that my light had changed. I said to my stepdaughter: 'Go to the house, if you don't mind, and bring me another canvas!' " And so Monet worked on the story: another canvas! Another! The fact is that ever since he had started to paint he had had the habit of working from the same *motif* under different conditions, as if to bring out the dominance of the effect. All through the campaigns of the eighties he had made extended groups of identical subjects from the same or nearly the same point of view. And yet there is something new here, a difference of emphasis. It has partly to do with the subject matter, partly with Monet's insistent presentation of it.

In the *Meules* made in the summers of 1884 and 1885 the round lumps of hay are features set at a distance within a complex landscape. These are cool yet summery paintings in which the light makes its entry through filtering hedgerows, wrapping the lumps, unrolling across the plane of the mowed field like a golden carpet. But the later stacks are not seen like this at all. These rough, shaggy cones on the cleared stubble, ringed with mud and hoarfrost, known to rats and rooks, are given on the canvas with the directness of an ace on a playing card. The nearest trees are a long way off. There are no complexities of enclosure or concealment. What we see is the stack.

We see it rather close up, a solid form. And it is generally against the light. In the whole series there are only five or six canvases in which the sunlight hits

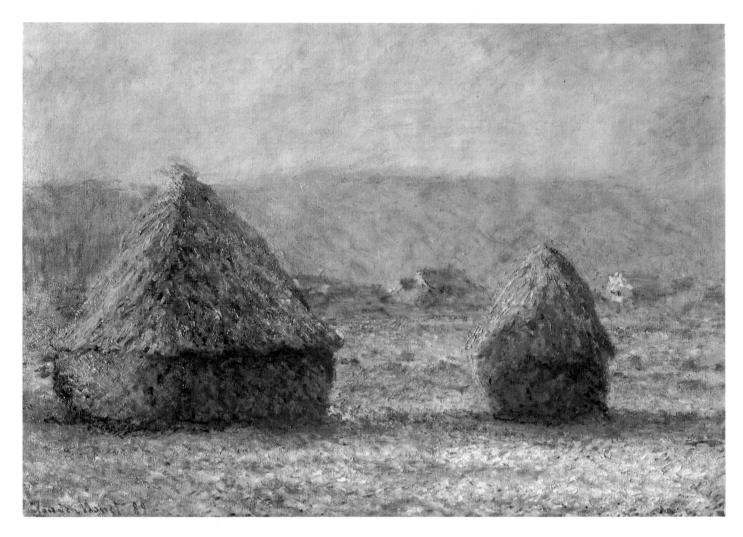

the stack from the side, modeling it, and only seven in which the sky is over-
cast and there is no shadow. In the remaining eighteen the sun comes toward
us and the stacks are seen either obliquely or squarely in its path, in full
silhouette. Their shadows are important, jagged and dramatic repetitions of
their geometry.

The *contre-jour* is deliberate; Monet could easily have stood with his back
to the sun. Working against the light allowed him to see the stack flattish,
unmodeled. Standing so close to it, he is able to peer into its umbra, to paint
the stack as a mass of color, a screen against which the thickness of the
atmosphere is palpable. In contrast to earlier paintings in which distance, the
depth of the envelope, had served to disembody form, to render it iridescent
and volatile, now the effect of the envelope is stated in strong colors, clear-cut
intervals of value, with a sense of substance. Monet worked all through the
winter on them. The dominant local colors must have been warm: the gold of
stubble and straw fading with rain and frost into warm grays, the red-brown of
mud, the umbers of sodden thatch; the sun was low, often with the intense rosy
gold of northern winter evenings; in many paintings there are powderings of
snow or frost. This gamut of colors allowed for extreme experimentation in an
area of the palette that until now had been only occasionally explored, on the
rocks of Belle-Île, at Fresselines, and in front of flowers.

Durand-Ruel showed fifteen *Meules* in May 1891. The catalogue had a long
introduction by Geffroy. The show had been anticipated. A month before
it opened, Pissarro, passing on the gossip to his son, had written, "For the
moment people want nothing but Monets, apparently he can't paint enough
pictures to meet the demand. Worst of all, they all want *Meules au Soleil*

ABOVE: Les Meules, Effet de Gelée Blanche
(Stacks, Hoarfrost). 1889

BELOW: Meules, Derniers Rayons de Soleil
(Stacks, Last Rays of Sunlight). 1890

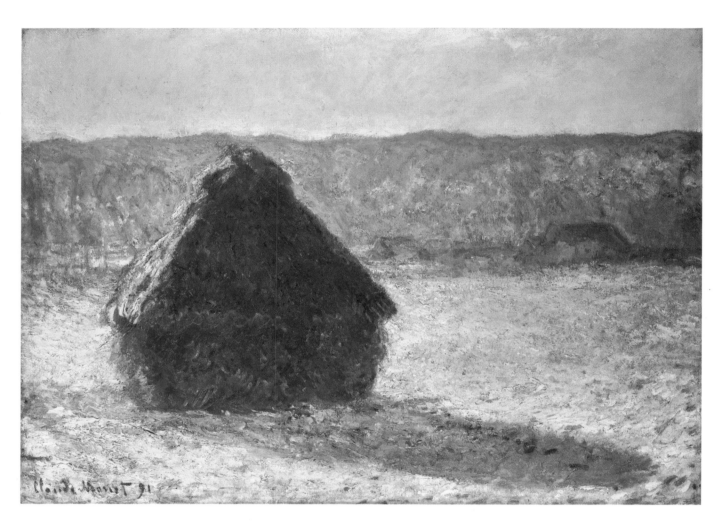

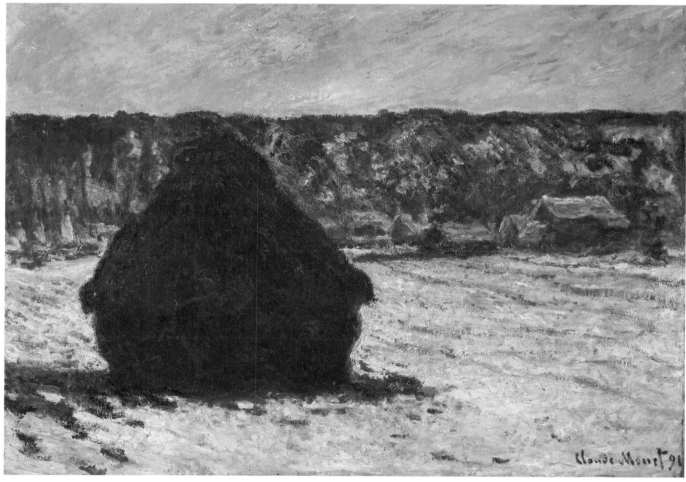

160

Although the idea of a painter showing a related series seems familiar today, in Monet's time it was a totally new concept. The Dutch critic W.G.C. Byvanck wrote this account of his visit to Monet's exhibition of the Meule *paintings:*

One of these paintings showed the stack in full glory. An afternoon sun there burned the straw with its crimson and gold rays and the kindled stalks flamed with a dazzling brightness. The warm atmosphere was visibly vibrating and bathed the objects in a transparency of bluish vapor....

This canvas taught me how to look at the others; it awakened them to life and truth. After having at first hesitated to cast my eyes around me, I now felt a rare pleasure in going over the series of paintings exhibited and the range of colors they showed me, from the scarlet crimson of summer to the gray coldness of the pale crimson of a winter evening.

At that moment, Claude Monet came into the room; I gave him my impression, for what it was worth.

"You're right," he said, with the fine directness of a great artist who is able to appreciate the sincerity of the words spoken to him. "This is what I was aiming at: first of all, I wanted to be true and accurate. For me, a landscape does not exist as landscape, since its appearance changes at every moment; but it lives according to its surroundings, by the air and light, which constantly change....

"And the result? Look at that painting, in the middle of the others, which caught your attention from the beginning, that one alone is perfectly successful—perhaps because the landscape then gave everything that it was capable of giving. And the others?—there are certainly a few of them that are not bad, but they acquire their full value only by comparison and the sequence of the whole series."

Gustave Geffroy wrote this evocation of the paintings in his preface to the catalogue for the exhibition held at the Galerie Durand-Ruel:
But he also knows that the artist can spend his life in the same place and look around himself without exhausting the constantly renewed

spectacle. And here he is, a stone's throw from his quiet house...stopping along the road on a late summer evening and looking at the field where the stacks stand, the humble earth adjoining a few low houses, encircled by the nearby hills, and decked with the ceaseless parade of clouds. It is at the edge of this field that he stays that day, and he comes back the next day and the day after, and every day until autumn, and during the whole autumn and at the beginning of winter....

These stacks, in this deserted field, are transient objects whose surfaces, like mirrors, catch the mood of the environment, the states of the atmosphere with the errant breeze, the sudden glow. Light and shade radiate from them, sun and shadow revolve around them in relentless pursuit; they reflect its dying heat, its last rays; they are shrouded in mist, soaked with rain, frozen with snow, in harmony with the distant horizon, the earth, the sky.

They appear at first in the serenity of a fine afternoon, their contours fringed with the sun's rosy glow. In the clear light they stand out sharply above the pale earth. On the same day, as evening approaches, the slope of the hillside, faintly tinged with blue, the earth more mottled, their straw turns purple, their contour is traced with an incandescent line. They then become colorful celebrations of autumn, sumptuous and melancholy. On overcast days, trees and houses hover in the distance like phantoms. On clearer days, blue shadows, already chill, are cast onto the pink earth. At the end of a day of timid warmth, after the obstinate sun has regretfully departed, spreading a golden sheen over the countryside, the stacks stand out in the confusion of evening, resplendent clusters of dull jewels. Their sides split open and catch fire, offering a glimpse of carbuncles and sapphires, amethysts and chrysolites, whilst, emerald-studded, the shadow of these red-glowing stacks slowly lengthens. Then, still later, beneath a sky of orange and red, darkness creeps over the stacks, which glow like burning embers. Veils, tragic with the red of blood and the purple of mourning, are draped around them, over the earth, above the earth, and into the atmosphere.

PAGE 160, ABOVE: Meule, Effet de Neige, le Matin *(Haystack in Winter).* 1891

PAGE 160, BELOW: Meule, Effet de Neige, Temps Couvert *(Haystack, Winter, Giverny).* 1891

PAGE 161, ABOVE: La Meule *(Stack).* 1891

PAGE 161, BELOW: Meule, Dégel, Soleil Couchant *(Stack, Thaw, Sunset).* 1891

PAGE 162, ABOVE: Meule au Soleil *(Stack in Sunlight).* 1891

PAGE 162, BELOW: Meule, Soleil Couchant *(Haystack at Sunset near Giverny).* 1891

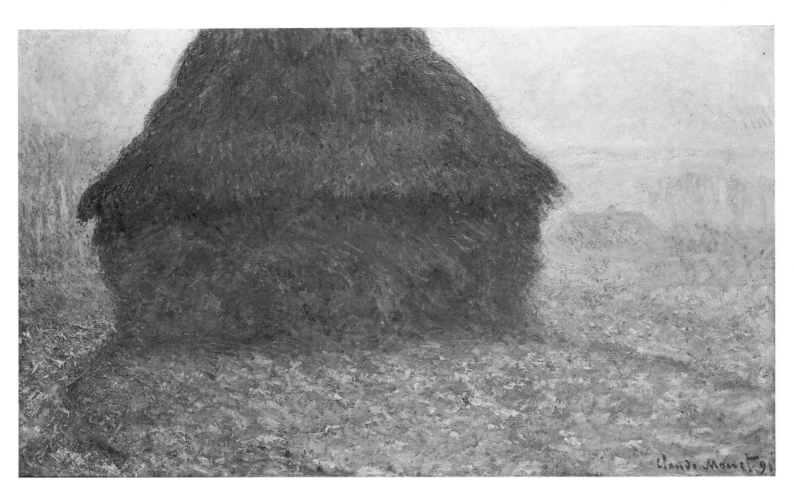

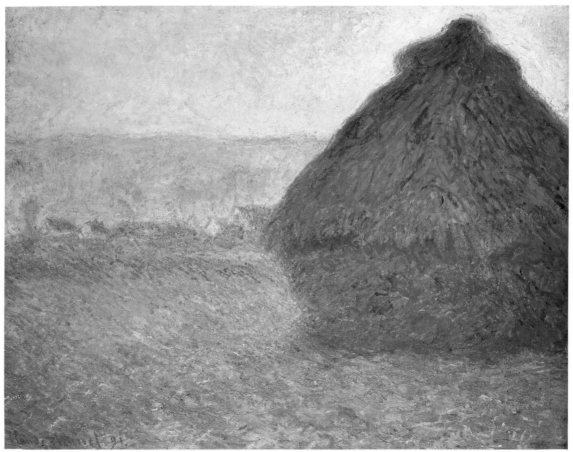

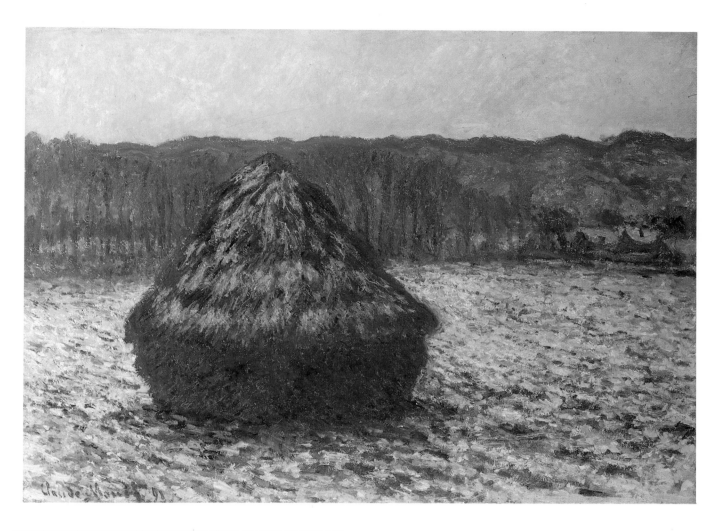

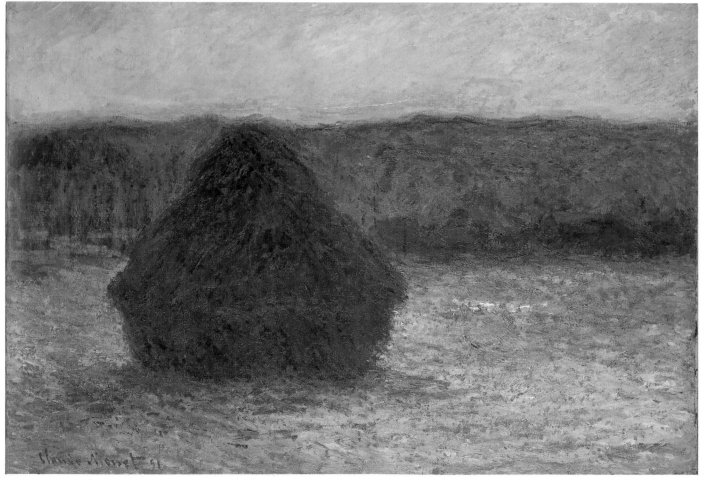

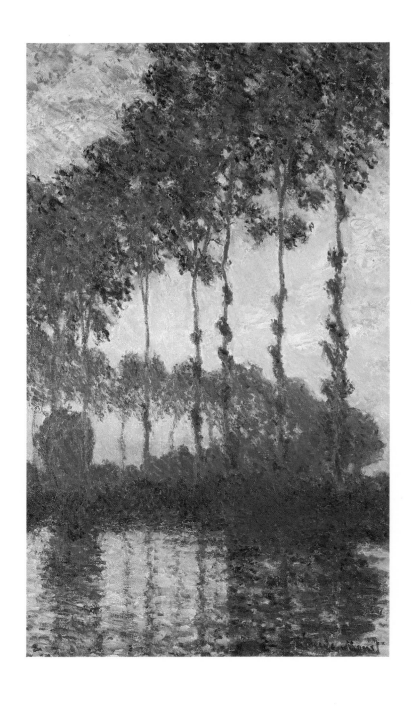

Peupliers, Coucher de Soleil *(Poplars, Sunset).* 1891

Just before the opening of the poplar exhibition at the Galerie Durand-Ruel on February 29, 1892, the novelist and playwright Octave Mirbeau, a close friend of the artist's, wrote Monet the following letter:

It is an absolutely magnificent work, this series, a work in which you renew yourself, through craft and feeling, and in which you reach the absolute beauty of great decoration.

There I felt complete joy, an emotion that I can't express, and so deep that I would have liked to kiss you. The beauty of those lines, the newness of those lines and their grandeur, and the immensity of the sky and the thrill of it all…you hear me, my dear Monet, never, never has any artist expressed such things, and it is again a revelation of a new Monet….I am overwhelmed.

Clément Janin published the following review of the exhibition in the newspaper L'Estafette of March 10, 1892:

What is it? Not much. Three or four poplars on the edge of a marsh. Their trunks are reflected in the water, the hair of their heads quivers in the sky; farther away, other poplars recede along a road. This is repeated fifteen times, at all hours of the day, with all the variations in appearance brought to things by changes in the surrounding atmosphere and light; here, the clear sweet song of the end of a summer day, before night falls but when already the sky is becoming like watered silk and a disquietude of light amethyst and turquoise disturbs the cerulean serenity of the horizon; there, in the fierce depths of the infinite, gather the dark shades of lapis lazuli through which the rays of the sun are concentrated and burn; elsewhere, like pink sailing boats on Oriental seas, fragile clouds driven by the evening breeze float pink against a sky of forget-me-nots, and everywhere the poplars sleep, breathe, and murmur, lifting up their supple trunks, mingling their efflorescence, living their own lives within that great collective life of nature.

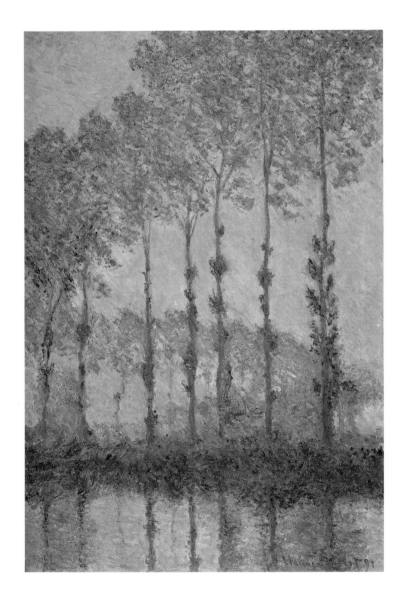

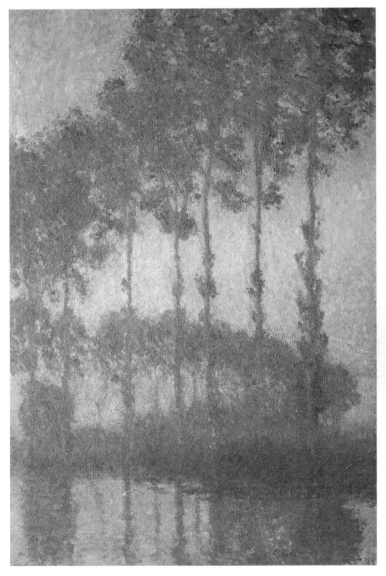

Peupliers au Bord de l'Epte, Automne
(Poplars Along the Epte River, Autumn). 1891

Peupliers au Bord de l'Epte, Crépuscule
(Poplars Along the Epte River, Dusk). 1891

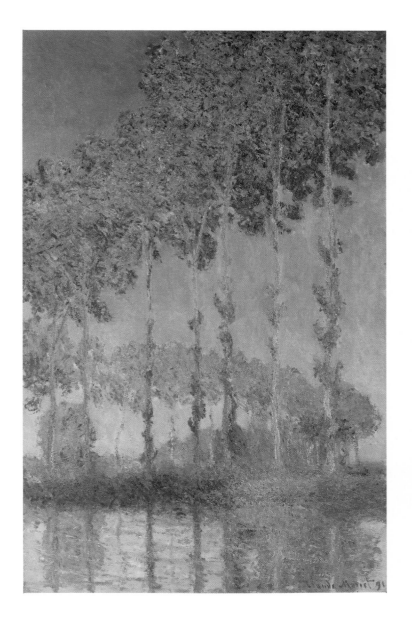

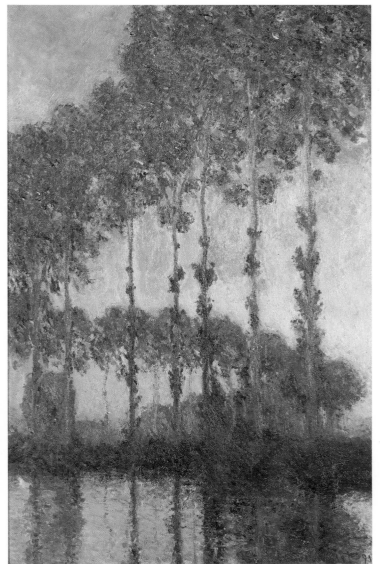

Peupliers au Bord de l'Epte, Effet de Soleil Couchant
(Poplars Along the Epte River, Sunset Effect). 1891

Rangée de Peupliers *(Row of Poplars)*. 1891

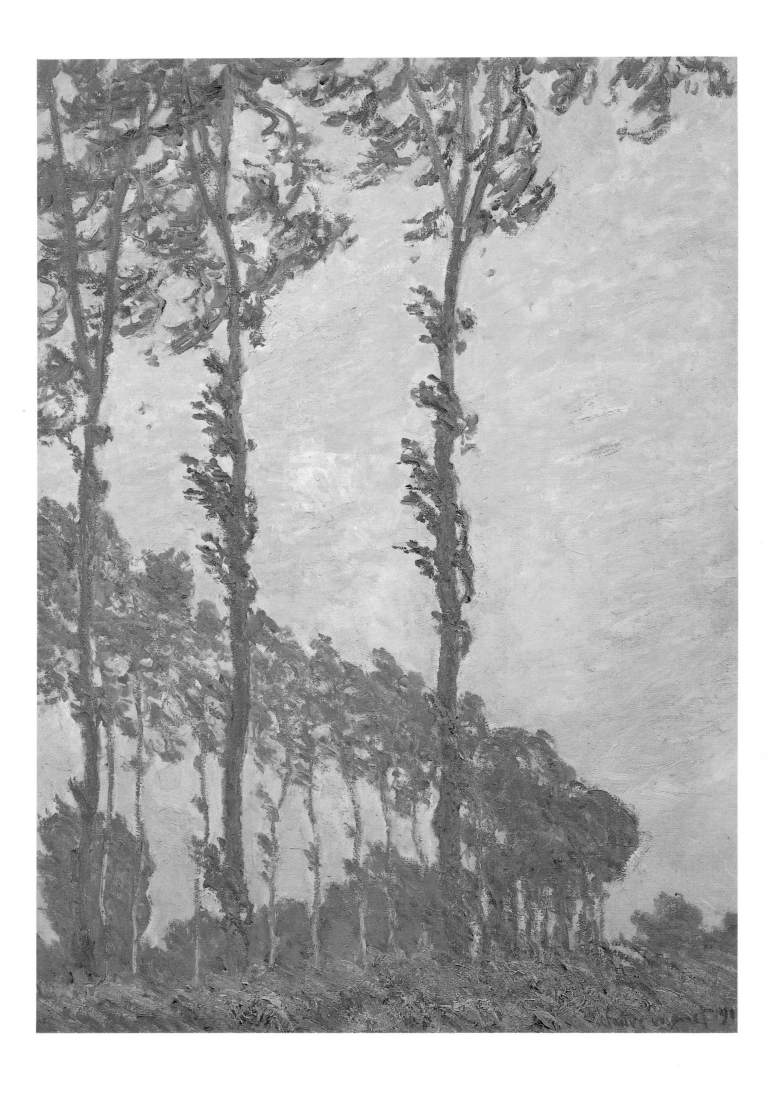

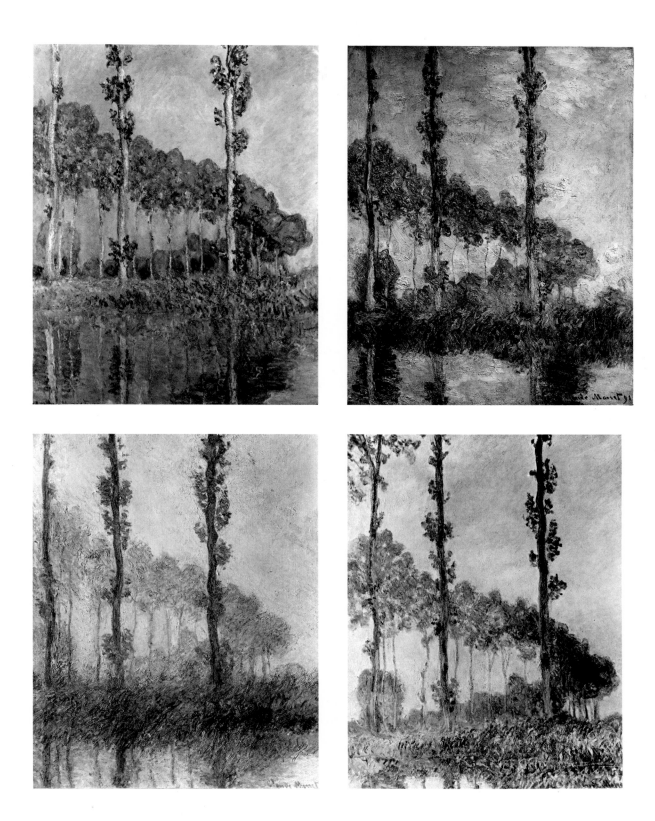

ABOVE, LEFT: Les Peupliers, Effet Rose *(Poplars, Pink Effect)*. 1891

ABOVE, RIGHT: Les Trois Arbres, Été *(Poplars in the Sun)*. 1891

BELOW, LEFT: Les Trois Arbres, Automne *(Three Trees, Autumn)*. 1891

BELOW, RIGHT: Les Trois Arbres, Temps Gris *(Three Trees, Cloudy Weather)*. 1891

OPPOSITE: Effet de Vent, Série des Peupliers *(Wind Effect, Poplar Series)*. 1891

Monet's viewpoint from his floating studio was not much above the level of the water. The nearest trees tower over him and the distant ones disappear beyond the rim of the bank. The foreground is taken up entirely by reflections. In the tall canvases on which the majority of the Poplars are painted, his eye roves up and down, from the bank to the soaring crowns of the trees and back again. The shorter canvases reflect less movement. He is not looking up at the treetops but rather ahead, finding new and surprising formations in the colonnade of trunks and their symmetrical extensions in the water.

Among the problems Monet confronted in painting his landscapes were some that were unrelated to the work itself. Looking back on his poplar series, Monet related the following anecdote:

…it was a funny story! I had to buy the poplars in order to finish painting them….The town of Limetz had put them up for sale. I went to see the mayor. He understood my reasons, but he couldn't postpone the auction. The only thing I could do was to attend the bidding myself, not a pleasant prospect, for I was saying to myself, "They're going to make you pay plenty for your caprice, old man!" Then I had the idea of going up to a wood dealer who wanted the lumber. I asked him how high a price he expected to pay, promising to make up the difference if the bid went over his amount, on condition that he would buy the trees for me and leave them standing for a few more months. And that's what happened, not without some sacrifice to my wallet.

Couchant! Always the same story, everything he does goes to America at prices of four, five, and six thousand francs." A week later he reports with special emphasis that Monet "will exhibit *nothing but Meules*. The clerk at Boussod and Valadon told me that the collectors want only *Meules*. I don't understand how Monet can submit to this demand to repeat himself—such is the terrible consequence of success!" Pissarro's note of bitterness is understandable. He had just closed a show in which he had sold almost nothing. Even so, it is remarkable that someone with as good an eye and so close to Monet should not have grasped the novel, serial character of the new paintings and should have assumed that they were mere repetitions. In the event, Pissarro was completely won over and like many other observers saw that the total effect of the show and the interconnectedness of each piece within it presented something that was entirely new.

This was well described by a visiting Dutch critic, Willem Byvanck, who wrote a book called *Un Hollandais à Paris en 1891: Sensations de Littérature et d'Art*. At first he had experienced nothing but bewilderment—understandably, for pictures like them, in which color had been seen in such degrees of saturation or in such combinations, had never been exhibited before. Byvanck describes how he spent some time looking at a single painting and how this one painting allowed him to approach the ensemble. It was only then that he understood the importance of the ensemble, that it was indeed to be seen as a whole. He describes how after having arrived at this opinion he met Monet himself, who agreed. For him, Monet said, the aim was a certain exactitude. But the truth lay not in the facts of a particular landscape so much as in its aspect at a particular moment, an aspect that changed continuously under the

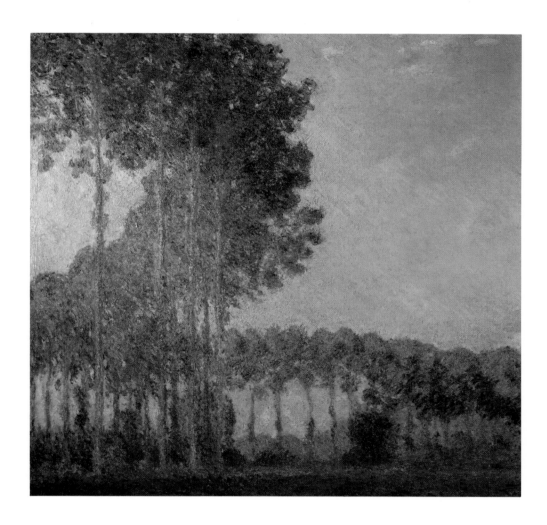

Peupliers au Bord de l'Epte, Vue du Marais *(Poplars Along the Epte River, View from the Marsh)*. 1891

Monet's inspiration for the monumental series of Rouen Cathedral paintings was related to the journalist François Thiébault-Sisson:

Thus having stopped one day in Vernon, I found the silhouette of the church so strange that I undertook to render it. It was early summer and the weather was still a little crisp. Cool foggy mornings were followed by sudden bursts of sunshine whose rays, warm as they were, succeeded only slowly in dissolving the mists clinging to all the rough surfaces of the building and which put an ideally vaporous envelope around the stone that time had made golden. This observation was the starting point for my series of *Cathedrals*. I told myself it wouldn't be a bad idea to study the same subject at different hours of the day and note the effects of light that modified in such a tangible way the appearance and colors of the building from one hour to the next. I didn't follow up the idea at the time, but little by little it germinated in my brain.

Monet's great champion, Georges Clemenceau, took the opportunity of the exhibition of the cathedral series to trumpet his friend's achievement, and he flung down the following challenge in an impassioned editorial that covered two-thirds of the front page of his newspaper La Justice *on May 20, 1895:*

How come! There has not been one millionaire to understand, even vaguely, the meaning of these twenty juxtaposed cathedrals and say: *I'm buying the lot,* as he would have done for a bundle of shares. It's enough to make you disgusted with Rothschild's profession.

And what about you, Félix Faure [President of the Republic]....Why has it never occurred to you to go and look at the work of one of your contemporaries, for whom France will be celebrated throughout the world long after your name has been forgotten?...Go and look at those series of cathedrals like the good bourgeois that you are, without asking anyone's advice. You may understand, and in your belief that you represent France, it may occur to you to give France these twenty canvases, which all together represent a moment of art, that is to say a moment of man himself, a revolution without gunfire.

The press greeted the first exhibition of Monet's cathedrals in May 1895 with enthusiasm, perhaps none so ebulliently as André Michel in the following review:

M. Claude Monet, whose eye is certainly constituted in a very particular way and marvelously sensitive to the most subtle modulations of light, came just at the right time to manifest by conclusive works the extreme point of this development.

Here then is the old church and, on each side of its facade, the powerful silhouette of its towers. Sometimes, against a background of sapphire blue sky and under an oblique light, it will stand out by large masses underscored in the projecting stones by delicately orange-colored pinks, bluish shadows, and in the depths of the portals great vibrations of shifting gold, a veritable fairy palace in an apotheosis of splendor. Sometimes, against a pearl-gray sky, it will appear in mauve, lilac, and rose-colored transparencies; against a turquoise-blue sky, it will be almost pink with contrasts of purplish and greenish yellow shadows, and its stones will shine like gems. Against a gray and northern sky, it will heavily raise its ghostly mass; at other times, it will efface itself and almost completely dissolve in a great bluish fog, or else, under a gray-mauve sky, it will be wrapped in grayish greens and very delicate pinks. Twenty times in a row, without ever repeating himself, with an astonishing virtuosity, a prodigious subtlety of eye, and a disconcerting passion of treatment, M. Claude Monet diversifies the theme, imagines different effects, and from dazzling light to the densest fog, in the caress of half tones or the glory of broad daylight, in the palpitation of the ether, he will make the stone ghost that has served as a pretext or opportunity for his arbitrary and powerful dream appear pink or green, vermilion or grayish. If you are willing, by the way, to give yourself the joy of this spectacle or enchantment, beware of getting too close! In the center of the room, eight or ten meters from the painting, there is a point, a single point, where with the optical mixture taking place on your retina, you will be able to seize the shifting and vibrating harmonies produced by the combination of colored particles in their delicate nuances and

subtle transparencies. Up close, it is a formless, rough surface, a piling up of unraveled or twisted little bundles of greens, pinks, vermilions, blues, and yellows, which produces exactly the effect of a saucer of cream with marmalade in which dozens of kittens have paddled....It looks as though one reaches the extreme tension of sensation, that one arrives at that point where a principle, by a kind of inner exaggeration, is exhausted and about to die. After such an effort and such an astonishing wager, such an abuse and dislocation of its craft, oil painting has nothing more to say, it has covered the whole field of possible expression.

The photograph opposite, from the same point of view that Monet adopted, is one of several of Rouen Cathedral that Monet had in his possession at the time of his death.

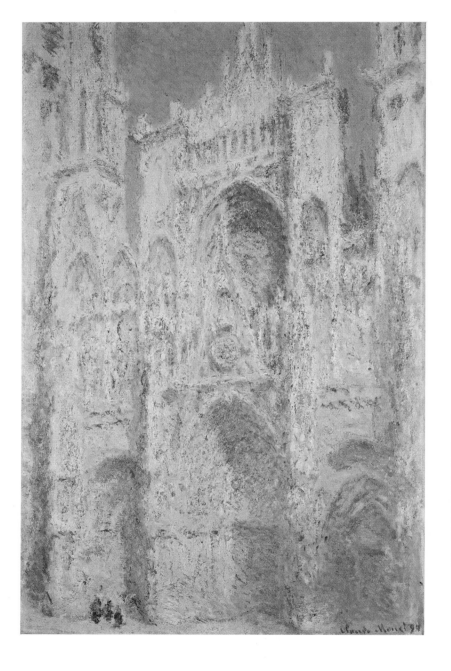

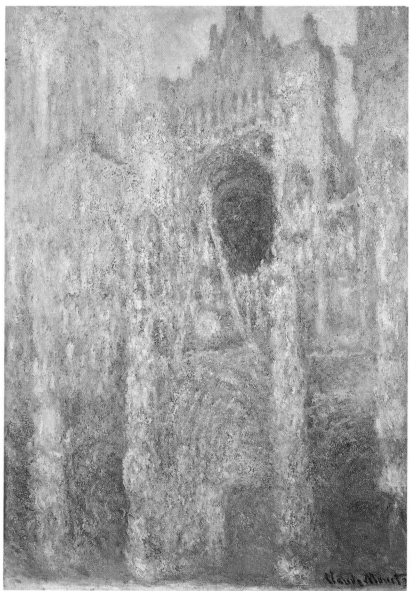

La Cathédrale de Rouen, le Portail (Soleil)
(Rouen Cathedral, West Facade, Sunlight). 1894

La Cathédrale de Rouen, le Portail Plein Midi, Lumière Reflétée
(Rouen Cathedral, the Facade in Sunlight). 1894

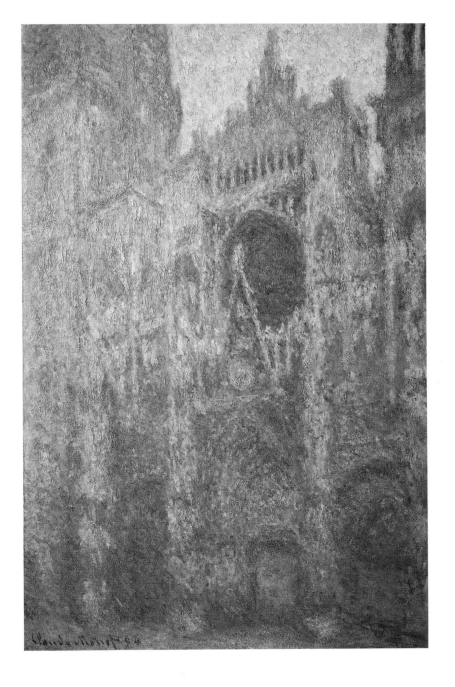

La Cathédrale de Rouen, le Portail
(Rouen Cathedral, West Facade). 1894

La Cathédrale de Rouen, le Portail (Effet du Matin)
(Rouen Cathedral, the Facade, Morning Effect). 1894

influence of light and atmosphere: "it lives according to its surroundings, by the air and light, which constantly change." This was the *motif* of each painting; but it was the whole series, the ensemble, that provided the context for the individual truths. Taken alone, each painting was less than when it was seen as a part of the whole: "they acquire their full value only by comparison and the sequence of the whole series."

That summer Monet started on another group of paintings based on a subject close to home, a magnificent row of poplars that lined the Epte a few kilometers upstream from his house. To reach his site he would make his way in a small boat up the Ru to where it joined the main stream, where his floating studio was moored. The poplars belonged to the commune of Limetz and were up for auction during the summer Monet was working from them. He was forced to buy them himself; when he had finished the new series he sold them back to the timber merchant who wanted them.

The poplars stood in a single file along the riverbank, which followed an S-curve at that point. There were three groups of paintings, one with seven trees, the nearest cut by the top of the canvas, the curving line of distant trees visible between them; another in which fewer trees, three or four only, are approached head on, their crowns out of the picture and their trunks and reflections making a portcullis of colored lines from top to bottom of the canvas; and the third, in which the perspective of trees on the curve of the river is allowed to expand into a generous arabesque. In this third group of paintings the poplars tower the full height of the canvas. The linear element, deriving from the slender, evenly spaced poles of the trees and their plumb reflections, is new to Monet's work, and its open airiness contrasts with the lumpish quality of the stacks.

At the end of the year Monet made a short visit to London. He was now on cordial terms with Whistler, whom he had known since the sixties. Whistler and Sargent, another old friend, introduced him to the artists and collectors in

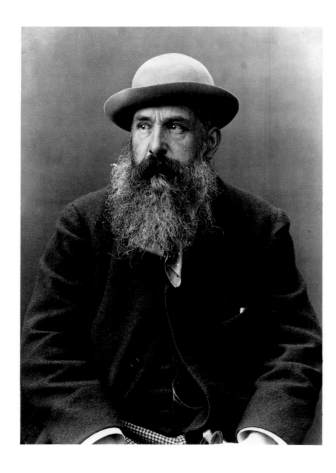

Portrait of Monet about 1900

London. For over a decade Monet had cherished the idea of working in London for a period of time, and it seems that this visit was made with the idea of planning an extended campaign. However, back in Giverny, for some reason he changed his mind. Instead of returning to London he went to Rouen and quickly found himself lodgings, and a painting room at a second-floor window in a shop directly opposite the great Gothic facade of the cathedral. Here he began to work on what was perhaps the strangest series he had yet undertaken.

By setting himself at a window he limited his viewpoint, not only in terms of what he could see out of the window but in the way his position restricted his view of his canvas. When the milliner from whom he had rented the room complained that his presence in the fitting room embarrassed his women customers, Monet constructed a screen that concealed him from the rest of the room. It must have been difficult to see the canvas at any distance over a few feet and impossible to see it and the *motif* together except at the range of his brush. Monet's years of experience on his floating studio would have prepared him for cramped conditions. But at Rouen they must have been extreme: the light on the canvas coming from a single source—the window—putting a fixed limit on the relationship between the canvas and the *motif.*

There is no clue why Monet should suddenly turn to architecture and this particular piece of architecture after a lifetime of landscape painting. National monument? Religious symbol? A demonstration of painterly detachment from all such considerations? The question may have had particular point during the nineties, when many intellectuals were turning toward Catholic mysticism and the anticlerical government was involved in a long-drawn-out controversy with the Vatican over the Church's property in France. The future of the cathedrals themselves was in doubt. As for Monet himself, there is no mystery about his beliefs. He had none.

The cathedral *Facades* gave him more than usual difficulty, and he gave up

Matinée sur la Seine
(Morning on the Seine). 1896

BELOW: Bras de Seine près de Giverny,
Brouillard *(The Seine at Giverny, Morning Mists).*
1897

The following description of Monet at work on his series of paintings Matinées sur la Seine *is from an article by Maurice Guillemot in* La Revue Illustrée, *published March 15, 1898:*
At daybreak, in August, three-thirty A.M.

His torso padded with a white woolen sweater, his feet shod in heavy hunting boots with thick soles impervious to dew, his head covered with a brown felt hat picturesquely dented, the brim down for protection from the sun, a cigarette in his mouth—a gleaming point of fire in the thickness of the large beard—he opens the gate, descends the steps, follows the path in the middle of his garden where the flowers stretch and awaken in the sunrise, crosses the road, deserted at this hour, passes between the barriers on the track of the little Gisors railroad, goes around the pond, marbled with water lilies, steps over the stream that ripples between the willows, enters the meadows all misty with fog, and reaches the river.

There are fourteen paintings, begun at the same time, almost a range of studies, depicting a single and unique subject whose effect is modified by the time, the sun, the clouds.

It is at the spot where the Epte merges with the Seine, amid small islands shaded by tall trees, some branches of the river forming what appear as peaceful and secluded lakes under the foliage, the mirrors of water reflecting the greenery, this is where Claude Monet has been working since last summer.

Fifteen of the Matinées *paintings were exhibited at the Galerie Georges Petit on June 1, 1898, and reviewed the following week in* Le Journal *by Gustave Geffroy:*
He looked at that spectacle in the morning mist, at sunrise, during the bright hours and the gray ones, at the golden hour of sunset. He became enamored of the nuances of that great passage of brightness, he followed them in the depths of the sky and water, he expressed them by the bluish darkenings and greenish and golden awakenings of the foliage. It is these landscapes that are here assembled, these dark forms, these distant ghosts, these mysterious evocations, these transparent mirrors.

Matinée sur la Seine *(Morning on the Seine)*. 1897

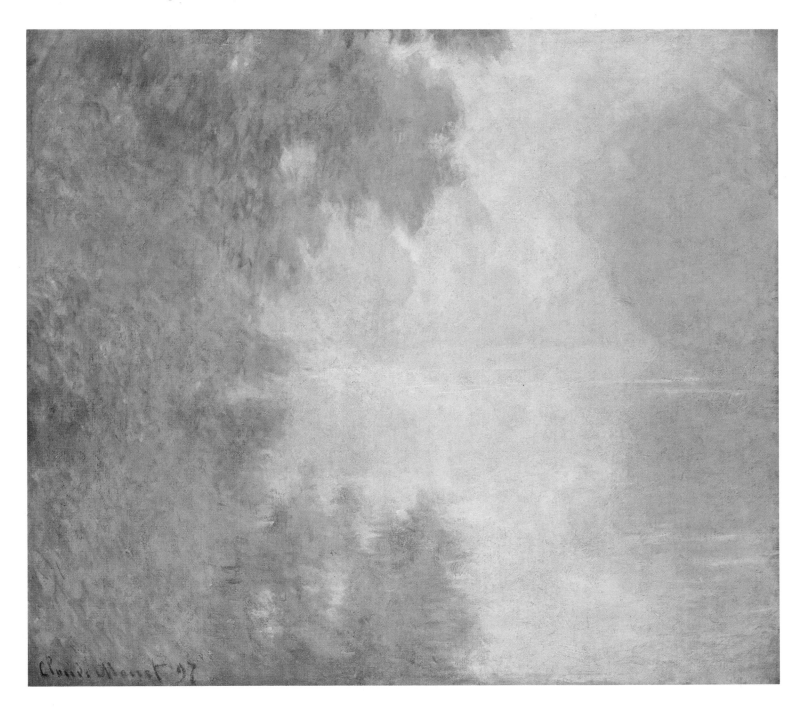

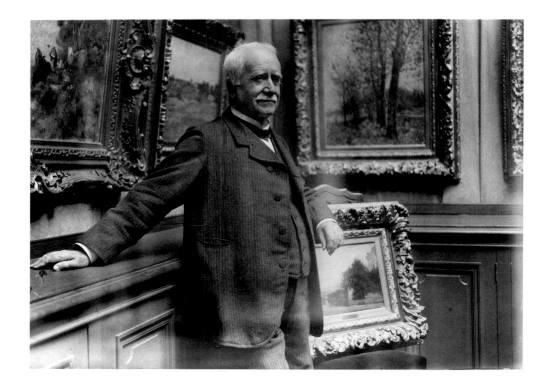

Portrait of Paul Durand-Ruel

after three months' work, not taking them up again until the following February. On his second visit he took a further room, a few doors to the right of the first one. "I can't achieve anything good," he wrote to Alice. "It is a stubborn crust of color…but it is not painting." He had to wait for the return to Giverny fully to understand what he had found in the paintings. The reworkings must have been tremendous.

The months between the two sessions in Rouen were busy. The two weddings took place. Work on his water garden had begun. It was not until the beginning of 1895 that he left home again, this time to visit Norway, where his stepson Jacques Hoschedé was married to a Norwegian woman and worked as a maritime agent.

As a painting campaign the journey to Norway is insignificant. Monet was feted in Christiania (now Oslo), where he was introduced to the Crown Prince of Sweden, and went to the theater. He worked for some weeks in an artists' colony in the village of Sandviken, where he astonished his hosts by his hardiness, working out of doors in the depths of the Norwegian winter.

He celebrated his return home by painting two studies of the newly built bridge over his pond, its reflection as yet unbroken by water lilies. There are few other paintings during the rest of the summer. Monet was preoccupied with Suzanne's illness.

Twenty of the cathedral *Facades* were shown at Durand-Ruel's in May 1895. They sold rapidly at the extremely high price of 15,000 francs each, a figure Monet had insisted on, much against Durand-Ruel's wishes. Among the many notices, one in particular had a prophetic importance. This was a long article in *La Justice* by its proprietor, Georges Clemenceau, an intimate friend of

ÉDOUARD VUILLARD.
Messieurs Josse Bernheim-Jeune (seated) and
Gaston Bernheim de Villers (in their office, Rue
Richepance, Paris). 1912

Geffroy's. Clemenceau's political fortunes were at a low ebb, and for the
time being he was more active as a journalist. In his article, "Révolution de
Cathédrales," Clemenceau took the series as a kind of hymn to material exis-
tence. More than any other writer had yet done he saw them as celebrations of
immediate experience. The significance of the cathedral was as a fixed point
against which the painter could register change, the continual unfolding of light
in time. Clemenceau insisted on reading the series as if it described a contin-
uous temporal event. He divided the paintings into groups to correspond with
his idea of their sequential meaning. He saw the program of the series as
analytical: ideally there should have been not twenty canvases but a hundred,
each one registering a moment. From this point of view the completeness of
the series was cardinal. Prophetically, Clemenceau called on the state to buy
and preserve the whole series. A quarter of a century later he was to inspire
and supervise such a transaction.

In February 1896 Monet went back to his old hunting grounds on the
Normandy coast between Dieppe and Pourville. It had been fourteen years
since he had last worked there, and he was delighted to rediscover his old sub-
jects. But his movements were more circumscribed than earlier. The weather
was terrible, with rain and a persistent northerly wind. He worked in a bathing
hut on the beach, and started several groups of paintings on the cliff tops,
meanwhile complaining to Alice of his timidity and indecision. He cannot
muster the courage, he tells her, to work on five or six canvases a day; he can
only face two or three. He left off when the grass became too green from the
persistent rain, deciding to come back the following spring.

During the summer he started an important new series from his floating

OPPOSITE, ABOVE: Waterloo Bridge. 1900

OPPOSITE, BELOW: Waterloo Bridge, le Soleil dans le Brouillard *(Waterloo Bridge, Sun in the Fog)*. 1903

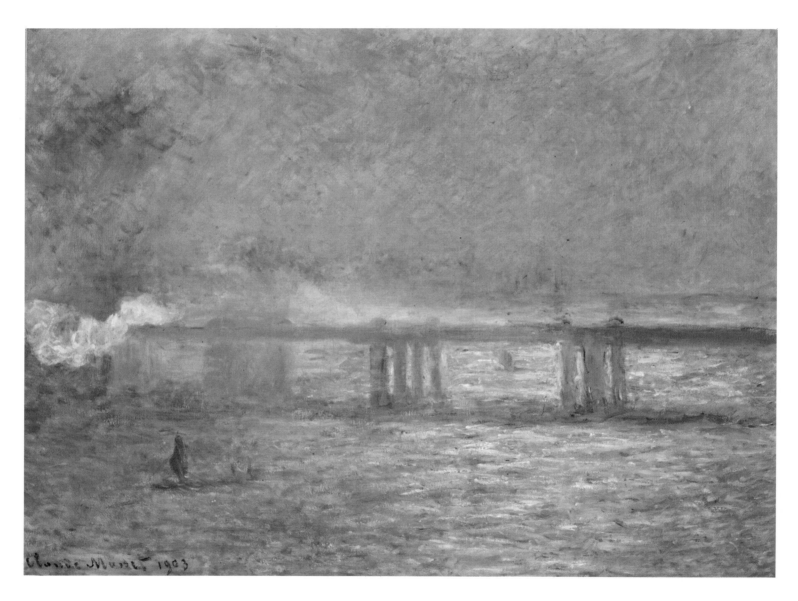

Charing Cross Bridge. 1903

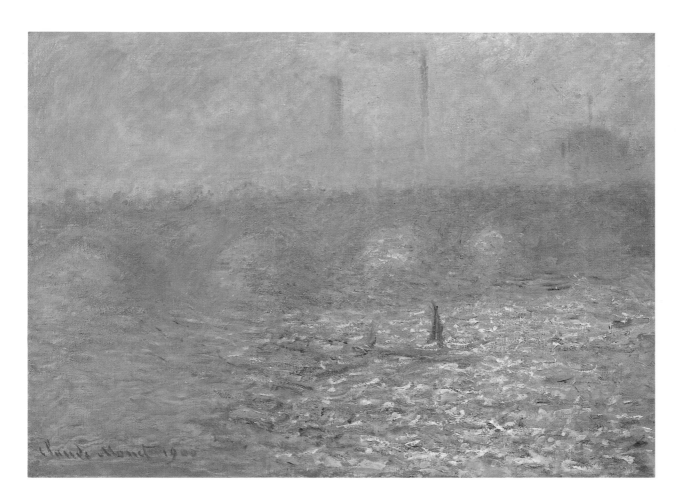

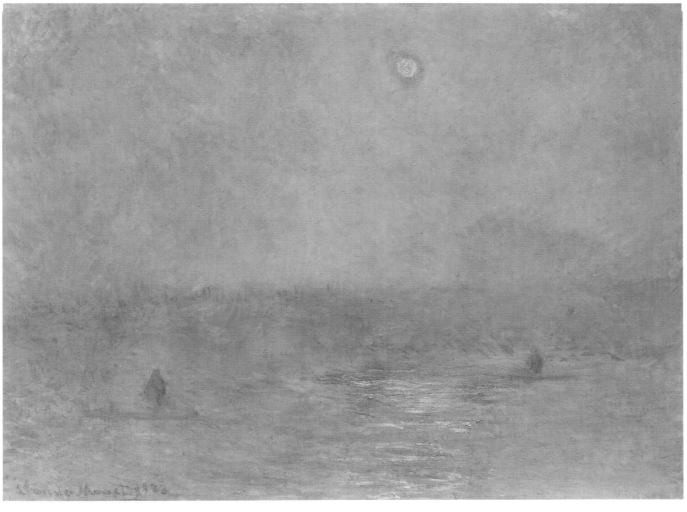

183

studio, the *Matinées, sur la Seine.* These too were put aside at the end of the season to be taken up again the following year.

The garden and above all the pond were claiming more and more of Monet's attention. His first series of the Japanese bridge was started in 1899.

That autumn he finally embarked on his long-cherished plan to paint the Thames, and this was his last major campaign away from home. He made a preliminary excursion, staying at the Savoy Hotel overlooking the river. He also found a painting site at Saint Thomas's Hospital from which he could see the north bank of the river with the Houses of Parliament. He was back the following spring, when he was visited by Clemenceau and Geffroy, and again in the spring of 1901. At one time he had as many as a hundred canvases in progress at the same time, and, reminiscing about it ruefully twenty years later Monet admitted the absurdity of having to search through them for the one that most closely resembled the effect of the minute. In wintertime London he would have been faced with more than a gentle envelope but with a blanket of fog, a shifting mantle of water vapor and smoke of a density unparalleled anywhere else in the world. The slightest breath of wind over the river would modify the fog in a matter of seconds, filtering or blotting out the light, changing its quality from a warm refractive haze to a dense green-brown blanket. The variables were more extreme than anything he had worked with before. The series was eagerly awaited by Durand-Ruel, who pressed him continually for pictures. Monet insisted that the series had to be completed as a whole, and when the paintings were finally shown in 1904 he had been working on them for over four years, much of the time in the studio at Giverny.

Monet made an interesting statement in connection with these paintings. The question of pleinairism was much discussed among English painters. In their eyes Monet stood for an extreme position. Irritated by tactless questions that Durand-Ruel had passed on, Monet wrote that one of these painters had indeed supplied him with a photograph of the Houses of Parliament, although it had not been of any use to him. "But that doesn't mean much, and whether my cathedrals, my Londons, and other canvases are done from nature or not is nobody's business and has no importance. I know so many painters who paint from nature and do nothing but awful things.... The result is what counts."

Monet's last working session away from home was in Venice in 1908. He took Alice with him for a much-needed rest. Both of them had been ill, and he had become aware of failing eyesight. He made numerous starts in Venice that he later reworked at home. Alice died in 1911. The Venice canvases were shown at the Bernheim-Jeune gallery the following year. Monet had fourteen years left to him.

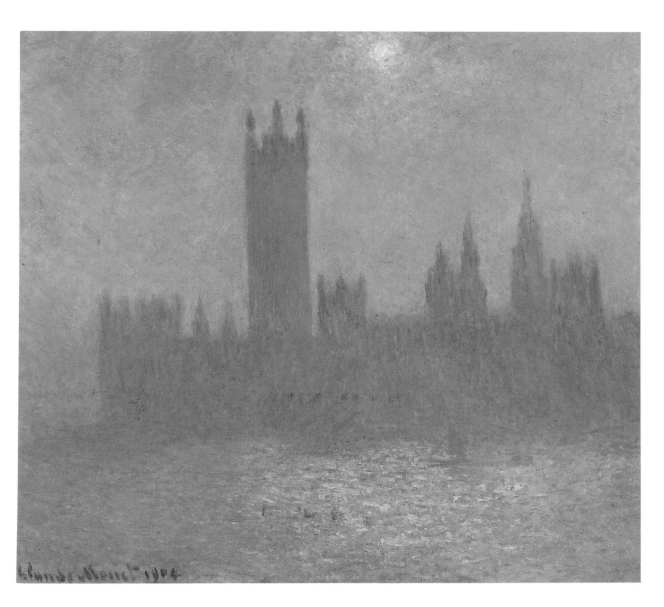

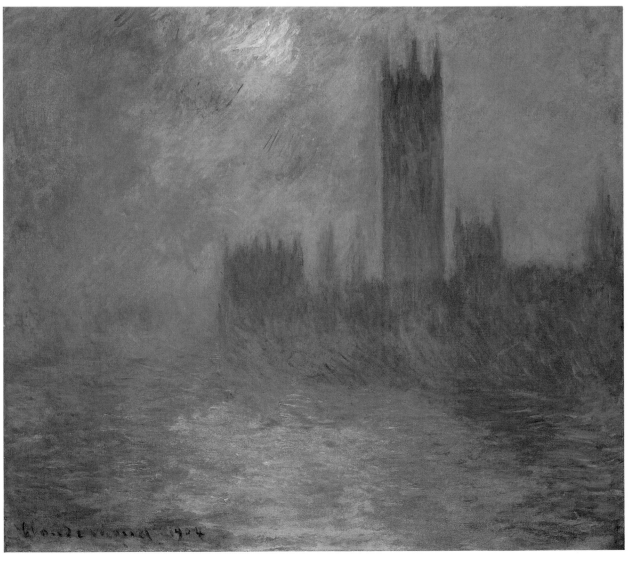

For his London paintings, Monet chose as his subjects Charing Cross and Waterloo bridges and the Houses of Parliament. All were painted from an elevated perspective and from a protected vantage. The views of the bridges were seen from room 504 at the Savoy Hotel; Parliament was painted from a room to which he was given access at Saint Thomas's Hospital across the Thames. One other site, a club mentioned in his letters home, served for three views of the city painted at night.

Despite Monet's protected vantage, the difficulties of working directly from nature asserted themselves, and in the following letters to his wife, Alice, at home in Giverny, he recounts his travails:
Today the weather was hellish, snow flurries, then sun, fog, and dark and clear weather. It was magnificent but really too unsettled, it is so difficult not to let oneself be induced to transform one's canvas, and it's no sooner begun when—boom!—it's something else, and often I feel sorry, finally there's no question one has to win, and if I were to have only a few canvases I like, five or six, I'd be satisfied. The only thing I'm afraid of is the weather, which looks bad, the barometer is dropping sharply.

Sunday, February 17, 1901

I will write you more tonight after the day is over because I'm working hard and it's going better today, gray foggy weather without sunshine.

2 P.M., February 18, 1901

The fog is back and I've stayed at my post still thinking that it might clear up, not daring to start writing, and the whole day kept changing, picking up one canvas then another, to put them back a moment later. In the end it was enough to drive you crazy, no longer knowing exactly what I was doing, even this evening at the hospital the weather was not good. Well, a real spell of bad luck because yesterday I had just settled down when the snow came to the point where I was covered with it and you could no longer see anything it was coming down so much. Now it's been at least a week without sun and for sure if it comes back I won't be able to go on well with the canvases, it's upsetting and still it feels like I'm on a better road and in any case I'm not losing courage, quite the opposite.

Friday, February 22, 1901

I worked hard today, there was some sun but so many changes, so many transformations, I was supposed to start painting tonight at the club but I'm so tired, especially my feet and legs after standing up all day.

February 28, 1901

While painting the London series Monet was confronted with the problem of integrating individual canvases into an ensemble. The photograph opposite shows at least four of the series in his studio, clearly in various stages of completion—evidence of the efforts about which he wrote to Paul Durand-Ruel on March 23, 1903:
No, I am not in London, except in thought, working hard on my canvases which are giving me a lot of trouble....I cannot send you a single London canvas because it is essential that I have them all before me, and to tell the truth I haven't completely finished a single one so far. I'm bringing them all along at the same time, or at least some of them, and don't yet know how many I could show, because what I'm doing is extremely delicate. One day I'm satisfied and the next day everything seems bad.

In an interview with Maurice Kahn published in Le Temps *on June 7, 1904, just after the closing of the exhibition of London paintings at the Galerie Durand-Ruel, Paris, Monet further revealed his frustrations working up this series:*
I had a hell of a lot of trouble. I spoiled more than a hundred canvases. It kept changing all the time. And I wouldn't find the same landscape from one day to the next. What a blasted country! After four years of work and retouching on the spot, I had to resign myself to taking only notes and finishing the work here in the studio.

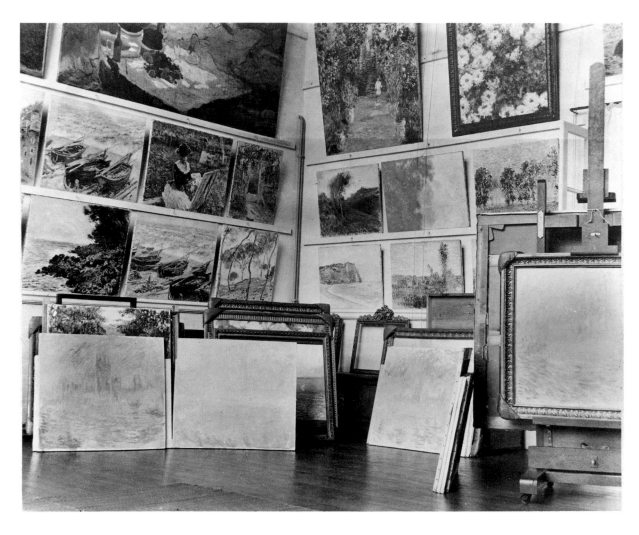

Monet's studio, at the time of his painting the London series

Following is an excerpt from the catalogue of the Galerie Durand-Ruel exhibition "Vues de la Tamise à Londres" held from May 9 to June 4, 1904:
This exhibition consists of exactly thirty-seven canvases, all brought from London. A single theme in these canvases, single and yet different: the Thames. Smoke and fog; forms, architectural masses, perspectives, a whole deaf and rumbling city in the fog, fog itself; the struggle of light and all the phases of that struggle; the sun prisoner of the mists, or piercing, in decomposed rays, the colored, radiant, swarming depths of the atmosphere; the multiple drama, endlessly changing and subtly varied, somber or enchanting, agonizing, delightful, florid, tremendous, of reflections on the waters of the Thames.

When the series of London paintings was seen complete at the Galerie Durand-Ruel in 1904, the critic Furetières was struck by its decorative unity; in a review published in the newspaper Soleil *on May 10, 1904, he remarked:*
It is M. Camille Mauclair who said that Monet was a symphonist and a decorator. Both judgments are true. M. Monet, with his qualities, would marvelously cover large walls. How come—he is sixty-four years old—he has never been commissioned to paint a decorative work? Would not the purpose of the present

exhibition be to call attention once again to the great landscapist who, having achieved success, is waiting only for the honors bestowed by the administration of the Beaux-Arts?

The idea had currency; it had been expressed by Clemenceau in his review of the cathedrals, and again by the critic André Michel. But the theme around which the decoration would be developed had already been announced by the critic Maurice Guillemot in his article in La Revue Illustrée *on March 15, 1898:*
The oasis [the water-lily garden] is charming, with all those subjects that he wanted: for they are subjects for a decoration the studies for which he has already started, large panels that he will show me later in his studio.

Octave Mirbeau wrote the introduction to the catalogue for the Venice painting exhibition at the Galerie Bernheim-Jeune, Paris, from May 28 to June 8, 1912. This is a passage:

The light arranges and reveals the objects. It is more solid and massive on the canals. The reflections pile up. One would say that the water and light gain support and strength on the facades....The reflection of the palaces is warm in the dense water. When the sun is high, the atmosphere applies itself and sumptuously gives body to the vertical surface of the walls and the horizontal surface of the water; it is mixed with the color as though it had passed through the rose of a stained-glass window.

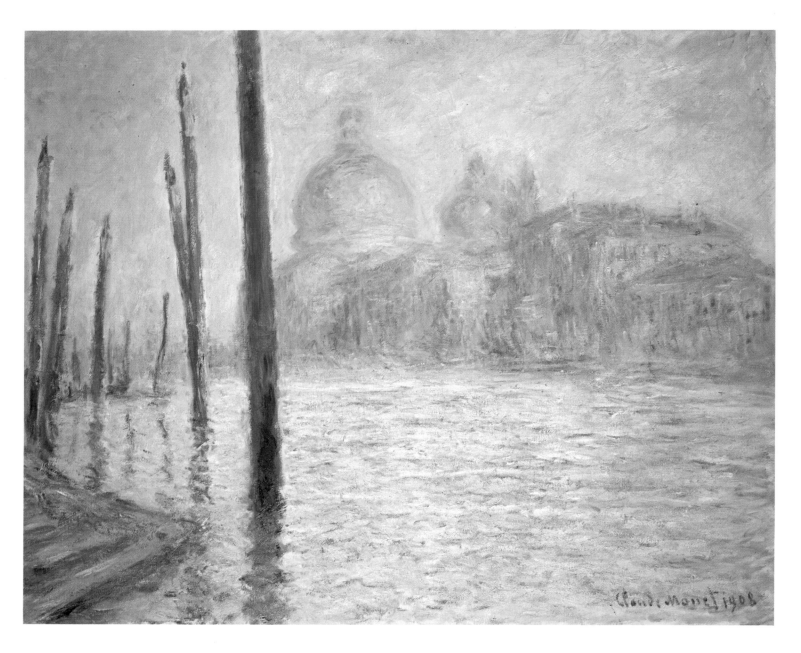

Le Grand Canal *(The Grand Canal, Venice).* 1908

OPPOSITE, ABOVE: Le Palais Contarini *(Palazzo Contarini, Venice).* 1908

OPPOSITE, BELOW: Le Palais Contarini *(Palazzo Contarini, Venice).* 1908

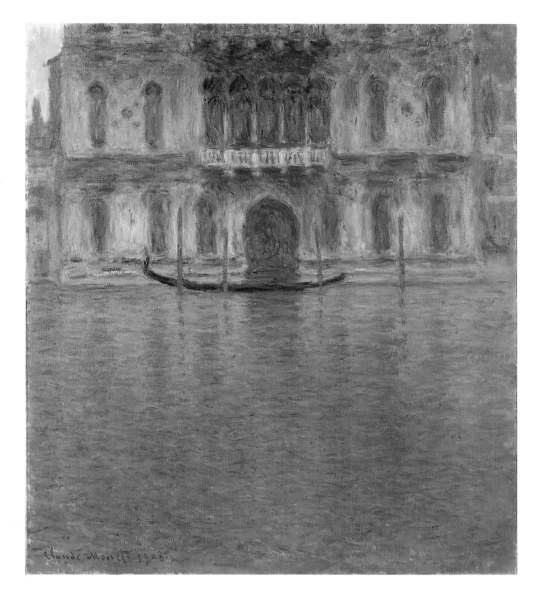

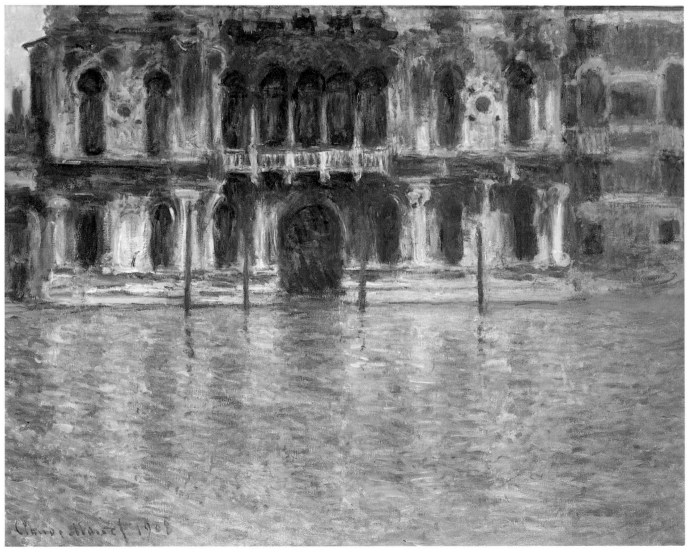

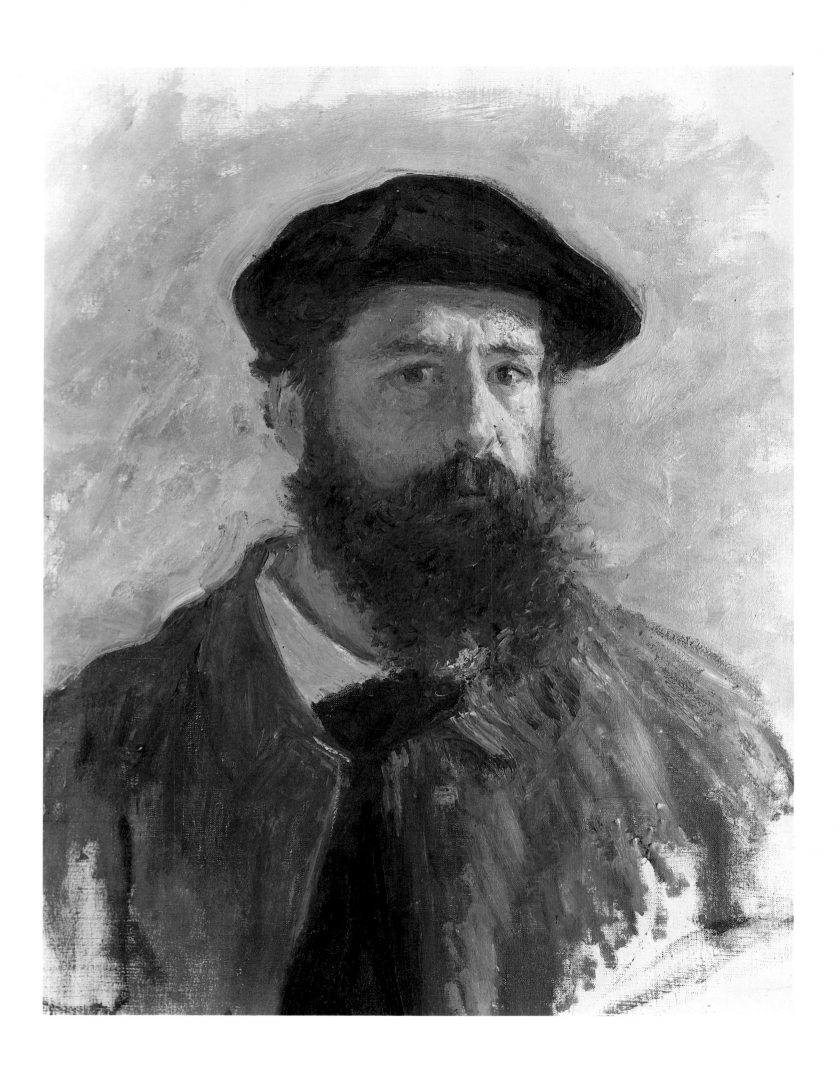

There is something contradictory about Monet's increasing insistence on the instant on one hand and his increasingly long-drawn-out and labored procedure on the other. On the face of it there would seem to be an inevitable connection between a short-lived *motif* and a rapid and spontaneous style.

Monet's pure Impressionist study of the seventies is incomprehensible except in the field of his "present" space. A painting like *Effet de Neige au Soleil Couchant* is directed from his viewpoint, from the here and now of his observation and brushing. To unravel its meaning is in a sense to enter into its making. The layering of crisp brushstrokes is sequential, each accent a note in time, the painter's present, to be read by a kind of archaeology. Over the roof of the building on the left there is a certain tightening of the fabric of the paint, a more emphatic direction in the drawing of the trees, a more incisive contrast in the black and sienna twigs against the creamy, lemony sky. The setting sun will leave the smoke still rising in the cold air, the snow glimmering; this warm suffusion will last only a few minutes longer. We can clearly read the spurring of Monet's attention at that point, his dash. That area between the twigs and the sky becomes like a knot into which all the open lines of the painting are quickly tied. It is an incisive moment.

What had broken Monet's belief in the connection between swift *motif* and swift execution, undermining his confidence in things that came in "one stroke"? Not, certainly, the kind of conviction that had driven Cézanne to work more and more slowly from observation. Cézanne's ambition had been to appropriate his sensations to structures derived from the art of the museums. The fleeting moment was of no interest to him, and his paintings never tell us about a segment of time. With Monet the fleeting moment is everything, and yet he arrives at a point where he is no longer trying to capture that fleeting moment so much as meditating on its passage: anticipating it, remembering it, contemplating its embodiment in a dense color structure.

In a sense his art had always been about time. His rejection of the art of the museums in favor of working out-of-doors was a polemical declaration and an argument about time: on an ideological level for the *now* of modern life against the motionless *then* of the museums, and on a practical and psychological level for the simultaneity of *motif* and painting act and against the layered reflective judgment implied by working in the studio. As he grew older he turned increasingly to "timeless" subjects—or rather to the time of the day and the time of the seasons, eschewing man's time. He was in his middle years: the present had become irradiated by memory, less intractably unique, less raw.

Autoportrait de Claude Monet Coiffé d'un Béret
(Self-Portrait of the Artist Wearing a Beret).
1886

And this revision of time informs the experiments in composition that proceed from Vétheuil onward. The familiar rhythms of perspective are broken up. The line of a cliff splits a picture diagonally from corner to corner, or the distant sea lines up with cliff tops miles nearer, and there is nowhere for the viewer to stand. Every aspect of the later paintings, the rhythm of the brushstrokes no less than the way the forms are disposed or the color structured, evokes more and more richly the wandering, scanning movements of an eye looking for looking's sake. It is a kind of anticomposition.

Traditional Western composition stresses self-contained wholeness in the pictorial structure itself, which, through its rhythmical ordering of forms and its concentration on certain central points of focus, seems to speak, like an ideal anatomy, to the viewer's own. Monet turns his back on all this. Vision precedes and preempts body sense. A new kind of wholeness is based on the omnipotent inclusiveness of the eye by which every surface is swept up—background, foreground, field—into a matrix of color. The model of the sea takes over.

Monet is fascinated by subjects that are ragged and disheveled, not so much so that he can whip them into shape as because they can become for him the instruments of oceanic spread. The melting ice on the flood, the creepers and vines of the Vallée de Sasso, a curtain of flickering leaves on the banks of the Epte have this in common: they have no apparent linear structure. They become the instruments for reflection on the movements of the eye and its search for structure. Two paintings are extreme examples. One is *Torrent de la Petite Creuse à Fresselines,* painted as if Monet was looking straight down into the stream. The canvas is filled with rushing water. There is no escape for the eye. The top of the canvas is closed off with rocks and shapeless herbiage. The other painting, *Les Quatre Arbres,* is divided into nearly equal sections by the poles of the tree trunks. The river is mirror-still, and the poles and their reflections cross the canvas from top to bottom. It is like a section from a possibly endless frieze. The ancient connection between the picture and the ideal visual cone—a connection that Monet had earlier asserted with unprecedented directness—has been dissolved. In his pictures now there will be few invitations to enter and to explore in a pointed, directional way; instead the pictures will seem to face us all at once, reciprocating our looking and our ways of looking.

Nowhere is this more so than with the pictures of Rouen Cathedral. The towers and buttresses bleed out of the edges of the picture, denying purchase to the facade as a shape seen at a distance. "Stubborn crusts of color" indeed. "Not enough sky around, not enough ground," one critic complained when

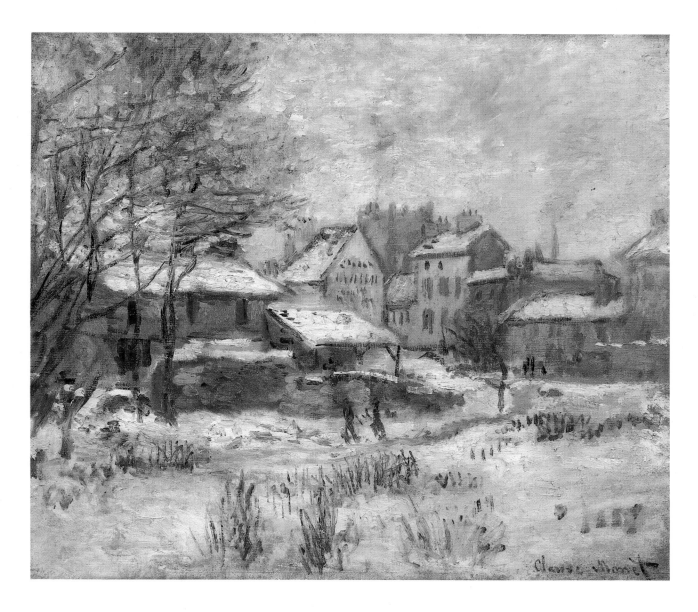

Effet de Neige au Soleil Couchant (Argenteuil
sous la Neige)
*(Snow Effect at Sunset [Argenteuil under the
Snow]).* 1875

they were first seen. The young Signac noted, "I fully understand what these
cathedrals are: marvelously executed walls." And yet the craggy fabric of those
walls, made up of rose and blue, of lilac and gold, is smelted out from the
light and atmosphere no less than from the stone—from the appearance of a
cathedral perceived *at a distance,* for all its immediate towering closeness on
the canvas. Somehow the facade and everything between it and Monet's eye
are rendered one.

Monet's time is always present: he never surrenders it. In the later paintings
his time is no longer a matter of high-speed observation and notation, for now
the present of the picture is in front of us, with its immediate invitation to our
looking. The *motif* emerges as a structure, which is the whole canvas, dense,
painted to a great depth in extraordinary chords of color, a totally materialized
equivalent for that fleeting contact of the eye with light. The passage of time
is revealed as formative, against the flicker of the present.

What emerges from the great series is a deeply convincing sense of the
continuous nature of experience in contrast to the shifting, transparent nature
of the world immediately observed. Each individual canvas, with the unique
observation that it contains and its special order of harmony, symbolizes the
ordering power the mind has within perception. It is as though in these later
works Monet had seen a way of including in his painting not just the data of
perception but the terms on which we build those data into our lives and make
them valuable. If the earlier paintings work from the position of a mid-century
materialism, the later ones seem to include in their formation something of
Henri Bergson's sense of time as duration and of his insistence on memory,
which "by allowing us to grasp in a single intuition multiple moments of

duration…frees us from the movement of the flow of things, that is to say, from the rhythm of necessity."

When the series finally appears as a fully acknowledged program it is a major innovation. We may see it growing out of Monet's practice of painting alternative versions, but pointing toward the future and toward a way of thinking that is characteristic of modern art. Monet did not have cinematography as a model, nor the sequential demonstrations of formal alternatives that were to be so important to the pioneers of abstract art. We need to remind ourselves that there were other ways of thinking about repetition: as a trial step on the way to the definitive picture, and also as a duplicate of the final picture. Courbet used to say that any painter worth his salt could paint a replica of any of his pictures, and Van Gogh would surely have agreed with him. It is Cézannism and the concept of each picture as a unique and unrepeatable accumulation that cuts us off from this view.

If the philosophy of plein-air sketching puts unprecedented emphasis on firsthand experience, it also gives encouragement to the idea that the *motif* is inexhaustible. It is not variety and inspiration in the *motif* that the painter is searching for, but variety and inspiration in his sensations in front of it. Meanwhile, a convenient site for the easel, easily reached and out of the wind, is worth a lot. Even in Monet's most adventurous moods on the slippery rocks at Étretat, the matter of shelter was a concern, qualifying and sometimes determining his choice of viewpoint. These limitations are welcomed, and in his final years, when the garden and the pond become surrogates for the whole world, insisted on.

At a certain moment Monet sees his array of versions in a new light. He sees the series as a form. This is quite a different matter from the banality he offered Trévise: "another canvas! Another!" Various factors must have brought this qualitative change home to Monet. One was surely the example of the Japanese, in particular works like Hokusai's *One Hundred Views of Mount Fuji,* in which many images circle around a constant form and the work itself is the sum of all these images. Another must have been Monet's gradual elaboration of his own legend. Both Geffroy in 1888 and Mirbeau the following year had pointed out that his repeated studies, each dealing with a different moment ("Almost as many studies as there are hours in the day," in Mirbeau's words), grouped themselves into a total statement. And it must surely have been the case that when Monet first saw his versions of the Creuse or the stacks exhibited as a continuous group he was able to see them in a new light. To see them singly or in small groups might be to see each painting as a summary of a particular moment, a condition of light and season. But en masse that

Torrent de la Petite Creuse à Fresselines
(Rapids on the Petite Creuse at Fresselines). 1889

reading would surely give way to a larger effect, an envelopment without beginning or end in which time is not so much depicted within the sequence of discrete moments strung together as experienced through a form; a time that includes memory, generated by repetition, analogous to architecture or to the beating out of music.

For there is a difference between alternative readings of a subject and the extended series as Monet finally developed it. If the first is like practicing a song, the second is more like an incantation.

The *motifs* that make up nearly all the series from the *Meules* to the Thames bridges have in common an element of frontal symmetry. Both the cathedral facades and the stacks, however different in other respects, are roughly symmetrical forms and impose their symmetry on the canvas. Reflections play an important part, enhancing symmetry, making it persuasive even within veils of mist, as in the *Matinées* or even within the receding perspectives of lilies, as in the series of the Japanese bridge. Repeated, such *motifs* take on the quality of strong beats.

Repetition asserts similarity but also lays the ground for finer discriminations. It is a two-way transaction. The Rouen facade endures from picture to picture, from effect to effect, but its very constancy is the ground against which these effects make their finer registrations of nuance and value. Repetition is something like a net or grid, any part of which gives a clue to potential extension in any direction but at the same time sets the stage for fine inflection. To move back and forth between one painting in a series and another is to become more finely attuned to each nuance and to be carried, as if in reverie, from one state to another.

With the series conceived as a whole, the matter of hanging takes on an inescapable importance. The total effect becomes distinct in the viewer's mind from the sum of the individual readings of each picture and introduces a different spatiality from that of each picture taken alone. We can recapture a whiff of this tension between the whole series and its parts whenever we see just a few examples reassembled, as with the five *Facades* in the Jeu de Paume of the Louvre, or in various exhibitions. It is easy to imagine the intensity of Monet's travail when he was beginning to make them, tormented by his attachment to the effect of the minute, his lifeline to truth, and having to grapple with unforeseen imperatives of that truth when he saw all the canvases spread out in his studio. It is notable that from the *Meules* to the *Poplars* to the *Facades* each picture in the series becomes more and more similar in its composition. The series is consolidated as a series, surely a consequence of having understood the series better from having seen it hung. No wonder

Monet defended himself so vigorously against Durand-Ruel's demands for individual pictures. The issue of whether they were finished or not now extended to the group as a whole and was by no means to be settled in terms of individual canvases.

It would have been a short step from the series to the idea of something extended beyond the limits of easel painting, a decorative ensemble. As early as 1898 there is a signal that Monet is thinking in this direction.

Once he has begun to entertain this idea, Monet's *motifs* are centered on the garden. London and Venice are the exceptions—famous views of famous places as obviously pictorial as they are public—but everything else he paints now is private and nameless, far from memorable, scarcely recognizable. The lily pond, with its surrounding of tangled foliage and its simultaneously interpenetrating depths and reflections, was not so much a place as a medium for the construction of a place. It was like raw material, returning the onlooker to reverie and a streaming inwardness, the opposite of an experience of recognition focused on some feature out there in the world.

There is another aspect of the relationship between the garden and the decorative project: it was not *any* garden but *his* garden. It was a deliberately devised environment he had worked on for years and was to continue to refine and elaborate until his death. With the garden he takes into his own hands those reciprocal transactions between his subject and the canvas that had shaped his art all his life. With the garden the landscape painter was able to exercise something of the omnipotence of the painter in his studio, planting wisteria, trimming the rafts of lilies, redrawing the edges of the pond as if adjusting the objects on a tabletop, reordering a drape, or changing a pose. Marcel Proust got the point even though he had never seen Monet's garden. Writing about it in *Le Figaro* he speculated that it was "less a flower garden than a color garden" in which flowers were planted as if a palette were being laid out, where the painter-gardener had "dematerialized" everything except color. The garden, in Proust's imagination, was a "transposition of art more than a model for a picture."

Perhaps the nearest parallel to what Monet was doing is to be found in Whistler's aesthetic experiments, and it is significant that Proust mentions Whistler's "Ten O'Clock" lecture in his article. But Monet's move toward decoration did not pull him away from his lifelong pact with what he saw. This is the paradox and mystery of the last work.

His painting had freed him from normal ties. He could look at anything. His "discovery" of light as the universal condition of seeing gave him a kind of omnipotence. That everything could be transmuted into color was like

Les Quatre Arbres *(Poplars)*. 1891

an alchemist's dream realized. And that the source of this power was his dis-
passionate, observing eye—the organ that spans distance, that takes in
whatever it lights on, that carries the instant in its glance—gave a freedom and
a power to his position that no earlier painter had ever enjoyed. In the best of
his painting there is a sense of access to the world. He is on good terms with
the particular portion he is painting, and he allows that portion as an aspect of
something much larger. His vision is commanding, yet he does not stamp it
with a flavor, his own atmosphere. His command is exercised through the
perceptual functions that his painting transcribes and symbolizes.

When we reflect on the vast range of his activity—the places he painted, out-
of-doors, in all weather, from pavements, riverbanks, windows, boats, from
Honfleur to Venice, Antibes to Norway, Hyde Park to the Gare Saint-Lazare, his
lights, seasons, bricks, rocks, flowers, girders, clouds, smokes, waves, meadows,
mountains, rivers, canals, trees, bridges—it seems that there is something
imperial about his consuming appetite and energy. All this was within his
power, the power of his eye. All this paid its contribution to his power: he
commanded it and fed off it. When finally, with his own property, he was able
to really create a garden, plant trees, dig a pond, deflect a river, it seems but an
extension of his extraordinary power—an extension which was not just to paint
further views but to create a place through the total command of his painting.

197

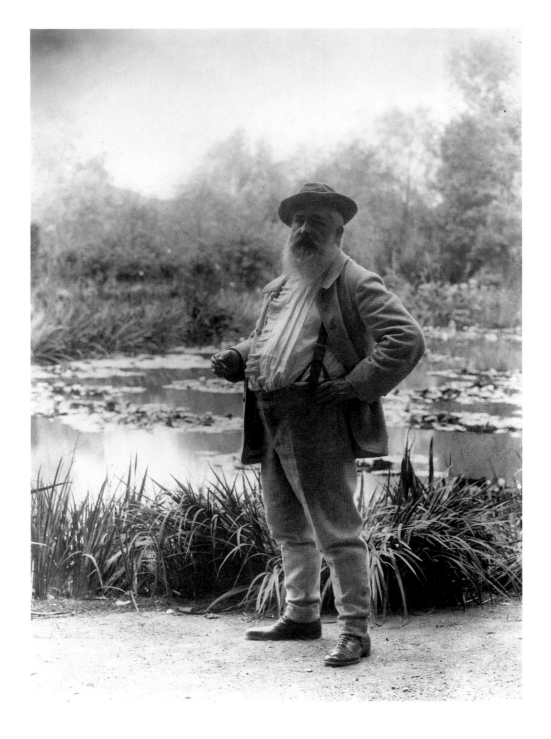

Monet beside the water-lily pond. c. 1904

"What I need most of all are flowers, always, always." So Trévise reported Monet saying as the eighty-year-old enthusiast led him around the nasturtium-strewn paths of his domain.

The first garden Monet had to call his own had been in Argenteuil, where Camille was painted among flowers and both Renoir and Manet had commemorated their friend at work, either at his easel or trowel in hand. Several of Monet's friends were ardent gardeners too. The painter Gustave Caillebotte, with whom he was close during the seventies, was something of an expert and helped him with advice. And more besides: a minor but highly original artist, Caillebotte undoubtedly influenced Monet in his treatment of flowers. Caillebotte planned a decoration for his own dining room, a suite of canvases of nothing but flowers, like vertical flowerbeds. Later this conception may well have played a part in the genesis of Monet's water-lily project. Another gardener friend was Mirbeau, and when the time came for Monet to have his own staff of gardeners their head was to be recruited from Mirbeau's estate.

Monet's operations at Giverny had started as soon as he had arrived. Not long after he had bought the property he had acquired another plot in the village, where he grew vegetables for his table. The main garden was given over entirely to flowers. With money to spend he now hired gardeners, built greenhouses, and embarked on an elaborate program of planting and propagation. He took advice from professionals and subscribed to gardening magazines and encyclopedias. In time rare plants and shrubs were to be imported from all over the world.

The garden lay on a gentle slope facing the valley of the Seine to the south. It was warm and sunny, but the chalk subsoil was near the surface and the beds needed much attention. It was a classical French country garden, laid out geometrically with a wide graveled walk, arched with rose pergolas, as its main axis. Flowerbeds lay in straight rows either parallel to it or at right angles, densely planted with a wide range of annuals and perennials so that there were continuous displays of carefully orchestrated color from spring to autumn. Visitors made the comparison with a painter's palette. Monet toured the garden several times a day.

In 1893 he had expanded his operations, buying a tract of land beyond the railway line and directly opposite the existing garden. The new land included a pond, watered by the Ru. When he bought it, it had wild arrowhead and water lilies. New hybrid strains of water lilies were being developed by the French horticulturist Maurice Toulouse-Marliac and were much discussed in the gardening literature, lilies that combined the hardiness of the plain yellow and white wild varieties with the pinks, reds, and strange lilacs of the exotics.

A celebrity by the turn of the century, Monet was described by Wynford Dewhurst in an article titled "A Great French Landscapist Claude Monet," published in the English magazine The Artist:

Monet is, perhaps, seen at his best, and certainly in his most genial mood, when, cigar in full blast, he strolls around his "propriété" at Giverny, discussing the mysteries of propagation, grafts and colour schemes, with his small army of blue-bloused, sabotted gardeners.

He is now fifty-six years of age, in the fulness of his powers, active and dauntless as ever. Each line of his sturdy figure and determined feature, and the glint of his keen blue eyes, betoken the grit within. He is of those men who would succeed in any line of life, and despite all—strong man, strong painter. Dressed in soft khaki felt hat, khaki jacket, lavender-coloured silk shirt, open at the neck and frilled as to cuff and front, leathern belt, wide drab pantaloons tapering to the ankle, and there secured by shiny horn buttons, "à la coster"; a stout pair of untanned cowhide boots, and heavy cane, completes a most comfortable and practical, albeit somewhat dandyish "get-up."

Camille dans le Jardin de la Maison d'Argenteuil
(Camille in the Garden of the House at Argenteuil). 1876

Le Jardin de Monet à Argenteuil *(Monet's
Garden at Argenteuil)*. 1873

200

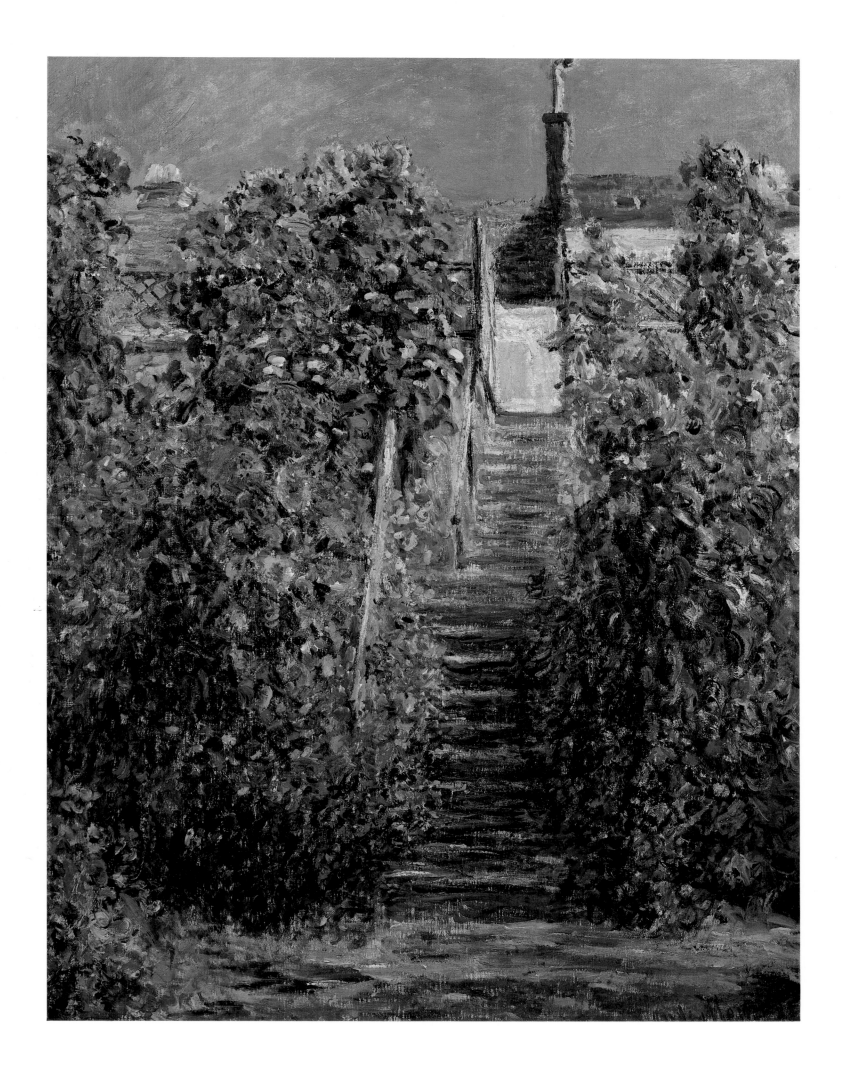

During the years at Argenteuil, Monet was in particularly close and cordial contact with his fellow painters. The first group exhibition of the Impressionists was in 1874, the second in 1876. It was a short period when much was to be gained by cooperative effort, and rivalries and defections had not yet divided the group. Renoir and Sisley both visited Argenteuil and worked with Monet, sometimes sharing the same motif. Renoir became very close to Camille Monet, whom he painted on several occasions. In 1874 Manet spent the summer nearby at Gennevilliers where his family had property. He followed the example of Monet and Renoir, painting in the open air and adopting an Impressionist palette. Another painter to join the group at this point was Gustave Caillebotte, whom Monet first met in 1873. Caillebotte not only collected his friends' work and involved himself in the organization of the group exhibitions, but was able to help Monet with his avocations, gardening and boating, in both of which he was expert.

Undoubtedly part of the attraction the pond had for Monet came from his admiration for things Japanese. Only a few days before making his purchase he had visited an outstanding collection of prints by Utamaro and Hiroshige at Durand-Ruel's, prints of the kind he himself had been collecting for years. The bridge he had built over his pond was of exactly the shape and construction he knew from his prints. In 1901 he was able to buy more land, nearly four thousand square meters, and immediately began to plan an enlargement of the pond. This was a fairly complicated procedure, involving excavation and construction of new sluices, besides the diversion of the Ru from its existing course. Monet's application to the commune of Giverny for permission to do this work met with local opposition: the farmers and laundresses who used the stream believed that Monet's tampering would cut off the supply of water and that his exotic plants might poison the cattle that drank downstream. The authorization that was finally issued was precise in its terms, specifying the width and depth of the new channel, the type of sluice, and the right to forbid all activity if things did not go according to plan. Robert Gordon, the first historian of all this, tells us that "to minimize the concern of the local farmers and washerwomen, Monet stealthily allowed the Ru to flow into its new bed late one summer evening, ensuring that the stream would be clear of all traces of mud and sediment the following morning."

The new pond was more than four times larger than the original one. The bridge now spanned its near tip, the main body of water stretching eastward from it. The displacement of the Ru had left an area of land between it and the pond of approximately the same size as the pond itself, and this was now planted with varieties of bamboo, Japanese apple, and flowering cherry. Cartloads of peat were brought in for rhododendron. Excavation left behind a tiny islet in the pond. A further novelty, later removed, was a basin of concrete of about five meters' diameter that was sunk in the pond to give an area of warmer water for special plantings. The bridge was modified with an arched trellis on which wisteria was trained. Within a few years its creepers had grown right across, forming a dense curtain that echoed the trailing lines of the weeping willows that stood at various points on the bank. Later Monet redrew the lines of the bank, breaking straight edges into sweeping curves.

Although the total area of the water garden was not very great, it seemed much larger. Paths curved unexpectedly, passing between thickets or into the hollow spaces under trees, each bend opening up new views. Weeping willows and irises on the bank provided swaying screens. The horizontal perspectives of the water, marked out by the lilies, reflected every change in the sky.

Monet was enraptured with his domain, which became his principal theme.

AUGUSTE RENOIR.
Madame Claude Monet avec son Fils *(Portrait of Madame Monet and her Son).* 1874

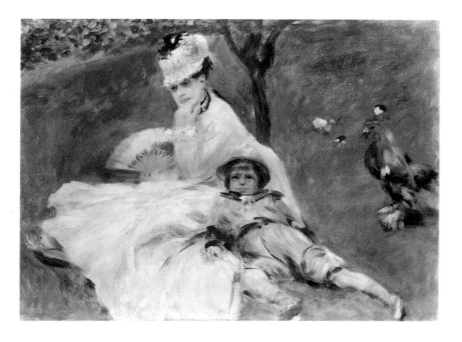

ÉDOUARD MANET.
La Famille Monet au Jardin *(The Monet Family in their Garden).* 1874

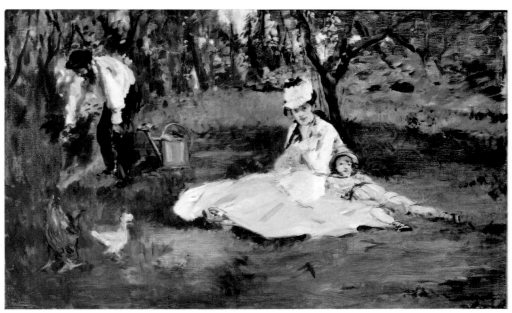

AUGUSTE RENOIR.
Monet Painting in his Garden at Argenteuil. 1873
The canvas on Monet's easel is most likely Le Jardin de Monet à Argenteuil (Monet's Garden at Argenteuil), *reproduced on page 200.*

The spectacular seasonal variation of Monet's garden was described by Octave Mirbeau:
It is spring.

...Already the nasturtiums and the eschscholzias display, the latter their young bronze greenery, the former their linear leaves of an acid and delightful green; and in the wide flower beds that they border against a background of blooming orchards, the irises raise their strange, curved petals, bedecked with white, mauve, lilac, yellow, and blue, streaked with brown stripes and purplish dots, evoking, in their complicated underparts, mysterious analogies, tempting and perverse dreams, like those that float around troubling orchids....And the summer plants...are getting ready everywhere for the joy of blossoming.

It is summer.

Nasturtiums of all colors and saffron-colored eschscholzias collapse in blinding ruins on both sides of the sandy pathway. In the wide flower beds, covering the irises stripped of their blossoms, surges the surprising magic of the poppies; an extraordinary mixture of tones, an orgy of bright nuances, a resplendent and musical muddle of white, pink, yellow, and mauve; an unbelievable kneading of blond flesh tones, on which the orange tones burst, the fanfares of burning copper ring out, the reds bleed and catch fire, the violet tones brighten, and the dark crimsons light up.

By 1900 he had painted it at least twenty times. From 1902 he was working on a long series of studies, mostly of a square or upright format. After many travails these were exhibited in 1909 under the collective title *Les Nymphéas, Paysages d'Eau.*

They were paintings of a kind that had never been seen before. One critic was to describe them as upside-down landscapes. They had been anticipated for years. As early as 1902 Mary Cassatt had reported in a letter, "Monet is painting a series of reflections in water; you see nothing but reflections." Monet was consumed by doubts. He wrestled with them for five years, putting off Durand-Ruel's demands for pictures to exhibit, defending the series as a complete entity. The exhibition was postponed for one year, then for another. Again, the unity of the group and its extraordinary decorative coherence led more than one writer to plead for a state purchase of the whole series.

By now the garden had become well known. Photographs and descriptions were published from 1901 onward and it was featured several times in the specialist journal *Jardinage.*

If we look at a bed of bright flowers such as scarlet geraniums partly in sunlight and partly in shadow we notice that although it is fairly easy to see how the foliage, the soil, the garden path at the side change color as they pass from sunlight to shade, becoming darker and cooler, it is not at all easy to be sure what happens to the flowers. The more temperate color of the path—a pinky gray perhaps—can easily be compared with adjacent colors. The changes it goes through can be measured. But with what can the geraniums be compared? Their red is so intense, so saturated, that it hardly seems to receive the light so much as to generate it, and thus in some way to be beyond

Le Jardin de Monet à Giverny *(Monet's Garden at Giverny)*. 1900

Monet wrote to Clemenceau on May 29, 1900:
I am still awaiting your long-promised visit.
Now is the time. You will see the garden in all
its splendor but you must hurry. Would you like
to come either on Sunday or Monday? Any later
and the blossoms will have withered....There
are piles of new paintings. Shake Geffroy and
come.

As soon as you push the little entrance gate, on the main street of Giverny, you think, in almost all seasons, that you are entering a paradise. It is the colorful and fragrant kingdom of flowers. Each month is adorned with its flowers, from the lilacs and irises to the chrysanthemums and nasturtiums. The azaleas, the hydrangeas, the foxglove, the hollyhocks, the forget-me-nots, the violets, the sumptuous flowers and the modest ones mingle and follow one another on this ever-ready soil, wonderfully tended by experienced gardeners under the infallible eye of the master. If it is the moment of the roses, all the marvels with glorious names surround you with their variations and fragrances. They are planted at intervals, on bushes, on hedges, on trellises, climbing walls, clinging to pillars and arches on the central pathway. There are the most unusual and the most ordinary, which are not the least beautiful, the simple roses, the clusters of sweetbrier, the brightest and the palest; and all the corollas toll an enchanted hour, vocalize the choir of summer, and make you believe in the setting of possible happiness.

Monet in the flower garden of his home

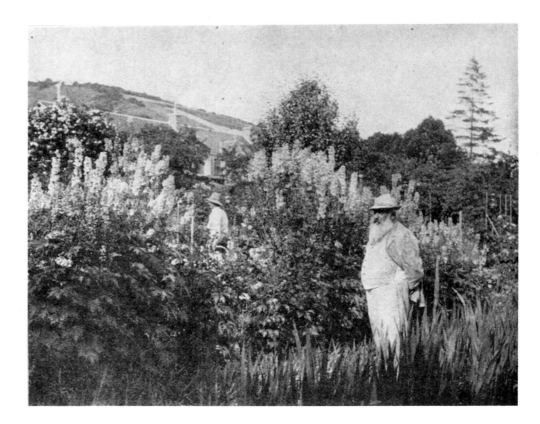

The flower garden at Giverny

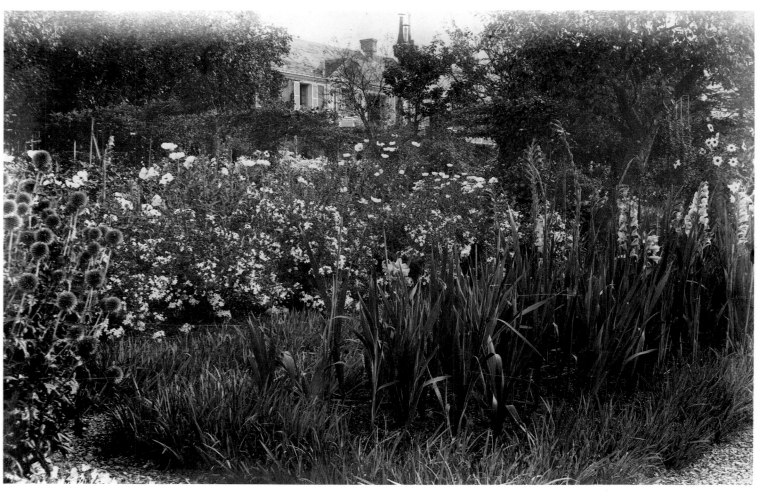

Postcard of the central path leading to the Monet house

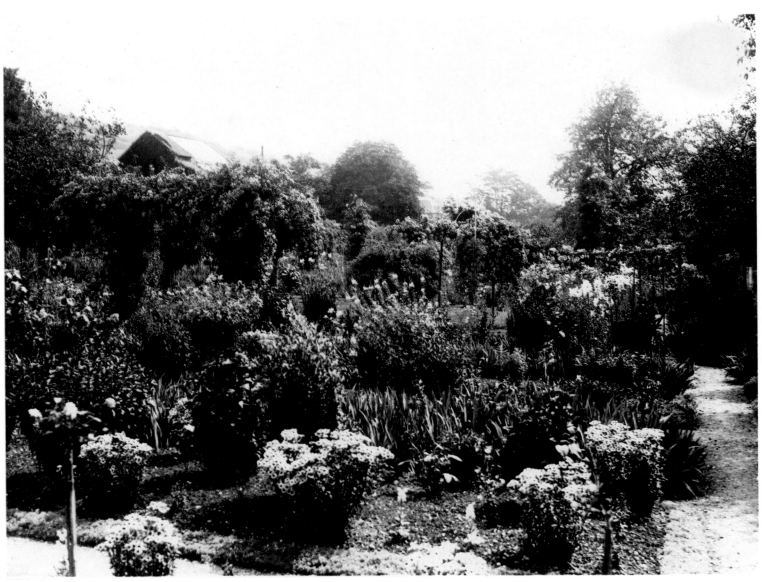

The flower garden and the studio built for the water-lily decorations

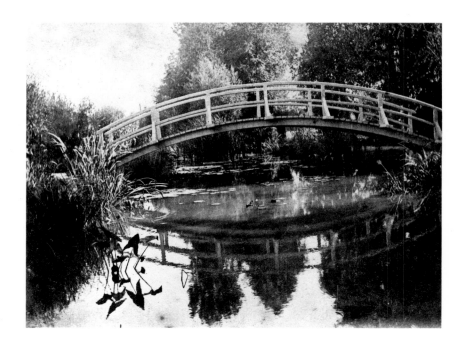

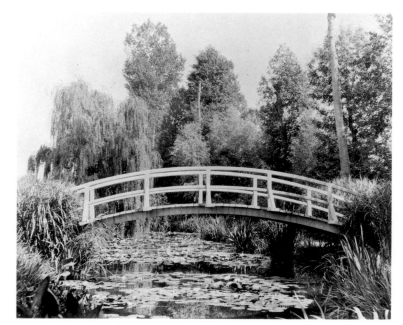

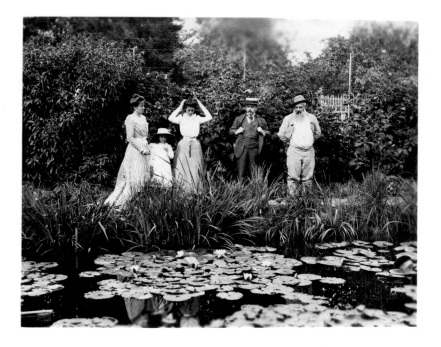

Looking back on the creation of his water gardens in a conversation with Marc Elder published in 1924, Monet described the whole process as quite a simple matter:

There was a stream, the Epte, flowing from Gisors, bordering my property. I had a trench dug to fill a small pond dug out in my garden. I love water, but I also love flowers. That is why, once the pond had been filled, I dreamed of garnishing it with plants. I took a catalogue, made a choice in a haphazard fashion, and that's all.

In truth it was not so simple, and in 1893 he had more than a few problems. His first was receiving the necessary authorization from the local governing authority, the Préfet de l'Eure. Here is Monet's well-reasoned application of March 17, 1893:

Monsieur le Préfet,

I have the honor to inform you that I am the owner of a piece of land situated between the Pacy-Gisors railroad and the left bank of a branch of the Epte, and tenant of the land forming the opposite bank of this branch. In order to renew the water of the ponds that I am going to dig on the land I own, for the purpose of growing aquatic plants, I should like to install a water feeder in the Epte by means of a small trench whose ends will be open on the right bank of the Epte and provided with a small sluice gate 60 or 70 cm wide. Nothing would be installed in the bed of the stream that could modify the level or flow of the water. It would, in short, be nothing but a small intermittent diversion whose water volume, insignificant in relation to the output of the stream, would be restored to it after watering my plants. I believe that my project lies within the limits of the usage rights belonging to riverside owners, and I hope you will be willing to grant me authorization as soon as possible for the installation of the water feeder that I would like.

In addition, in order to pass from my land to the land that I rent on the other bank and vice-versa, I plan to install over the stream of the Epte two small, light, wooden footbridges. As far as the width and height at both ends of these footbridges are concerned, I will conform to the instructions that you will be kind enough to give me in the authorization that I request in order to build them.

Monet's most irksome problem, however, was with the local villagers. He considered them spiteful and petty: opposition centered principally on persons he had either dismissed from his employment or had refused to hire. From Rouen, where he was entrenched painting the cathedral, he expressed his fury to his wife Alice in this letter of March 20, 1893:

I'm upset about these new difficulties. I was completely involved in my painting and fairly pleased. This enrages me and I want no longer to have anything to do with…all those people in Giverny; no more engineers, no more dig-

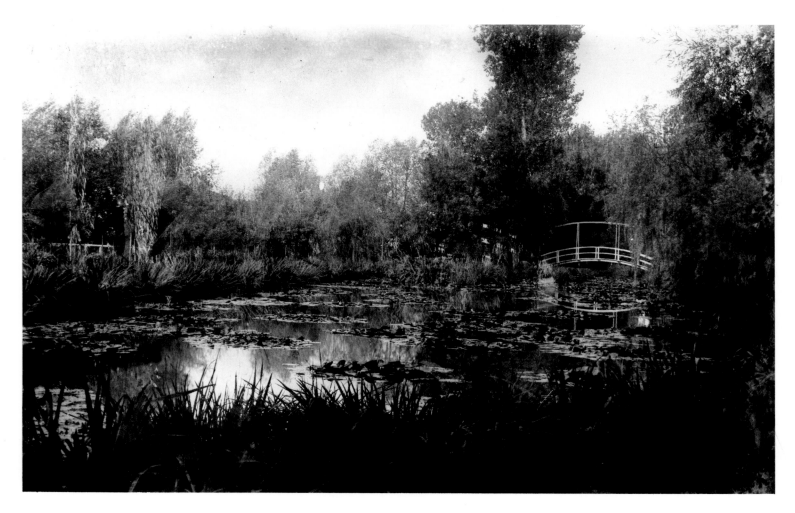

gers, etc. There is nothing but trouble ahead and, believe me, I give it up completely. I am not writing to the prefect, I'm going to wire Lagrange not to send anything. Don't rent a thing, don't order any lattice, and throw the aquatic plants in the river; they'll grow there. I want to hear no more about it, I want to paint. Shit on the natives of Giverny, and the engineers.

I give the land to whoever wants it.

I'm furious, that's all, and I ask you to forgive me for these words, but I have no luck; every time I'm able to work, some trouble comes up to bother me.

On July 17 with summer now well advanced, Monet wrote again to the Prefect, amplifying his reasons for wanting to enlarge the water garden:

I also want you to know that the said cultiva-tion of aquatic plants does not have the impor-tance implied by the word and that it has only to do with something agreeable and for the pleasure of the eyes, and also for the purpose of having subjects to paint; and finally that in this pond I grow only such plants as water lilies, reeds, and irises of different varieties that gen-erally grow wild along our river, and that there can be no question of poisoning the water.

I will promise nevertheless, should the peas-ants continue to disbelieve, to renew the water of the said pond only during the hours of the night when no one uses water.

His problems were resolved finally on July 24, 1893, when permission was granted for Monet to employ a water intake on the communal branch of the Epte and to construct the two footbridges.

The water garden, showing the Ru, the communal stream that feeds the pond, in the foreground

OPPOSITE, ABOVE: The Japanese bridge. c. 1895

OPPOSITE, CENTER: The Japanese bridge, September 1900

OPPOSITE, BELOW: Monet with Georges Durand-Ruel, Madame Joseph Durand-Ruel, and members of his family. September 1900

ABOVE: The water-lily pond, showing the trellises that Monet had recently installed on the Japanese bridge for the trailing of wisteria. c. 1904

Two views of the water-lily pond

*The Japanese bridge, the irises, agapanthus, willows, and water lilies—*motifs *that Monet treated in his thirty-year ode to his water garden—are present in these photographs.*

Postcard of the water-lily pond

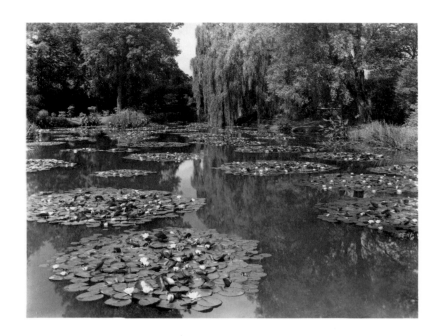

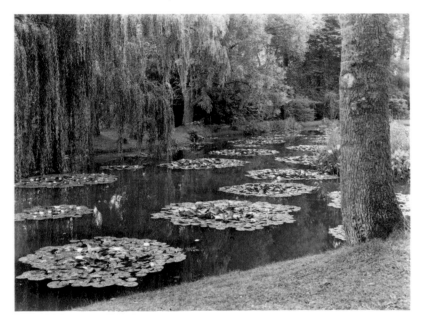

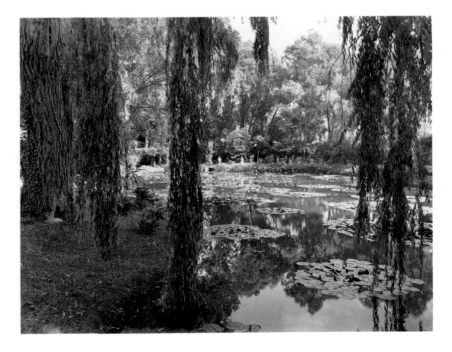

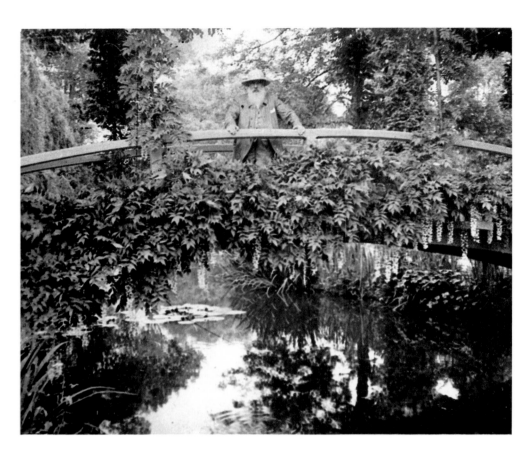

ABOVE: Monet on the wisteria-covered Japanese bridge

BELOW: Monet and Madame Kuroki with members of his family

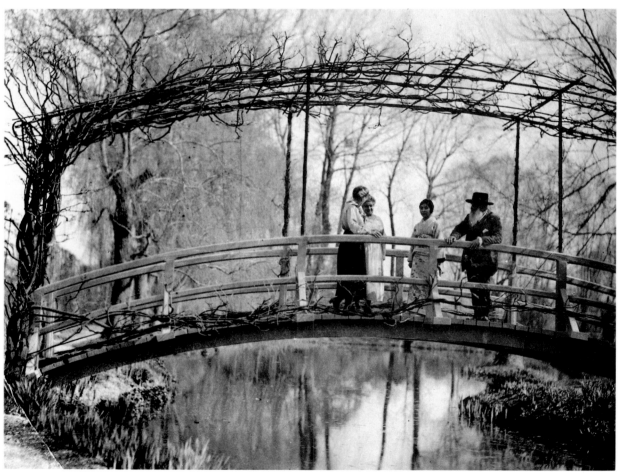

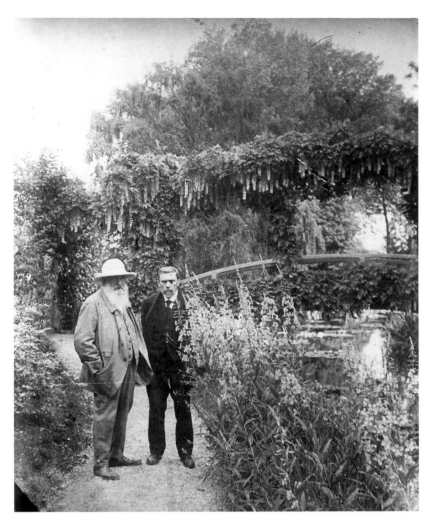

Monet with his close friend and biographer, Gustave Geffroy

A visitor gave his impression of the water garden:
You enter the aquatic garden over a hog-backed bridge covered with wisteria. In June the fragrance is so heavy that it is like going through a pipe of vanilla. The clusters, white and mauve, a light mauve that one would say was painted in watercolor, fall like fanciful grapes in the watery greenery of the creepers. The passing breeze harvests the aroma.

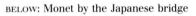

BELOW: Monet by the Japanese bridge

Dahlias. 1880

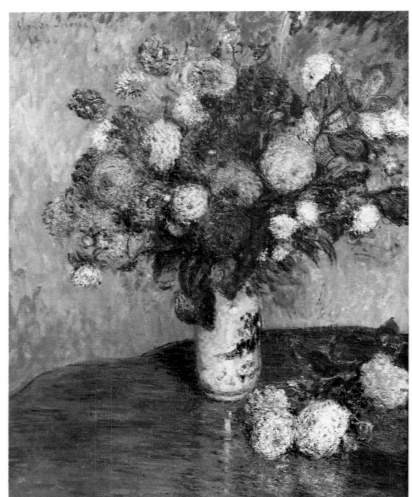

Chrysanthèmes *(Chrysanthemums).* 1878

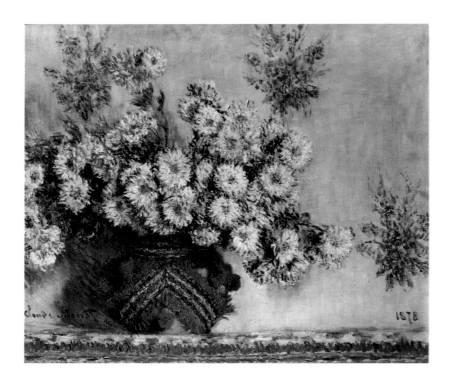

chiaroscuro. Those red points hover somewhere on a plane of their own and with a unique constancy. The whole garden is reshaped by the passage from morning into afternoon, but the invitation of the scarlet geraniums burns steadily.

Flowers are seductive. Most, particularly ones with structures that are clear-cut, not fuzzy, are strong focal points. The color of flowers, because of its purity and saturation combined with the silky, refractive structure of petals, often approaches film color, like the sky, unattached to a surface. Looking up into a summer sky or down into the heart of a bright flower one might experience similar intimations of infinity.

We are not bees. The luxury of flowers is gratuitous; hence their readiness as symbols. To Monet their gratuitousness offered other rewards. In the early *Femmes au Jardin* the flowers add a staccato of pure color to the modulated greens, browns, tans, and pinks on which the light of the picture is developed, overriding its chiaroscuro and giving back light and flutter to the eye *from within the picture itself.* Here is yet another pictorial model, an exchange between the picture idea and the *motif,* that has the force of a lesson. Is it farfetched to think of the flowering of the Impressionist palette? Or of a picture like *Les Glaïeuls* or the *Champ de Coquelicots* as a garden or field in which the presence of flowers gives a key to the blossoming of all the colors?

How distant Monet is from Cézanne in this context—from the Cézanne who complained that even his paper flowers faded! For Monet the painter, flowers are the very epitome of transience, wet-weather stand-ins for the ever changing *motif* outside. Flowers are the only things he paints really close to at a still-life range (one discounts the occasional pheasant, tart, and absurd portrait). Monet

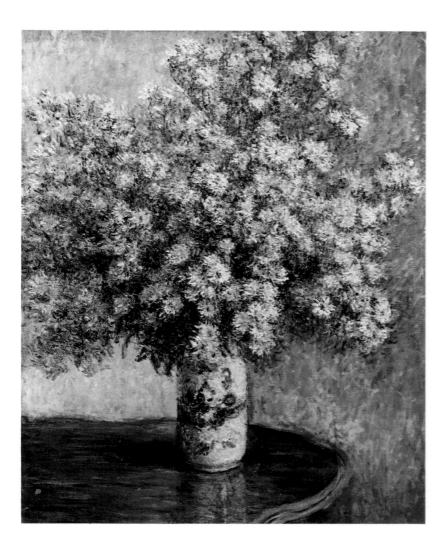

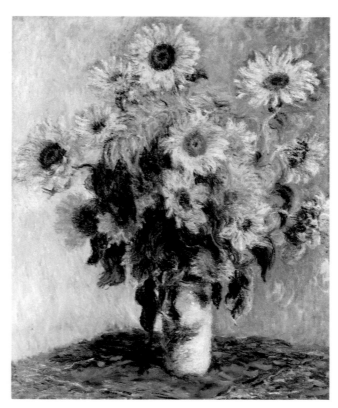

comes at them head on, without a compositional attitude: they are dumped in front of him, bushy or svelte, vivid, teeming with their specific energy, without atmosphere, an explosion. They are the nearest he ever comes to figurative art in the sense of a centered form standing out against its background. The whole question of emphasis, focus, figure-field discrimination that his attention to the envelope has thrust to one side is opened up in his flower paintings from a new angle.

Here surely is one reason for the extraordinary difficulty he had finishing a set of decorative panels he made for Durand-Ruel's apartment. These were to be fitted onto six double doors. Each door had a very tall, narrow panel at the top, a small landscape-shaped one just below the level of the doorknob, and a squarish upright at the bottom. Of the thirty-six panels twenty-nine are of flowers and the rest fruit. There are various other paintings of flowers that must have been made for the scheme and rejected, and Monet estimated in a letter to the dealer that he had destroyed between twenty and thirty others. We can only guess at what the whole scheme looked like installed, but we can at least see from the photographs some of the things Monet did not do.

He did not use the flowers and fruit to garland the door. Each panel is a painting in its own right. Nor is there a consistent program: flowers of summer appear side by side with flowers of spring. There is no unified theme of illumination or scale or space. Indeed there is evidence from a letter that Monet had no fixed idea how they were to be arranged. He tells Durand-Ruel that he wants to be there when they are installed so as to make the final decisions. In fact, the sixth pair of doors was never installed.

Enormous sunflowers are side by side with daisy-sized chrysanthemums in a

"Gauguin was telling me the other day," Vincent van Gogh wrote to his brother in December 1888, "that he had seen a picture by Claude Monet of sunflowers in a large Japanese vase, very fine, but—he likes mine better. I don't agree—only don't think that I am weakening." Van Gogh's admiration for Monet was genuine. In an earlier letter he had exclaimed, "I shall go on working and here and there among my work there will be things which will last, but who will be in figure painting what Claude Monet is in landscape? You must feel as I do that such a one will come....The painter of the future will be a colorist such as has never yet existed."

It is particularly in Monet's still lifes that we recognize what it was that Van Gogh learned from him: not simply the powerful and expressive palette but also a quality of impassioned drawing that is much more apparent in the flower paintings—forms painted at the range of stereoscopic vision, therefore more tactile—than in most of his landscapes. In these sumptuous flower paintings done only when the weather prevented outdoor work, the drawing and color are carried along together with tremendous impetus. His love for flowers is unmistakable. The character, the quality of growth, the specific rhythm of each bouquet is given its due.

fussy vase; a single strand of clematis is juxtaposed with profuse azaleas. The door itself is ignored except as the determinant of the shapes of the panels, and these shapes are so extreme in their proportions that every one of the paintings looks as though it had been cropped by the door, which acts less as a picture frame to each panel than as a window frame through which one can see, set back, the different groups of flowers assembled with bizarre inconsistency. One door, for instance, includes a pot of gladioli standing on a table; below it the little slot-shaped panel is crammed with a bunch of daisies seen from above; and at the bottom is a bunch of tulips in silhouette as if seen at eye level. The total effect is disorientating, as though the fields of vision supposed by each panel are rising, tilting, retreating, sliding. There is one pair of doors for which each top panel shows half a huge bunch of dahlias in a vase. The eye tries unhappily to read the two halves as one. The door gets in the way.

For Monet the painter flowers were surrogates for his out-of-doors *motifs* cut off by rain. For Monet the gardener their fragile presence would have been a token of return, of the cycle of seasons and next year's responsibility. The change in his palette that comes about in the early nineties, when his color transpositions become more extreme and his palette is the source of light rather than a mode of response to light, coincides with the ambitious development of his garden, as though flowers were models for more than their transient appearance but for their faithful return, their fragile moments and tough enduring morphology providing at some level a kind of example for the series as a form.

In June of 1897 he exhibited at Petit's a group of four canvases of chrysanthemums he had painted the preceding November. The flowers are seen from above, as if the painter was looking squarely down on them. In one of the four there is a slight hint of perspective and the flowers curve away from him, but in the rest their bright mops look straight back without recession, filling the canvas as if they were packed into a box. Each head is rounded firmly. The paintings might be mistaken for a particularly florid chintz except that there is no pattern at all, no formalization of the arrangement, simply a random mass of flowers, their burnished crowded heads making the picture.

It is a strange experiment. By the time he had made it he had already started to think of an encompassing decoration with the lily pond as its theme.

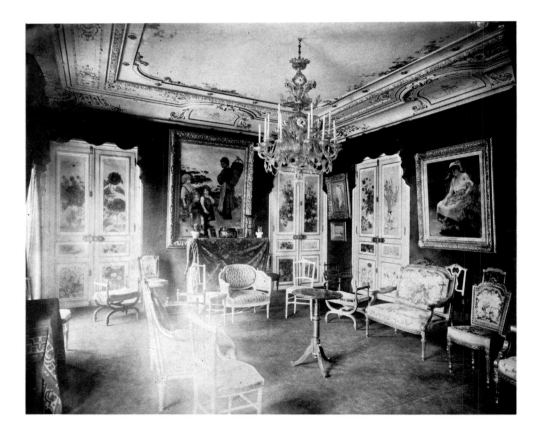

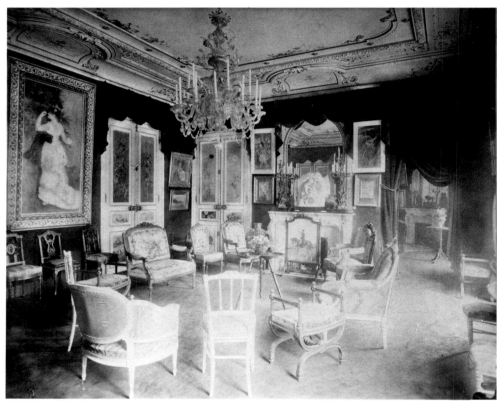

The decorations painted by Monet
for the *grand salon* of Paul Durand-Ruel
at 35, Rue de Rome, Paris

*The door-panel decorations commissioned by
Paul Durand-Ruel in 1882 were installed in his
grand salon at 35, Rue de Rome, Paris, in April
1885. Two views of the room are at left.*

*Opposite are photographs of the doors them-
selves and details of two of the panels. The
paintings on the door at left are:* Vase of
Dahlias, Dahlias, Yellow Daisies, White Daisies,
Peaches, *and* Basket of Apples. *On the right
door are* Chrysanthemums in a Vase, Sun-
flowers, Chrysanthemums, Jonquils, White
Azaleas, *and* Anemones.

*The doors were removed from Paul Durand-
Ruel's home in 1922 after his death and the pan-
els have subsequently been dispersed.*

OPPOSITE, ABOVE: Door-panel decorations for the *grand salon* of Paul Durand-Ruel

OPPOSITE, BELOW, LEFT: Pêches (Panneau Décoratif) *(Peaches [Decorative Panel]).* 1883

OPPOSITE, BELOW, RIGHT: Vase de Tulipes *(Vase of Tulips).* 1885

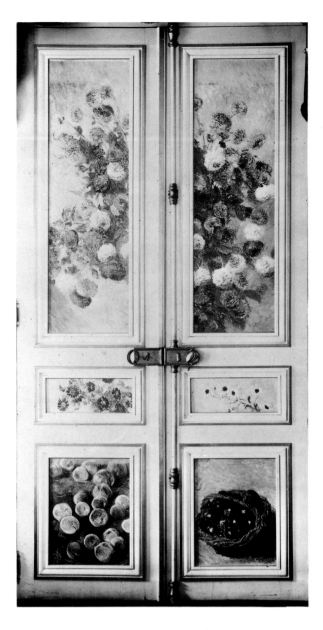

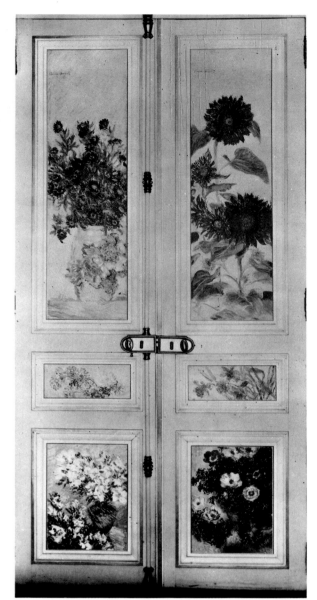

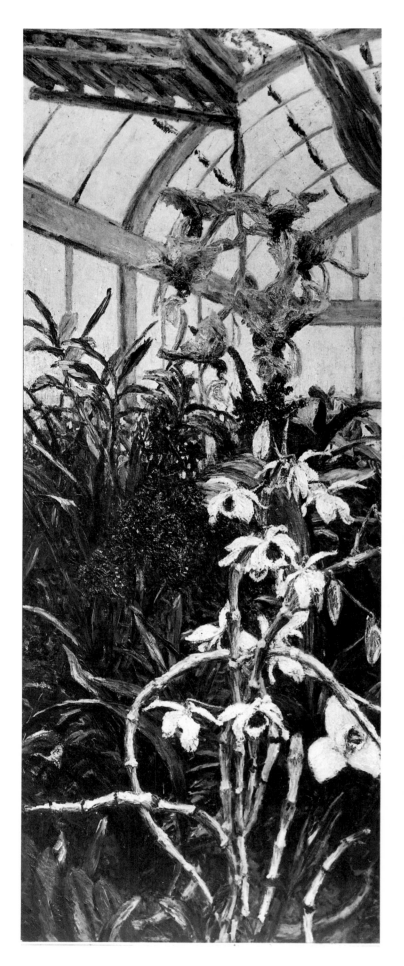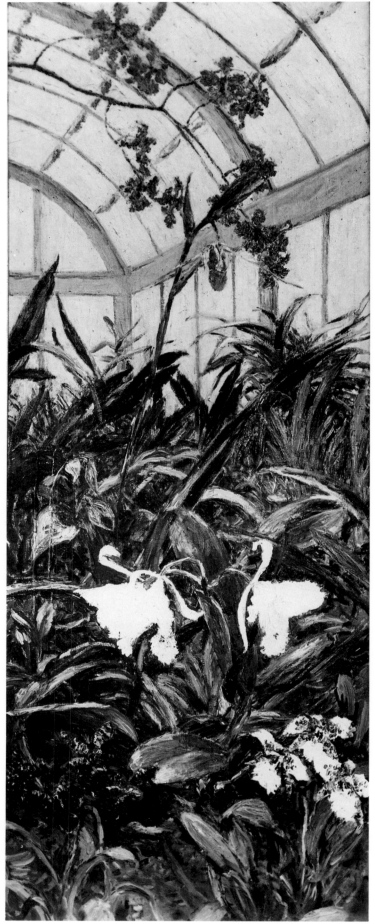

GUSTAVE CAILLEBOTTE. Orchidées (Cattleya et Antonium) et Orchidées à Fleurs Jaunes *(Orchids [Cattleya and Antonium] and Orchids with Yellow Blooms)*. 1893

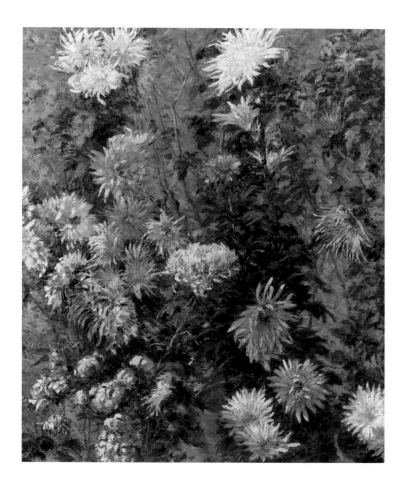

GUSTAVE CAILLEBOTTE.
Chrysanthèmes *(Chrysanthemums)*. 1893

This painting was in Monet's private collection.

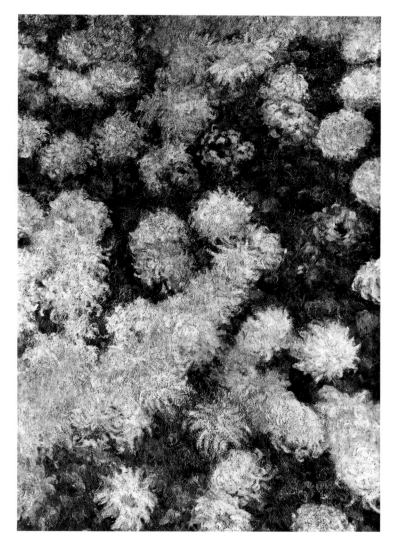

Chrysanthèmes *(Chrysanthemums)*. 1897

Gustave Caillebotte was the son of a judge who had left him in comfortable circumstances. He had studied painting briefly at the École des Beaux-Arts and with Bonnat, but his real beginnings as a painter date from his friendship with Monet and Renoir. He dedicated himself to the Impressionist group, forming an outstanding collection of their work that included sixteen Monets.

As a painter Caillebotte had the modesty of an amateur but the best of his work is highly intelligent, unconventional, and innovative. A project to decorate his dining room with panels of flowers treated en masse *may well have contributed to Monet's later thoughts about a decorative environment. Caillebotte's paintings of his greenhouse (opposite), so different in conception from Monet's earlier flower decorations for Durand-Ruel's apartment, were painted the same year that Monet began to develop his water garden.*

Monet, Caillebotte, and Octave Mirbeau were friends and fellow gardeners. Their curiosity and passion for flowers are illustrated by the letters below, the first two from Monet to Caillebotte, the third from Mirbeau to Monet:
Dear friend,
Don't fail to come on Monday as we agreed, all my irises will be in bloom, and later on some would be withered.

Here is the name of the Japanese plant that I get from Belgium: *Crythrochaete*. Try to speak of it to M. Godefroy and give me some information on how to grow it.

I have seen the flower show in Paris, some magnificent things. There I met your friend Godefroy.

We must let him know when we will go to see him with Mirbeau.

Can you tell me where I would be able to find seedlings of annual flowers, I saw some superb ones at the show, but it is too late to plant, especially chrysanthemums—and layias with yellow flowers, maybe you would have a few yourself, anyway try to find out.

See you Tuesday, won't I?

I'm very glad that you're bringing Caillebotte. We'll talk gardening, as you say, because as for art and literature, it's all humbug. There's nothing but the earth. As for me, I've reached the point of finding a lump of soil marvelous, and I spend whole hours contemplating it. And humus! I love humus the way one loves a woman. I smear it on myself, and in the fuming heaps I see the beautiful forms and beautiful colors that will be born from it! How little art is next to that! And how simpering and false.

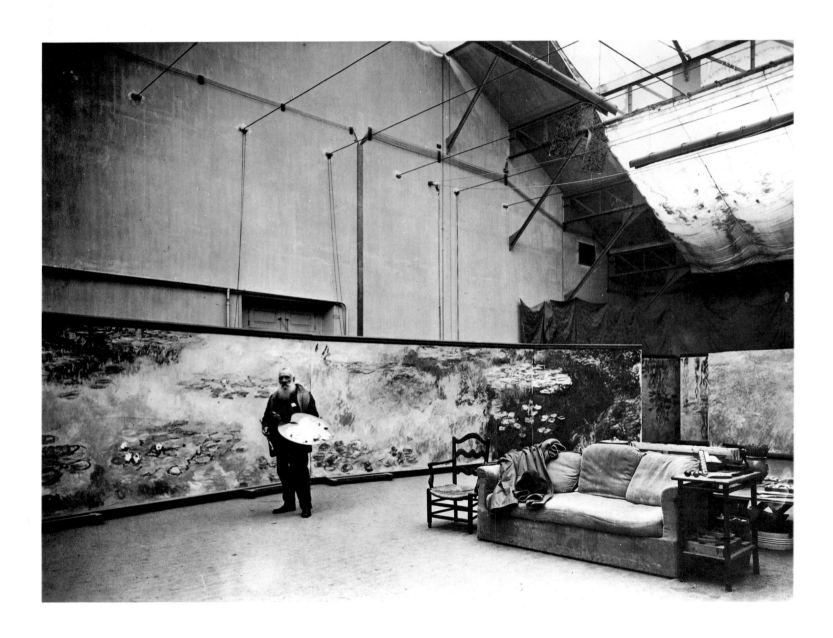

Monet in the studio constructed for the water-lily decorations. c. 1923

The word *"décoratif"* had been used by critics to characterize that aspect of Monet's work that was most difficult for them to accommodate: the paintings seemed not to be *of* anything. Neither anecdotal nor heroic, topographical nor inspiring, they seemed to have no purpose except to be looked at. It was not unreasonable for those among Monet's early critics who were open-minded enough to appreciate his high-toned color and lively surface to use the word "decorative," but when they did so in the early seventies it was not an outright compliment. By the nineties, however, the academic hierarchies had dissolved. Greeting the new series, the *Poplars,* exhibited at Durand-Ruel's in May 1892, Octave Mirbeau wrote, "It is an absolutely magnificent work....You have reached the absolute beauty of great decoration," and he meant it as a supreme commendation. At the time of the Exposition Universelle of 1900, in which Monet was well represented, several critics called for his recognition by the state in his role of decorator: "If I were a millionaire," André Michel wrote, "or minister of Fine Arts—I would ask Claude Monet to do for me the decoration of some immense festival hall in a Palace of the People...."

The idea of Monet as a decorator on a grand scale gained ground among his admirers. The same year as the poplars were exhibited Rodin had proposed Monet as a replacement for Jules Breton in a program of landscape decoration for the new Hôtel de Ville. In the end the proposal was defeated by four votes to ten. It would have been a nice turn of events if Monet had won, for Breton had been his most implacable opponent twenty years earlier when Monet had been desperate to gain acceptance in the Salon.

Monet had already begun to form a conception of a grand decoration of a particular kind, in which the lily pond would provide a model for a total environment. In 1898 Maurice Guillemot published an account of a visit to Giverny during which Monet had shown him the beginning of such a decoration. The project was extraordinary.

Imagine a circular room whose wall below the support plinth would be entirely occupied by a horizon of water spotted with vegetation, partitions of a transparency made by turns green and mauve, the peace and quiet of the still water reflecting flowering expanses; the tones are vague, delightfully varied, of a dreamlike subtlety.

Hints of this plan continued to appear in articles by writers who were close to Monet. At the time of the *Paysages d'Eau* exhibition in 1909, when many writers were commenting on the decorative unity of the series and regretting its breakup, Arsène Alexandre reported that Monet wanted to decorate a circular room, which would be completely filled with a painting "passing

Although Clemenceau did not always understand Monet's intentions, he was capable of remarkable insights:
Monet tried to seize the light and throw it on his canvases. It was a madman's idea. A moment came when what he was doing was no longer painting; he had left painting behind. It was a kind of escape....He should have lived another ten years: then we would no longer have understood anything of what he was doing; there might no longer have been anything on his canvases.

through all possible modulations, a painting of waters and flowers." A few months later a very important article appeared by Roger Marx in which he presented his version of a conversation with Monet describing a project for the *Nymphéas*. Monet said:

For a moment the temptation came to me to use this water-lily theme for the decoration of a drawing room: carried along the walls, enveloping all the partitions with its unity, it would have produced the illusion of an endless whole, of a wave with no horizon and no shore; nerves exhausted by work would have relaxed there, following the restful example of those stagnant waters, and to anyone who would have lived in it that room would have offered a refuge of peaceful meditation in the middle of a flowering aquarium.

When his second wife died in the spring of 1911, Monet withdrew into mourning. He was not able to overcome his depression and discouragement until the autumn, when he mustered the will to rework the Venice canvases. "I work a bit on my Venice," he wrote to one of his stepdaughters, "but not without difficulty, and I do not stop thinking of her while painting. We were both so happy during our visit; she was so proud of my zeal."

That summer a specialist in Paris had confirmed the diagnosis of cataracts in Monet's eyes, but reassured him that it would be some years before an operation would be necessary. Meanwhile, Monet reported to Durand-Ruel, "Fortunately I am not forbidden to go on painting, and if the weather finally agrees to improve, I will bravely resume work, which I need more than ever."

In 1912 Rodin had made a massive donation to the state, representing almost his entire life's work. When it was announced both Monet and Clemenceau publicly applauded the gift. Possibly Monet had thought of his own great project in the same light: as a permanent monument to his life's enterprise. But now, enfeebled, certain that total blindness was inevitable, his mood vacillated more extremely than ever between despair and euphoric omnipotence.

Jean Monet, his older son, died in 1914 after a lingering illness. From then until his death Monet was cared for by his widowed daughter-in-law and stepdaughter Blanche Hoschedé-Monet. Her faithful care must have given the aged but still formidable painter the tranquillity he needed to reconsider his great project. But it was Georges Clemenceau, his old and intimate friend, himself on the brink of the supreme effort of his long and controversial career, who, according to Monet's own testimony, gave the final impetus that was needed.

By the summer of 1914 Monet had drawn up plans for a studio large enough to hold the vast work he had in mind. By June he wrote to Durand-Ruel: "As you must know, I've taken up my work again, and you know that when I go at it seriously, to the point of getting up as early as four in the morning, I grind away at it all day long and when evening comes I'm worn out with fatigue...."

Thanks to work, the great consolation, all goes well."

Europe was near war. General mobilization in France at the end of July put a halt to work on the new studio. Michel left for the army. The Butlers went back to America. Monet found himself alone with Blanche.

The years from the summer of 1914 until Monet's death in 1926 were a period of almost unimaginable productivity, even by his standards. Far from a peaceful decline toward his end, the last decade of his life was one of unremitting conflict—with his work, with his own eyes, with the French government. For the devoted Blanche life must often have been very hard indeed. We do not know exactly what happened during this time, in spite of the wealth of firsthand accounts from Monet's many visitors. His own state of mind was volatile. Not many new works from this period left the studio while he was alive. He destroyed unknown numbers of canvases by boot, knife, and fire. His self-criticism was so stubborn and corrosive, and what was left in the studio was so baffling and foreign to the expectations of his admirers, that it is not surprising that it lay virtually forgotten until some three decades later.

The decision to build the new studio was crucial. It was a commitment to the very large canvases that make up the *Nymphéas* decorative group. The vertical dimensions of the first series of *Paysages d'Eau* (1903–6) had ranged between 73 cm and 90 cm. The later group (1907–8) ranged between 73 cm and 107 cm, the average being around one meter. Once Monet formulated the decorative scheme his work divides into two kinds of format: the long canvases intended for the decorations with vertical dimensions of two meters and lengths up to six meters and others of a nearly square or upright format which were to be worked on in the open air. Some of these latter are up to two meters in height but much narrower. These are large surfaces to work on in the open air, but not unmanageable, especially with the help of gardeners. But it seems that the long panels intended for the decoration itself were never worked on by the side of the pond. In common sense it would have been absurdly impractical and, even by the light of fanaticism, impossible to reconcile with Monet's concern for an instantaneous unity.

The new studio, which was about 23 meters by 12, was to be both the painting space for the long canvases, for which special easels on rollers were made, and the space in which they could be maneuvered end to end, the beginning of the enveloping painted environment he had dreamed of for so long.

In an account of the genesis of the *Nymphéas* by François Thiébault-Sisson, published after the artist's death, Monet explains that his decision to build the studio arose from the problems he was having with his eyes. He had found that with the advance of the cataracts he could no longer see color with any accuracy—above all he could not distinguish subtleties of color of the same value—although he could still see distinctions of light and dark as clearly as ever. His

ABOVE, AND RIGHT: The second studio with the
Nymphéas, Paysages d'Eau. March 1908

*In the photographs above, all the water-lily
paintings hanging on the lowest tier were
destroyed by the artist.*

*From 1902 Monet was caught up in the creation
of a radically new series of water-lily paintings;
unwilling to relinquish a single canvas until the
series had completely evolved, he found him-
self having repeatedly to fend off his dealer,
Durand-Ruel, who wanted to offer an exhibition
of the new work. The to and fro is well sum-
marized in this letter from Monet to Durand-
Ruel of April 27, 1907:*
Dear Monsieur Durand,
Like you, I am sorry not to be able to exhibit
the series of *Water Lilies* this year, and if I have
made this decision, it is because it was not pos-
sible. It may be true that I am very hard on
myself, but this is better than showing things
that are mediocre. And it is not because I want
to exhibit many that I postpone this exhibition,
certainly not, but I really do not have enough
satisfactory ones to put the public to the incon-
venience of coming. I have at most five or six
acceptable canvases, and by the way I have just
destroyed at least thirty, which gave me a lot of
satisfaction.
I still enjoy painting them very much, but as
time goes on I become well aware of the can-

vases that are good and of those that should not
be saved, which does not prevent me—quite
the contrary—from being full of enthusiasm
and confidence to do better ones.
But I must talk about what you asked me,
and in spite of my wish to please you, I cannot
promise you anything, at least right now. Any-
way it would be very bad to show even a little
bit of this new series, since the total effect can
only be produced by an exhibition of the whole.
Besides that, I must have the things I have
done before my eyes in order to compare them
with the ones I am going to do.
You remind me, it is true, that I sold one of
these canvases to Mr. Sutton. I am the first to
feel sorry about it, because if I still had it, it
would be to destroy it, and at any rate I would
not want it to be part of the planned exhibition.

*A year later, after a lengthy correspondence
between the painter and his dealer, Durand-
Ruel once again resigned himself to the necessity
of postponing the exhibition, although it had
been programmed for the following month. He
wrote to Monet as follows on April 30, 1908:*
I am very sorry to hear of your troubles and
anxieties. You have overworked yourself for
several months and you obviously need, as you
yourself write, to take some rest. I hope that the
weather will at last become less awful and
allow you to immerse yourself again in your

work and regain confidence in front of nature.
As for the planned exhibition, it will take
place a little later and when you like. Do not
worry about it. Do not be concerned any more
about the small advance that I gave you. All
that will be settled.
I would be very happy to pay you a visit if
my presence could help to calm your anxieties;
on the other hand, you might prefer to be left
alone. Tell me very frankly.
In any case, please accept all my apologies
for having bothered you so much, and always
count on my everlasting devotion.

*Monet acknowledged Durand-Ruel's thoughtful
letter on May 1:*
Dear Monsieur Durand,
I want to thank you for your affectionate letter,
which I appreciate very much. Yes, I very much
need to rest. To be no longer haunted by the
thought of exhibiting and to think about some-
thing else will do me a lot of good, and after-
wards I may see things in a better light.

*A joint exhibition of older works by Monet with
paintings by Renoir was then scheduled by
Durand-Ruel for the middle of May; before it
opened a* New York Times *reporter got hold of
a totally erroneous story:*
Pictures with a market value of $100,000 and
representing three years of constant labor were

226

destroyed yesterday by Claude Monet, the French impressionist master, because he had come to the conviction that they were unsatisfactory....

At the last moment, while he was reviewing the pictures and superintending the framing of them, the artist became discouraged. He declared that none of his new works was worthy to pass on to posterity. With a knife and paint brush he destroyed them all, despite the protests of those who witnessed his act.

The story spread like wildfire through the press, appearing in bold headlines as far away from Paris as Duluth, Minnesota. Joseph Durand-Ruel gave a more accurate account of the situation in a letter dated May 19, 1908, to his brother in New York, who most certainly was wondering exactly what had happened in Paris:
Our exhibition of Monet and Renoir landscapes has opened; already a fairly good number of art lovers have come and I think it will be a great success. Many people come thinking that we are showing Claude Monet's new series.

Some newspapers are beginning to report why this series is not being shown; you'll see by the article in the *Daily Mail* and the one in the Paris *New York Herald*, which I enclose, that they are embroidering the truth. It is not absolutely correct to say that Monet has destroyed his paintings; he only spoiled a cer-

tain number of them; mostly he is so tired that he was unable to keep working so as to have them ready for the exhibition; besides he is upset at the moment, but in a few months, when he feels rested, he will easily be able to resume a large number of his canvases and have the exhibition next year.

The question of destruction was certainly not a new one for Monet. Like most other painters of talent, he had often destroyed works. On two separate occasions he explained:
I must look after my artistic reputation while I can. Once I am dead no one will destroy any of my paintings, no matter how poor they may be.

I had the example of Manet. Let me explain: after the artist died, the antiquarians threw themselves on his works. They grabbed everything, including his most minor sketches. So that made me afraid, and I've preferred to destroy everything I didn't like while I was still alive. That way I won't have any regrets!

The water-lily paintings were finally exhibited in May 1909 and were greeted with overwhelming enthusiasm. Following are excerpts from reviews by Gustave Geffroy, Louis de Fourcaud, and Georges Rivière:
It is this spectacle, which he had before his eyes, that he wanted to render; it is with this

delightful undertaking that he struggled for years. We see its result today, and first of all, while walking through the three rooms where these water landscapes are assembled, one has the impression of a magnificent decorative ensemble, and one dreams of keeping it that way, on walls, in peaceful rooms, where spectators would come in search of distraction from social life, relief from fatigue, the love of eternal nature.

It makes me sad to think of the imminent dispersal of these ravishing works, which constitute only a single work. Made to complete each other, they will have succeeded only once, and for a short period of time, in conveying the entire idea and entire feeling of the poem they unfold. Never again, and nowhere else, will they be seen together as we are seeing them. They will be at the four corners of the earth, exquisite, but each giving only a portion of their common secret.

If readers of the *Journal des Arts* care to recall the column I devoted to the famous English artist, they will surely remember that Turner began, as did Monet, with completely realistic studies....And Turner ended his work with strange, mysterious dreams. What does Claude Monet's vision have in store for us?

paintings had begun to look like "old paintings." It was as though he had lost his own vision in the most exquisite sense. Then he made the discovery that this loss of color only affected his vision at normal painting range. If he looked at his paintings from a distance he could see color as well as ever. He made many direct studies to test this out. Then:

Sometimes, in the morning or evening—because I had stopped working during the bright, clear hours and only come here in the afternoon to rest—I would tell myself, while doing my sketches, that a series of general impressions, set down at the hours when my eyesight had the most chance of being accurate, would not be lacking in interest.

I waited until the idea took shape, until the arrangement and composition of the *motifs* had little by little inscribed themselves in my brain, and on the day when I felt enough skill in my hand to try my luck with a real hope of success, I decided to act and I acted.

The decision followed to build the studio.

As to how the canvases were painted, Monet told Thiébault-Sisson:

If it is true that I've rediscovered the meaning of color in the large canvases that I've just shown you, it is because I adjusted my work methods to my sight and most of the time placed the tone at random, relying only, on the one hand on the labels on my tubes, on the other on the invariable order that I'd adopted for setting out the paints on my palette. I got used to it fairly soon....

The new studio was not completed until the spring of 1916, although even this was an achievement, considering the conditions of the time. No doubt there was a good deal of string pulling, as there was also over the supply of painting materials and coal to warm his studio. In June 1915 a group of friends, members of the Académie Goncourt, paid a visit to Giverny, where large canvases were already in progress in the old studio. Mirbeau, who was one of the party, asked how long the entire project would take. Monet told him five years. Work in the new studio was limited to the winter months. In the summer Monet continued to work out of doors, maintaining his ancient complaints about the weather.

The project spurred the curiosity of everyone connected with Monet. Durand-Ruel, who approached him in February 1917, was told firmly, "I cannot think of selling, not knowing whether I will be able to carry it off." When Georges Bernheim and René Gimpel visited Giverny in August 1918 they saw about thirty large canvases, all of which Bernheim wanted to buy, to no avail.

In spite of his impatience with central authority, Monet had the strong

patriotic sentiments of any French bourgeois. He had long resented the exile of so many of his paintings in America. During the war he suffered on behalf of his son in the army and the cities and villages of France threatened by the Germans. His feelings about the bombardment of the cathedral at Reims, reduced by the German artillery in 1914, must have become known in official circles, for in October 1917 he received an invitation from the Ministry of Public Instruction and the Fine Arts to paint a picture of the cathedral. The news was reported in the New York *Herald*, suggesting that Monet had solicited the commission. His reaction was predictable: "You know that I have never solicited anything from the Beaux-Arts," he wrote indignantly to Durand-Ruel, "and it is not for me to start at my age....The truth is that they offered and I accepted because of the interest that it had for me."

However, nothing came of the proposal. Monet's work on the decorations was approaching a final form. At the same time as the Reims affair, Durand-Ruel had been to Giverny to photograph the large panels. It seemed that there had been a possibility of selling the entire group to a museum. On November 17 Durand-Ruel sent photographic prints to Monet with the comment that they were "of little interest; one would need a wide-angle lens...." Monet wrote back that he found them "not bad at all." In the same letter he announced the delivery of a canvas, a 1907 *Paysage d'Eau*, that he was giving to a hospital for auction in aid of the war-wounded. Meanwhile Clemenceau had become prime minister and commander-in-chief. "Here's my old friend Clemenceau in power," Monet wrote to the Bernheim-Jeune partners: "what a load for him; may he do a good job in spite of all the traps that they will lay for him! What magnificent energy all the same."

The Armistice was declared on November 11, 1918. The next day Monet wrote to Clemenceau:

Dear and great friend, I am just about to finish two decorative panels that I want to sign on the day of victory, and am coming to ask you to offer them, through your good offices, to the state. It is not much, but it is the only way I have to be part of the victory. I would like for these two panels to be placed in the Musée des Arts Décoratifs and would be happy if they were chosen by you.

It was a modest proposal, but the whole of the rest of Monet's life was to be overshadowed by its consequences.

Six days after Monet's letter, the premier visited Giverny with Geffroy. The two friends persuaded Monet to agree to a donation on a completely different scale from his own proposal: nothing less than the entire project of the

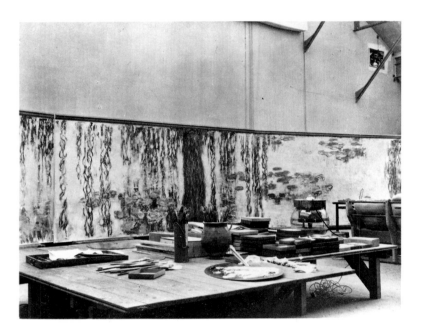

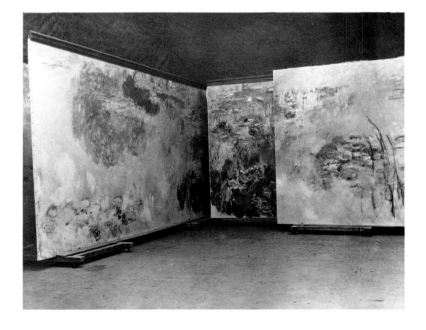

The water-lily decorations, photographed in Monet's studio on Sunday, November 11, 1917

The Durand-Ruel family had been among the first to see the new decorations in an early stage of development in Monet's studio. Joseph Durand-Ruel, in New York, wrote the following to his brother, Georges, in Paris, believing that these works might best be sold as an ensemble in America.

I have talked with Mr. Ryerson [Chicago] and also with Mr. Desmond FitzGerald [Boston] of the large decorations which Monet is now painting. They were both very interested and think they would like their cities to own them. They both wanted to know all the details about the sizes, subject, color, etc. Although I have seen the pictures it was difficult for me to give them a good explanation. Would it not be possible to have these paintings photographed in Monet's studio with his approval?—of course views of *l'ensemble* not each painting separately. Perhaps also Monet could be induced to give an idea as to the price values of each of these two series. Next time you see him, do not forget to speak to him about the matter. I think something might come out of it.

On February 9, 1917, Georges Durand-Ruel asked Monet to consider having the paintings photographed:

My brother has asked me if it would be possible to have photographs of the large decorations that you are doing; he mentioned it to several of our clients who have an interest in the museum in their city and he thinks that if he had photographs of the decorations and the prices that you would like to have, he would have a good chance of selling them.

Monet answered only three days later, apparently closing the door on the whole question:

Dear Monsieur Georges,

I have no photograph of the decoration and I will not have any made until this work, which, I might add, does not always go as well as I would like, is more or less ready, at least in part.

Furthermore, for the same reason, I cannot consider selling, not knowing if I will get to the end of it. So for the time being it is useless to talk about sale and price.

On November 11, 1917, during a visit by Durand-Ruel, the work was photographed; the six pictures shown here are from one of the family albums.

Three years later, the Duc de Trévise visited Monet and described the effect of the paintings:

In the studio, vast as the empty stage of a theater, the artist turns into a workman and moves around the heavy easels with casters on which, almost at floor level, panels are placed lengthwise. I soon feel as though I were at the center of an enchanted pool: there is not a single brushstroke, despite its violence, that jars. All are essential. A vast story of enchantment

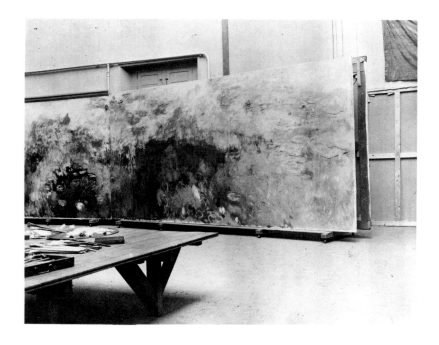

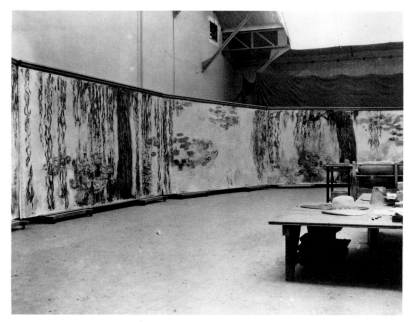

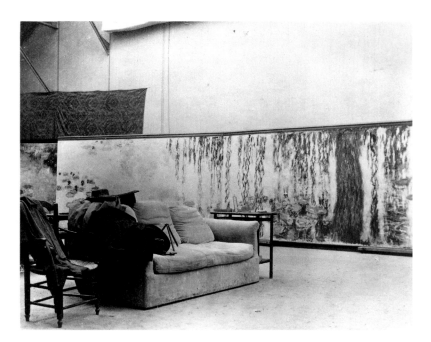

invented by Monet, it is just as one might have hoped. The characters are named reflections of clouds, ripples of water, corollas of water lilies. The subject? It is the subtle play of air and water, under the varied fire of the sun. The earth, being too material, is excluded; the shore is above the frames. With so few elements, how was it possible to fill large spaces? With such iridescence, how was it possible to achieve such exquisite harmonies?

At this early stage in the evolution of the water-lily decorations, certain of the themes of the compositions had been worked out: irises, aga-panthus, weeping willows. The precise ordering and the exact number of panels in each of these compositions, however, were still to be deter-mined. At the tops of these pages, left and right, can be seen two panels of the agapanthus com-position. At center, left and right, and at bottom right, are the three willows. And at bottom left is an iris triptych.

In the photograph at top right, it is also clear that the canvases were mounted back to back on easels with casters, as the Duc de Trévise had described. In addition to being able easily to move the panels for juxtaposition, Monet had only to swivel them around to work on another.

Label of the architectural plans

Ground plan of the Hôtel Biron showing the building proposed by Monet at lower left and the Rodin museum above center

The plans on the following pages have never been reproduced in any publication. Submitted by Louis Bonnier, the architect designated by Monet, to the General Council for Public Buildings in 1920, they were discovered sixty years later in the Archives Nationales, Paris.

Facade of the Monet museum to be constructed of reinforced concrete

After visiting Monet's studio in August 1918 the art dealer René Gimpel recorded these impressions in his diary:

…we were confronted by a strange artistic spectacle: a dozen canvases placed one after another in a circle on the ground, all about six feet wide by four feet high: a panorama of water and water lilies, of light and sky. In this infinity the water and the sky had neither beginning nor end. It was as though we were present at one of the first hours of the birth of the world. It was mysterious, poetic, deliciously unreal. The effect was strange: it was at once pleasurable and disturbing to be surrounded by water on all sides and yet untouched by it.

For the next few years Monet continued his work on these decorations, and during the summer of 1920 negotiations between Monet and representatives of the state were begun to discuss where the paintings could be housed, should Monet consent to an official donation.

Clemenceau most certainly played an active role. François Thiébault-Sisson, a critic interviewing Monet at the time, became privy to details of these deliberations, and—swept along with journalistic enthusiasm—published the following unsolicited account in Le Temps *on October 14, 1920:*

Thanks to M. Clemenceau, the agreement has now been reached. It only remains to go before a notary for an exchange of signatures. As soon as the Senate and the Chamber of Deputies reconvene, the government will submit to them a credit plan for the building, on land belonging to the Hôtel Biron, of a special construction to house the Claude Monet gift. In this construction, which will be in the form of a rotunda, the twelve canvases will be spaced along the wall end to end, in such a way as to produce for the eye, in series, the impression of only a single canvas. The series will be separated by relatively narrow gaps, which will provide passage for those entering and leaving, or symmetrically face the entrance and exit. The glass ceiling will be high enough so that between the lower part of the glass and the canvases there

will be a space wide enough for M. Claude Monet to fill with decorative *motifs*, here and there above the gaps separating the series. The artist even intends to decorate the vestibule leading into the rotunda with a rather large composition.

Standing at the center of the room, the visitor will have the illusion of being, at the hour of noon, under a summer sun, on the islet planted with quivering bamboo that occupies the center of the water-lily pond on the artist's property at Giverny. He will see, in the middle of the little lake fed by the Epte River, the sky and its clouds reflected on the limpid mirror of calm water, in spots of azure and gold or of white tinged with pink; over the broad round leaves that carry them the water lilies will raise their corollas, now yellow, now white, now scarlet, pink, or purple. Weeping willows on the shores will at intervals lift their strong rough trunks and let their hair droop in long disconsolate threads—and one will marvel at the spectacle of this luminous enchantment, characterized by dark blue, pink and white, and green and gold harmonies.

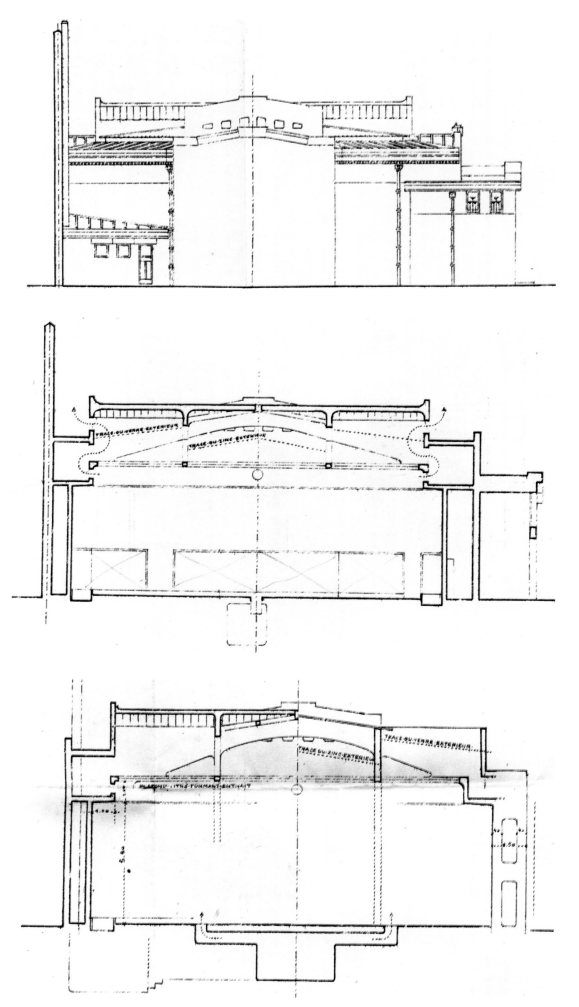

Arsène Alexandre, in an article entitled "The Epic Poem of the Water Lilies," published an additional description of the proposed setting for the paintings in Le Figaro *on October 21, 1920. Although erring in some details, Alexandre conveyed the impression of the decorative ensemble:*

One of the decorative works to befall the State in such a timely manner consists of only two canvases, predominantly blue. What vigor and devotion in this song of victory, for that is what it is, both literally and figuratively! A successful victory for the artist in the middle of the war; a commemoration of our victory, spontaneously offered by Monet to France on the very morrow of the cannons and flags of the Armistice.

This magnificent diptych in blue will form one of the extremities of the oval in which this Monet museum, next to the Rodin museum, will glory. The other end will consist of three paintings in which molten gold predominates. One of the larger sides will be silver and pink, of all the most tender freshness of the morning. The other large side will be the one where, punctuating without interrupting the dialogue of sky and water, the trunks of the willow rise like two dark votive columns beyond which stretches the mirage. These decorative paintings, placed very low, will seem to emerge from the floor, and the spectator will be, so to speak, placed not only in the middle of the lily

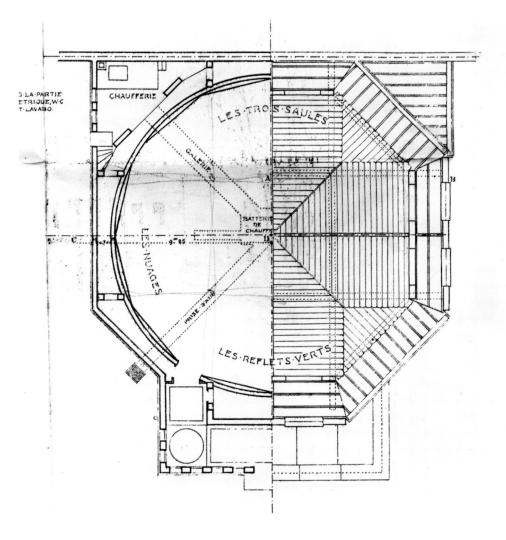

pond, from which Monet since 1903 has drawn so many exquisite small paintings, but also plunged fully into the great artist's passion for color and hundredfold dream. Such is the sum of Claude Monet's present.

Despite the good press generated by the announcement of the donation, the project had yet to come before the General Council for Public Buildings for approval. On December 23, 1920, the members convened and unanimously rejected the proposal. Below is the report of M. Girault, Inspector General of Public Buildings: Gentlemen,

The Minister of Public Education and Fine Arts has transmitted to us on the date of December 20, while asking us to report on it to the Council, a plan concerning the construction, on the vacant grounds of the Hôtel Biron, of a pavilion intended for the permanent exhibition of 12 canvases donated to the State by Claude Monet....

The economy of the projected operation is established as follows:

On the one hand: The State receives 12 large canvases from the painter Claude Monet: green reflections, clouds, three willows, etc.

On condition, on the other hand:

That the State promises to build at its own expense, on the grounds of the Hôtel Biron, the rotunda project that has been submitted to you.

It is not up to us to compare the value of what each party gives and receives, but we consider it our duty to call the Council's attention to what it will cost the State to house the Claude Monet donation....

Adhering to the custom of the Council, we refrain from expressing an opinion on the aesthetics of M. Bonnier's [Monet's architect's] plan. He indicates in his notice that he has not sought any effect that might prejudice the architecture of the Hôtel Biron. We, for our part, hope that the forbidding appearance of the exterior will be compensated by the pleasant views that the visitor will find inside.

Your reporter, however, is deeply embarrassed when it comes to formulating an opinion on the advisability of adopting the plan that has been submitted to you.

To reject it could mean to expose the State once again to uncertainty in the whole matter. To adopt it means to oblige the State, which at its own expense is going to undertake a construction of so peculiar an aesthetic, to shoulder a kind of patronage. We therefore leave the expression of this opinion to the wisdom of the Council.

Were we inclined to allow for a solution, we would advise the construction for next spring of a rotunda of wooden planks in which, under the conditions foreseen in the plan, the twelve canvases by Claude Monet would be exhibited

for a few weeks. This experiment would enlighten everyone on the arrangements to be adopted and the importance of the space taken up by the projected building on the grounds of the Hôtel Biron.

We cannot end our report without mentioning how regrettable it is that the architect of the Hôtel Biron should be dispossessed of work that, according to custom, lies within his province, and how even more regrettable that an architect should be imposed on the State over whom it will have no control. Such a requirement might be explained if the donor were building the projected pavilion at his own expense. It surpasses understanding since we are here dealing with a construction built at the expense of the State, on land belonging to the State.

It would be, in our opinion, an unfortunate precedent, and it can be predicted with certainty that a time will come when the grounds of the Hôtel Biron will be strewn with constructions built to the taste of donors.

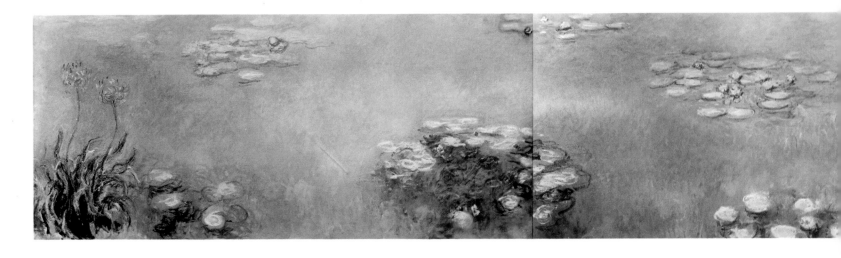

Nymphéas, to be realized within a special architectural space, according to his wishes, and the whole to be a monumental decoration dedicated to the glory of France. This agreement was secret.

Having given his promise, Monet now had to wait for Clemenceau's own plans to mature. He needed definite information about the building the *Nymphéas* were to be housed in. There was a period of marking time during which he turned his attention to smaller, one-by-two-meter versions of the *Nymphéas,* four of which were bought jointly by Durand-Ruel and Bernheim-Jeune, who showed them in Paris and New York.

If Clemenceau had stayed in power, the whole story of the *Nymphéas* might have turned out very differently. The election for the presidency was held on January 16, 1920. Clemenceau spent the following day at Giverny, where he received the news of his defeat. It seems that Monet now assumed that the grand promises on both sides were void. He began to receive approaches from collectors who had heard of his ambitious project. One of these was Tajiro Matsukata, a Japanese Maecenas, who wanted to house the decorations in Japan in a special building. Another was the Chicago collector Martin Ryerson, who, it was reported, brought along his curator and an architect.

It was the journalist Thiébault-Sisson who was responsible for resuscitating the idea of the donation. He was working on a monograph about Monet, who had lent him a file of clippings. Here Thiébault-Sisson found a letter from Clemenceau that discussed the gift to the nation. Monet warned the author that he did not want the matter made public. It would embarrass Clemenceau and disturb Monet's peace of mind: "I have always lived quietly and insist on ending my days far from these issues." Filled with well-meaning enthusiasm, Thiébault-Sisson nevertheless published the story of the decorations, concluding: "Imagine the effect they would produce reunited in the hall of the Grand Palais and ask how greatly the spectacle would increase the prestige of France throughout the world."

In spite of Monet's efforts to hush the matter up, it is clear that by the summer of 1920 negotiations were fully under way again, and there was a site in view—the grounds of the Hôtel Biron, now a museum dedicated to the work of Monet's old friend and colleague Rodin. In October it was reported in the *Bulletin de la Vie Artistique* that the administration was seeking credit from the Chambre des Députés for the construction of a special pavilion at the Hôtel Biron, and chastising the daily press for not having had the scruples to keep quiet about the negotiations. Another report in the *Bulletin de l'Art Ancien et Modern* completed the picture. The Hôtel Biron had been settled upon after Monet had offered the nation his house and the contents of his studio—but at a

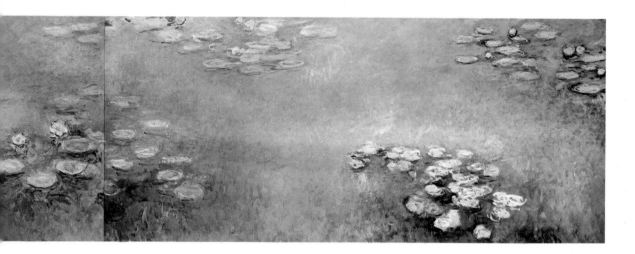

price that the administration could not afford. "They'll have to build the room
as I want it, according to my plan," Monet told René Gimpel when the latter
visited him that autumn, "and the pictures will leave my house only when I'm
satisfied with the arrangements. I'm leaving these instructions to my heirs, for
I've painted these pictures with a certain decorative aim...."

Clearly he had emerged from his mood of pessimism and was on the offen-
sive. The project he had been absorbed with for twenty years was on the point
of realization. The old independent was not going to let the government off a
hook it seemed finally to have swallowed. He knew exactly what he wanted by
way of a building, and he had chosen the sequences of panels that were to be
hung. His plan included a decorative frieze with a *motif* of wisteria to go above
the doors, and parts of this were already painted when the Duc de Trévise, an
amateur and also a member of the Chambre des Députés, visited Giverny on
Monet's eightieth birthday. But the government was not to get anything for
nothing. A certain whiff of vengeance hangs over the fact that at this time
Monet negotiated the sale to the state of the *Femmes au Jardin* of 1866, the
treasured reject from the Salon of the following year, for the staggering sum
of 200,000 francs. This, he told Gimpel, was in compensation for the "gift" of the
Nymphéas. It may be this transaction more than anything else that trapped him
and, when the time came, forced him to compromise.

But in the winter of 1920 he seems to have been carried along on a wave of
euphoria. He warned Thiébault-Sisson, who with scant tact was assuming the
role of midwife to the whole affair, that his intervention was embarrassing to
him, and he snubbed the journalist's efforts to drum up parliamentary support.
Monet must have made enemies when he rejected an invitation to stand for
election to the Institut de France, which would have set the seal of official
recognition on his name. "I thank you, gentlemen," he claimed to have told the
representatives of the Institut who had approached him, "but I have been, I am,
and always shall be, an independent."

This, and his failing sight, which was common knowledge, were to give his
opponents—and, more significantly, Clemenceau's opponents—plenty of
ammunition to use when the time came to decide whether public money was
to be spent on the Hôtel Biron proposal. In December 1920, the moment came
when Monet's architect—it is not clear whether Monet himself commissioned
him—submitted his plans to the Conseil des Bâtiments Civils. The architect,
Louis Bonnier, occupied a senior position in the architectural hierarchy of the
Ville de Paris. He did not belong to the inner circle of government architects,
however, and this may have weighed against him. His plans for the Monet
pavilion, only recently rediscovered by Robert Gordon, called for an octagonal

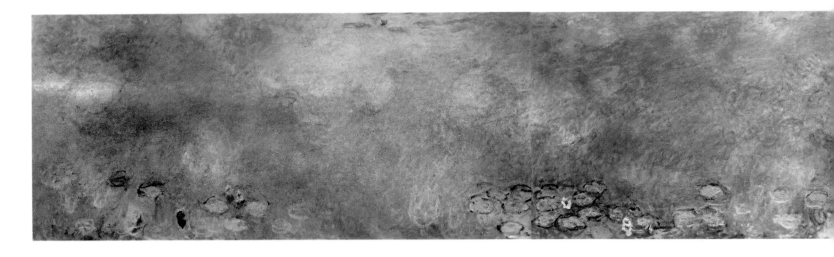

building of quite modest proportions that would be set against the boundary wall of the Hôtel Biron grounds in the northeast corner on the Rue de Varenne, more or less where Rodin's *Gates of Hell* now stand. Within the octagonal exterior of reinforced concrete was to be a circular cell to house the paintings in a line unbroken except for the entrance. The plan shows that Monet's intention was for four groups, a total of twelve panels: *Les Reflets Verts* (two panels), *Les Nuages* (three panels), *Les Trois Saules* (four panels), and a further three-panel group, possibly *Les Agapanthes.* (This was ten fewer than the final arrangement in the Orangerie.)

The plan represented the clearest expression of Monet's idea of a circular, nearly unbroken space in which the visitor could find himself totally enfolded by the paintings. Bonnier's building was estimated to cost half a million francs. The plan was rejected. It never came before the Chambre des Députés.

Clemenceau had been abroad from September 1920, traveling in the Far East seeing sights and bagging tigers. He did not get back to France until late in March 1921. We can only guess what would have happened if he had been in Paris that autumn. The *professeur d'énergie,* as Geffroy once called him, had committed his formidable strength to the project. He loved Monet deeply. His investment of *amour propre* in the *Nymphéas* was not lost on his political opponents.

The ups and downs of the affair would be comical if it were not for the terrible urgency Monet felt under the shadow of his blindness. He had come to distrust his own work. His predisposition was to distrust officialdom. One senses that the whole idea had got out of proportion, had gathered more public and political momentum than Monet had bargained for, and that he was being forced into a specificity not matched by the way things were progressing in the studio, now that the original plan for the Hôtel Biron pavilion was necessarily compromised.

Ten days after his return home Clemenceau, now aware of the disastrous state of the negotiations, launched new proposals for the Monet donation: a deal with his friends within the system. On March 31 he, Paul Léon (Minister of Fine Arts), Geffroy (now director of the state Gobelins tapestry factory), and Bonnier made a visit to the Jeu de Paume and to the Orangerie, which was then standing empty and had recently come under the administration of the fine arts. After the visit Clemenceau wrote recommending the Orangerie and advising Monet to accept it. "It appears that you have to come to Paris because of your eyes. Say when. I will be there with the others." A week later Monet spent the day with Clemenceau, inspecting the Orangerie and visiting the Louvre. Shortly afterward he wrote to Léon, giving his assent but warning that

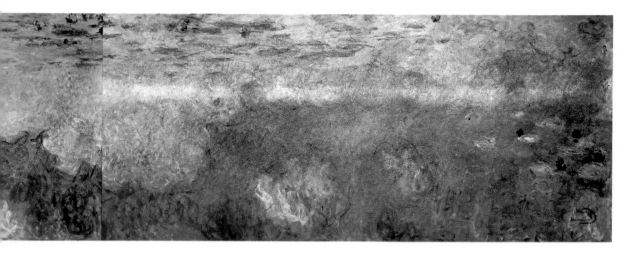

Les Nuages *(Clouds)*,
photographed in Monet's studio
between February 14 and 16, 1921

he would sign nothing until he was satisfied with the remodeling of the space, which must be of a circular or elliptical plan. If I die before it is finished, he wrote, the gift is off. But it seems that the proper reassurance about the work of remodeling was not forthcoming. A week later Monet had "ripely reflected" on the proposal and had come to the conclusion that he must withdraw his gift. He had worked on it all these years with the thought in mind of a special space in which the decoration would be shown on a concave surface. In the Orangerie the paintings would have to be shown in straight lines, and consequently everything he had wanted to do would have been perverted.

The summer must have seen prodigious diplomatic activity on the part of Clemenceau, backed by Geffroy. In November, Clemenceau writes triumphantly to Léon that he has just come back from Giverny and "everything is arranged"; Monet is pleased with the new proposals and is even prepared to enlarge on his original donation. But Monet must have a firm promise from the government in three days. A letter from Monet to Clemenceau on the same day makes the burden of his ultimatum clear. If the state will promise him a curved space, which is what he has always wanted, he will give eighteen panels instead of twelve. The number does not matter, only the quality; he adds, "I can think of nothing except this work."

Again Clemenceau reports, *"Tout est arrangé."* The deadline has been met. He and Léon will come to Giverny, bringing Bonnier. (The architect was soon to be dropped in favor of an official colleague.) Clemenceau adds in confidence that he has entered into negotiations with the Louvre for the gift of a self-portrait Monet had given him.

On December 14 Clemenceau writes to Monet that within a few days the budget for the works will have been voted and all that remains is for the donation to be formally signed. Monet is nervous, at one moment carried away with impatience, the next ready to call everything off. Clemenceau warns Léon that if he does not show signs of eagerness, Monet's goodwill will evaporate. The new architect, Camille Lefevre, the official architect in charge of the Louvre, has several consultations with Monet that result not in one space but in two large interconnecting oval spaces. Lefevre's first drawing (January 14, 1922) is not far from the present arrangement, although it gives slightly more hanging space and envisages ten panels in each room. At some time in the new year there must have been strenuous discussions with Monet, for a later drawing (March 7) gives a very different proportion between the two rooms. One space is even longer than before, while the other is smaller, a perfect egg shape with its blunt end farthest from the entrance. According to this plan there would be only one doorway between the two rooms instead of the

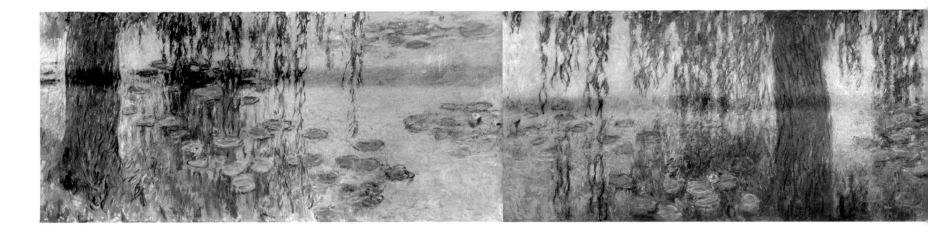

present two, and that doorway would be situated on the central axis so that from each room it would be possible to look from one gallery to the next and still find oneself in the same floating world without horizons. This was the nearest of the Orangerie plans to Monet's conception of an unbroken, continuous painted environment. It too envisaged ten panels in each room.

For whatever reason, this plan was rejected and its place taken by an earlier drawing of January 20, 1922. In this, two passages between the two rooms are offset from the central axis so there is no longer a view from one room to the other. In the inner room the ovoid plan was modified to a more regular shape with semicircular ends and straighter, although still curving, sides. The total wall area was slightly smaller and allowed for nineteen panels.

On March 10 Clemenceau announced to Monet that he planned to visit, with a draft of the contract. Apparently he got an angry telegram in reply, followed by an abject letter of apology. Léon also stalled. Finally on April 12 the document was signed by Monet and Léon, witnessed by the mayor of Vernon, the nearest town to Giverny, and a lawyer acting for the state.

The terms of the contract guaranteed the painter's right to go on working on the panels as he saw fit. The state was to exhibit them in the Orangerie according to the agreed plans. There were never to be other paintings or sculptures exhibited in the same space. The paintings were to be handed over only when the space had been made ready for them. This must take place in two years at the latest. Once the paintings were hung their arrangement must never be changed. The canvases must never be varnished.

The signing of the document allayed certain anxieties, but it must have been the cue for many new ones. Although Monet had committed himself to a total of nineteen panels he was still quite undecided about their final arrangement. The rejected plan of March 7 had shown an unbroken sequence of ten panels in the second room, Monet's last bid for his dream of complete envelopment. By returning to the earlier plan Monet was accepting a compromise. Whether this was forced on him by the architect on aesthetic grounds or on budgetary ones we do not know. In any case, this revision led to rethinking the groups of canvases and to much repainting.

The most dramatic revisions concern the two groups called *Le Matin, avec Saules Pleureurs.* Photographs of the studio showing work in progress indicate the right panel of *Le Matin II* with its weeping-willow trunk on the left end of the sequence now called *Le Matin I.* Together they would have made up the group described in the contract (and in Bonnier's drawing) as *Les Trois Saules.*

Much of this repainting is directed toward an opening-out of the spaces. The paintings become attenuated, purged of detail, as if an oceanic emptiness was

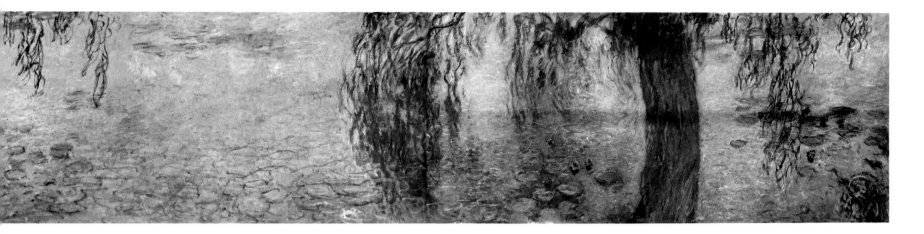

declaring itself in more and more radical terms. In the final version only hints remain of the near bank here and there. Only vestiges remain of the foreground plants whose role had once been so important. The transition from three willows to two takes Monet in this direction, stretching the empty expanse of the pond between flanking willow trunks instead of allowing it to be filled by the central figure of a triad. It was an unprecedented experiment he was involved in, and he was staking everything on its outcome; the canvases were to be glued to the walls of the Orangerie in perpetuity.

A day or two after the signing Clemenceau wrote that he was happy that at last things were settled. It was high time. But, he went on, "You are perfectly ridiculous when you tell me that you are in doubt about what you will produce. You know very well that you have reached the limit of what can be accomplished by the power of the brush and brain." No doubt Clemenceau would have liked it better if the paintings could have been handed over there and then. But he knew Monet.

That is to say, he knew Monet's temperament. Whether he understood precisely what was being attempted with the *Nymphéas* decorations is another matter. It seems doubtful whether Clemenceau or anyone else realized just how much had been given up when the Hôtel Biron project foundered. It was probably easier for Clemenceau to think about the project as a large space hung with large pictures celebrating Monet's genius than to share Monet's dream of a completely integrated environment in which the paintings' and the viewers' space interlocked. Carried along with the enthusiasm of friendship, offering every service that his energy and influence could provide, Clemenceau was in a curious way at cross purposes with Monet, who had been plunged into an agonizing reconsideration of the whole scheme, not because individual panels were "unfinished," but because the space of which they were to be part was different.

As 1922 went on Monet's eyesight rapidly declined. To his persistent doubts as to the value of his work were now added a practical and unanswerable doubt as to what his work really looked like. During the summer he engaged in a tremendous bout of destruction, knifing and burning many canvases. Clemenceau wrote him in May, reminding him that an eye operation was possible. In June Monet wrote to Léon, urging him to press forward the ratification of the agreement and to speed the work in the Orangerie so that he could supervise the hanging, explaining that his sight was getting weaker every day and that it would be painful for him not to be able to see enough any longer. In September he informed Durand-Ruel, "I've given up all work...."

Now Clemenceau urged him to agree to an operation: "There are great

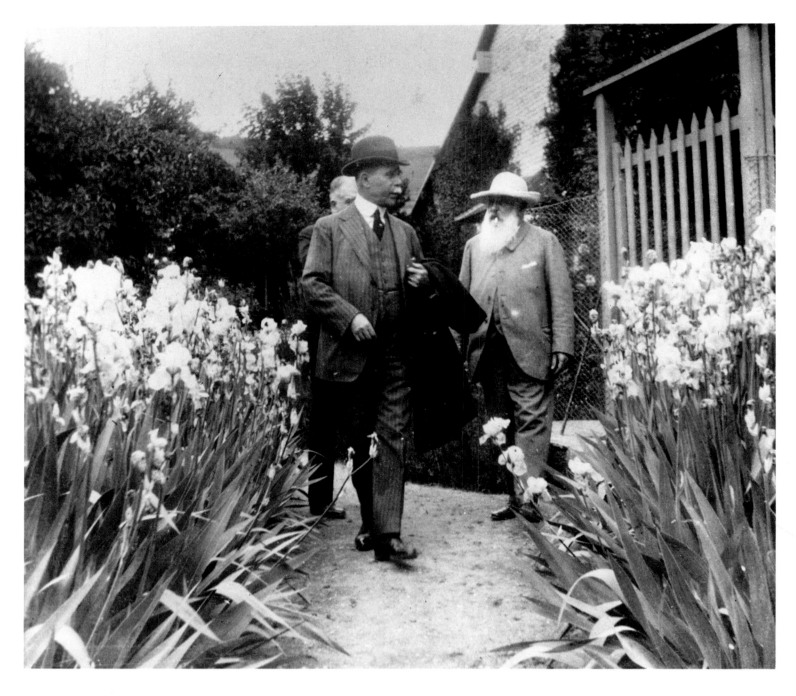

Visit of Mr. Martin A. Ryerson, Friday, June 4, 1920

With the disposition of the great decorative scheme of water-garden paintings still unresolved, Monet's dealers Durand-Ruel arranged a visit on June 4, 1920, for Martin A. Ryerson, a leading patron of the Art Institute of Chicago:
Dear Monsieur Monet,
I have just received your letter of yesterday. It is all right for Friday. I will arrive at your place by car around 2:30 with M. Ryerson, his wife, and Mme. Hutchinson, wife of the president of the

Art Institute of Chicago. The sole purpose of this visit is to see your decorative paintings. M. Ryerson will not make you any offer and will certainly not talk business. The deal could only be discussed in Chicago. You can therefore say that you have never thought of selling these decorations and that you do not have the slightest idea of what they are worth. If the deal goes through, the museum will make you an offer.

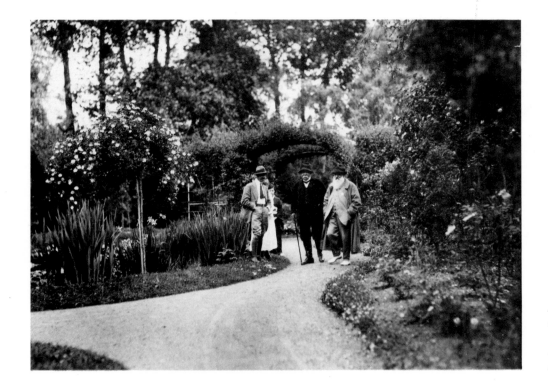

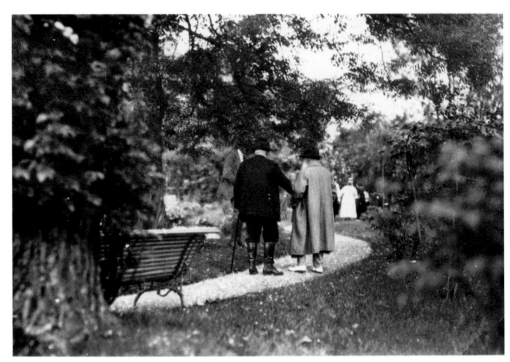

Attended by Monet's son Michel, his daughter-in-law Blanche, and a guest—Madame Kuroki—the two close friends, Monet and Clemenceau, stroll the path beside the water-lily pond in June 1921.

Delighted with the official gift to the state of the water-lily decorations signed on April 12, 1922, Clemenceau sent this warm message to Monet:
Dear friend,
The good news made me very happy, for it was time it was over. It is really a *bargain* to everyone's advantage; the artist and the receiver. I'll be damned if you owe me an ounce of gratitude in this matter. You are perfectly ridiculous when you tell me that you are in doubt about what you will produce. You know very well that you have reached the limit of what can be accomplished by the power of the brush and brain. If you were not driven at the same time by an everlasting search for the beyond, you would not be the creator of so many masterpieces, by which it was good that our France could adorn herself. If I have been able to contribute a little to it, I am glad. Until the last minute of your life, you will always try, and thus you will complete the most beautiful cycle of work.

I love you because you are you, and because you taught me how to understand light. You have thereby made me bigger. I only feel sorry for not being able to give it back to you. Paint, paint always, until the canvas bursts from it. My eyes need your color and my heart is happy with you.

resources in the impossible...." On a visit to Paris to consult with the specialist Dr. Coutela, Monet called at the Orangerie to see how the work was progressing but found, to his discouragement, nobody there and no sign of work.

The operation took place in January 1923, Coutela operating on one eye only. A second operation was intended, apparently on the same eye. This was to be done in the summer. Meanwhile by February Clemenceau was already making arrangements for Monet to meet with the architect and to review progress at the Orangerie.

By the end of the summer surgical work was complete. One can imagine Monet's feelings, bandaged, time passing, the thought of the *Nymphéas* continually on his mind. Coutela, who reported in several letters to Clemenceau, pronounced himself satisfied with the result of the operations. Monet's vision was restored—in the doctor's opinion. But for Monet there now began yet another round of torment. The first operation had restored some sight—enough to make him realize the oddness of what he had been doing in his painting before the operation. The second operation gave him improved vision, but now a series of aberrations showed themselves in his perception of color. At one point everything would look blue, then yellow. The quality of his vision changed continually: close vision improved; at a distance the color distortions were more marked. Coutela was unable to explain what was happening. Spectacles he prescribed sometimes made matters better, sometimes worse. They were, however, necessary: the lens of Monet's eye, rendered opaque by a cataract, had been removed. The eye which had not been operated on was almost entirely blind. There was another bout of destruction, reported by visitors such as the writer Marc Elder, who described seeing shattered canvases in piles. Clemenceau wrote Monet frequently, trying to calm his anxiety, to explain the phenomena, counseling patience. Monet answered that he would rather be blind than condemned to this.

But matters gradually improved. By September Monet reported that his near sight was almost perfect. He could read without difficulty. Clemenceau commended his handwriting but could offer no comfort on the question of the distorted color. He told Monet that the doctor was considering experiments with colored lenses, adding that he himself did not have any faith in the experiment. The doctor was satisfied with the general acuity of Monet's eyes, both near and far. Monet was not. His sarcasm appears to have missed its target for Coutela reports complacently that if "all nature were in black and white everything would be perfect." Coutela had evidently made tests with Monet in the studio. He did recognize that Monet demanded more of his eyes than for "ordinary life." Monet could see the palette at its normal distance, and

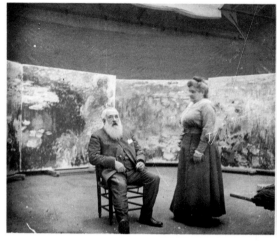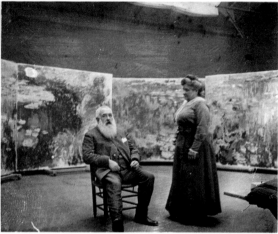

his sight was perfect at the distance at which he made his *touches,* his strokes of the brush. However, when he had made a few *touches* he habitually stepped back four or five meters, and it was then that the trouble began. At that distance, Coutela felt, what Monet saw would do very well for "a quiet bourgeois, but not enough for a man like him." Coutela concluded by recommending a further operation, on the other eye. Clemenceau passed this advice on. Clearly he was disturbed by Monet's attempts to finish the *Nymphéas* decorations—attempts made under conditions of sight that were the exact reverse of those under which he began them, although neither Monet nor Clemenceau commented on this extraordinary stroke of fate.

Then Monet found himself able to work. Things were not going too badly, he told Clemenceau, who interpreted the remark as signaling a marvelous improvement. Just before Christmas 1923 Clemenceau heard from Léon that the Orangerie would be ready by Easter as promised. He urged Monet on: "There's only one thing that matters at this moment, and that's not to do a dandelion when you want to paint a water lily." One can read between the lines of Clemenceau's teasing, invigorating, loving letters a mounting anxiety about the progress of the decoration. "A man like you is never finished with what he wants to do. Still every undertaking must have a beginning and end."

As the new year moved toward spring Monet's anxiety increased. By the beginning of March 1924 the reaction to his recent months of work had set in. After years of goading Léon into activity over the decorations, Clemenceau now undertook to argue for a postponement. Monet continued to work all summer, his vision still unstable but sufficiently improved to put talk of a further operation into the background. In October the lack of progress and Monet's continual self-denigration—there was talk of starting the whole series over—provoked an explosion from Clemenceau. He reminded Monet angrily of the promises he had exchanged with France, promises that on her part had been kept to the letter and at great expense. Clemenceau's honor and Monet's were both at stake. "First you wanted to finish some incomplete parts. It was not absolutely necessary but it was understandable. Then you conceived the absurd idea of improving the others. Who knows better than you that the painter's impressions change at every moment?"

Toward the end of that summer a young painter, André Barbier, had put Monet in touch with Jacques Mawas, an oculist who had successfully treated the painter Maurice Denis, who was also nearly blind. Mawas, using special Zeiss lenses, prescribed new spectacles for Monet that resulted in an immediate improvement. "I see colorations much better and can work with more assurance."

Monet and Blanche Hoschedé-Monet in the studio of the water-lily decorations. 1922–23

This stereoscopic photograph is a clue to the successive transformations of the painting Le Matin (Morning), *the right-hand side of which may be seen behind Monet's right shoulder. In 1917, when the work was photographed in the studio (page 230, bottom), it consisted of three large panels. By 1923, about when this photograph was made, Monet had replaced one of the panels with two square canvases designed for the ends of the composition. A later image of the painting in his studio appears on page 222. The finished work is reproduced in color on pages 252–54 as it finally was mounted in the Musée de l'Orangerie.*

The painting seen behind Monet's daughter-in-law Blanche is Reflets Verts (Green Reflections), *the diptych which Monet requested that Clemenceau offer to the Musée des Arts Décoratifs as his participation in the celebration of France's victory in World War I.*

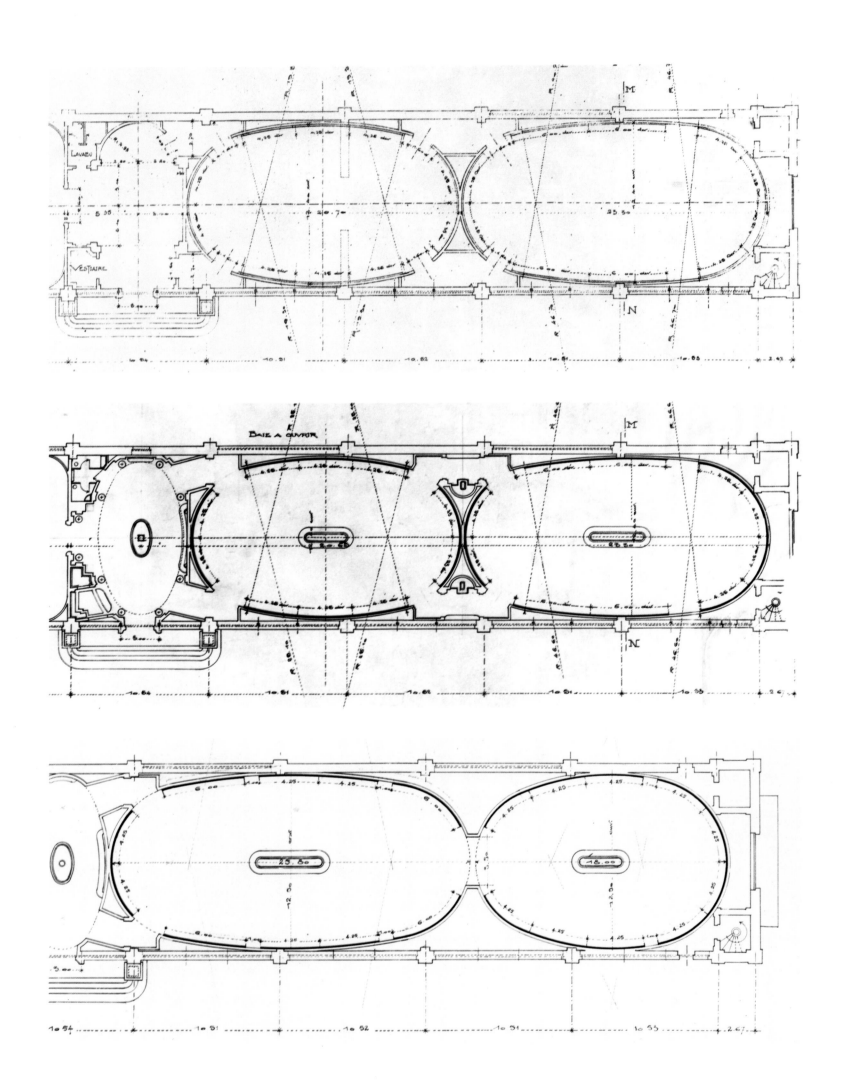

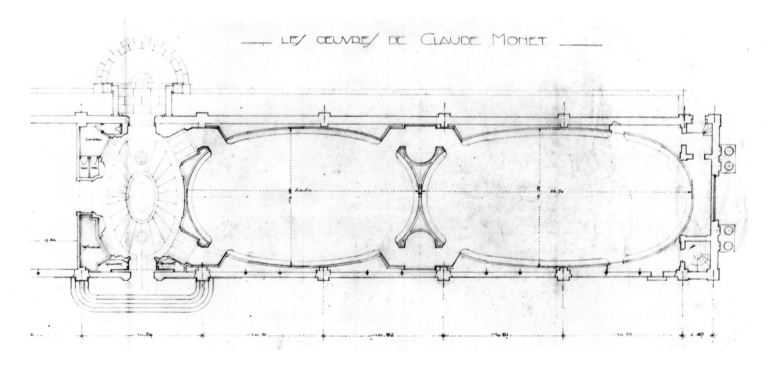

Architectural plans of the Musée de l'Orangerie: January 14, 1922; January 20, 1922; March 7, 1922; May 1927

On his return from a long voyage in the Far East, Clemenceau was briefed on the collapse of negotiations for the Monet museum in the gardens of the Hôtel Biron. He immediately threw his energy into finding the paintings another suitable site in the center of Paris. Although certainly well-meaning, he was perhaps unaware of just how much Monet had lost when the bid for the Hôtel Biron, the ideal architectural setting for his paintings, had been rejected. The following letter of March 31, 1921, from Clemenceau to Monet contains the first mention of the location eventually selected, the Orangerie:
I went this morning to visit the Jeu de Paume with Paul Léon, Geffroy, and Bonnier. Good light that can be increased at will by piercing the ceiling. Width perhaps insufficient 11 meters. We compared it with the Orangerie (near the water). 13.50 meters, that seems very good to me. The ceiling will be redone the way you want it. It will cost more than the Jeu de Paume, but Paul Léon will take care of it. I advise you to strike a bargain there.

The following series of letters and an interview, identified individually, document in part the struggle Monet faced over the succeeding years—problems with the paintings, the architectural plans, and his deteriorating eyesight and general health. Toward the end of his life he hears his good friend Clemenceau proffer some gentle taunts and renew his undying affection.
As regards the Orangerie, I'm afraid that the architect is having difficulties and that he only thinks of doing it as cheaply as possible; still he certainly ought for once to be told frankly whether or not the gift I am making deserves to have what it needs, so that my decorations may be displayed as I wish. (Monet to Clemenceau, December 8, 1921)

As soon as the weather gets a little better and the temperature drives me out of my large studio, I will invite you to lunch, but until then I want to devote all my time to my work, because afterwards who knows if I won't be completely blind. (Monet to Gaston Bernheim de Villers, March 7, 1922)

Your letter reached me at a very bad moment. For the past few days I have not been very well and unable to take care of anything except the duty I have to complete the panels that I've donated to the State, and that, unknown to everyone, is real torture for me because of the state of my eyesight. Therefore I am asking you to wait, and to keep to yourself everything I am saying to you here. (Monet to Jeanne Baudot, February 29, 1924)

What do you think? *I* don't know. I can't understand it. It keeps me awake. At night I'm constantly haunted by what I'm trying to achieve. I get up exhausted every morning. The dawning day gives me back my courage. But my anxiety comes back as soon as I set foot in my studio. *I* don't know....Painting is so difficult. And a torture. Last fall I burned six canvases along with the dead leaves from my garden. It's hopeless. Still I wouldn't want to die before saying all that I have to say, or at least having tried to say it. And my days are numbered. (Monet in an interview by René Delange, c. 1922–23)

I warn you that I must be free at ten o'clock, being in the middle of my work and happy as never before. For since your last visit my sight has completely improved. I work as I have never worked, am pleased with what I'm doing, and if the new glasses are better still, then I only ask to live to be a hundred. (Monet to André Barbier, July 17, 1925)

Excuse me, but, taken up by work, I forget everything, being so happy to have at last regained the sight of colors. It is a real resurrection. (Monet to Gaston Bernheim de Villers, October 6, 1925)

Your good letter seems to show a good state of physical and moral health. That is all I need. If you were paralyzed in both arms, you would paint with your nose. (Clemenceau to Monet, January 9, 1926)

Visit yesterday with Monet, whom I found failing. The human machine cracks on all sides. He is stoical and even cheerful at times. His panels are finished and will not be touched any more. But it is more than he can do to let them go. The best thing is to let him live from day to day. (Clemenceau to a friend, April 5, 1926)

My dear old friend,
You are a pretty good fellow, despite your countless faults. Your letter brought me a joy that expressed itself by disordered gestures, for I could see that you were finally on the rebound. I was sure that in your incoherent skull you had a dose of elasticity.

...As for your paintings, I don't doubt that you have some new idea in your head. But I think it would be wise to give you time to change it, the way you constantly do. You could promise them to China and give them to Santo Domingo with the obligation to exhibit them in Java in a room without windows. As long as you agitate such ideas, I'm not worried. It means you're in good health.

...I am as crazy as you but it's not the same craziness. That's why we'll get along well together until the end. (Clemenceau to Monet, September 21, 1926)

Monet and the willows panels

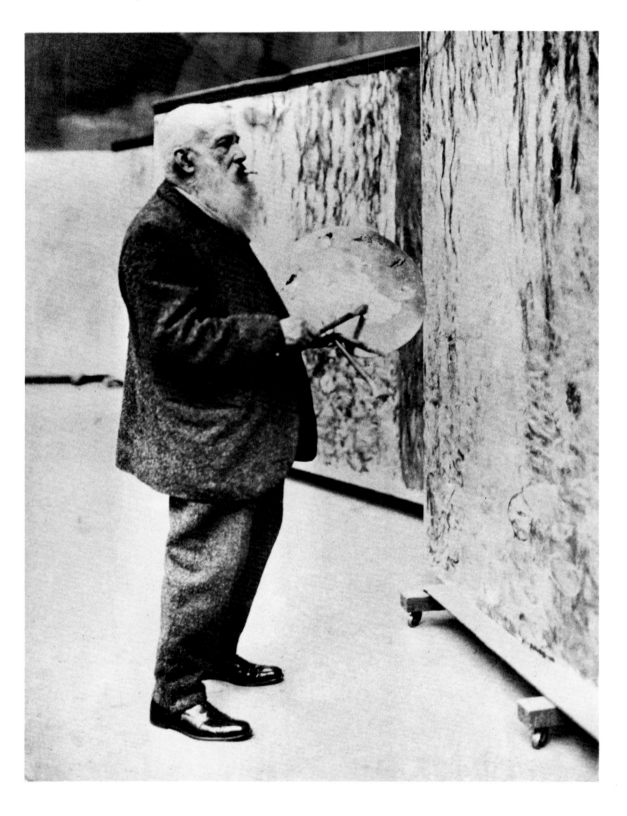

The Water-Lily Decorations

Étienne Clémentel, France's Minister of Commerce from 1915 to 1919, first came to visit Monet with Georges Clemenceau. A close friendship developed, and on several occasions the Minister was able to render great service to the painter: securing permission for Monet to circulate freely in his car during wartime; facilitating the transport of the large canvases destined for the water lilies from Paris despite reluctant railroad officials; obtaining coal to heat the vast studio; and, when the painter's supplier ran out, procuring oils so that Monet might continue to paint.

A great amateur of photography, Clémentel was the first to capture Monet and his gardens in color. The originals from which these single images were made are stereoscopic autochromes.

Monet and his gardens. c. 1917

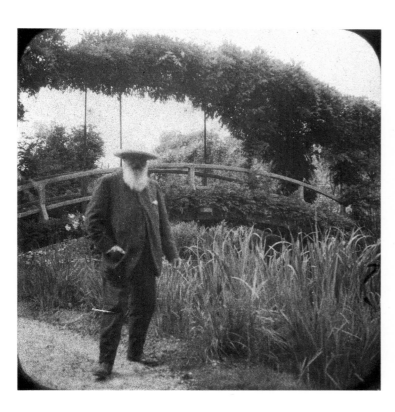

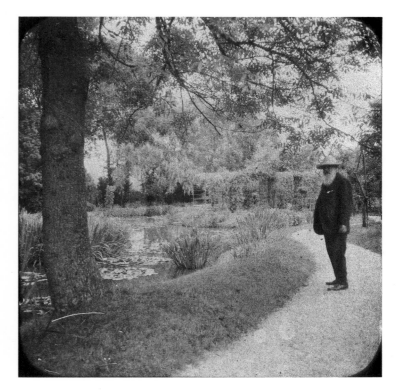

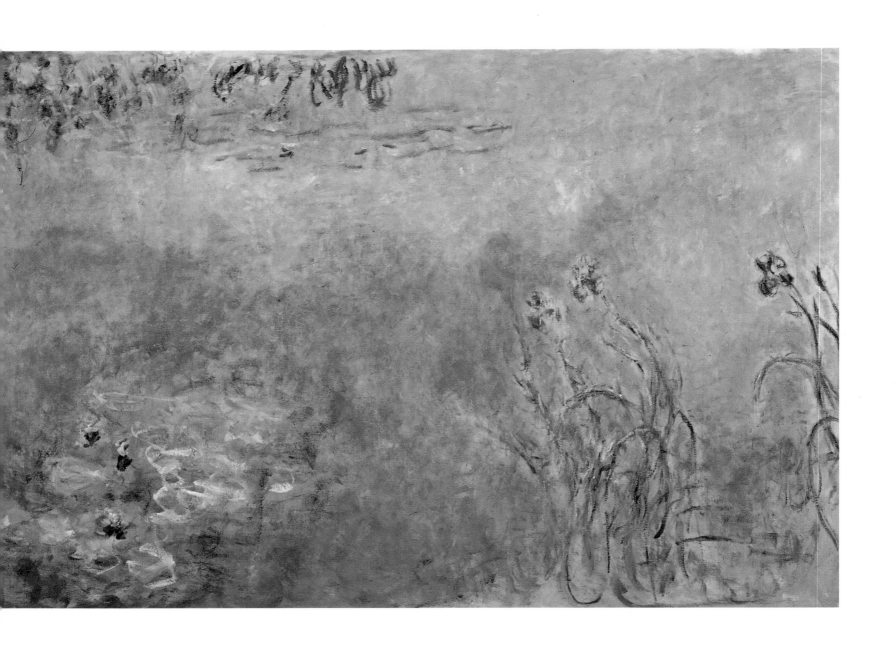

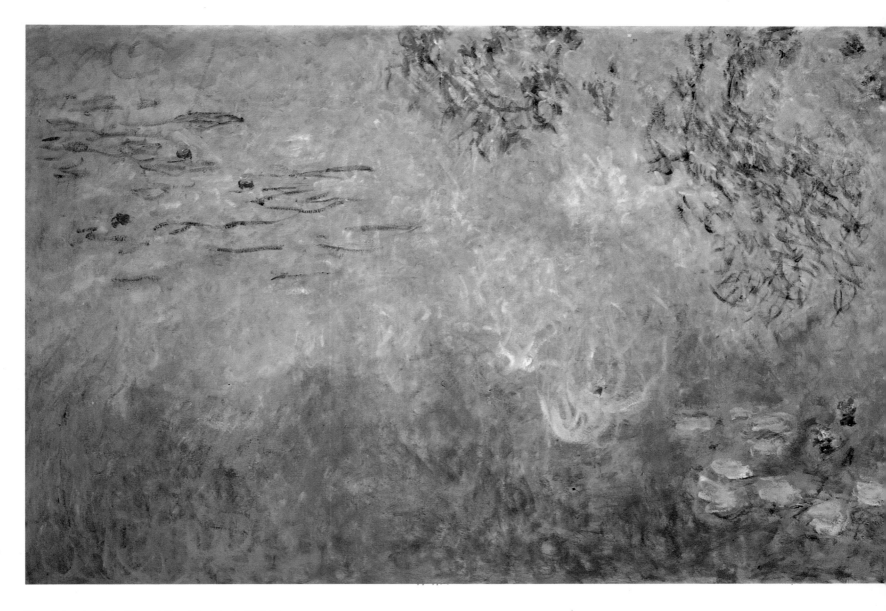

Nymphéas. Les Iris *(Water Lilies. The Irises)*. 1916–23

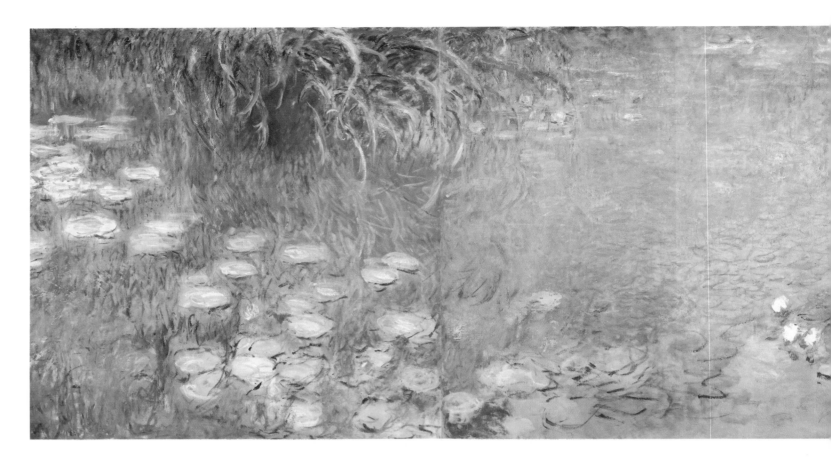

Le Matin *(Morning).* 1916–26

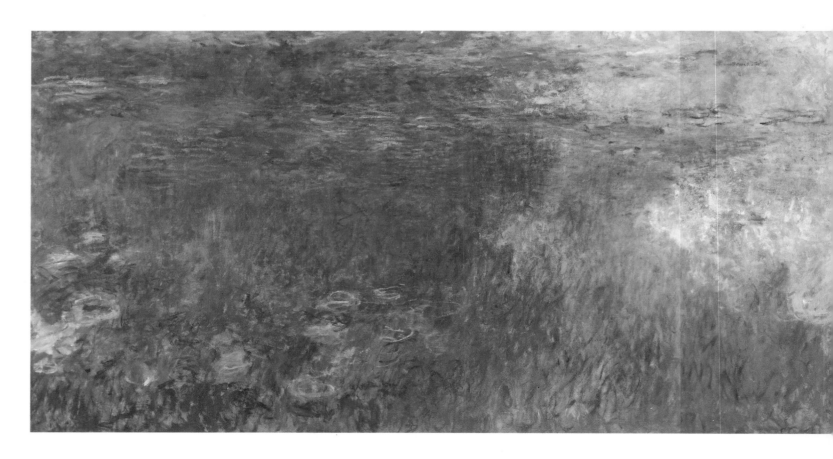

Les Nuages *(Clouds).* 1916–26

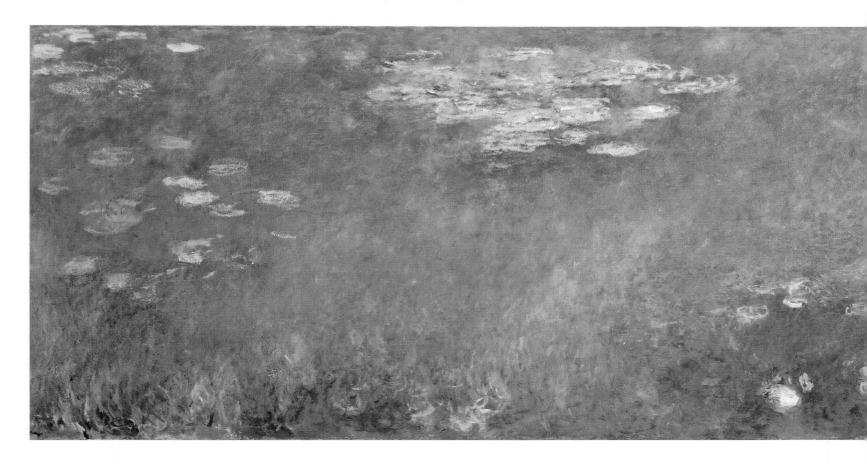

Nymphéas (formerly Agapanthes) *(Water Lilies* [formerly *Agapanthus]). 1916–26*

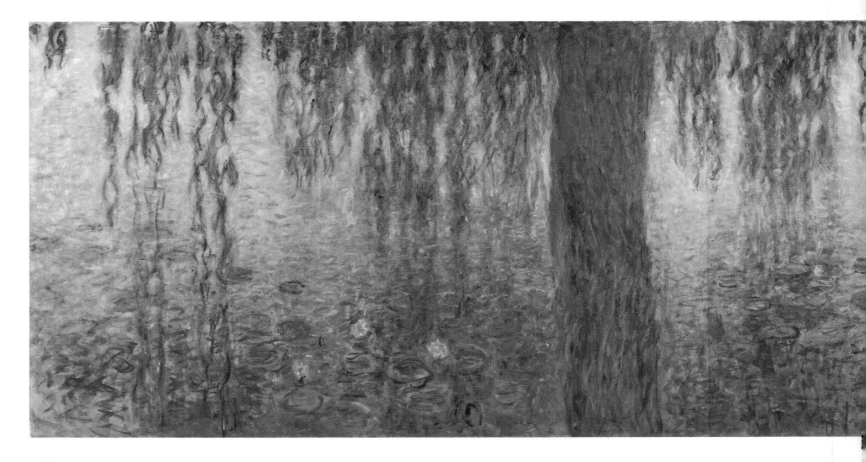

Le Matin, avec Saules Pleureurs *(Morning with Weeping Willows). 1916–26*

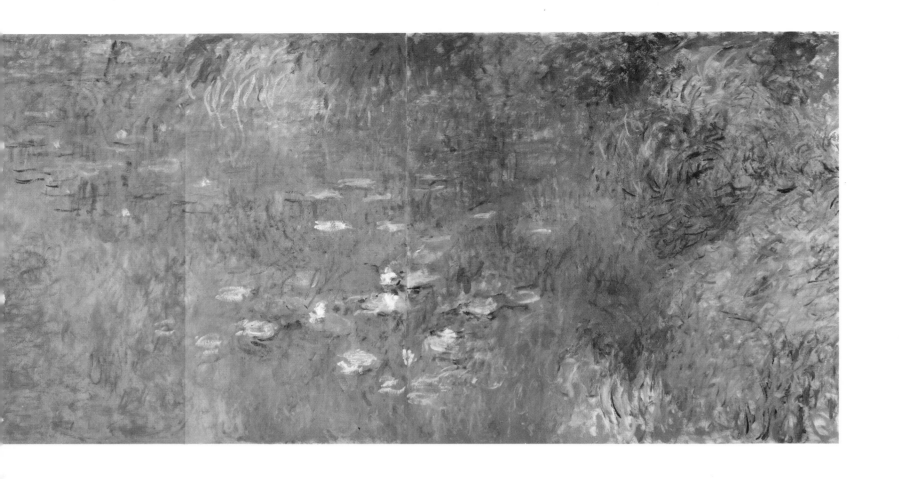

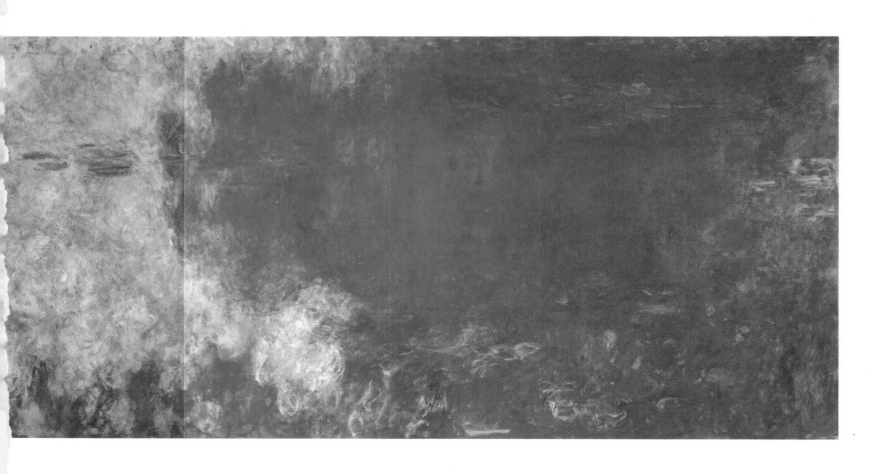

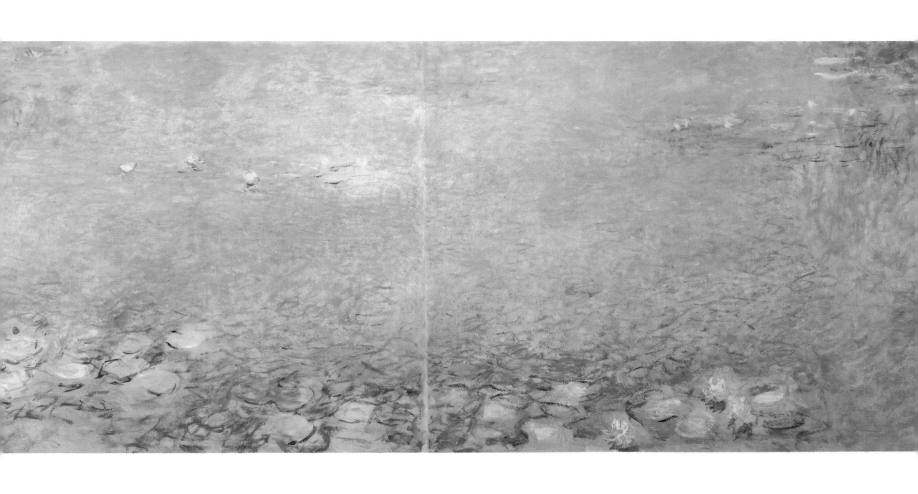

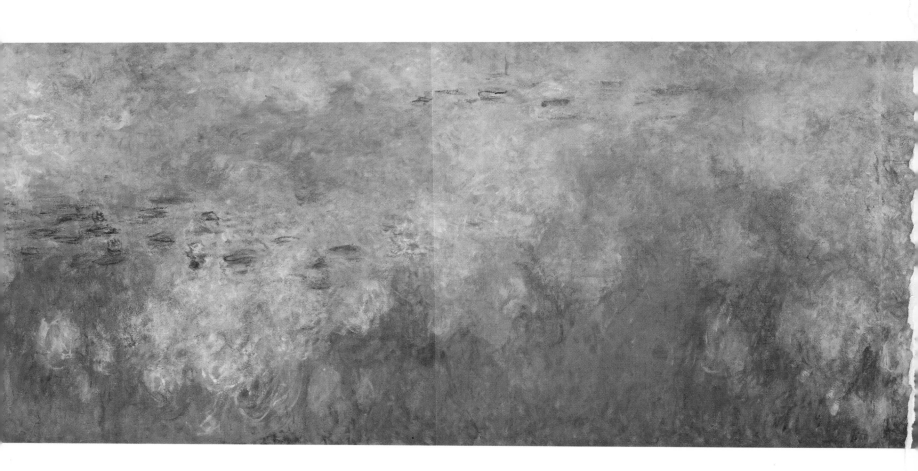

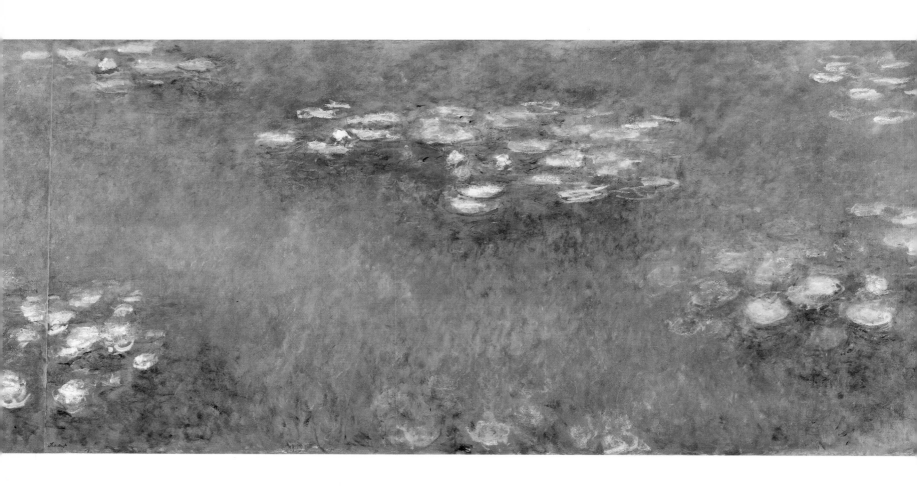

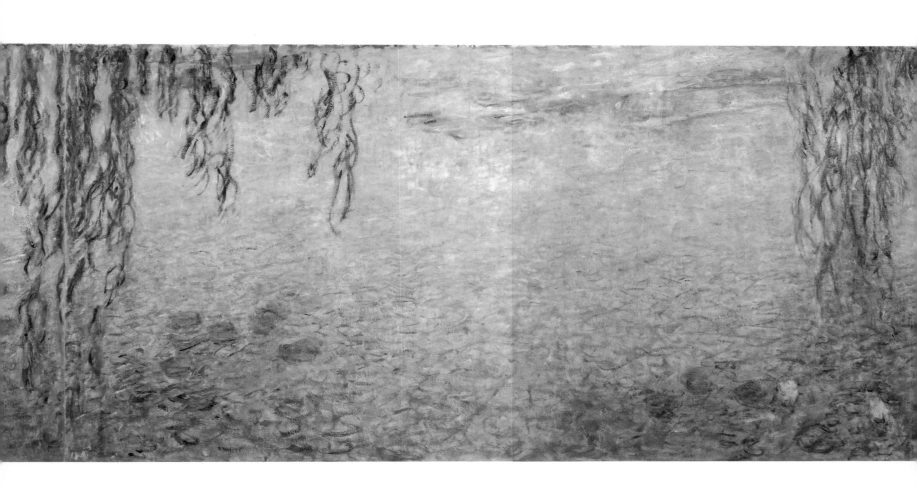

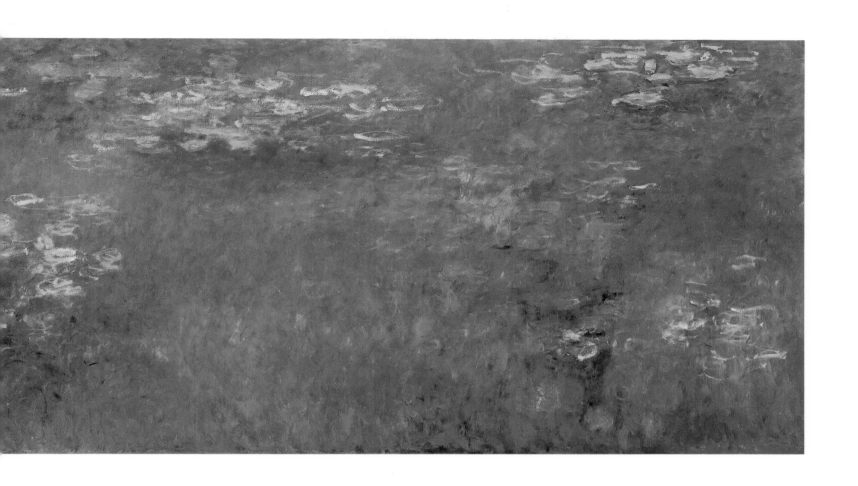

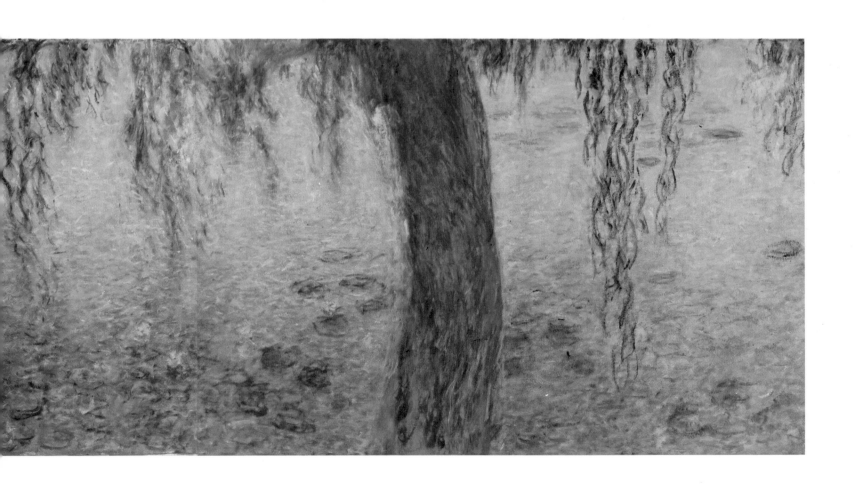

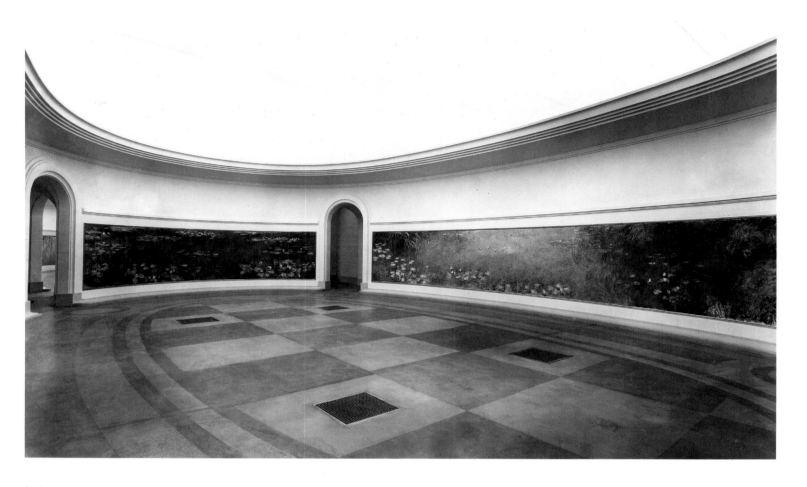

Le Matin and Reflets Verts *(Morning* and *Green Reflections)* in Room I of the Musée de l'Orangerie

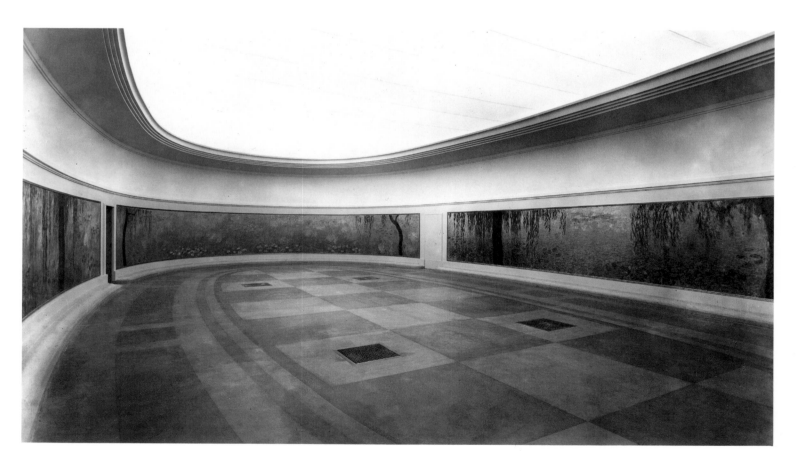

Les Deux Saules *(Two Weeping Willows)* on the far wall, and on each side compositions entitled Le Matin, avec Saules Pleureurs *(Morning with Weeping Willows)* in Room II of the Musée de l'Orangerie

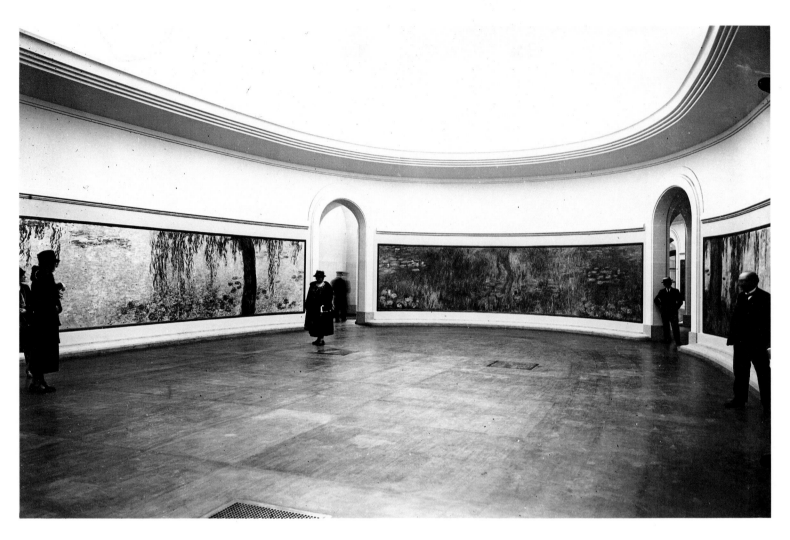

Reflets d'Arbres *(Reflections of Trees)* on the far wall, and on each side weeping-willow compositions in Room II of the Musée de l'Orangerie

Had this improvement shown Monet aspects of his work he had not seen before? The first hopeful response was followed by a tremendous reaction. Clemenceau had encouraging news in December; then in January 1925, without warning Clemenceau, Monet wrote to Léon, renouncing the decorations. Clemenceau, offended and outraged, washed his hands of the whole affair. If Léon mentioned the decorations to him, Clemenceau wrote furiously to Blanche, he would refer him to Monet. By March Monet was still trying to extricate himself and was thinking of compensating the state by offering his own collection, which included paintings by Cézanne.

The drama moved into its final act that summer. Both men from their different perspectives had probably decided that the decorations would never leave the studio as long as Monet was alive. The painter enjoyed a long period of amelioration during the summer, and Blanche was able to report that he was working at full force. In July Monet told Clemenceau that he could see better now with one eye than he used to with two. He would like to live to be a hundred, he told Barbier.

He worked all through that summer, making the final moves on the decorations. Then during the winter of 1925–26 he began to fail. When the summer came again he was not painting but thinking only of his garden. He could no longer enjoy eating. The cigarettes he had smoked incessantly all his adult life now choked him. He was dying of cancer. He died on December 5, Clemenceau at his side.

From the beginning Monet wanted a vestibule integrated into the architectural plans of his museum to act as a transition from the outside world to the "refuge of peaceful meditation" offered by the paintings. Respecting this desire, Camille Lefevre, architect of the Louvre, created that space for the Orangerie museum. The vestibule was destroyed in transformations imposed by a later donation to the museum.

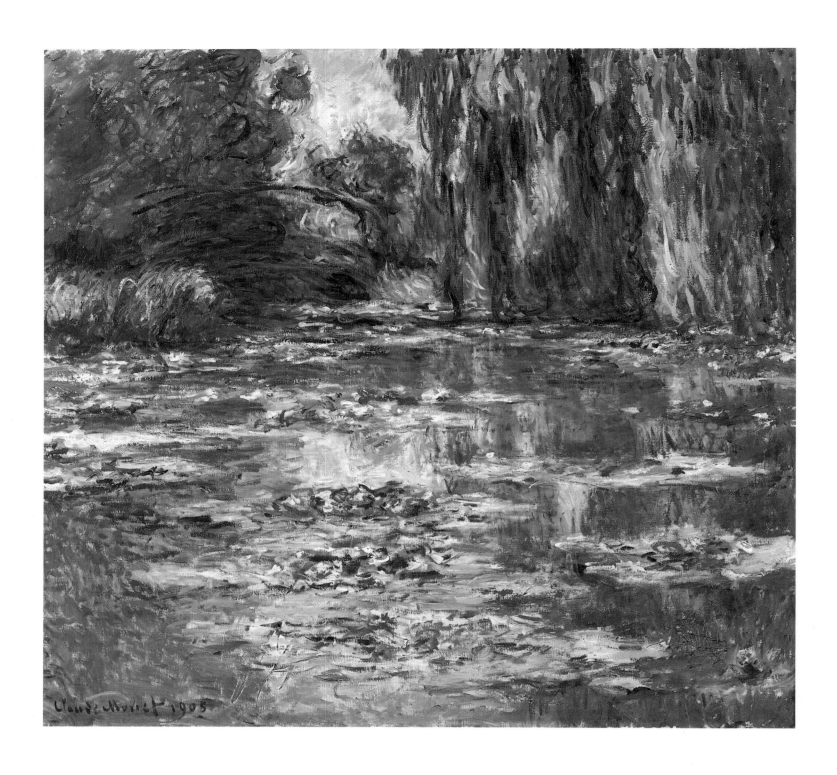

Les Nymphéas, Paysage d'Eau *(Water Lilies)*. 1905

For Monet his garden became a world, standing in for every landscape he had ever explored. He could find within it every intimation of shelter and of infinity he had asked of any *motif.*

His earlier paintings of the Japanese bridge are on canvases that are nearly square—the typical size is 89 by 92 cm—that is to say, very close to a shape that is symmetrical and motionless. In most of them the main form of the bridge springs from near the center point of the side of the canvas, dividing it into equal parts. Its reflection is always in evidence, whether as an unbroken curve or as a dark hint between the lily pads. In any case its presence is felt, rounding the lower half of the picture, implying a truncated ellipse.

Within the narrow compass of this series there are two versions. The paintings dated 1899 are the most symmetrical. The arch spans the canvas from side to side and in at least three versions is cut by the edge of the canvas on both sides, showing no attachment to the bank. These are the paintings in which the answering curve of the bridge's reflection is most in evidence. They are flat in their structure, frontal. In the others a bushy thicket of water iris and pampas grass thrusts in on the left, supporting the springing of the arch like a bracket and locating it in relation to the plane of the water.

The 1900 paintings all show more of the left bank, sometimes even including the path and the profuse growth of pampas grass in the immediate foreground, the pond glimpsed beyond it. The bridge is no longer centered. In at least two canvases it is cut off before it begins its return curve to the right bank.

The pond is bounded by trees, notably the big weeping willow. Only occasionally is the sky glimpsed beyond them. One senses Monet's attention drawn more and more downward, finding the sky in the surface of the water. The trees and their reflections give a vertical order to his brushstrokes, across which floats the horizontal order of the lilies. The sense of enclosure, of which the truncated ellipses of the bridge and its reflection is both condition and emblem, is partnered by its opposite: a sense of endless proliferation, of limitlessness. The pale-cerulean bridge in the Metropolitan's *Le Bassin aux Nymphéas* hangs there in absolute stillness. The curved opening it makes on the canvas is like an apparition or mirage: we know nothing about the bridge as a fact, where it is going to or coming from—it is as spectral as its reflection. Yet this hovering ellipse is irrefutably in front of us, a window onto distance. The water lilies in their ordered flotillas evoke those rare times when the sky is marked out in perspective by small clouds. There is something minute about the picture too, and it carries over the buzzing details of summer into its iridescence, its glittering grain.

In other pictures in this series the movement of the sun sets up violent con-

With a painter who slashes his canvases and weeps, who dies of rage in front of his painting, there is hope.
 Georges Clemenceau

In a conversation with Marc Elder published in 1924, Monet recalled:
It took me some time to understand my water lilies....I had planted them for the pleasure of it; I was growing them without thinking of painting them. A landscape doesn't get under your skin in one day. And then all of a sudden I had the revelation of how enchanting my pond was. I took up my palette. Since then I've hardly had any other subject.

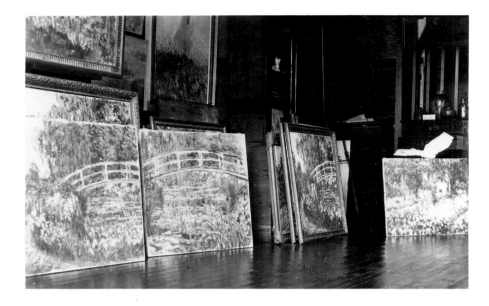

trasts. In Chicago's *Le Bassin aux Nymphéas* the trees are in a deep shadow dominated by purples and gloomy reds. The bridge leaps blackly. The light is descending vertically, hammering streaks of yellow down one edge of the weeping willow, making the tops of the pampas grass glitter, flaring onto the far water lilies. Everything is pushed to its limit. The drama of the light gains potency from the fact that we cannot see its source but only its effect on the closed area of the pond and its circling trees. The sky looms elsewhere, a controlling, invisible presence.

These opposite qualities of closure and expanse persist. The garden thrives. The series started in 1903 and finally shown in 1909 as *Les Nymphéas, Paysages d'Eau* is committed to the surface of the pond itself. Only rarely does even the far bank enter at the top of the canvas. Trees, sky, the light of day are found simultaneously, condensed, within the water's surface. The lilies are the only presences of the first order. They define the otherwise invisible water. Their placement is locked into the reflected shapes of the weeping willow and its shades. It is as though we could see in a single image those mental processes by which the immediate present is steadied and given meaning by memory and reflection.

As with the Japanese bridges the earlier paintings of this series are on squarish canvases, and there is at least one that is actually square. Against the decorative frontality of this shape the water lilies drift in perspective, often in a diagonal rank across one corner of the canvas, implying a turning of the edge. There is a group of five in this series that are on round canvases, as if to rehearse in miniature the condition of curvature that was at the back of Monet's mind.

Toward the end of the series he becomes preoccupied with the shape of the reflected sky between the willows, a wobbly, flaming shape like a decayed pyramid—almost an exact repetition of the shape of the pyramid rock that had featured in various canvases from the season in Belle-Île in 1886. (This is not the only example of a shape discovered at other times and other places reentering his work in a new role.) As this theme develops he turns to taller canvases, the final group being around one meter high and 73 cm wide. He is looking down more steeply into the pond. In *Les Nymphéas, Paysage d'Eau* the trees are made of browns and purples streaked with red. The sky is based on a deep orange over which is scumbled a paler, more acid and opaque yellow. The water lilies drift across, hardly touched by the fiery events overhead, rafts of deep cool green and shadowy blue. The strange shape of the sky twists the eye back to the top of the picture, its shaggy apex glowing with the hottest color. By its shape it reads as a strange perspective, leaping to the top of the

canvas, drawing the eye back and along to its glowing climax. At the same time it is a reflection: up is down. The farthest sky is at the foot of the canvas; the nearest water lilies are floating over it.

We notice a change in these paintings in both the color structure and the handling. They read more broadly in terms of interlocking areas of light and dark. The fine-textured palette of the squarer *Nymphéas* has become broader in its intervals. The brushstrokes are long and raking, carrying color across the picture surface, never hesitating over details. The lilies are often whipped in as if by a spinning wrist. Sometimes an ellipse of pure alizarin or ultramarine will be inscribed on top of an area of green, reading as a general notation for a leaf.

These features underline a more synthetic quality common to the vertical *Paysages d'Eau.* The ingredients of each painting, from the profile of the reflected trees to the constellation of lily pads, are virtually identical.

On the other hand, although all of this series is of an vertical format, the ratios of the canvas are not uniform at all, ranging from 92 cm by 81 cm at the broadest to 105 cm by 73 cm at the narrowest. Identical compositions are fitted into these shapes with great consistency—stretched out in the broad ones, compressed in the narrow ones, but always there in all their features, even down to the apparent accidents of cut on the left edge of the canvas. Would one not expect a broader canvas to include a wider field?

Monet returned to the *Nymphéas* theme in the spring of 1914. By the summer he was so deeply involved in it that he refused an invitation to Paris to the opening of the Camondo bequest at the Louvre, an important occasion that saw the entry of fourteen of his paintings to the national collection. His letter of regret was published in the *Bulletin de la Vie Artistique:* "Impossible for me to leave just now, I am hard at work, and no matter what the weather, I paint…. I have undertaken a large work that thrills me."

He could have added that he had undertaken a new way of working. In response to the massive scale of the project and the vagaries of his eyesight he had begun to use much larger brushes, working more openly and with a more elliptical notation, a more autonomous gesture. The brush is responsive to the direct effect of the painting, the impact and presence of the painting as a source of sensation at firsthand. Of all the phrases Monet used later to describe what had happened when he began to work on a large scale, the most telling is surely "I waited until the idea took shape, until the arrangement and composition of the *motifs* had little by little *inscribed themselves in my brain…*" (my italics). This formulation is the key to all the other issues he talks about: the disparities between what he saw near and what he saw at a distance; the fact that he could trust himself to work with the color read off the tubes; the

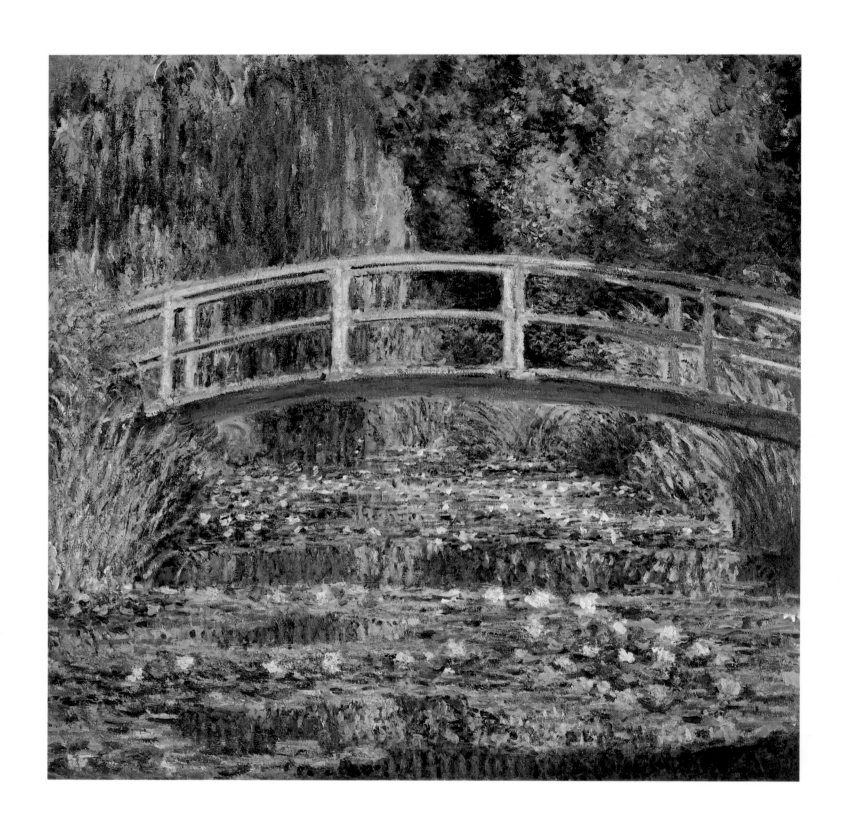

Le Bassin aux Nymphéas *(Water Lilies and Japanese Bridge)*. 1899

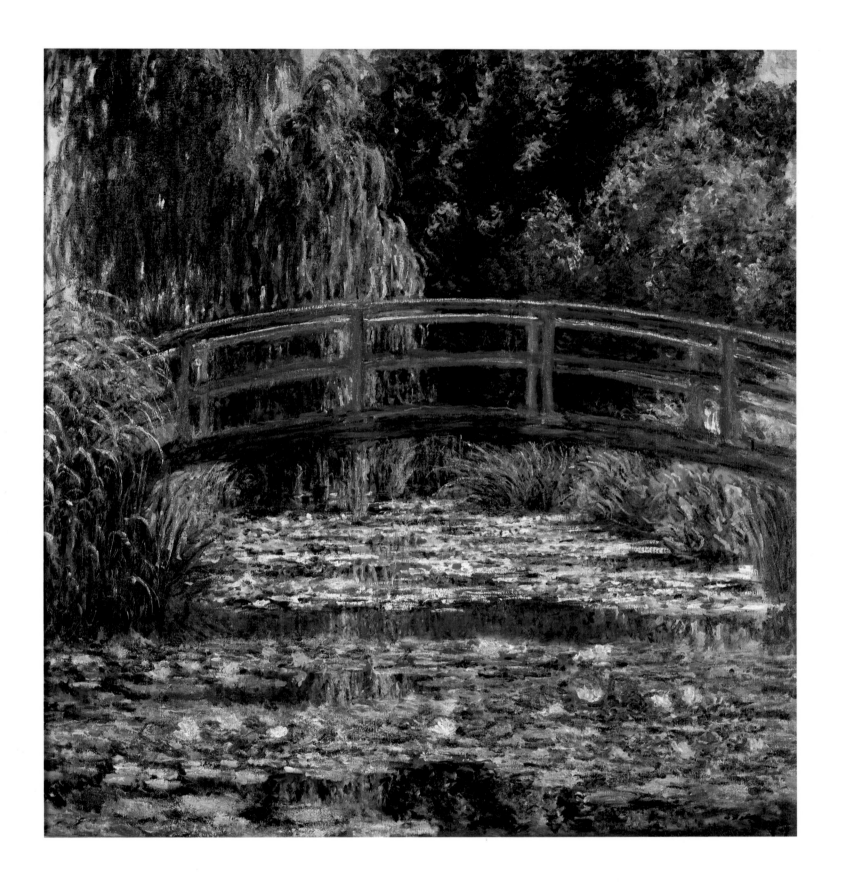

Le Bassin aux Nymphéas *(Water-Lily Pond).* 1899

Portrait of Monet in 1922, by H. B. Lachman

relationship between the decorations and the studies painted directly by the side of the pond.

The work of this period—from 1914 to his death—can be divided into several groups: first the large panels themselves; then large studies that he painted directly beside the pond and that often include plants and flowers growing on the banks as well as the pond itself; and a number of much smaller paintings constituting four series, of the weeping willow, of the rose arbor leading to the pond, of his house seen from the garden, and of the Japanese bridge, now swathed with curtains of wisteria.

He was learning to paint blind in more than one sense. The pondside studies are mostly rather large—far larger than convenient plein-air canvases that would allow the painter to see subject and painting on a comparable scale. A photograph taken in 1915 shows Monet, in the shade of an enormous umbrella, perched on a high stool in front of the six-foot canvas, at work on the sketch now in the Portland Art Museum. It is not a situation in which one can imagine him stepping back frequently, still less between each brushstroke; he is making something there at close range, a structure of color based on deep blackish greens and intense purply blues within which the blue and pink lily blossoms stand out. The brush marks are wide and sweeping. They are like a conceptualization on a grand scale of the repertoire of gestures he had had at his command for so long: long trailing streamers of paint that re-create in color the twigs of the willow, flat spinning loops of paint that float across the surface of the water, vigorous scribbling movements on an arm's-length scale, zigzags, violent *W*s.

The graphic, freestanding quality of the marks, predicated on the physical fact of the canvas at arm's length, is paralleled in the color structure. A two-meter study of agapanthus is made up of a deep green that is moved in two directions on the palette—toward yellow and toward white, warm and cool—and a deep blue that is moved toward white. The flowers of the agapanthus are dots and flecks of pink; the plant is rooted in a patch of orange soil. The whole painting is drawn in these colors, woven out of them as if out of long threads. Monet's large brushes are worked off the tip in fast, dancing movements that sometimes suggest a leaf; sometimes dance over an existing area of color, beginning to blend with it, to push it back or bring it suddenly forward into a changed condition of light; sometimes scribbling around a form as if to throw it into clearer relief, more visible to his eyes.

One can well imagine that such a painting as this was made out of a predetermined array of color ingredients—cadmium yellow, viridian, ultramarine, madder—laid out like building blocks on a scrupulously prepared palette.

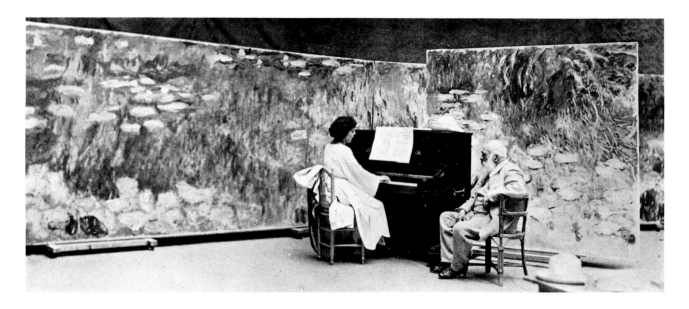

In 1922 Marguerite Namara of the Chicago Opera Company sang to Monet in the *Nymphéas* studio. Behind the singer is the diptych *Reflets Verts;* behind Monet is the left-hand panel of *Le Matin.*

Not that this in itself is an innovation. Working from a prepared palette is in the grain of nineteenth-century studio practice. Monet would have learned it in the studio from Gleyre and out-of-doors from Boudin. A half-finished painting of the early eighties of fishing boats drawn up on a beach is a lesson in prepared color structure. The whole painting is set up with a single red, a single blue, and a single yellow. Whatever the later elaborations of Monet's method, they were based on this extremely simple and logical foundation. His account of working from the labels of his tube is plausible.

Many of these pondside studies are of rafts of lily pads placed centrally within a squarish canvas, sometimes floating clear in the water, sometimes framed by the dark reflections of trees. Others focus on the growth on the bank, fringes of irises outlined against the water and reflected sky. Monet's first plan for the decoration had been to make a frieze over the top of the *Nymphéas* paintings in which long swags of wisteria would be seen against a blue sky. This frieze, which was dropped from his plans as soon as the Orangerie site was settled upon would have acted as a transparent frame for the pond paintings, reconstructing in real space the conditions if not the view from the Japanese bridge: upward through heavy fringes to the sky, downward to the water and its reflected world. It is a place that is being made, not a viewpoint; a world that has the concrete dimensions of a real location. The wisteria frieze would have provided a boundary of sorts. Many of the pondside studies of iris and agapanthus clumped at Monet's feet or snaking out over the water suggest a fencing off of the expanse of the pond. The iris panel now in Zurich gives a suggestion of this line of thought: irises are silhouetted in the lower right corner, and fronds of foliage trail down from above. It is as though we are seeing the vast muted surface of the pond between half-closed eyelids or through a tress of hair.

How *outward* one of his canvases from the seventies would look if we could see it in the company of one of the decorations—a vivid aperture, packed with data! His questioning, measuring eye, as sharp as a bird's, would be felt in every transition. The paradox is that the late canvases, for all their overwhelming scale, enclose us in an interior world. We are drawn into a vastness as of the mind's eye; their objective dimensions are no more than the device that precipitates the plunge. As we move through their spaces it is less a movement "out there" that we rehearse than a movement "here," within the corridors of our dream.

There are three orders of form in the water: the water lilies themselves floating on its surface, the weeds and the murky underwater growths of the water lilies, and the reflections of trees and sky. Lilies and reflections are in a

Le Bassin aux Nymphéas
(A Bridge over a Pool of Water Lilies). 1899

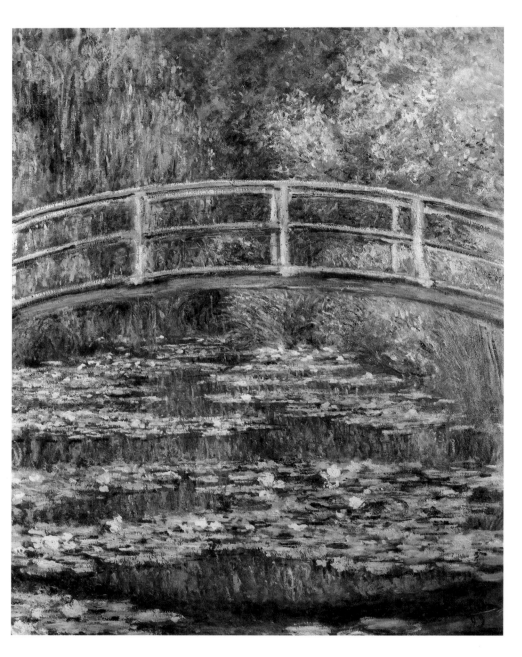

Le Bassin aux Nymphéas, et Sentier au Bord de
l'Eau *(Water-Lily Pond and Path Along the
Water).* 1900

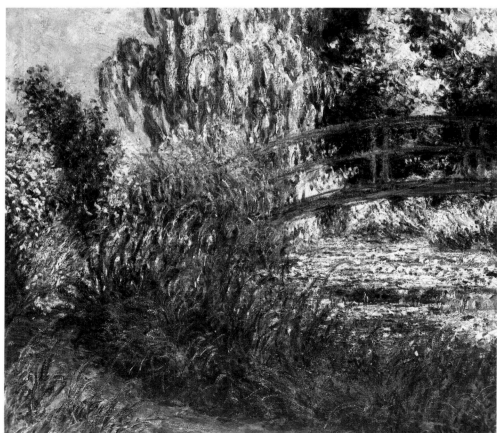

OPPOSITE, ABOVE: Le Bassin aux Nymphéas
(Water-Lily Pond). 1899

OPPOSITE, BELOW: Le Bassin aux Nymphéas
(Pool of Water Lilies). 1900

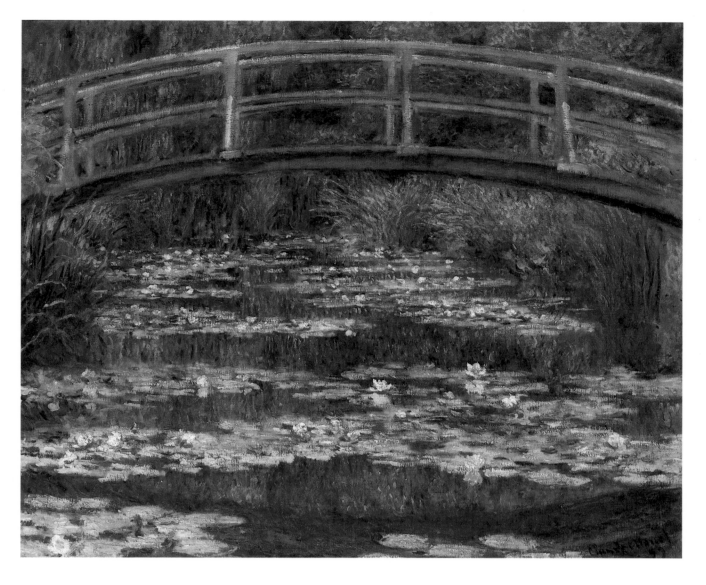

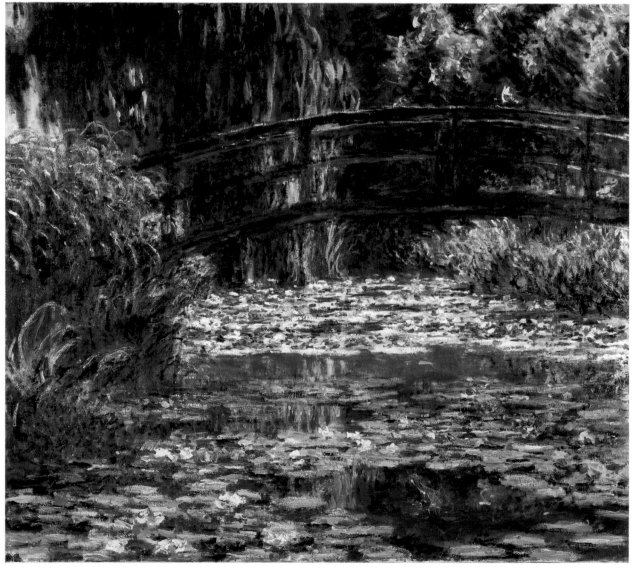

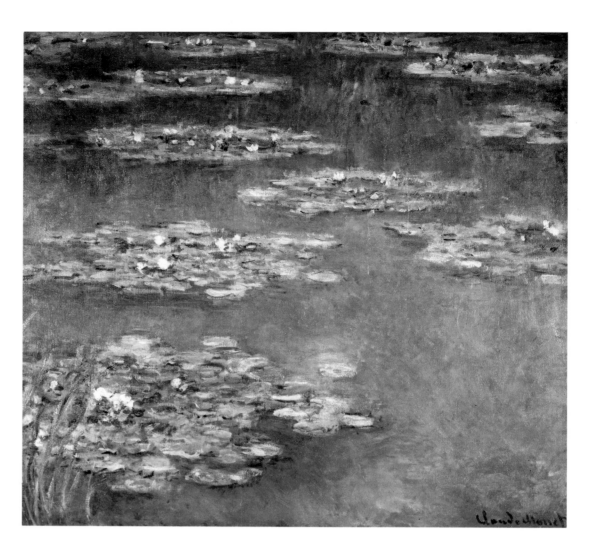

Les Nymphéas, Paysage d'Eau
(Water Lilies). 1907

continuous interaction, the lilies marking out a consistent plane from front to back, the reflections cutting into the plane from above, carving it into dark and light masses, introducing clouds. Monet tightens his grip on perspective when he wants to affirm the surface and relaxes it when he wants to promote the fusion of surface and reflection. An extreme example of the emphasis of the pond's surface is on one of the panels in which the lilies are composed in ordered flotillas that stream back in fast, almost anamorphic perspective. The leaves themselves foreshorten markedly; at their farthest points they are mere lines on the surface, as though the water was curving away from the eye, as though the world of the pond was turning.

In the triptych in the Museum of Modern Art, New York, the perspective moves from the left panel in one long sweep toward the right, into the path of light made by the reflected sky and its conjunction with the round bushy reflection of trees. This bushy shape, which appears several times in the different versions and finally in *Les Nuages,* in the Orangerie, juts out like a symmetrical extremity from the dark mass of tree reflections that fills the right end of the composition. It has a strangely compelling presence, more definite than anything else and charged with an earlier life. We have seen this shape before, in the *Matinées* series of 1897, when it formed the main group of trees jutting in from the left. Then, in its previous existence, this shape derived from reflection; and now, a line of water lilies crosses it horizontally, appearing to split its roundness into two halves. The reading suggests an internal horizon, a reflection within a reflection, a shifted viewpoint that in a strange but inescapable way gives a second scale to the whole, opening up even more distant perspectives.

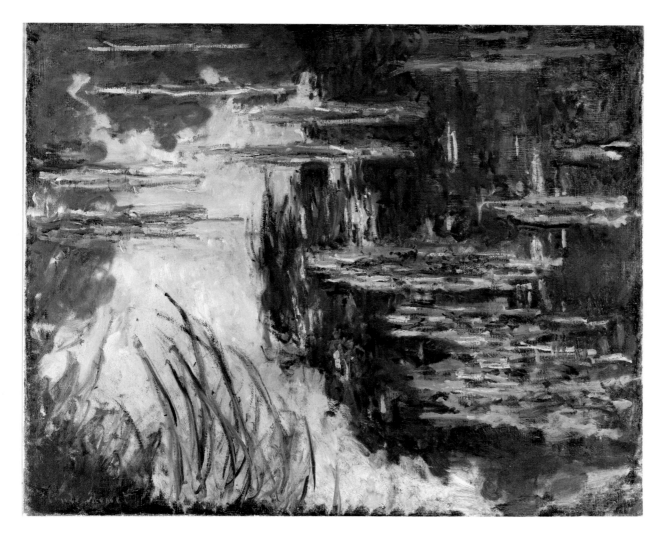

In *Les Nuages* the perspective of lilies is reduced. Less clear-cut in their patterns, they are almost lost within the surface, mere notes, indications. Priority is with the sky and its deep rosy clouds.

In other panels Monet withdraws even farther from the surface and its perspective. In the great triptych divided among Cleveland, St. Louis, and Kansas City but once reunited at the Metropolitan Museum in 1978, each raft of lilies is distributed in a somewhat regular diamond pattern stretching in every direction, perspective suppressed. (In 1921 it was the triptych of agapanthus, one of the four compositions intended for the Hôtel Biron. Monet heroically reworked the painting.) There is a warm pinkish undertone that runs through all three panels, and in the spaces between the lilies it is overlaid by a golden scumble. The water under the lilies is hollowed, shadowed with green and dark rose that move toward the top of the picture into blue and deep violet. Nowhere else is the transparency of the water more compelling. The pool is completely open to us, without bright reflections, without planar recessions, gentle, a golden shadowed hollowness rather than a depth.

In the Orangerie *Deux Saules* a pale-emerald array of lilies is lined up along the bottom edge for almost the whole length of the painting. Pink fluffy clouds line the top. The two willows—which appear to be invented—close the ends of the immensely long composition with a wandering cupping gesture toward the center. We can see them in this way only at a distance. As we draw in to the painting, which is on the end wall of the inner room, the most rapidly curving wall of all, the willows move out to the periphery of our vision, but their cupping rounding influence is still felt. To approach the curved surface of the painting is to feel oneself ushered in to the inner side of an enormous globe.

Nymphéas, Soleil Couchant
(Water Lilies, Sunset). c. 1907

271

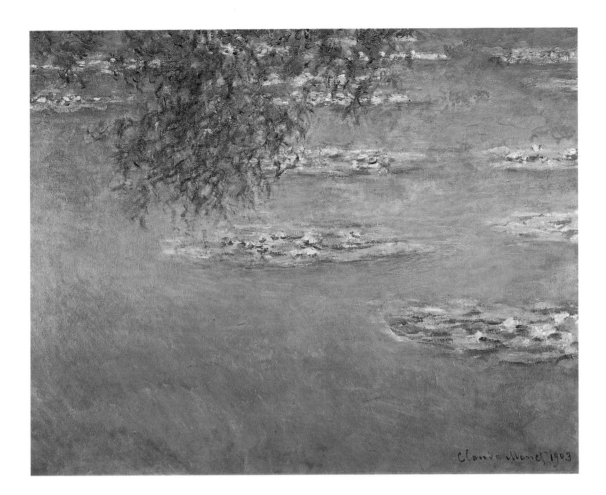

Les Nymphéas, Paysage d'Eau
(Water Lilies). 1903

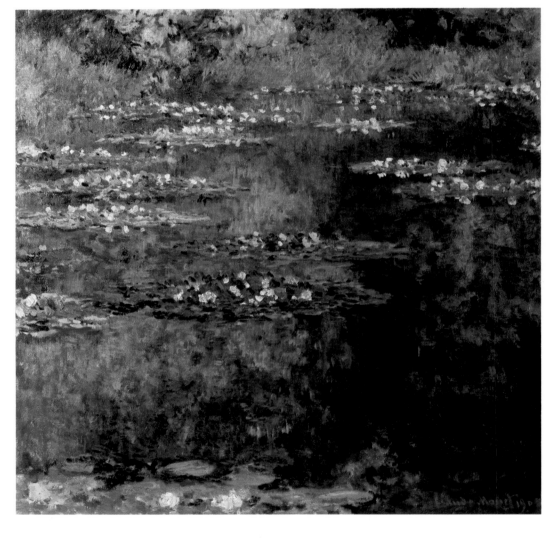

Les Nymphéas, Paysage d'Eau
(Water Lilies). 1904

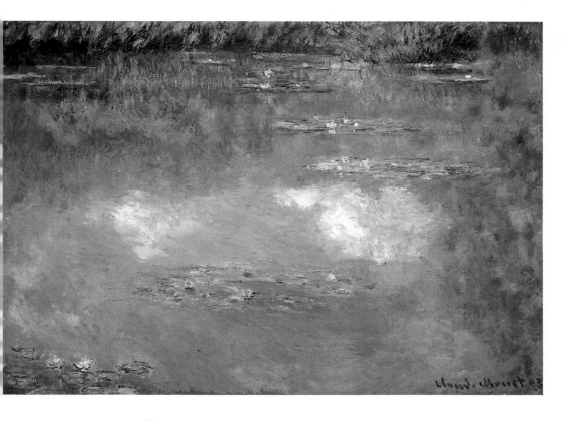

Le Bassin aux Nymphéas
(The Cloud). 1903

When The Cloud—*the painting discussed in Monet's letter of April 27, 1907, to Durand-Ruel (page 226)—appeared at the auction of the Sutton estate in 1917, spectators took it to be upside down.*

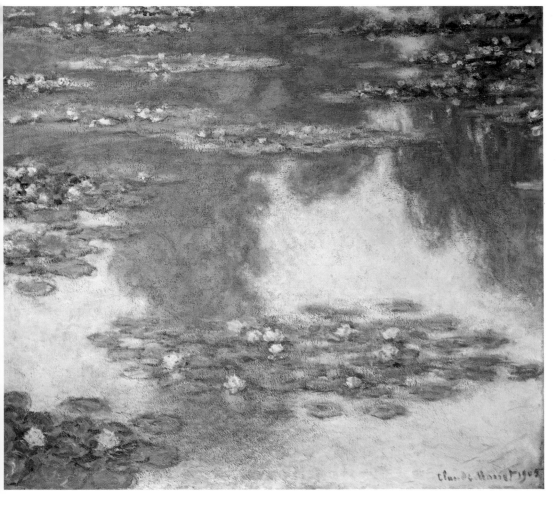

Les Nymphéas, Paysage d'Eau
(Water Lilies). 1905

Arsène Alexandre and Gérard d'Houville were two of the many enthusiastic critics at the Nymphéas *exhibition held at the Galerie Durand-Ruel in 1909. Following are excerpts from their newspaper reviews of May 7 and May 18:*
Here then, insofar as it can be explained by words, is the essence of these water landscapes. M. Claude Monet has painted the surface of the pond in a Japanese garden where water lilies bloom; but he has painted only this surface, seen in perspective, and no horizon is given to these paintings, which have no beginning or end other than the limits of the frame, but which the imagination easily extends as far as it likes. Therefore, as elements of the painting, we have only the aquatic mirror and the leaves and flowers that rest upon it—and then the reflection, dappled and infinitely varied, of the surrounding landscape, and of the sky above us. They are, in a word, paintings of reflections mingled with real objects, but which harmonize themselves with them in a marvelous and capricious diversity.

...there is in these waters the reversed reflection of unseen trees, and then at the end one gets a little dizzy and is surprised not to be walking on the ceiling and seeing upside down the people who, with us, have come to admire these somewhat magical portraits of fragile flowers, treacherous waters, changing reflections, rapid hours, and fleeting instants.

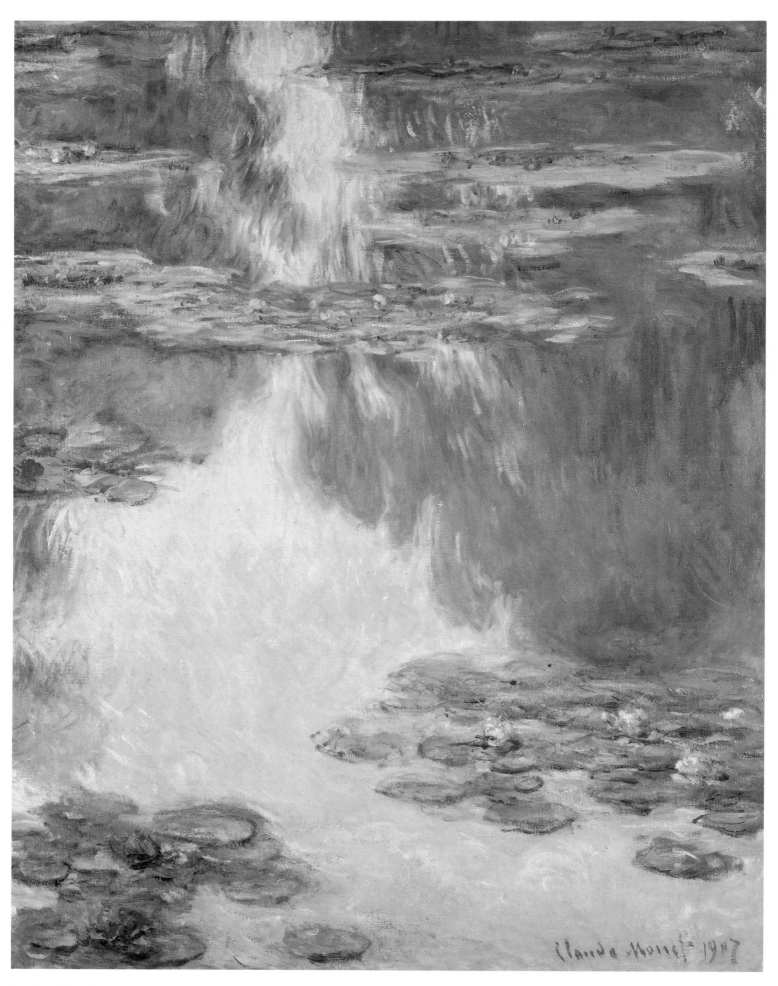

Les Nymphéas, Paysage d'Eau *(Water Lilies).* 1907

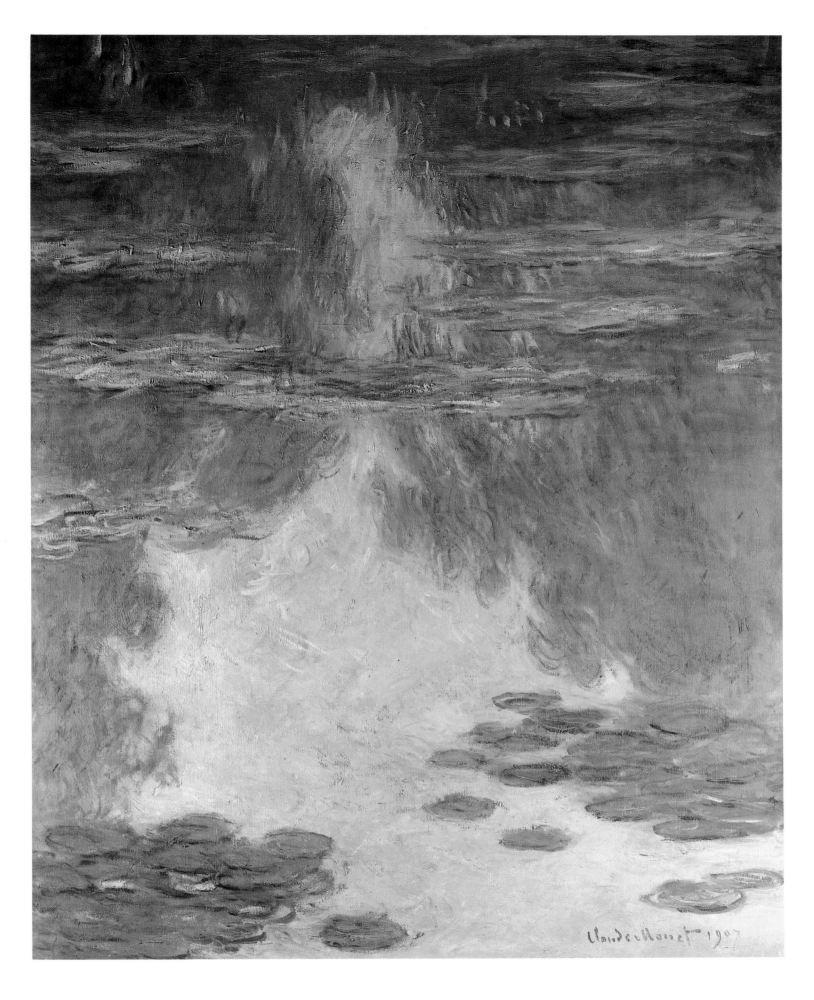

Les Nymphéas, Paysage d'Eau *(Water Lilies)*. 1907

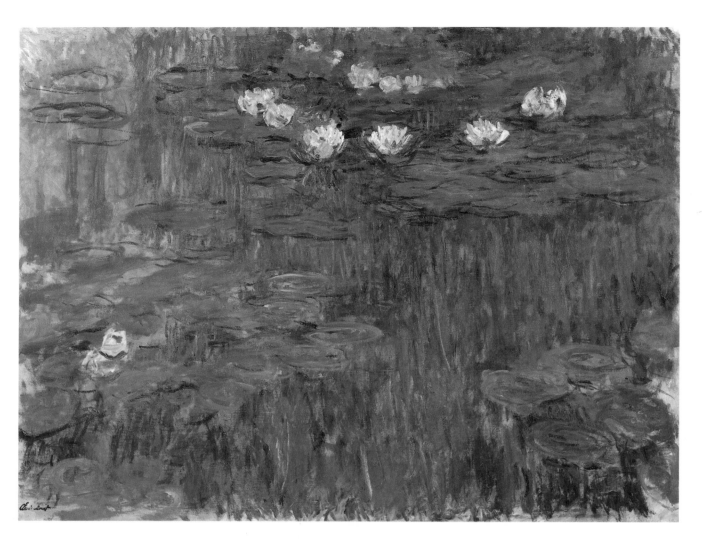

Nymphéas *(Water Lilies).* 1915

In a letter of August 25, 1919, to the partners of the Galerie Bernheim-Jeune, Monet described his new work, including the paintings opposite:
...I was and still am completely involved in my work, helped by magnificent weather. I have started a whole series of landscapes, which I love, and which I think will interest you; I wouldn't go so far as to say that I'm pleased with them, but I am working at them with enthusiasm and it gives me a rest from my *Decorations,* which I have put aside until winter.

All possible conjunctions are to be found on the pond's surface. The plane of the water brought everything, near and far, into a single pattern, combining the drive of perspective with the enveloping frontality of the sea. When Monet returned to the land in the mysterious series of 1919–24 he brought with him a new painting language. The vigorous brushstrokes, the arm gestures that got him across the expanse of the large *Nymphéas* canvases, are dangerously compressed into canvases an eighth the size. Yet these are ambitious paintings, far more densely worked, more serious in their energy, than the pondside studies he made for the decorations.

There are about six *Saules Pleureurs,* two signed and dated 1918, one from the following year, and three undated. The tree is conceived as screen, seen from within, as if Monet was inside the tent of its branches. The trunk, a red cranking column, runs the length of the picture. It is as though the red ground at the very foot of the canvas has spurted upward and burst into falling tresses of yellow and purple and blue, filling the canvas with a screen of streaked, wriggling light, whipped into movement, opaque, undulating between golden yellow and blue, its opening showing not distance but a claustrophobic ground bass of blood red.

Inevitably we bring to Monet's painting the idea that the picture describes his seeing. It is a fiction, of course, for both his seeing and ours are readings. But in front of the last canvases the idea takes one that here it is the limit of his seeing that he is painting—and while he is painting, protesting.

In the *Saule Pleureur,* the tree presents a curtain to the canvas, and the canvas presents its flat surface to the tree. The upper right corner writhes and leaps; purple and dark-green trails mold the tree into the form of the canvas.

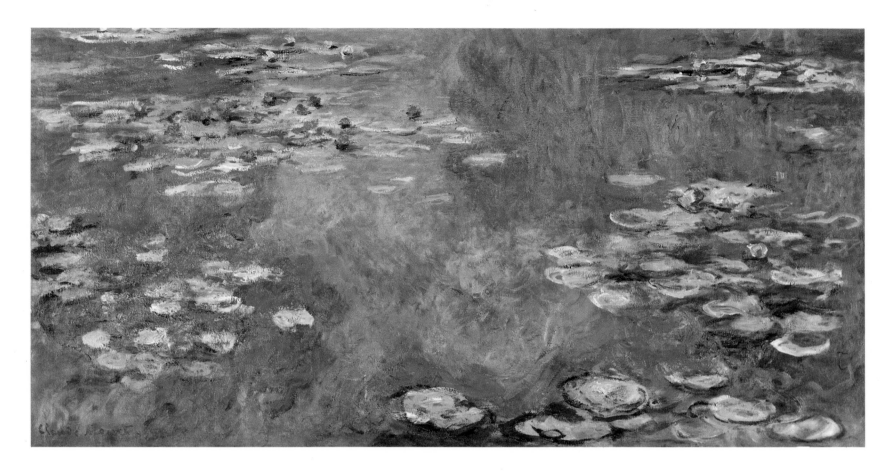

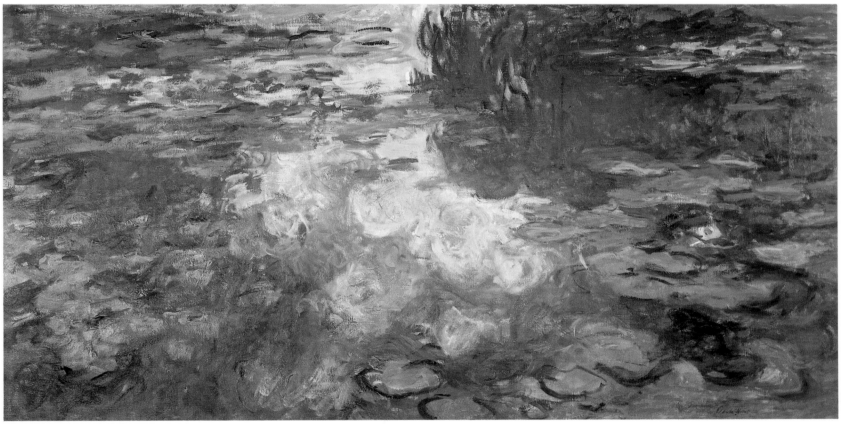

ABOVE: Le Bassin aux Nymphéas, Giverny *(Water-Lily Pond, Giverny)*. 1919

BELOW: Nymphéas *(Water Lilies)*. 1919

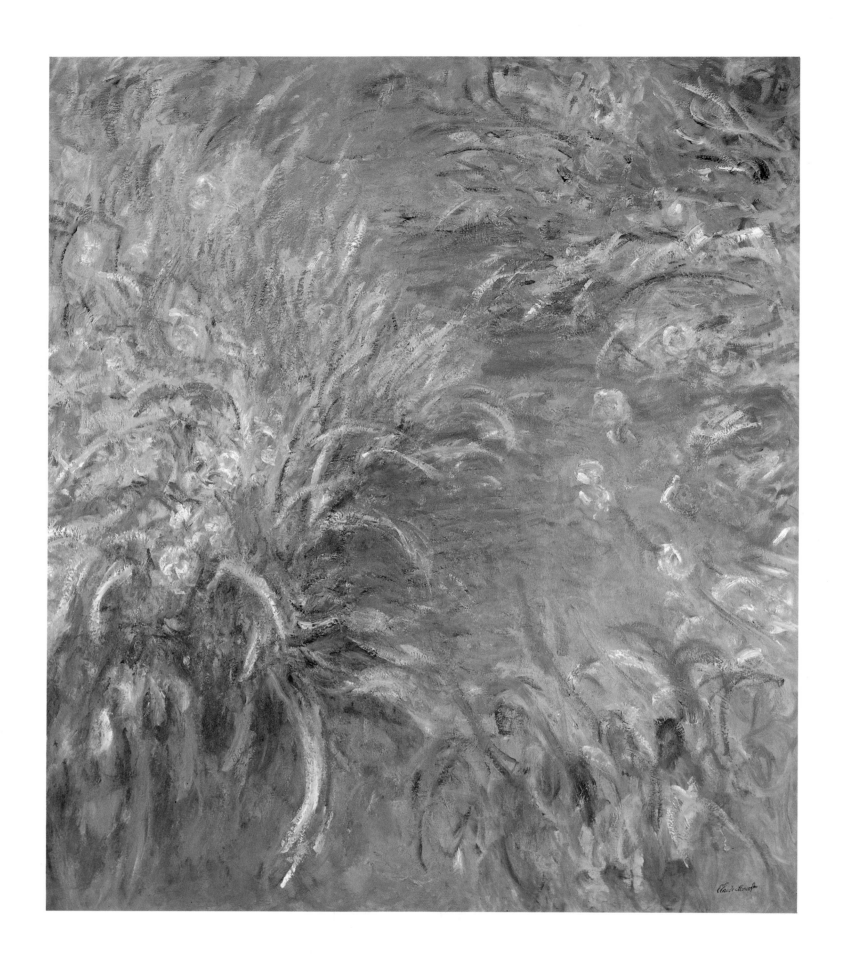

Les Iris *(The Path Through the Irises)*. 1916–17

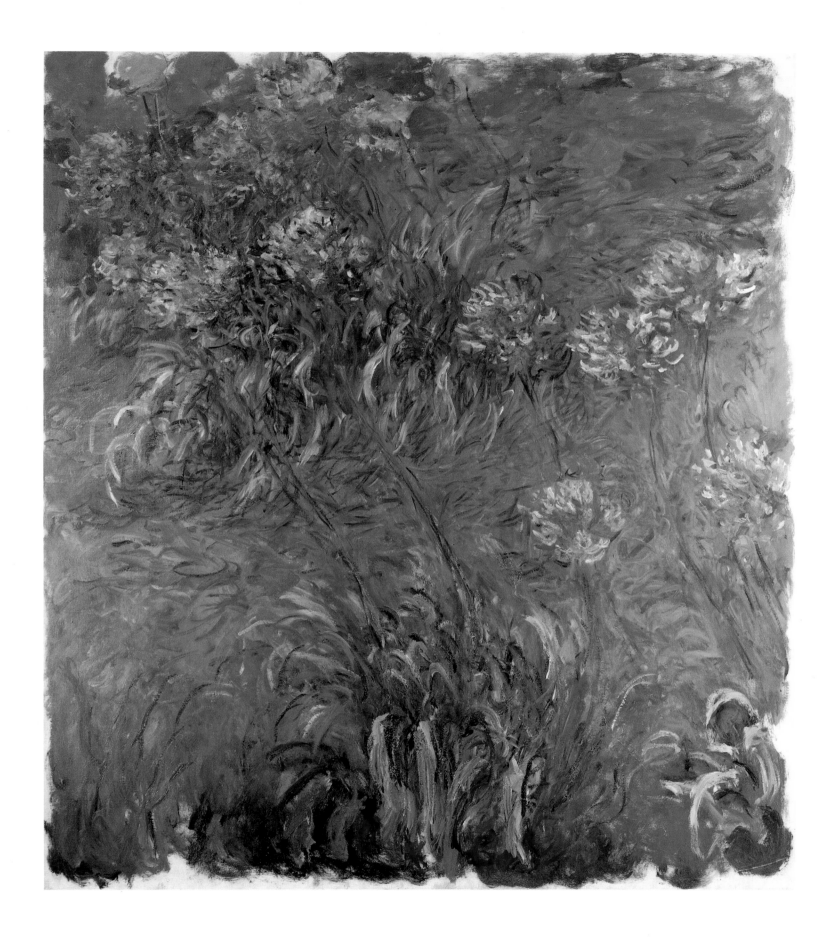

Agapanthes *(Agapanthus)*. 1916–17

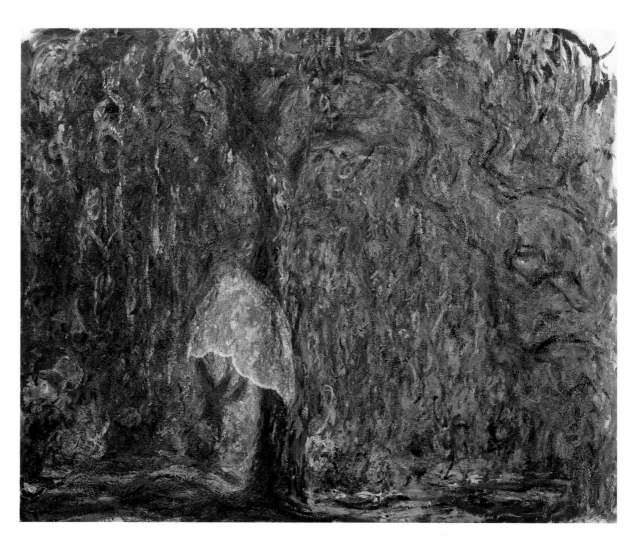

Saule Pleureur *(Weeping Willow)*. 1919

In the final chapter of his biography of Monet published in 1922, Gustave Geffroy wrote this reverie of the painter and his water garden:
This endless measure of his dream and of the dream of life, he formulated, resumed, and formulated it again and unceasingly through the wild dream of his art before the luminous abyss of the water-lily pond. There he found, so to speak, the last word of things, if things had a first and last word. He discovered and demonstrated that *everything* is *everywhere,* and that after running around the world worshipping the light that brightens it, he knew that this light came to be reflected with all its splendors and mysteries in the magical hollow surrounded by the foliage of willows and bamboo, by flowering irises and rose bushes, through the mirror of water from which burst strange flowers which seem even more silent and hermetic than all the others.

As the eye moves inward to the red trunk the scale of movement closes down, falling in finer threads of yellow and blue. The trunk is in high relief. White light falls on it, moving to pink, flame orange, viridian, blackish red in the deepest shadow. The screen of the weeping foliage hardens as it nears the trunk, molds itself into yellow columns as if displacing the trunk, absorbing it into itself. To the left of the trunk a blaze of yellow, white, and emerald turns the foliage into light, not as an opening onto distance but rather as a compact incandescent mass flush with the trunk, matching its fiery darkness with a white blaze. All sorts of architectures spread over the surface of the picture, nameless structuring energies, tightly packed movements in relief, like folds in a curtain. The image of a blind man is inescapable, groping, palpating, raking. The bottom right edge of the tree trunk is cut straight and sharp as if by an exasperated thumbnail. It is as though the tree had embodied the limit of Monet's sight with a physical, curtainlike presence, a thickness.

It is this wall that he appears to be attacking in the series of the rose trellises and the late Japanese bridges. Like a reminiscence of his ancient down-the-road *motifs,* the tunnel of the rose alley drives back in fast perspective. The arches, heavy with foliage, are faced frontally. It is a symmetrical *motif,* with the vanishing point in the bottom quarter of the canvas. Some of the paintings are highly worked, with a wide range of mark and color. Others are raw, their surfaces swirling with skeins of paint moving loosely. In neither case is the *motif* defined except as a dark, hollow tunnel. The arches could be anything. It is their drive back that is there, an awe-inspiring black funnel rimmed with glowing ribs. It could be the throat of hell.

For these paintings are anything but calm: they belong to a different universe

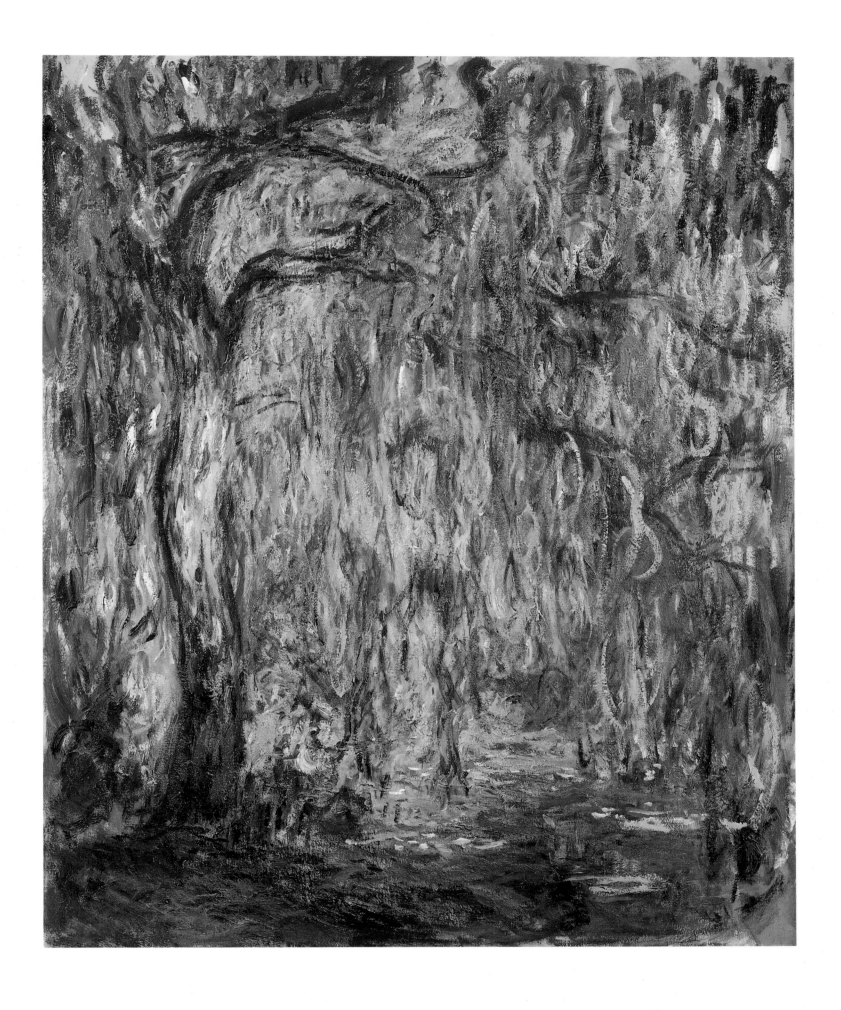

Paysage, Saule Pleureur *(Landscape, Weeping Willow)*. 1918

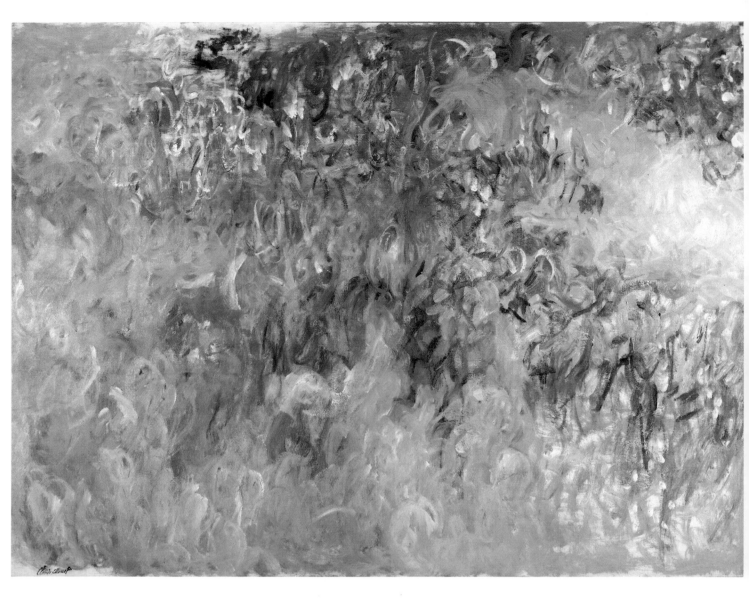

Glycines *(Wisteria)*. 1918–20

from the oceanic, cradling unities of the *Nymphéas.* The brush moves angrily with delinquent force, drilling into the membrane of Monet's blindness, hollowing, reaming, boring inward as if to reach the brink of the world. They must be the most concave pictures in the whole of painting, like tunnels dug with the fingernails, blind, fearful. Color is a tool pure and simple, long since split away from description or a time of day. Whatever reads reads. The tunnel drives into darkness on the strength of blues, purples, and a red the color of dried blood that is everywhere at once, groping into the depth of the tunnel, flickering over its entrance and around the ragged openings in arches overhead that are like a row of dying suns.

Monet's dependence on massive contrasts of light and dark increases. In many of the last paintings he silhouettes the Japanese bridge against bright light, fusing the water and far bank into lumps of saturated yellow streaked with red. It is a different world from the bridges of 1900 with their closely woven detail and luxurious light. Now the bridge is a somber barrier, a charred timber fallen.

All *motifs* are mirrors—or else the project of pleinairism is as shallow as Baudelaire had once argued. The painter's transactions with the *motif* have as many dimensions as his sense of self and of his place in the world. The givenness of the *motif,* its intractable visage, is the stake for which the game is played. Victory can be nothing less than control over that givenness, and its subjugation to painting. Monet's courting of the unpaintable—his impossible exertions between wave and cliff or under the very movement of the sun—was a desperate matter in which each achievement was also a setback, a mocking

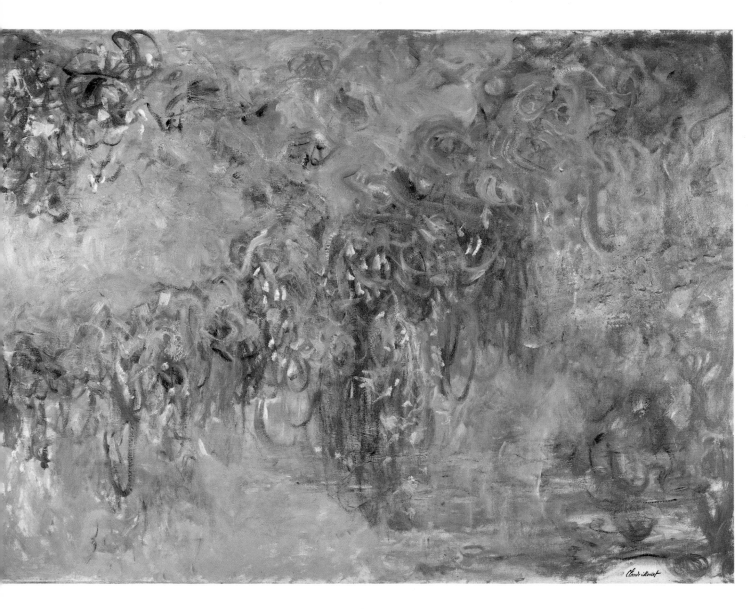

reminder of the limitations of mere painting, a flick of the whip and a promise
that there were still riddles waiting to be read. This is what gives such gloomy
weight to the legend of the oak tree at Fresselines. When Monet hired those
workmen to strip its leaves it was as though he was wringing a secret out of
his quarry by torture.

For landscape is not still life, not a domestic celebration of painting's
extension over object. The poignance of landscape is finally in the absurd con-
trast between nature's sufficiency and the painter's imperious demands on
it—a relationship so hopeless that the painter's defense "nature is my only
master" takes on the authority of a school. The leap over the abyss is attempted
again and again, indomitably; succeeding, or seeming to succeed, only in the
heroic unveiling of the picture out there and of nature here, a heroic joining as
if in love, of which the aftermath is the insight, arrived at in *tristesse*, that
painting is "only" painting, nature "only" nature.

But the garden, it seems, closes the gap. It is a containment in which Monet's
choices are effective on both sides of the encounter. His ardent hunting is
steadied by husbandry—his own. The narrow banks of the pool define the
places where he can stand. His plantings give stations to his wandering. The
pool embodies his quest and everything that his quest could reveal. Its reflec-
tion is literally a looking back. It is both nature and picture, the world and
himself. All possible conjunctions are to be found on its surface. Looking, the
riddle of the seen, is as near to decipherment, to painting, as it can ever be.

Above all, perhaps, in the ending: the unspeakable irony of blindness fallen
on a man ("only an eye") who in his prime had boastfully invoked the myth of
the man born blind who suddenly gains his sight. For now, when he is groping

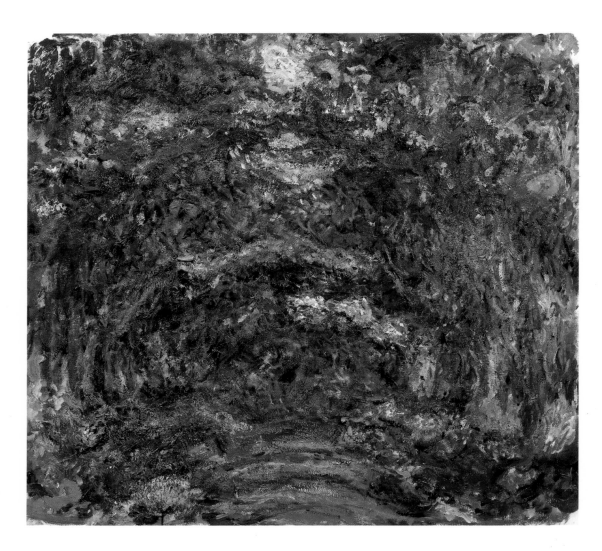

L'Allée de Rosiers à Giverny
(The Path with Rose Trellises at Giverny).
1920–22

over his color, furiously pitting a yellow against a black, netting the whole canvas with a saturated red, cut off from the outwardness of vision, the *motif* comes fully into its own as symbol.

There is a fearful vulnerability, a nakedness, about these last paintings. We don't know why they were painted, at least not in any sense that would satisfy an art historian. We don't know what Monet could see—either of his *motif* or, more important, of the canvas itself. All we know is that he could not stop working. He could not turn his back on the canvas to garden, smoke, withdraw into blindness.

There are two paintings of the Japanese bridge that are larger than any others: they are double squares, 1 by 2 meters, the only versions of the bridge in this format. Their palette and handling are not far from those of the *Saule Pleureur* of 1919: the same gamut from cold green through brassy yellow to crimson, the same dense weave. They are heavily worked, their surfaces deeply layered and built up into a crumbly mat of color so complex that at close quarters it is difficult to read as color at all. The springing of the bridge is hidden on both sides by tussocks of grass and a trailing bush on the right. The wisteria, itself a turbulent green cloud, arches out of the top of the canvas. The long leap of the bridge is half masked from us. The corners of the canvas in both pictures are left unpainted as they would be on a canvas worked on the spot. There is a hint of vignette, the image growing out from the center, rounded within the edges of the canvas.

The whole surface is a furor of long strokes, yellow into dark green, red, purple into yellow. Yellow plays brassy and dull through everything. The bridge is half buried in it, coming and going within its glare. The bridge has no

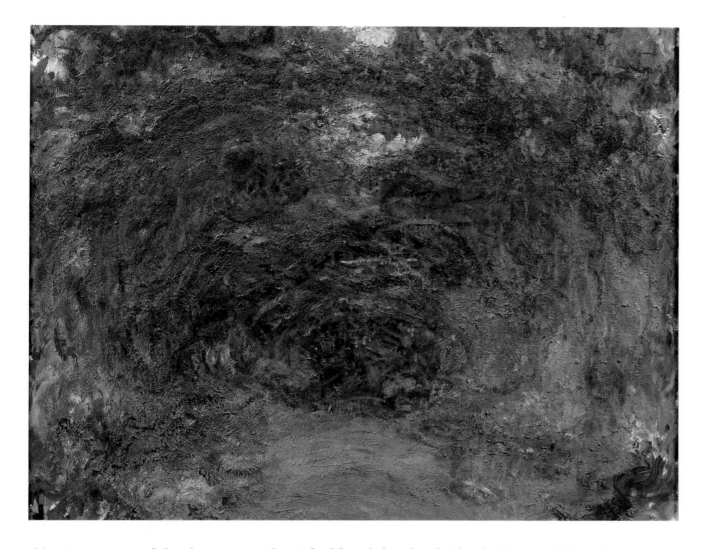

objective structure. It has become a pathway for Monet's brush, a bridge for his green arching strokes. It works like a living presence among the foliage, half hidden from us by the falling willow on the right. The light behind the bridge flickers up and down in twists and swirls of burnt gold and acid yellow. At the foot of the canvas the water spreads in yellow. Somehow the bridge finds its space within this zone of yellow as into a tightly compressed shallow relief. A red moves across the entire surface, burrowing into the depth of shadow on the left, dragging the bridge, skipping, twirling, falling in the dense air between the bridge and the water, a movement in space rather than a picturing, recklessly at one with the picture surface, as if the whole extent of the picture, its furrowed front, had been felt at brush length to be the place.

We are concealed by the picture, couched in front of it, its knotted surface closing our view. Light, graphic yellow, hangs there framed by dark wings, the bridge buried in it as if light was solid, a thicket. And yet within that thickness, as dense as any wall, there opens up an extraordinary recession. The water's surface is opened by a floating constellation; the lilies drift back into the glare, passing under the bridge, rounding the dark jungle bluff, white, pink, tiny flecks against yellow, transparency won from matted opacity, depth, distance, the infinite mystery of space won from the closing of the terrible yellow wall.

L'Allée de Rosiers à Giverny
(The Path with Rose Trellises at Giverny).
1920–22

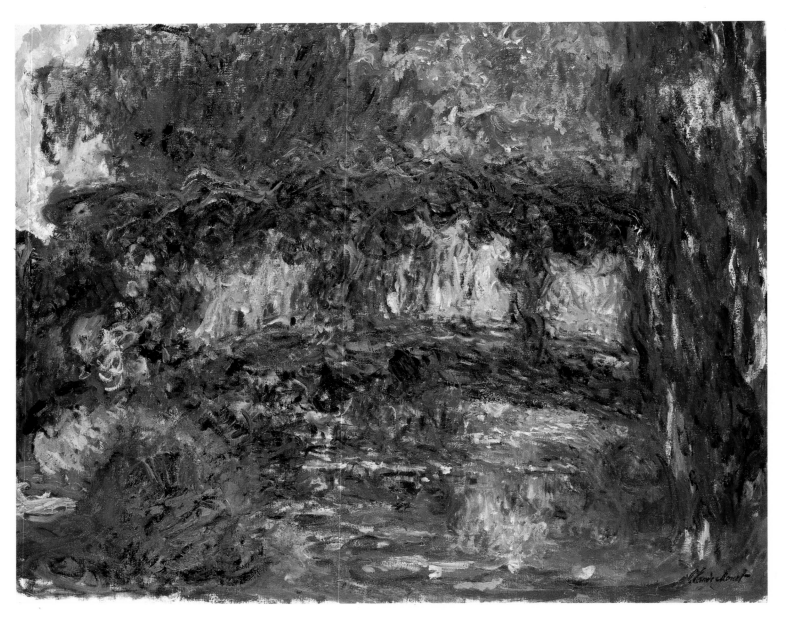

Le Pont Japonais à Giverny, also known as Nymphéas: Pont Japonais *(Japanese Bridge at Giverny,* or *Water Lilies: The Japanese Bridge).* c. 1923

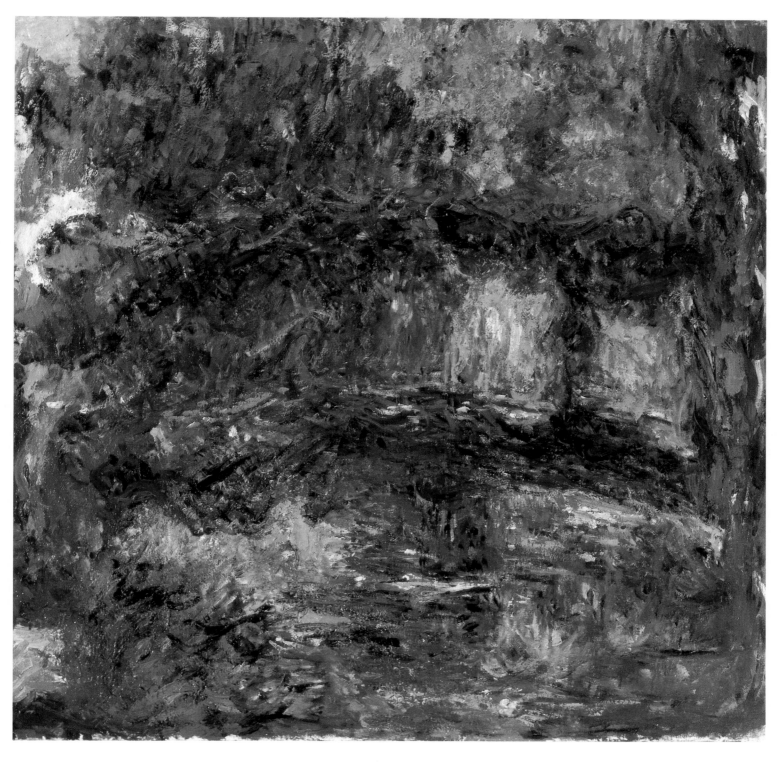

Le Pont Japonais à Giverny *(The Japanese Footbridge at Giverny)*. c. 1923

Critic Louis Gillet described the last works as follows:
He was, however, painting disordered landscapes, more and more feverish and hallucinated in appearance, in impossible color ranges, all red or all blue, but magnificent in style; the mark of the lion could still be felt.

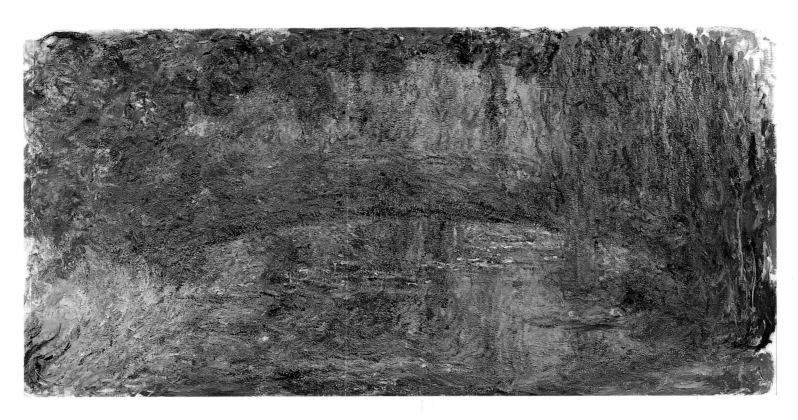

Le Pont Japonais *(Japanese Bridge)*. 1919

Clemenceau was beside Monet at the moment of the painter's death. He recalled the last days: I knew he was close to the end and now I would come every Sunday to distract him from his illness as much as I could. To tell the truth he was not suffering from it much. Barely at times a few attacks when he was unable to breathe, the cause of which Monet suspected even less because he was not laid up in bed. Two weeks before his death, I still had lunch with him at the table. He had talked to me about his garden, had told me that he had just received a whole shipment of bulbs, Japanese lilies, his favorite flower, and that he was expecting any day two or three boxes of seeds, very expensive but which, once they had bloomed, would produce magnificent colors. "You'll see all this in the spring," he told me. "I won't be here anymore." But one felt that secretly he didn't believe it at all and was fully expecting to be here in May to enjoy the spectacle.

List of Illustrations

Note: In the following list, dimensions of works of art are given in centimeters, except in the few cases where American collections provided information in inches. In each instance height precedes width. To convert centimeters to inches, divide the centimeter figure by 2.54. All works are oil on canvas unless otherwise noted.

Camille Monet sur la Plage à Trouville *(Camille Monet on the Beach at Trouville)*. 1870. 45 x 36 cm. Private Collection

48: La Plage de Trouville *(The Beach at Trouville)*. 1870. 38 x 46 cm. Reproduced by courtesy of the Trustees, The National Gallery, London

Sur la Plage à Trouville *(On the Beach at Trouville)*. 1870. 38 x 46 cm. Musée Marmottan, Paris

49: Eugène Boudin. La Plage de Trouville *(Beach Scene)*. 1865. Pencil and watercolor, 4½ x 9″. The Saint Louis Art Museum

50: La Tamise et le Parlement *(The Thames and Parliament)*. 1871. 47 x 73 cm. Reproduced by courtesy of the Trustees, The National Gallery, London

Moulin à Zaandam *(Windmill at Zaandam)*. 1871. 48 x 73.5 cm. Private Collection. Photograph Galerie Durand-Ruel, Paris

51: La Zaan à Zaandam *(The Zaan River at Zaandam)*. 1871. 42 x 73 cm. Private Collection. Photograph The Acquavella Galleries, Inc., New York

52: Édouard Manet. Monet Peignant dans son Atelier. *(Monet Painting in his Floating Studio.)* 1874. 80 x 98 cm. Bayerische Staatsgemaldesammlungen, Munich

54: Le Pont de Bois *(The Wooden Bridge)*. 1872. 54 x 73 cm. Private Collection. Photograph Christie's, London

Vue de Rouen *(View of Rouen)*. Black crayon on white scratchboard (Gillot plate). 1883. 12⅞ x 19¹³⁄₁₆ inches. Sterling and Francine Clark Art Institute, Williamstown, Massachusetts

55: Vue de Rouen *(View of Rouen)*. 1872. 54 x 73 cm. Private Collection

56: Le Pont du Chemin de Fer, Argenteuil *(The Railroad Bridge, Argenteuil)*. 1874. 55 x 72 cm. Galerie du Jeu de Paume, Musée d'Orsay, Paris. Photograph Musées Nationaux

Le Pont du Chemin de Fer, Argenteuil *(Railroad Bridge)*. 1874. 54.5 x 73.5 cm. Philadelphia Museum of Art. The John G. Johnson Collection

57: Le Pont du Chemin de Fer à Argenteuil *(The Railroad Bridge at Argenteuil)*. 1873. 58.2 x 97.2 cm. Stavros S. Niarchos Collection. Photograph Paul Rosenberg & Co., New York

58: Le Pont Routier, Argenteuil *(The Bridge at Argenteuil)*. 1874. 60 x 81 cm. National Gallery of Art, Washington. Bequest of Mr. and Mrs. Paul Mellon

59: Impression, Soleil Levant *(Impression, Sunrise)*. 1873. 48 x 63 cm. Musée Marmottan, Paris. Bequest of Madame Donop de Monchy

Soleil Levant, Marine *(Sunrise, Seascape)*. 1873. 49 x 60 cm. Private Collection. Photograph Galerie Schmit, Paris

60: Le Bassin d'Argenteuil *(The Seine at Argenteuil)*. 1872. 60 x 81 cm. Galerie du Jeu de Paume, Musée d'Orsay, Paris. Photograph Musées Nationaux

La Promenade d'Argenteuil *(Argenteuil)*. 1872. 50.5 x 65 cm. National Gallery of Art, Washington. Ailsa Mellon Bruce Collection, 1970

61: La Seine à Bougival, le Soir *(The Seine at Bougival)*. 1870. 60 x 73.3 cm. Smith College Museum of Art, Northampton, Massachusetts. Purchased 1946

62: Les Bords de la Seine à Argenteuil *(The Banks of the Seine at Argenteuil)*. 1872. 53 x 71 cm. Private Collection. Photograph The Lefevre Gallery, London

Bateaux de Plaisance à Argenteuil *(Pleasure Boats at Argenteuil)*. 1875. 54 x 65 cm. Private Collection

63: Bords de l'Eau, Argenteuil *(Riverbanks, Argenteuil)*. 1874. 55 x 65 cm. Destroyed in a fire c. 1950 at the Jockey Club, Buenos Aires. Photograph Galerie Durand-Ruel, Paris

Voilier au Petit-Gennevilliers *(Sailboat at Le Petit-Gennevilliers)*. 1874. 56 x 74 cm. Private Collection

64: Neige à Argenteuil *(Snow at Argenteuil)*. 1874. 57 x 74 cm. Museum of Fine Arts, Boston. Bequest of Anna Perkins Rogers

Le Train dans la Neige. La Locomotive *(Train in the Snow. The Locomotive)*. 1875. 59 x 78 cm. Musée Marmottan, Paris. Bequest of Madame Donop de Monchy

65: La Mare, Effet de Neige *(The Pond, Snow Effect)*. 1875. 60 x 81 cm. Private Collection. Photograph Paul Rosenberg & Co., New York

Effet de Neige à Argenteuil *(Snow Effect at Argenteuil)*. 1875. 61 x 82.5 cm. Private Collection. Photograph Galerie Durand-Ruel, Paris

66: La Seine près d'Argenteuil *(The Seine near Argenteuil)*. 1874. 55 x 66 cm. Private Collection. Photograph Galerie Nathan, Zurich

Effet d'Automne à Argenteuil *(Autumn at Argenteuil)*. 1873. 56 x 75 cm. Home House Society Trustees, Courtauld Institute Galleries, London (Courtauld Collection)

67: Coucher de Soleil sur la Seine *(Marine View—Sunset)*. 1874. 49.5 x 65 cm. Philadelphia Museum of Art: Purchased: The W. P. Wilstach Collection

68: Paris, Pont Neuf, after 1854. Photograph by Charles Soulier. Albumen print (oval) from collodion negative. 30.7 x 39.6 cm. Collection André Jammes, Paris

69: Le Quai du Louvre *(The Quai du Louvre)*. 1867. 65 x 92 cm. Collection Haags Gemeentemuseum, The Hague

Saint-Germain-l'Auxerrois. 1867. 81 x 100 cm. Nationalgalerie. Staatliche Museen Preussischer Kulturbesitz, Berlin (West). Photograph by Jörg P. Anders.

70: Le Boulevard des Capucines *(The Boulevard des Capucines)*. 1873. 61 x 80 cm. Pushkin Museum, Moscow

71: Le Jardin de l'Infante *(The Garden of the Princess, Louvre)*. 1867. 92 x 62 cm. Allen Memorial Art Museum, Oberlin College. R. T. Miller, Jr. Fund

72: Le Boulevard des Capucines *(The Boulevard des Capucines)*. 1873. 80 x 60 cm. The William Rockhill Nelson Gallery of Art—Atkins Museum of Fine Arts, Kansas City, Missouri. Acquired through the Kenneth A. and Helen F. Spencer Foundation. Photograph E. V. Thaw & Co., New York

75: Au Bord de l'Eau, Bennecourt *(The River)*. 1868. 81 x 100 cm. The Art Institute of Chicago. Potter Palmer Collection

76: La Gare Saint-Lazare *(The Gare Saint-Lazare)*. 1877. 75 x 100 cm. Galerie du Jeu de Paume, Musée d'Orsay, Paris. Photograph Musées Nationaux

77: La Gare Saint-Lazare, le Train de Normandie *(Saint-Lazare Station, Paris)*. 1877. 60 x 81 cm. The Art Institute of Chicago. Mr. and Mrs. Martin A. Ryerson Collection

Le Pont de l'Europe, Gare Saint-Lazare *(The Pont de l'Europe, Gare Saint-Lazare)*. 1877. 65 x 81 cm. Musée Marmottan, Paris. Bequest of Madame Donop de Monchy

78: La Gare Saint-Lazare, Arrivée d'un Train *(Gare Saint-Lazare, Paris)*. 1877. 82 x 101 cm. Fogg Art Museum, Harvard University, Cambridge, Massachusetts. Bequest—Collection of Maurice Wertheim

79: La Gare Saint-Lazare, Vue Extérieure *(The Gare Saint-Lazare, Outside View)*. 1877. 64 x 81 cm. Private Collection

La Gare Saint-Lazare, à l'Extérieur (Le Signal) *(Outside the Gare Saint-Lazare [The Signal])*. 1877. 65 x 81.5 cm. Niedersächsisches Landesmuseum, Hannover, West Germany

81: Portrait of Monet about 1875. Reproduced from *À Giverny, chez Claude Monet* by Marc Elder, plate 41. Bernheim-Jeune, Éditeurs d'Art, Paris, 1924. Photograph Galerie Bernheim-Jeune, Paris

82: Camille au Jardin, avec Jean et sa Bonne *(Camille in the Garden with Jean and his Nurse)*. 1873. 59 x 79.5 cm. Private Collection

Le Banc *(Madame Monet on a Garden Bench)*. 1873. 60 x 80 cm. Collection the Honorable and Mrs. Walter H. Annenberg. Photograph The Lefevre Gallery, London

83: La Promenade. La Femme à l'Ombrelle *(Woman with a Parasol—Madame Monet [Camille] and her Son)*. 1875. 100 x 81 cm. National Gallery of Art, Washington. Bequest of Mr. and Mrs. Paul Mellon

84: Au Jardin, la Famille de l'Artiste *(In the Garden, the Artist's Family)*. 1875. 61 x 80 cm. Private Collection. Photograph Paul Rosenberg & Co., New York

Dans la Prairie *(In the Meadow)*. 1876. 60 x 81 cm. Private Collection. Photograph Galerie Durand-Ruel, Paris

85: Camille et Jean Monet au Jardin d'Argenteuil *(Camille and Jean Monet in the Garden at Argenteuil)*. 1873. 131 x 97 cm. Private Collection. Photograph Rosenberg & Stiebel, Inc., New York

86: L'Été, Champ de Coquelicots *(Summer, Field of Poppies)*. 1875. 60 x 81 cm. Private Collection

La Femme à l'Ombrelle au Jardin d'Argenteuil *(Woman with Parasol in the Garden at Argenteuil)*. 1875. 75 x 100 cm. Private Collection

Les Glaïeuls *(Gladioli)*. 1876. 60 x 81.5 cm. The Detroit Institute of Arts. City of Detroit Purchase

87: Le Déjeuner *(The Luncheon)*. 1873. 162 x 203 cm. Galerie du Jeu de Paume, Musée d'Orsay, Paris. Photograph Musées Nationaux

90: Sur la Falaise de Pourville, Temps Clair *(On the Cliff at Pourville, Clear Weather)*. 1882. 65 x 81 cm. Private Collection

92: La Mer à Fécamp *(The Sea at Fécamp)*. 1881. 65 x 81 cm. Staatsgalerie, Stuttgart, West Germany

Fécamp, Bord de la Mer *(Seashore at Fécamp)*. 1881. 67 x 80 cm. Private Collection. Photograph Galerie Durand-Ruel, Paris

93: Les Glaçons *(Ice Floes)*. 1880. 97 x 150.5 cm. Shelburne Museum, Shelburne, Vermont

94: Église de Varengeville, Effet Matinal *(Church of Varengeville, Morning Effect)*. 1882. 60 x 73 cm. Private Collection. Photograph Marlborough Fine Art (London) Ltd.

95: Les Falaises et l'Église à Varengeville *(Cliffs and Church at Varengeville)*. 1882. 60 x 81 cm. Private Collection. Photograph Galerie Durand-Ruel, Paris

96: Three postcards of Varengeville—Sur les Falaises *(Varengeville—On the Cliffs)*. Private Collection

98: La Cabane de Douanier à Varengeville *(Custom Officer's Cabin at Varengeville)*. 1882. 60 x 78 cm. Museum Boymans-van Beuningen, Rotterdam

99: Falaise à Varengeville *(Cliff at Varengeville)*. 1882. 65 x 81 cm. Private Collection. Photograph The Lefevre Gallery, London

100: The Porte d'Aval and the Needle, Étretat. Photograph Collection Sirot-Angel, Paris

The Porte d'Aval and the Needle seen through the Manneporte. Photograph Collection Sirot-Angel, Paris

101: Gustave Courbet. Plage d'Étretat, Soleil Couchant *(Beach at Étretat, Sunset)*. 1869. 54 x 65 cm. Private Collection. Photograph The Lefevre Gallery, London

Gustave Courbet. Falaise d'Étretat après l'Orage *(Cliff at Étretat after the Storm)*. 1870. 133 x 162 cm. The Louvre, Paris. Photograph Musées Nationaux

102: Étretat, Mer Agitée also known as Falaise à Étretat *(Étretat, Rough Sea, or Cliff at Étretat)*. 1883. 81 x 100 cm. Musée des Beaux-Arts, Lyon. Photograph Giraudon, Paris

La Falaise d'Aval *(Cliff at Étretat)*. 1885. 65 x 92 cm. Private Collection. Photograph Galerie Durand-Ruel, Paris

103: L'Aiguille et la Falaise d'Aval *(The Cliffs at Étretat)*. 1885. 65 x 81 cm. Sterling and Francine Clark Art Institute, Williamstown, Massachusetts

La Porte d'Aval, l'Aiguille d'Étretat *(Cliffs at Étretat)*. 1886. 73 x 92 cm. Collection Mr. and Mrs. Nathan L. Halpern

106: La Manneporte près d'Étretat *(The Manneporte, Étretat, II)*. 1886. 81 x 65 cm. The Metropolitan Museum of Art, New York. Bequest of Lizzie P. Bliss, 1931

107: La Manneporte *(The Manneporte, Étretat, I)*. 1883. 65 x 81 cm. The Metropolitan Museum of Art, New York. Bequest of William Church Osborn, 1951

La Manneporte, Marée Haute *(The Manneporte, Étretat, High Tide)*. 1885. 65 x 81 cm. Collection of Mrs. A. N. Pritzker. Photograph E. V. Thaw & Co., Inc., New York

108: La Porte d'Amont, Étretat *(Cliffs at Étretat)*. c. 1868–69. 81 x 100 cm. Fogg Art Museum, Harvard University, Cambridge, Massachusetts. Gift of Mr. and Mrs. Joseph Pulitzer, Jr.

109: L'Aiguille Vue à Travers la Porte d'Amont *(The Needle Seen Through the Porte d'Amont, Étretat)*. 1885. 73 x 60 cm. Private Collection. Photograph Galerie Durand-Ruel, Paris

L'Aiguille Vue à Travers la Porte d'Amont *(The Needle Seen Through the Porte d'Amont, Étretat)*. 1885. Size unavailable. Private Collection. Photograph Galerie Bernheim-Jeune, Paris

110: Bordighera. 1884. 65 x 81 cm. The Art Institute of Chicago. Potter Palmer Collection

Bordighera, Italie *(Bordighera, Italy)*. 1884. 60 x 73 cm. Private Collection. Photograph Galerie Durand-Ruel, Paris

111: Étude d'Oliviers à Bordighera *(Study of Olive Trees, Bordighera)*. 1884. 73 x 60 cm. Private Collection. Photograph Galerie Durand-Ruel, Paris

Villas à Bordighera *(Bordighera)*. 1884. 73 x 92 cm. The Santa Barbara Museum of Art. Bequest of Katherine Dexter McCormick in memory of her husband, Stanley McCormick

112: Rochers à Belle-Île *(Rocks at Belle-Île)*. 1886. 60 x 73 cm. Ny Carlsberg Glyptotek, Copenhagen

Pyramides de Port-Coton, Mer Sauvage *(Pyramids of Port-Coton, Stormy Sea)*. 1886. 65 x 81 cm. Pushkin Museum, Moscow

113: Les Pyramides de Port-Coton, Belle-Île, Effet de Soleil *(The Pyramids of Port-Coton, Belle-Île, Sunlight Effect)*. 1886. 64 x 64 cm. Private Collection. Photograph Galerie Durand-Ruel, Paris

114: Bloc de Rochers à Port-Goulphar *(Rock Formations at Port-Goulphar)*. 1886. 66 x 65.4 cm. Private Collection. Photograph Richard L. Feigen & Co.

Port-Coton, le Lion *(Port-Coton, the "Lion")*. 1886. 60 x 73 cm. Private Collection. Photograph The Acquavella Galleries, Inc., New York

115: Bloc de Rochers, Belle-Île *(Rock Formations, Belle-Île)*. 1886. 65 x 81 cm. Private Collection. Photograph Galerie Durand-Ruel, Paris

Côte Rocheuse, Rocher du Lion, Belle-Île *(Rocks at Belle-Île)*. 1886. 65.5 x 81 cm. Des Moines Art Center, Iowa. Coffin Fine Arts Trust Fund, 1961. Photograph Hirschl & Adler Galleries Inc., New York

116: Port-Domois, Belle-Île, also known as Port-Donnant: Belle-Île. 1886. 65 x 81 cm. Yale University Art Gallery, New Haven. Gift of Mr. and Mrs. Paul Mellon, B.A., 1929

Grotte de Port-Domois *(Grotto of Port-Domois)*. 1886. 65 x 81 cm. Private Collection

117: Pointes de Rochers à Belle-Île *(Points of Rock Formations at Belle-Île)*. 1886. 81 x 65 cm. Private Collection

118: Rochers à Belle-Île, Port-Domois *(Rocks at Belle-Île, Port-Domois)*. 1886. 73 x 60 cm. The Saint Louis Art Museum. Gift of Mr. and Mrs. Joseph Pulitzer, Jr. Photograph Galerie Durand-Ruel, Paris

La Côte Sauvage *(The Wild Coast)*. 1886. 65 x 81 cm. Galerie du Jeu de Paume, Musée d'Orsay, Paris. Photograph Galerie Durand-Ruel, Paris

119: Pointe de Rochers à Port-Goulphar *(Point of Rock Formations at Port-Goulphar)*. 1886. 81 x 65 cm. Private Collection. Photograph Galerie Durand-Ruel, Paris

Mer Démontée *(Raging Sea)*. 1886. 65 x 81 cm. Musée des Beaux-Arts, Alger. Photograph Giraudon, Paris

120: Antibes Vue de la Salis *(Antibes Seen from La Salis)*. 1888. 65 x 92 cm. Private Collection

121: Juan-les-Pins. 1888. 73 x 92 cm. Private Collection

122: Plage de Juan-les-Pins *(The Beach of Juan-les-Pins)*. 1888. 73 x 92 cm. Private Collection. Photograph Galerie Durand-Ruel, Paris

123: Arbres au Bord de la Mer, Antibes *(Trees by the Sea, Antibes)*. 1888. 73 x 92 cm. Stavros S. Niarchos Collection. Photograph Galerie Durand-Ruel, Paris

124: Les Eaux Semblantes, Creuse, Effet de Soleil *(Eaux Semblantes at Fresselines on the Creuse)*. 1889. 65 x 92 cm. Museum of Fine Arts, Boston. Juliana Cheney Edwards Collection. Bequest of Robert J. Edwards in memory of his mother

125: Ravin de la Petite Creuse *(Ravine of the Creuse)*. 1889. 65 x 81 cm. Museum of Fine Arts, Boston. Bequest of David P. Kimball in memory of his wife, Clara Bertram Kimball

126: Les Eaux Semblantes, Temps Sombre *(Eaux Semblantes, Cloudy Weather)*. 1889. 73 x 92 cm. Von der Heydt-Museum der Stadt, Wuppertal-Elberfeld. Photograph Galerie Beyeler Basel

127: Le Vieil Arbre à Fresselines *(The Old Tree at Fresselines)*. 1889. 81 x 100 cm. Plundered during World War II. Photograph Galerie Durand-Ruel, Paris

Le Vieil Arbre au Confluent *(Torrent, Dauphine, Montagnes)*. 1889. 65 x 92 cm. The Art Institute of Chicago. Potter Palmer Collection

128: Route à Louveciennes, Neige Fondante, Soleil Couchant *(Road to Louveciennes, Melting Snow, Sunset)*. 1870. 40 x 54 cm. Private Collection. Photograph The Lefevre Gallery, London

130: Route à Louveciennes, Effet de Neige *(Road to Louveciennes, Snow Effect)*. 1870. 55.9 x 65.4 cm. Private Collection. Photograph E. V. Thaw & Co., Inc., New York

131: Le Pont de Bougival *(The Seine at Bougival)*. c. 1870. 65.4 x 92.4 cm. The Currier Gallery of Art, Manchester, New Hampshire. Mabel Putney Folsom Fund

Camille Pissarro. La Route de Versailles à Louveciennes—Effet de Pluie *(The Road to Versailles at Louveciennes—Rain Effect)*. 1870. 40.2 x 55.3 cm. Sterling and Francine Clark Art Institute, Williamstown, Massachusetts

134: À Travers les Arbres, Île de la Grande Jatte *(Through the Trees, Island of La Grande Jatte)*. 1878. 54 x 65 cm. Private Collection. Photograph Galerie Durand-Ruel, Paris

La Seine à Argenteuil *(The Seine at Argenteuil)*. 1877. 60 x 73 cm. Private Collection. Photograph Galerie Durand-Ruel, Paris

135: Les Bords de la Seine, Île de la Grande Jatte *(Banks of the Seine, Island of La Grande Jatte)*. 1878. 54 x 65 cm. Private Collection

Au Bord de la Seine, près de Vétheuil *(Banks of the Seine, Vétheuil)*. 1880. 73 x 100 cm. National Gallery of Art, Washington. Chester Dale Collection

137: Chemin Creux à Pourville *(Sunken Path at Pourville)*. 1882. 73 x 60 cm. Private Collection. Photograph Galerie Durand-Ruel, Paris

138: Le Chemin de la Cavée à Pourville *(Chemin de la Cavée at Pourville)*. 1882. 73 x 60 cm. Private Collection

Chemin de la Cavée, Pourville. 1882. 60 x 81 cm. Museum of Fine Arts, Boston. Bequest of Mrs. Susan Mason Loring

139: La Vallée de Sasso—Bordighera *(Valley of Sasso, Bordighera)*. 1884. 65 x 92 cm. Private Collection

Champ de Coquelicots, Environs de Giverny *(Poppy Field near Giverny)*. 1885. 65 x 81 cm. Museum of Fine Arts, Boston. Juliana Cheney Edwards Collection. Bequest of Robert J. Edwards in memory of his mother

140: View of the Sea at Sunset. c. 1874. Pastel on paper, 25.4 x 50.8 cm. Museum of Fine Arts, Boston. Bequest of William P. Blake in memory of his sister, Anne Dehon Blake

Rivière de Pourville, Marée Basse (River at Pourville, Low Tide). 1882. 65 x 81 cm. Private Collection. Photograph Sotheby's, London

Gros Temps à Étretat (Rough Weather at Étretat). 1883. 65 x 81 cm. National Gallery of Victoria, Melbourne. Felton Bequest, 1913

141: James McNeill Whistler. Harmony in Blue and Silver: Trouville. 1865. 50 x 76 cm. Isabella Stewart Gardner Museum, Boston

142: Plage et Falaises de Pourville, Effet du Matin (Beach and Cliffs at Pourville, Morning Effect). 1882. 60 x 73 cm. Private Collection. Photograph Galerie Durand-Ruel, Paris

143: Falaises près de Pourville (Cliffs near Pourville). 1882. 60 x 81 cm. Private Collection. Photograph E. J. van Wisselingh, Amsterdam

145: Vétheuil dans le Brouillard (Vétheuil in the Fog). 1879. 60 x 71 cm. Musée Marmottan, Paris

148: Les Peupliers à Giverny (Poplars at Giverny, Sunrise). 1887. 73 x 92 cm. The Museum of Modern Art, New York. The William B. Jaffe and Evelyn A. J. Hall Collection

149: Un Tournant de l'Epte (A Bend in the Epte River, near Giverny). 1888. 73 x 92 cm. Philadelphia Museum of Art. William L. Elkins Collection

Arbres en Hiver, Vue sur Bennecourt (Trees in Winter, View of Bennecourt). 1887. 81 x 81 cm. Private Collection

150: Cabane de Douanier (The Custom House at Varengeville). 1882. 60 x 81 cm. Philadelphia Museum of Art. William L. Elkins Collection. Photograph by Eric Mitchell

La Pointe du Petit Ailly (The Tip of the Petit Ailly). 1897. 73 x 92 cm. Private Collection. Photograph Galerie Durand-Ruel, Paris

La Mer—Vue des Falaises (The Sea—View from the Cliffs). 1881. 60 x 75 cm. Private Collection. Photograph Hirschl & Adler Galleries, Inc., New York

Au Val Saint-Nicolas, près Dieppe, Matin (On the Cliffs, Dieppe). 1897. 65 x 100 cm. The Phillips Collection, Washington

151: Cabane de Douaniers à Varengeville, Effet du Matin (Customs Cabin at Varengeville, Morning Effect). 1882. 54 x 65 cm. Private Collection. Photograph Galerie Durand-Ruel, Paris

Marée Montante à Pourville (Rising Tide at Pourville). 1882. 65 x 81 cm. The Brooklyn Museum. Gift of Mrs. Horace Havemeyer

152: Église de Varengeville, Soleil Couchant (Church at Varengeville, Sunset). 1882. 65 x 81 cm. Private Collection. Photograph Galerie Durand-Ruel, Paris

L'Église de Varengeville, Soleil Couchant (Church at Varengeville, Sunset). Charcoal drawing on Gillot paper, 30 x 42 cm. Published in the Gazette des Beaux-Arts, April 1883. Private Collection. Photograph Galerie Durand-Ruel, Paris

153: Église de Varengeville, Temps Gris, also known as L'Église sur la Falaise, Varengeville (Church at Varengeville, Cloudy Weather, or Church on the Cliff, Varengeville). 1882. 65 x 81 cm. The J. B. Speed Art Museum, Louisville, Kentucky

154: Promenade, Temps Gris (Promenade, Cloudy Weather). 1888. 92 x 81 cm. Private Collection. Photograph Galerie Durand-Ruel, Paris

157: Les Meules à Giverny (Haystacks at Giverny). 1885. 65 x 81 cm. Private Collection. Photograph Galerie Nathan, Zurich

158: Postcard of Giverny, près Vernon—Paysage d'Automne (Giverny, near Vernon—Autumn Landscape). Private Collection

Photograph of stacks in the field just above Monet's house. Reproduced from an article by Louis Vauxelles, "Un Après-midi chez Claude Monet," published in the magazine L'Art et les Artistes, November 1905, page 90

159: Les Meules, Effet de Gelée Blanche (Stacks, Hoarfrost). 1889. 65 x 92 cm. By permission of the Trustees of the Hill-Stead Museum, Farmington, Connecticut

Meules, Derniers Rayons de Soleil (Stacks, Last Rays of Sunlight). 1890. Reproduced from Arsène Alexandre, Claude Monet, Bernheim-Jeune, Éditeurs d'Art, Paris, 1921

160: Meule, Effet de Neige, le Matin (Haystack in Winter). 1891. 65 x 92 cm. Museum of Fine Arts, Boston. Gift of Misses Aimee and Rosamond Lamb

Meule, Effet de Neige, Temps Couvert (Haystack, Winter, Giverny). 1891. 65 x 92 cm. The Art Institute of Chicago. Collection of Mr. and Mrs. Martin A. Ryerson

161: La Meule (Stack). 1891. 65 x 92 cm. Private Collection

Meule, Dégel, Soleil Couchant (Stack, Thaw, Sunset). 1891. 65 x 92 cm. Private Collection. Photograph The Acquavella Galleries, Inc., New York

162: Meule au Soleil (Stack at Sunset). 1891. 60 x 100 cm. Kunsthaus Zürich

Meule, Soleil Couchant (Haystack at Sunset near Giverny). 1891. 73 x 92 cm. Museum of Fine Arts, Boston. Juliana Cheney Edwards Collection. Bequest of Robert J. Edwards in memory of his mother

164: Peupliers, Coucher de Soleil (Poplars, Sunset). 1891. 100 x 60 cm. Private Collection

165: Peupliers au Bord de l'Epte, Effet de Soleil Couchant (Poplars Along the Epte River, Sunset Effect). 1891. 100 x 65 cm. Private Collection

Rangée de Peupliers (Row of Poplars). 1891. 100 x 65 cm. Private Collection

166: Peupliers au Bord de l'Epte, Automne (Poplars Along the Epte River, Autumn). 1891. 100 x 65 cm. Private Collection. Photograph The Acquavella Galleries, Inc., New York

Peupliers au Bord de l'Epte, Crépuscule (Poplars Along the Epte River, Dusk). 1891. 100 x 65 cm. Private Collection

168: Effet de Vent, Série des Peupliers (Wind Effect, Poplar Series). 1891. 100 x 73 cm. Private Collection

169: Les Peupliers, Effet Rose (Poplars, Pink Effect). 1891. 92 x 73 cm. Private Collection. Photograph Galerie Durand-Ruel, Paris

Les Trois Arbres, Été (Poplars in the Sun). 1891. 93 x 73.5 cm. The National Museum of Western Art, Tokyo. Photograph M. Knoedler & Co., Inc., New York

Les Trois Arbres, Automne (Three Trees, Autumn). 1891. 92 x 73 cm. Private Collection. Photograph M. Knoedler & Co., Inc., New York

Les Trois Arbres, Temps Gris (Three Trees, Cloudy Weather). 1891. 92 x 73 cm. Private Collection. Photograph Galerie Durand-Ruel, Paris

171: Peupliers au Bord de l'Epte, Vue du Marais (Poplars Along the Epte River, View from the Marsh). 1891. 88 x 93 cm. Private Collection. Photograph The Acquavella Galleries, Inc., New York

173: Rouen Cathedral. Photograph H. Roger-Viollet, Paris

174: La Cathédrale de Rouen, le Portail (Soleil) (Rouen Cathedral, West Facade, Sunlight). 1894. 100 x 65 cm. National Gallery of Art, Washington. Chester Dale Collection

La Cathédrale de Rouen, le Portail Plein Midi, Lumière Reflétée (Rouen Cathedral, the Facade in Sunlight). 1894. 106 x 73 cm. Sterling and Francine Clark Art Institute, Williamstown, Massachusetts

175: La Cathédrale de Rouen, Le Portail (Rouen Cathedral, West Facade). 1894. 100 x 65 cm. National Gallery of Art, Washington. Chester Dale Collection

La Cathédrale de Rouen, Le Portail (Effet du Matin) (Rouen Cathedral, The Facade, Morning Effect). 1894. 100 x 65 cm. Museum Folkwang, Essen, West Germany

177: Portrait of Monet, about 1900, at the time he was working on his London series. Photograph Galerie Durand-Ruel, Paris

178: Matinée sur la Seine (Morning on the Seine). 1896. 89 x 92 cm. Private Collection. Photograph The Acquavella Galleries, Inc., New York

Bras de Seine près de Giverny, Brouillard (The Seine at Giverny, Morning Mists). 1897. 89 x 92 cm. North Carolina Museum of Art, Raleigh. Purchased with funds from the Sarah Graham Kenan Foundation and the North Carolina Art Society

179: Matinée sur la Seine (Morning on the Seine). 1897. 81 x 92 cm. Amherst College, Mead Art Museum. Gift of Miss Susan Dwight Bliss

180: Portrait of Monsieur Paul Durand-Ruel. Photograph Galerie Durand-Ruel, Paris

181: Édouard Vuillard. Messieurs Josse Bernheim-Jeune (seated) and Gaston Bernheim de Villers (in their office, Rue Richepance, Paris). 1912. 157 x 159 cm. Photograph Galerie Bernheim-Jeune, Paris

182: Charing Cross Bridge. 1903. 73 x 100 cm. The Saint Louis Art Museum. Purchase

183: Waterloo Bridge. 1900. 65 x 92 cm. Santa Barbara Museum of Art. Bequest of Katherine Dexter McCormick in memory of her husband, Stanley McCormick

Waterloo Bridge, le Soleil dans le Brouillard (Waterloo Bridge, Sun in the Fog). 1903. 73 x 100 cm. National Gallery of Canada, Ottawa. Galerie Nationale du Canada, Ottawa

185: Le Parlement, Effet de Soleil dans le Brouillard (Parliament, Sunlight Effect in the Fog). 1904. 81.5 x 92 cm. Private Collection

Le Parlement, Coucher de Soleil (The Houses of Parliament, Sunset). 1904. 81 x 92 cm. Private Collection. Photograph Christie's, London

186: Monet's studio with the London series. Photograph Galerie Durand-Ruel, Paris

188: Le Grand Canal (The Grand Canal, Venice). 1908. 73 x 92 cm. Private Collection. Photograph Sotheby's, London

189: Le Palais Contarini *(Palazzo Contarini, Venice)*. 1908. 92 x 81 cm. Kunstmuseum Saint Gallen. Purchased with funds from the Ernst Schürpf Foundation. Photograph by Carsten Seltrecht

Le Palais Contarini *(Palazzo Contarini, Venice)*. 1908. 73 x 92 cm. Private Collection

190: Autoportrait de Claude Monet Coiffé d'un Béret *(Self-Portrait of the Artist Wearing a Beret)*. 1886. 56 x 46 cm. Private Collection. Photograph Galerie Durand-Ruel, Paris

193: Effet de Neige au Soleil Couchant (Argenteuil sous la Neige) *(Snow Effect at Sunset [Argenteuil under the Snow])*. 1875. 53 x 64 cm. Musée Marmottan, Paris. Bequest of Madame Donop de Monchy

195: Torrent de la Petite Creuse à Fresselines *(Rapids on the Petite Creuse at Fresselines)*. 1889. 65 x 92 cm. The Metropolitan Museum of Art, New York. Bequest of Miss Adelaide Milton de Groot (1876–1967), 1967

197: Les Quatre Arbres *(Poplars)*. 1891. 81.9 x 81.6 cm. The Metropolitan Museum of Art, New York. Bequest of Mrs. H. O. Havemeyer, 1929. The H. O. Havemeyer Collection

198: Standing portrait of Monet beside the water-lily pond. c. 1904. Photograph Bulloz, Paris

200: Camille dans le Jardin de la Maison d'Argenteuil *(Camille in the Garden of the House at Argenteuil)*. 1876. 81 x 59 cm. Collection the Honorable and Mrs. Walter H. Annenberg

Le Jardin de Monet à Argenteuil *(Monet's Garden at Argenteuil)*. 1873. 60 x 81 cm. Private Collection

201: L'Escalier à Vétheuil *(Steps at Vétheuil)*. 1881. 80 x 65 cm. Private Collection. Photograph William Beadleston, Inc., New York

203: Auguste Renoir. Madame Claude Monet avec son Fils *(Portrait of Madame Monet and her Son)*. 1874. 50 x 68 cm. National Gallery of Art, Washington. Ailsa Mellon Bruce Collection

Édouard Manet. La Famille Monet au Jardin *(The Monet Family in their Garden)*. 1874. 61 x 99.7 cm. The Metropolitan Museum of Art, New York. Bequest of Joan Whitney Payson, 1975

Auguste Renoir. Monet Painting in his Garden at Argenteuil. 1873. 18⅜ x 23½". The Wadsworth Atheneum, Hartford. Bequest of Anne Parrish Titzell. Photograph Joseph Szaszfai

205: Le Jardin de Monet à Giverny *(Monet's Garden at Giverny)*. 1900. 81 x 92 cm. Private Collection

206: Monet in the flower garden of his home. Reproduced from an article by Royal Cortissoz, "The Field of Art; Claude Monet," published in *Scribner's Magazine*, March 1927, page 336

The flower garden at Giverny. Photograph Bulloz, Paris

207: Postcard of the central path leading to the Monet house. Private Collection

The flower garden and the studio built for the water-lily decorations. Photograph H. Roger-Viollet, Paris

208: The Japanese bridge. c. 1895. Photograph Family of Lilla Cabot Perry

The Japanese bridge. September 1900. Photograph Galerie Durand-Ruel, Paris

Monet with Monsieur Georges Durand-Ruel, Madame Joseph Durand-Ruel, and members of his family. September 1900. Photograph Galerie Durand-Ruel, Paris

209: The water-lily pond. c. 1904. Photograph Bulloz, Paris

The water-lily pond. Photograph Collection Georges Truffaut. Courtesy Société Clause

210: Two views of the water-lily pond. Photograph Collection Georges Truffaut. Courtesy Société Clause

Postcard of the water-lily pond. Private Collection

211: The water-lily pond. 1933. Photographs *Country Life* magazine, London

212: Monet on the wisteria-covered Japanese bridge. Photograph Collection Sirot-Angel, Paris

Monet and Madame Kuroki with members of his family. Photograph Families Kuroki/Matsukata

213: Monet with his close friend and biographer, Gustave Geffroy. Photograph H. Roger-Viollet, Paris

Monet by the Japanese bridge. Photograph H. Roger-Viollet, Paris

214: Chrysanthèmes *(Chrysanthemums)*. 1878. 54.5 x 65 cm. Galerie du Jeu de Paume, Musée d'Orsay, Paris. Photograph Musées Nationaux

Dahlias. 1880. 81 x 65 cm. Private Collection. Photograph E. V. Thaw & Co., Inc., New York

215: Asters. 1880. 83 x 68.5 cm. Private Collection. Photograph Galerie Schmit, Paris

Bouquet de Soleils *(Sunflowers)*. 1880. 101 x 81.3 cm. The Metropolitan Museum of Art, New York. Bequest of Mrs. H. O. Havemeyer, 1929. The H. O. Havemeyer Collection

216: Deux Vases de Chrysanthèmes *(Two Vases of Chrysanthemums)*. 1888. 73 x 92 cm. Private Collection. Photograph William Beadleston, Inc., New York

Bocal de Pêches *(Jar of Peaches)*. 1866. 55.5 x 46 cm. Staatliche Kunstsammlungen, Dresden. Photograph by Gerhard Reinhold, Leipzig-Mölkau

218: The decorations painted by Monet for the *grand salon* of Paul Durand-Ruel at 35, Rue de Rome, Paris. Commissioned in 1882 and completed in 1885. Photographs Galerie Durand-Ruel, Paris

219: Door-panel decorations for the *grand salon* of Paul Durand-Ruel. Photographs Galerie Durand-Ruel, Paris

Pêches (Panneau Décoratif) *(Peaches [Decorative Panel])*. 1883. 50.5 x 37 cm. Private Collection. Photograph Galerie Durand-Ruel, Paris

Vase de Tulipes *(Vase of Tulips)*. 1885. 50.5 x 37 cm. Private Collection. Photograph Galerie Schmit, Paris

220: Gustave Caillebotte. Orchidées (Cattleya et Antonium) et Orchidées à Fleurs Jaunes *(Orchids [Cattleya and Antonium] and Orchids with Yellow Blooms)*. 1893. Each panel 108 x 42 cm. Private Collection

221: Gustave Caillebotte. Chrysanthèmes *(Chrysanthemums)*. 1893. 73 x 60 cm. Musée Marmottan, Paris

Chrysanthèmes *(Chrysanthemums)*. 1897. 130 x 89 cm. Private Collection. Photograph Paul Rosenberg & Co., New York

222: Monet in the studio specially constructed for the water-lily decorations. c. 1923. Photograph Galerie Durand-Ruel, Paris

226–27: The second studio with the *Nymphéas, Paysages d'Eau.* **March 1908**. Photographs Galerie Durand-Ruel, Paris

230–31: The water-lily decorations. Sunday, November 11, 1917. Photograph Galerie Durand-Ruel, Paris

232–35: Architectural plans for Monet's proposed museum in the gardens of the Hôtel Biron, Paris. Prepared by Monsieur Louis Bonnier. Archives Nationales, Paris

236–37: Agapanthes *(Agapanthus)*. February 14–16, 1921. Triptych, each panel 200 x 425 cm. Photograph Galerie Bernheim-Jeune, Paris

238–39: Les Nuages *(Clouds)*. February 14–16, 1921. Triptych, each panel 200 x 425 cm. Photograph Galerie Bernheim-Jeune, Paris

240–41: Les Trois Saules *(Three Willows)*. February 14–16, 1921. Quadriptych, each panel 200 x 425 cm. Photograph Galerie Bernheim-Jeune, Paris

242: Visit of Mr. and Mrs. Martin A. Ryerson with Monet. Friday, June 4, 1920. Photograph by Mrs. Charles L. Hutchinson. Collection The Art Institute of Chicago

243: Monet with Georges Clemenceau in the water garden. June 1921. Photographs Families Kuroki/Matsukata

245: Monet and Blanche Hoschedé-Monet in the studio of the water-lily decorations. 1922–23. Photograph Librairie Jean Viardot, Paris

246–47: Architectural plans of the Musée de l'Orangerie. Photographs Service d'Architecture du Palais du Louvre

248: Monet and the willows panels. Photograph H. Roger-Viollet, Paris

249–50: Nymphéas. Les Iris *(Water Lilies. The Irises)*. 1916–23. 200 x 600 cm. Kunsthaus Zürich

251: Autochromes of Monet and his gardens by Monsieur Étienne Clémentel. c. 1917. Photographs Madame James Barrelet-Clémentel and Madame Jacques Arizzoli-Clémentel

252–54: Le Matin *(Morning)*. 1916–26. Quadriptych: 200 x 200 cm., 200 x 425 cm., 200 x 425 cm., 200 x 200 cm. Musée de l'Orangerie, Paris. Photograph Georges Routhier (Studio Lourmel) and Central Color, Paris

Les Nuages *(Clouds)*. 1916–26. Triptych, each panel 200 x 425 cm. Musée de l'Orangerie, Paris. Photograph Georges Routhier (Studio Lourmel) and Central Color, Paris

255–57: Nymphéas (formerly Agapanthes) *(Water Lilies [formerly Agapanthus])*. 1916–26. Triptych, each panel 200 x 425 cm. From left to right: The Cleveland Museum of Art, Purchase, John L. Severance Fund; The Saint Louis Art Museum, Gift of the Steinberg Charitable Fund; The William Rockhill Nelson Gallery of Art-Atkins Museum of Fine Arts, Kansas City, Missouri, Nelson Fund

Le Matin, avec Saules Pleureurs *(Morning with Weeping Willows)*. 1916–26. Triptych, each panel 200 x 425 cm. Musée de l'Orangerie, Paris. Photograph Georges Routhier (Studio Lourmel) and Central Color, Paris

258: Le Matin and Reflets Verts *(Morning and Green Reflections)*. Room I, Musée de l'Orangerie, Paris. Photograph Caisse Nationale des Monuments Historiques et des Sites. © Arch. Phot. Paris/ S.P.A.D.E.M.

Les Deux Saules *(Two Weeping Willows)* on the far wall, and on each side compositions entitled Le Matin, avec Saules Pleureurs *(Morning with Weeping Willows)*. Room II, Musée de l'Orangerie, Paris. Photograph Caisse Nationale des Monuments Historiques et des Sites. © Arch. Phot. Paris/ S.P.A.D.E.M.

259: Reflets d'Arbres *(Reflections of Trees)* on the far wall, and on each side weeping-willow compositions. Room II, Musée de l'Orangerie, Paris. Photograph H. Roger-Viollet, Paris

Vestibule of the Musée de l'Orangerie. Reproduced from an article by François Thiébault-Sisson, "Un Nouveau Musée Parisien, Les Nymphéas de Claude Monet à l'Orangerie des Tuileries," published in *La Revue de l'Art Ancien et Moderne,* June 1927, page 42

260: Les Nymphéas, Paysage d'Eau *(Water Lilies)*. 1905. 90 x 100 cm. Private Collection

262: A corner of Monet's studio in September 1900 prominently showing paintings from the series Le Bassin aux Nymphéas *(The Water-Lily Pond)* of 1899–1900. Photograph Galerie Durand-Ruel, Paris

264: Le Bassin aux Nymphéas *(Water Lilies and Japanese Bridge)*. 1899. 90.5 x 89.7 cm. The Art Museum, Princeton University. From the Collection of William Church Osborn, Class of 1883, Trustee of Princeton University (1914–51), President of the Metropolitan Museum of Art (1941–47); given by his family

265: Le Bassin aux Nymphéas *(Water-Lily Pond)*. 1899. 93 x 90 cm. Private Collection

266: Portrait of Monet in 1922, by H. B. Lachman. Reproduced from *Le Bulletin de l'Art Ancien et Moderne,* January 1924, No. 704, page 15

267: Marguerite Namara and Monet in the *Nymphéas* studio. Reproduced from "Monet—His Garden, His World" by Muriel Ciolkowska, published in *International Studio,* Volume 76 No. 309, February 1923, page 378

268: Le Bassin aux Nymphéas *(A Bridge over a Pool of Water Lilies)*. 1899. 92 x 73 cm. The Metropolitan Museum of Art, New York. Bequest of Mrs. H. O. Havemeyer, 1929. The H. O. Havemeyer Collection

Le Bassin aux Nymphéas, et Sentier au Bord de l'Eau *(Water-Lily Pond and Path Along the Water)*. 1900. 89 x 100 cm. Private Collection. Photograph Galerie Durand-Ruel, Paris

269: Le Bassin aux Nymphéas *(Water-Lily Pond)*. 1899. 81 x 100 cm. Private Collection

Le Bassin aux Nymphéas *(Pool of Water Lilies)*. 1900. 89 x 100 cm. The Art Institute of Chicago. Mr. and Mrs. Lewis L. Coburn Memorial Collection

270: Les Nymphéas, Paysage d'Eau *(Water Lilies)*. 1907. 89 x 100 cm. Collection Mrs. Charles W. Engelhard

271: Nymphéas, Soleil Couchant *(Water Lilies, Sunset)*. c. 1907. 73 x 92 cm. Private Collection. Photograph Galerie Bernheim-Jeune, Paris

272: Les Nymphéas, Paysage d'Eau *(Water Lilies)*. 1903. 81 x 99 cm. Bridgestone Museum of Art. Ishibashi Foundation, Tokyo

Les Nymphéas, Paysage d'Eau *(Water Lilies)*. 1904. 90 x 92 cm. Private Collection. Photograph The Lefevre Gallery, London

273: Le Bassin aux Nymphéas *(The Cloud)*. 1903. 74.3 x 106.7 cm. Private Collection. Photograph by David Wharton

Les Nymphéas, Paysage d'Eau *(Water Lilies)*. 1905. 90 x 100 cm. Private Collection. Photograph The Acquavella Galleries, Inc., New York

274: Les Nymphéas, Paysage d'Eau *(Water Lilies)*. 1907. 92 x 73 cm. Private Collection

275: Les Nymphéas, Paysage d'Eau *(Water Lilies)*. 1907. 100 x 81 cm. Private Collection. Photograph Sotheby's, London

276: Nymphéas *(Water Lilies)*. 1915. 149 x 200 cm. Musée Marmottan, Paris

277: Le Bassin aux Nymphéas, Giverny *(Water-Lily Pond, Giverny)*. 1919. 100 x 200 cm. Collection the Honorable and Mrs. Walter H. Annenberg

Nymphéas *(Water Lilies)*. 1919. 100 x 200 cm. Private Collection. Photograph The Acquavella Galleries, Inc., New York

278: Les Iris *(The Path Through the Irises)*. 1916–17. 200 x 180 cm. Collection the Honorable and Mrs. Walter H. Annenberg

279: Agapanthes *(Agapanthus)*. 1916–17. 200 x 180 cm. Private Collection

280: Saule Pleureur *(Weeping Willow)*. 1919. 100 x 120 cm. Musée Marmottan, Paris

281: Paysage, Saule Pleureur *(Landscape, Weeping Willow)*. 1918. 130 x 110 cm. Private Collection

282–83: Glycines *(Wisteria)*. 1918–20. Diptych, each panel 150 x 200 cm. Private Collection

284: L'Allée de Rosiers à Giverny *(The Path with Rose Trellises at Giverny)*. 1920–22. 89 x 100 cm. Musée Marmottan, Paris

285: L'Allée de Rosiers à Giverny *(The Path with Rose Trellises at Giverny)*. 1920–22. 81 x 100 cm. Musée Marmottan, Paris

286: Le Pont Japonais à Giverny, also known as Nymphéas: Pont Japonais *(Japanese Bridge at Giverny,* or *Water Lilies: The Japanese Bridge)*. c. 1923. 89 x 116 cm. The Minneapolis Institute of Arts. Bequest of Putnam Dana McMillan

287: Le Pont Japonais à Giverny *(The Japanese Footbridge at Giverny)*. c. 1923. 89 x 93 cm. Museum of Fine Arts, Houston. John A. and Audrey Jones Beck Collection

288: Le Pont Japonais *(Japanese Bridge)*. 1919. 100 x 200 cm. Musée Marmottan, Paris

304: Monet on the nasturtium-covered path leading to his house. Photograph Musée Marmottan, Paris

BIOGRAPHIES AND MONOGRAPHS ON MONET

Alexandre, Arsène. *Claude Monet.* Paris: Les Éditions Bernheim-Jeune, 1921.

Clemenceau, Georges. *Claude Monet: Les Nymphéas.* Paris: Librairie Plon, 1928.

Elder, Marc. *À Giverny, chez Claude Monet.* Paris: Bernheim-Jeune, Éditeurs d'Art, 1924.

Fels, Marthe de. *La Vie de Claude Monet.* Vie des Hommes Illustres No. 33. Paris: Librairie Gallimard, 1929.

Geffroy, Gustave. *Claude Monet: Sa Vie, Son Temps, Son Oeuvre.* Paris: G. Crès, 1922.

Grappe, Georges. *Claude Monet.* L'Art et le Beau. Paris: Librairie Artistique Internationale, n.d. (1909).

Gwynn, Stephen. *Claude Monet and His Garden.* London: Country Life Limited, 1934.

House, John. *Monet.* Oxford: Phaidon, 1977.

Isaacson, Joel. *Observation and Reflection: Claude Monet.* Oxford: Phaidon, 1978.

Joyes, Claire, Robert Gordon, Jean-Marie Toulgouat, and Andrew Forge. *Monet at Giverny.* London: Mathews Miller Dunbar, 1975.

Reuterswärd, Oscar. *Monet.* Stockholm: Å. Bonnier, 1948.

Rouart, Denis, Jean-Dominique Rey, and Robert Maillard. *Monet: Nymphéas ou Les Miroirs du Temps.* Paris: Fernand Hazan, 1972.

Seitz, William C. *Monet.* The Library of Great Painters. New York: Harry N. Abrams, 1960.

Werth, Léon. *Claude Monet.* Paris: Les Éditions G. Crès et Cie, 1928.

Wildenstein, Daniel. *Claude Monet: Biographie et Catalogue Raisonné,* I, II, and III. Lausanne and Paris: Bibliothèque des Arts, 1974, 1979.

STYLISTIC AND CRITICAL ANALYSES

Alexandre, Arsène. "Claude Monet, His Career and Work." *The Studio,* vol. 43 (March 1908), pp. 89–106.

————. "L'Épopée des Nymphéas." *Le Figaro,* October 21, 1920, p. 1.

————. "Un Paysagiste d'Aujourd'hui et un Portraitiste de Jadis." *Comoedia,* May 8, 1909, p. 3.

————. "La Vie Artistique: Les Nymphéas." *Le Figaro,* May 19, 1927, p. 2.

Bachelard, G. "Les Nymphéas ou les Surprises d'une Aube d'Été." *Verve,* nos. 27 and 28 (1952).

Baudot, Jeanne. *Renoir: Ses Amis, Ses Modèles.* Éditions Littéraires de France (1949).

Berhaut, Marie. *Gustave Caillebotte: Sa Vie et Son Oeuvre, Catalogue Raisonné des Peintures et Pastels.* Paris: La Bibliothèque des Arts, 1978.

Blanche, Jacques-Émile. "Claude Monet." *La Revue de Paris,* February 1, 1927, pp. 557–75.

Blume, Mary. "The Garden that Monet Tended." *International Herald Tribune,* December 31, 1975, p. 12.

————. "The Gardener of Giverny." *Artnews,* vol. 77, no. 4 (April 1978), pp. 50–54.

Bonnier, Louis. "Avant Projet d'un Pavillon d'Exposition pour Claude Monet." Paris, December 9, 1920.

Burty, Philippe. "Les Paysages de M. Claude Monet." *La République Française,* March 27, 1883, p. 3.

Cahen, Gustave. *Eugène Boudin: Sa Vie et Son Oeuvre.* Paris: H. Floury, 1900.

Champa, K. S. *Studies in Early Impressionism.* New Haven and London: Yale University Press, 1973.

Clemenceau, Georges. "Révolution de Cathédrales." *La Justice,* May 20, 1895, p. 1.

Cortissoz, Royal. "The Field of Art: Claude Monet." *Scribner's Magazine,* vol. 81 (March 1927), pp. 226, 329–36.

Dashiell, Samuel. "Claude Monet and Georges Clemenceau." *Arts and Decoration,* November 1923, pp. 16, 60–63.

Dittière, Monique. "Comment Monet Recouvra la Vue Après l'Opération de la Cataracte." *Sandorama,* vol. 32 (January–February 1973), pp. 26–32.

Dormoy, Marie. "La Collection Arnhold." *L'Amour de l'Art,* July 1926, pp. 241–45.

Duret, Théodore. *Histoire des Peintres Impressionistes.* Paris: H. Floury, 1906.

"Échos et Nouvelles: La Donation Claude Monet." *Le Bulletin de l'Art Ancien et Moderne,* no. 653 (October 25, 1920), p. 187.

Fénéon, Félix. *Oeuvres Plus Que Complètes.* Ed. Joan U. Halperin. Geneva: Librairie Droz, 1970.

———— (unsigned). "Le Précieux Don de Claude Monet." *Le Bulletin de la Vie Artistique,* vol. 1 (October 15, 1920), pp. 623–24.

FitzGerald, Desmond. "Claude Monet—Master of Impressionism." *Brush and Pencil,* vol. 15 (March 1905), pp. 181–95.

Flaubert, Gustave. *Par les Champs et par les Grèves (Voyage en Bretagne).* 1885.

Fourcaud, Louis de. "M. Claude Monet et le Lac du Jardin des Fées." *Le Gaulois,* May 22, 1909.

Furetières. "Au Jour le Jour: Claude Monet." *Soleil,* May 10, 1904.

Geffroy, Gustave. "Claude Monet." *L'Art et les Artists,* N.S. no. 11 (November 1920), pp. 51–81.

————. "Claude Monet." *Le Journal,* June 7, 1898. Reprinted in *Le Gaulois* (Supplément), June 16, 1898.

————. "Claude Monet." *La Justice,* March 15, 1883.

————. "Les Paysages d'Eau de Claude Monet." *Dépêche de Toulouse,* May 15, 1909.

————. *La Vie Artistique.* 8 vols. Paris: É. Dentu (vols. 1–4) and H. Floury (vols. 5–8), 1892–1903.

Gillet, Louis. *Trois Variations sur Claude Monet.* Paris: Librairie Plon, 1927.

Girault, C. "Rapport Fait au Conseil; Conseil Général des Bâtiments Civils: Hôtel Biron Pavillon Claude Monet." Paris, December 23, 1920.

This is only a selection from the wealth of material devoted to Monet; it represents those works that most contributed to the preparation of this book.

Gordon, Robert. "The Lily Pond at Giverny: The Changing Inspiration of Monet." *The Connoisseur,* vol. 184, no. 741 (November 1973), pp. 154–65.

Gordon, Robert, and Claire L. Joyes. "Claude Monet in Giverny." *Du,* December 1973, pp. 870–93.

Gordon, Robert, and Charles F. Stuckey. "Blossoms and Blunders: Monet and the State." *Art in America,* vol. 67 (January–February 1979), pp. 102–17.

Grappe, Georges. "Visites et Promenades: Chez Claude Monet." *L'Opinion,* October 16, 1920, pp. 442–43. .

Greenberg, Clement. "The Later Monet." *Art News Annual,* vol. 26 (1957), pp. 132–48, 194–96.

Hamilton, George Heard. "Claude Monet's Paintings of Rouen Cathedral." Charlton Lecture, University of Durham. London, 1960.

Hillier, Bevis. "The Monet Demesne: A Case for Restoration." *The Connoisseur,* vol. 184, no. 741 (November 1973), p. 153.

House, John. "New Material on Monet and Pissarro in London in 1870–71." *The Burlington Magazine,* October 1978, pp. 636–42.

———. "The New Monet Catalogue." *The Burlington Magazine,* October 1978, pp. 678–81.

Houville, Gérard d'. "Lettres à Émilie." *Le Temps,* May 18, 1909.

Isaacson, Joel. *Monet: Le Déjeuner sur l'Herbe.* London, 1972.

Janin, Clément. "Claude Monet." *L'Estafette,* March 10, 1892.

Jean-Aubry, Georges. *Eugène Boudin d'Après des Documents Inédits: L'Homme et l'Oeuvre.* Paris: Les Éditions Bernheim-Jeune, 1922.

Kahn, Gustave. "L'Exposition Claude Monet." *Gazette des Beaux-Arts,* 3rd ser., vol. 32 (July 1904), pp. 82–88.

———. "Les Impressionistes et la Composition Picturale." *Mercure de France,* vol. 99 (September 16, 1912), pp. 427–30.

Koechlin, Raymond. "Claude Monet." *Art et Décoration,* vol. 51 (February 1927), pp. 33–47.

Kuroe, Mitsuhiko. "Claude Monet dans les Collections Japonaises." *Bulletin Annuel du Musée National d'Art Occidental* (Tokyo), no. 2 (1968).

Lecomte, Georges. "Claude Monet ou le Vieux Chêne de Giverny." *La Renaissance de l'Art Français et des Industries de Luxe,* October 1920, pp. 402–8.

Levine, Stephen Z. *Monet and His Critics.* Outstanding Dissertations in the Fine Arts—19th Century. New York and London: Garland Publishing, Inc., 1976.

Lewison, Florence. "Theodore Robinson and Claude Monet." *Apollo,* vol. 78 (September 1963), pp. 208–11.

Lostalot, Alfred de. "Exposition Internationale de Peinture" (Galerie Georges Petit). *Gazette des Beaux-Arts,* 2nd ser., vol. 31 (June 1885), pp. 529–32.

———. "Exposition des Oeuvres de M. Claude Monet." *Gazette des Beaux-Arts,* 2nd ser., vol. 27 (April 1, 1883), pp. 342–48.

Martet, Jean. *M. Clemenceau Peint par Lui-Même.* Paris: A. Michel, 1930.

———. *Le Tigre.* Paris: A. Michel, 1930.

Marx, Roger. "Les 'Nymphéas' de M. Claude Monet." *Gazette des Beaux-Arts,* 4th ser., vol. 1 (June 1909), pp. 523–31.

Michel, André. "Les Arts à l'Exposition Universelle de 1900: L'Exposition Centennale: La Peinture Française." *Gazette des Beaux-Arts,* 3rd ser., vol. 24 (November 1, 1900), pp. 463–82.

———. "Les Salons de 1895: De Quelques Manières de Peindre: Huile et Détrempe." *Feuilleton du Journal des Débats,* May 17, 1895.

Mirbeau, Octave. "Claude Monet." *L'Art dans les Deux Mondes* (Paris: Durand-Ruel), March 7, 1891, pp. 183–85.

———. *Claude Monet: Vues de la Tamise à Londres (1902–1904).* Paris: Galeries Durand-Ruel, 1904.

———. *Les "Venise" de Claude Monet.* Paris: Bernheim-Jeune et Cie, 1912.

Mitchell, Henry. "Earthman: The Gardener Monet: His Images, His Reality." *The Washington Post,* October 26, 1975, p. E 15.

Moffett, Charles S. *Monet's Water Lilies.* New York: The Metropolitan Museum of Art, 1978.

Monet, Claude. "Donation par Mr. Claude Monet à l'État Français." April 12, 1922.

Olmer, Pierre. "Le Musée Claude Monet à l'Orangerie des Tuileries." *L'Architecture,* vol. 40 (June 15, 1927), pp. 183–86.

"$100,000 in Pictures Destroyed by Monet." *The New York Times,* May 16, 1908.

Pays, Marcel. "Un Don Précieux: 'Les Nymphéas' de Claude Monet Attendent un Emplacement." *Excelsior,* May 16, 1921.

Proietti, Maria Letizia. *Lettere di Claude Monet.* Assisi: Beniamino Carucci Editore, 1974.

Proust, Marcel. "Les Éblouissements." *Le Figaro* (Supplément Littéraire), June 15, 1907, p. 1.

Régamey, Raymond. "La Formation de Claude Monet." *Gazette des Beaux-Arts,* 5th ser., vol. 15 (February 1927), pp. 65–84.

Rewald, John. *The History of Impressionism.* 4th rev. ed. New York: The Museum of Modern Art, 1973.

———. "Theo van Gogh, Goupil and the Impressionists." *Gazette des Beaux-Arts,* January and February 1973.

Rivière, Georges. "Les Nymphéas de Claude Monet et les Recherches Collectives des Impressionistes." *L'Art Vivant,* June 1, 1927, pp. 426–29.

———. "Les Nymphéas: Exposition de Paysages d'Eau par Claude Monet." *Journal des Arts,* June 2, 1909.

Robinson, Theodore. "Claude Monet." *The Century Magazine,* vol. 44 (September 1892), pp. 696–701.

Sabbrin, Celen. *Science and Philosophy in Art.* Philadelphia: William F. Fell & Co., 1886.

Seiberling, Grace. *Monet's Series.* Outstanding Dissertations in the Fine Arts, no. 5. New York and London: Garland Publishing, Inc., 1982.

Seitz, William C. "Monet and Abstract Painting." *College Art Journal,* vol. 16 (Fall 1956), pp. 34–46.

Silvestre, Armand. Preface to *Galerie Durand-Ruel: Receuil d'Estampes Gravées à l'Eau-forte.* Paris, London, and Brussels: Maisons Durand-Ruel, 1873.

Sloane, Joseph C. "The Paradoxes of Monet." *Apollo 103* (June 1976), pp. 494–501.

Suarez, Georges. *La Vie Orguilleuse de Clemenceau.* Paris: Les Éditions de France and Gallimard, 1930.

Symons, Arthur. "Art: A Monet for London." *The Outlook,* March 25, 1905.

Thiébault-Sisson, François. "Claude Monet." *Le Temps,* December 7, 1926, p. 3.

———. "Un Don de M. Claude Monet à l'État." *Le Temps,* October 14, 1920, p. 2.

———. "À l'Orangerie des Tuileries: Les 'Nymphéas' de Claude Monet." *Le Temps,* May 18, 1927, p. 4.

———. "La Vie Artistique: Claude Monet." *Le Temps,* April 6, 1920, p. 3.

Tschudi, Hugo von. "Die Sammlung Arnhold," *Kunst und Künstler.* Berlin: Bruno Cassirer, 1908–9.

Tucker, Paul H. *Monet at Argenteuil.* New Haven: Yale University Press, 1982.

Van Gogh, Vincent. *The Complete Letters of Vincent van Gogh.* 3 vols. Greenwich, Conn.: New York Graphic Society, 1958.

Venturi, Lionello, ed. *Les Archives de l'Impressionisme.* 2 vols. Paris and New York: Durand-Ruel, 1939.

INTERVIEWS AND WITNESS ACCOUNTS

Alexandre, Arsène. "Le Jardin de Monet." *Le Figaro,* August 9, 1901.

Arnyvelde, André. "Chez le Peintre de la Lumière: 'Je Sais Tout' Interviewe Claude Monet." *Je Sais Tout,* vol. 10 (January 15, 1914), pp. 29–38.

Barbier, André. "Monet, C'est le Peintre." *Arts,* July 31–August 6, 1952, p. 10.

Billot, Léon. "Exposition des Beaux-Arts." *Journal du Havre,* October 9, 1868.

Byvanck, Willem G. C. *Un Hollandais à Paris en 1891: Sensations de Littérature et d'Art.* Paris: Perrin et Cie, 1892.

Ciolkowska, Muriel. "Monet—His Garden, His World." *International Studio 76* (February 1923), pp. 371–78.

Clemenceau, Georges. *Lettres à une Amie 1923–1929.* Ed. Pierre Brive. Paris: Gallimard, 1970.

Delange, René. "Claude Monet." *L'Illustration,* January 15, 1927, pp. 54–60.

Dewhurst, Wynford. "A Great French Landscapist: Claude Monet." *The Artist,* vol. 29 (October 1900), pp. 56–66.

Gassier, Pierre. "Monet et Rodin Photographiés chez Eux en Couleur." *Connaissance des Arts 278* (April 1975), pp. 92–97.

Gimpel, René. *Journal d'un Collectioneur, Marchand de Tableaux.* Paris: Calmann-Lévy, 1963. English translation: *Diary of an Art Dealer.* New York: Farrar, Straus and Giroux, 1966.

Guillemot, Maurice. "Claude Monet." *La Revue Illustrée,* vol. 13 (March 15, 1898), n.p.

Hoschedé, Jean-Pierre. *Claude Monet: Ce Mal Connu.* 2 vols. Geneva: Pierre Cailier Éditeur, 1960.

————. *Blanche Hoschedé-Monet—Peintre Impressioniste.* Rouen: Lecerf, 1961.

Howard-Johnston, Paulette. "Une Visite à Giverny en 1924." *L'Oeil, 171* (March 1969), pp. 28–33, 76.

Jean-Aubry, Georges. "Une Visite à Giverny: Eugène Boudin et Claude Monet." *Havre-Éclair,* August 1, 1911.

Jeanniot, Georges. "Notes sur l'Art: Claude Monet." *La Cravache Parisienne,* June 23, 1888, pp. 1–2.

Kahn, Maurice. "Le Jardin de Claude Monet." *Le Temps,* June 7, 1904.

Le Roux, Hugues. "Silhouettes Parisiennes: L'Exposition de Claude Monet." *Gil Blas,* March 3, 1889.

Maupassant, Guy de. "La Vie d'un Paysagiste." *Gil Blas,* September 28, 1886.

Mirbeau, Octave. "Lettres à Claude Monet." *Les Cahiers d'Aujourd'hui,* vol. 5 (November 29, 1922), pp. 161–76.

Pach, Walter. "The Field of Art: At the Studio of Claude Monet." *Scribner's Magazine,* vol. 43 (June 1908), pp. 765–67.

Pays, Marcel. "Une Visite à M. Claude Monet dans Son Ermitage de Giverny." *Excelsior,* January 26, 1921.

Perry, Lilla Cabot. "Reminiscences of Claude Monet from 1889 to 1909." *The American Magazine of Art,* vol. 18 (March 1927), pp. 119–25.

Salomon, Jacques. "Chez Monet, avec Vuillard et Roussel." *L'Oeil, 197* (May 1971), pp. 20–25.

Taboureux, Émile. "Claude Monet." *La Vie Moderne,* June 12, 1880, pp. 380–82.

Thiébault-Sisson, François. "Autour de Claude Monet: Anecdotes et Souvenirs." *Le Temps,* December 29, 1926, p. 3.

————. "Autour de Claude Monet: Anecdotes et Souvenirs, II." *Le Temps,* January 8, 1927, p. 3.

————. "Claude Monet: Les Années d'Épreuves." *Le Temps,* November 26, 1900.

————. "Un Nouveau Musée Parisien: Les Nymphéas de Claude Monet à l'Orangerie des Tuileries." *La Revue de l'Art Ancien et Moderne,* vol. 52 (June 1927), pp. 40–52.

Trévise, Duc de. "Le Pèlerinage de Giverny." *La Revue de l'Art Ancien et Moderne,* vol. 51 (January and February 1927), pp. 42–50 and 121–34.

Truffaut, Georges. "Le Jardin de Claude Monet." *Jardinage,* no. 87 (November 1924), pp. 54–59.

Vauxcelles, Louis. "Chez les Peintres: Un Après-midi chez Claude Monet." *L'Art et les Artistes,* vol. 2 (December 1905), pp. 85–90.

EXHIBITION CATALOGUES

Several of the catalogues cited contain essays of great value to Monet scholarship.

1874 Paris, 35, Boulevard des Capucines. *Société Anonyme des Artistes Peintres, Sculpteurs, Graveurs, Etc.*

1928 Berlin, Galerien Thannhauser. *Claude Monet.*

1931 Paris, Musée de l'Orangerie. *Claude Monet.*

1936 Paris, Galerie Paul Rosenberg. *Claude Monet (Oeuvres de 1891 à 1919).*

1945 New York, Wildenstein Galleries. *Claude Monet.*

1952 Zurich, Paris, and The Hague: Kunsthaus; Galeries des Beaux-Arts; and Gemeentemuseum. *Monet.*

1954 London, Marlborough Fine Art. *Claude Monet.*

1957 Edinburgh and London: Royal Scottish Academy sponsored by the Edinburgh Festival Society; The Tate Gallery arranged by The Arts Council of Great Britain. "Claude Monet."

1957 Saint Louis and Minneapolis: City Art Museum of Saint Louis; The Minneapolis Institute of Arts. *Claude Monet.*

1959 Paris, Galerie Durand-Ruel. *Claude Monet.*

1960 New York and Los Angeles: The Museum of Modern Art; Los Angeles County Museum. *Claude Monet—Seasons and Moments.*

1962 Basel, Galerie Beyeler. *Claude Monet, Letzte Werke.*

1969 New York, Richard L. Feigen Gallery. *Claude Monet.*

1969 London, The Lefevre Gallery. *Claude Monet: The Early Years.*

1970 Paris, Galerie Durand-Ruel. *Claude Monet.*

1971 Paris, Musée Marmottan. *Monet et Ses Amis, le Legs Michel Monet, la Donation Donop de Monchy.*

1973 Tokyo, Kyoto, and Fukuoka: Galeries Seibu; Kyoto Municipal Museum; Centre Culturel de Fukuoka. *Exposition Claude Monet.*

1973 London, Hayward Gallery sponsored by The Arts Council of Great Britain. *The Impressionists in London.*

1974 Paris, Grand Palais. *Centenaire de l'Impressionisme.*

1974 Paris, Galerie Durand-Ruel. *Hommage à Paul Durand-Ruel—Cents Ans d'Impressionisme.*

1975 Chicago, Art Institute of Chicago. *Paintings by Monet.*

1976 New York, Acquavella Galleries, Inc. *Claude Monet.*

1977 Boston, Museum of Fine Arts. *Monet Unveiled: A New Look at Boston's Paintings.*

1978 New York, The Metropolitan Museum of Art. *Monet's Years at Giverny: Beyond Impressionism.*

1980 Paris, Grand Palais. *Hommage à Claude Monet.*

1982–83 Tokyo and Kyoto: Musée National d'Art Occidental; Musée National d'Art Moderne. *Claude Monet.*

ARCHIVES IN PARIS

The archives of the Galerie Durand-Ruel and Galerie Bernheim-Jeune, and documents from the Académie Goncourt, the Archives Nationales, and the Musée Clemenceau have been crucial to the development of this book.

Monet on the nasturtium-covered path leading to his house; his last summer

Just after the unveiling of the water-lily panels in the spring following the death of Monet, Paul Signac wrote this letter to the painter's daughter-in-law:
My first outing was for the *Water Lilies*. I came away marveling; there are no doubts to entertain, no criticisms to make. Monet succeeded in what he wanted to do. Too bad for those who have reservations: it proves that they are not sensitive to painting and insist on making literature. Monet was able to conduct his orchestra to the end. There is not the slightest discord. And those who say that the final retouching spoiled the work are being too clever. I looked in vain for those last retouchings. And all the same I know a little about painting. Besides, among these subtle critics, who are the ones who were admitted to Monet's house and could have compared the two stages?

Let's not forget that the last Turners, the most beautiful of all, were judged and ranked as insane, senile, and unpresentable by Ruskin, his admirer....

That is how it always is when an artist outdoes himself. It is the case with Monet.

Generally, when I leave a painting exhibition, I am glad to see the sky, trees and streets again; when I left the *Water Lilies*, everything looked dry and flat to me.

I will go back often.